THE PRINCETON SERIES IN
NINETEENTH-CENTURY ART, CULTURE,
AND SOCIETY

The Landscape of Belief

The Landscape of Belief

ENCOUNTERING THE HOLY LAND

IN NINETEENTH-CENTURY AMERICAN

ART AND CULTURE

John Davis

PRINCETON UNIVERSITY PRESS

PRINCETON, NEW JERSEY

Library of Congress Cataloging-in-Publication Data

Davis, John, 1961–
The landscape of belief : encountering the Holy Land in nineteenth-
century American art and culture / John Davis.
p. cm.—(The Princeton series in nineteenth-century art,
culture, and society)
Includes bibliographical references and index.
ISBN 0-691-04373-6
1. Palestine in art. 2. Art, American. 3. Art, Modern—19th
century—United States. 4. Art and religion—United States—
History—19th century. I. Title. II. Series.
N8214.5.I75D38 1995
758'.15694'097309034—dc20 95-7051
 CIP

This book has been composed in Adobe Garamond
by The Composing Room of Michigan, Inc.

Princeton University Press books are printed on acid-free paper and meet the
guidelines for permanence and durability of the Committee on Production Guidelines
for Book Longevity of the Council on Library Resources

Printed in the United States of America by Princeton Academic Press

10 9 8 7 6 5 4 3 2 1

DESIGNED BY CAROL S. CATES

For My Parents

✦

Contents

List of Illustrations xi

Acknowledgments xvii

Introduction 3

PART I

Chapter One
The American Identification with the Holy Land 13

Chapter Two
The American Presence in the Holy Land 27

Chapter Three
Panoramic Imagery in the Early Nineteenth Century 53

Chapter Four
Landscape, Photography, and Spectacle in the Late Nineteenth Century 73

PART II

Chapter Five
Miner Kellogg, Mount Sinai, and the New Jerusalem Church 101

Chapter Six
Edward Troye's Holy Land Series: The Flow of Sacred Waters 127

Chapter Seven
James Fairman: The View from Outside 149

Chapter Eight
Frederic Church's Late Career: The Landscape of History 168

Epilogue 208

Notes 219

Select Bibliography: Primary Sources 245

 Secondary Sources 249

Index 257

Illustrations

(*Unless otherwise noted, all dimensions are in inches, and the medium is oil on canvas.*)

Plates

1. Miner Kellogg, *The Top of Mount Sinai with the Chapel of Elijah*, n.d. 19-1/2 × 28-1/2. National Museum of American Art, Smithsonian Institution, Washington, D.C.

2. Edward Troye, *The Dead Sea*, c. 1856. 66 × 124. Bethany College, West Virginia

3. James Fairman, *The Mussulman's Call to Prayer*, 1876. 31-3/4 × 45. Private collection

4. James Fairman, *Sunset*, n.d. 32 × 44-1/2. Graham Company, Philadelphia

5. Frederic Church, *Jerusalem from the Mount of Olives*, 1870. 54-1/4 × 84-3/8. The Nelson-Atkins Museum of Art, Kansas City, Missouri (Gift of the Enid and Crosby Kemper Foundation), F77-40.

6. Frederic Church, *Syria by the Sea*, 1873. 56 × 85. © Detroit Institute of Arts. Gift of Mrs. James F. Joy

7. Frederic Church, *El Khasné, Petra*, 1874. 60-1/2 × 50-1/4. New York State Office of Parks, Recreation, and Historic Preservation, Olana State Historic Site, Taconic Region

Figures

1. Thomas Hovenden, *Jerusalem the Golden*, n.d. 30 × 40. Metropolitan Museum of Art, New York. Gift of Mrs. Helen C. Hovenden

2. Washington Allston, *Belshazzar's Feast*, 1817–43. 144-1/8 × 192-1/8. © Detroit Institute of Arts. Gift of the Allston Trust

3. William S. Jewett, *The Promised Land—The Grayson Family*, 1850. 50-7/8 × 65. Courtesy Berry-Hill Galleries, New York

4. Thomas Cole, *The Course of Empire: Destruction*, 1836. 39-1/4 × 63-1/2. Courtesy of the New-York Historical Society, New York

5. Thomas Cole, *The Course of Empire: Desolation*, 1836. 39-1/2 × 61. Courtesy of the New-York Historical Society, New York

6. John Landis, *Jesus in the Upper Room*, 1836. 13-7/8 × 19. Philadelphia Museum of Art, the Titus C. Geesey Collection

7. John Landis, *Madonna and Child Visiting the Family of John the Baptist*, n.d. Watercolor, 9-5/16 × 13-7/16. © 1994 The Board of Trustees, National Gallery of Art, Washington. Gift of Edgar William and Bernice Chrysler Garbisch

8. William Herman Rau, *E. Wilson Seated atop the Great Pyramid, with American Flag Jacket*, 1882. Stereo photograph. Dan Kyram Collection, Jerusalem

9. *Patriotic Pageant, American Colony, Jerusalem*, n.d. Photograph. Private collection

10. *George Jones Adams*, n.d. Photograph. Library of Congress, Washington, D.C.

11. Thomas Hicks, *Bayard Taylor*, 1855. 24-1/2 × 29-3/4. National Portrait Gallery, Smithsonian Institution, Washington, D.C.

12. Fridolin Schlegel, *Braheem Effendi, Por-*

trait of *William C. Prime*, 1857. 36 ×
29-1/8. Courtesy of the New-York His-
torical Society, New York

13. Thomas Cole, *The Angel Appearing to
the Shepherds*, 1833–34. 101-1/2 × 185-1/2.
The Chrysler Museum, Norfolk, Vir-
ginia. Gift of Walter P. Chrysler, Jr., in
memory of Colonel Edgar William and
Bernice Chrysler Garbisch

14. David Roberts, *The Departure of the Is-
raelites from Egypt*, 1829. 137.2 × 182.9
cm. Birmingham City Museum and Art
Gallery

15. John Martin, *Belshazzar's Feast*, 1820. 32
× 48. Wadsworth Atheneum, Hartford,
Connecticut, The Ella Gallup Sumner
and Mary Catlin Sumner Collection
Fund

16. Engraved key to John Whichelo, *The
Destruction of Jerusalem, A.D. 70*, n.d.
From *Grand Exhibition of Paintings*

17. Frederick Catherwood broadside (de-
tail), c. 1838. Private Collection

18. Catherwood panorama key, 1837. From
*Description of a View of the City of
Jerusalem*

19. *The Machinery for Banvard's Moving
Panorama*. From *Scientific American*, 16
December 1848

20. John Banvard broadside (detail), 1852.
Missouri Historical Society, St. Louis

21. Currier and Ives, *Entrance to the Holy
Sepulchre, Jerusalem*, 1849. Lithograph,
13.1 × 8.4. Library of Congress, Wash-
ington, D.C.

22. Key to *Banvard's Historical Landscape*,
1863

23. William James, *Mount Olivet*, 1866.
Stereo photograph. The Bert M.
Zuckerman Collection

24. "Map of Modern Jerusalem," 1900.
From Kent, *Descriptions*

25. R. E. M. Bain, *Mt. Tabor*, 1894. From
Vincent and Lee, *Earthly Footsteps*

26. R. E. M. Bain, *Inn of the Good Samar-
itan*, 1894. Photograph. Library of Con-
gress, Washington, D.C.

27. R. E. M. Bain, *The Arch of the Ecce
Homo, Jerusalem*, 1894. From Vincent
and Lee, *Earthly Footsteps*

28. R. E. M. Bain, *The Lower Pool of Solo-
mon*, 1894. Photograph. Library of
Congress, Washington, D.C.

29. R. E. M. Bain, *The Spot Where Christ
Prayed—Garden of Gethsemane*, 1894.
From Vincent and Lee, *Earthly
Footsteps*

30. R. E. M. Bain, *Flocks near the Pit into
which Joseph was Thrown by His Breth-
ren*, 1894. Photograph. Library of Con-
gress, Washington, D.C.

31. R. E. M. Bain, *The Tower of Jezreel*,
1894. Photograph. Library of Congress,
Washington, D.C.

32. R. E. M. Bain, *Ancient Bronze Doors,
Tiberias*, 1894. Photograph. Library of
Congress, Washington, D.C.

33. R. E. M. Bain, *A Woman of Samaria*,
1894. Photograph. Library of Congress,
Washington, D.C.

34. R. E. M. Bain, *Dervish Beggars*, 1894.
From Vincent and Lee, *Earthly Footsteps*

35. *Palestine Park*, after 1888. Photograph,
used by permission of the Chautauqua
Institution Archives

36. *Palestine Park*, n.d. Photograph, used by
permission of the Chautauqua Institu-
tion Archives

37. *Chautauqua Men in Middle Eastern
Dress*, n.d. Photograph, used by permis-
sion of the Chautauqua Institution
Archives

38. *Oriental Group in Palestine Park*. From
Harper's New Monthly Magazine 59 (Au-
gust 1879)

39. H. C. White Co., *Walls of Jerusalem and
the Ferris Wheel Looking from West
Restaurant Pavilion*, 1904. Stereo photo-

graph. Library of Congress, Washington, D.C.

40. Miner Kellogg, *Self-Portrait*, n.d. 29-1/8 × 23-1/8. Cincinnati Art Museum. Gift of Paul G. Pennoyer

41. Miner Kellogg, *Nile, 3rd and 4th Views*, 1844. Pencil on paper, 13 × 8-3/4. National Museum of American Art, Smithsonian Institution, Bequest of Martha F. Butler

42. Miner Kellogg, *View of Theban Mountains*, 1844. Pencil on paper, 8-3/4 × 13. National Museum of American Art, Smithsonian Institution, Bequest of Martha F. Butler

43. Miner Kellogg, *Sphynx with Pyramids of Ghizeh*, 1844. Pencil on paper. National Museum of American Art, Smithsonian Institution, Bequest of Martha F. Butler

44. Miner Kellogg *Jerusalem*, 1844. Watercolor, 10-3/4 × 17-1/2. National Museum of American Art, Smithsonian Institution, Washington, D.C. Bequest of Martha F. Butler

45. Miner Kellogg, *Sketch of the Artist Camped outside Jerusalem*, n.d. Oil on cardboard, 11-3/4 × 10. Cincinnati Art Museum. Gift of Paul G. Pennoyer

46. Miner Kellogg, map of Mount Sinai and surrounding area. From *Literary World* 3 (February 1848)

47. Miner Kellogg, *Mount Sinai and the Valley of Es-Seba'iyeh*, n.d. 53 × 89. Present whereabouts unknown. Photograph, National Museum of American Art, Smithsonian Institution, Bequest of Martha F. Butler

48. Henry Cheever Pratt, *Moses on the Mount*, 1828–29. 48-1/2 × 60-1/2. Shelburne Museum, Vermont

49. Miner Kellogg, *St. John—Descent of the New Jerusalem*, n.d. Pencil on paper. National Museum of American Art, Smithsonian Institution, Bequest of Martha F. Butler

50. Miner Kellogg, *The Sphinx*, 1858. Gallier House Museum, Tulane University, New Orleans, Louisiana

51. Edward Troye, *John Bascombe*, n.d. 25 × 30. Yale University Art Gallery, Whitney Collections of Sporting Art, New Haven, Connecticut. Given in memory of Harry Payne Whitney, B.A. 1894, and Payne Whitney, B.A. 1898, by Francis P. Garvan, B.A. 1897, M.A. (Hon.) 1922

52. Edward Troye, *Bazaar in Damascus*, c. 1856. 84 × 64. Bethany College, West Virginia

53. Edward Troye, *The Sea of Tiberias*, c. 1856. 44 × 66. Bethany College, West Virginia

54. Edward Troye, *River Jordan—Bethabara*, c. 1856. 44 × 66. Bethany College, West Virginia

55. Edward Troye, *Syrian Ploughman*, c. 1856. 72 × 120. Bethany College, West Virginia

56. François Marius Granet, *The Choir of the Capuchin Church of Santa Maria della Concezione in Rome*, 1815. 77-1/2 × 58-1/4. Metropolitan Museum of Art, New York, gift of L.P. Everard

57. Edward Troye, *Self-Portrait in a Carriage*, 1852. 38 × 54. Yale University Art Gallery, Whitney Collections of Sporting Art, New Haven, Connecticut. Given in memory of Harry Payne Whitney, B.A. 1894, and Payne Whitney, B.A. 1898, by Francis P. Garvan, B.A. 1897, M.A. (Hon.) 1922

58. Benjamin W. Kilburn, *Tilling the Soil in Palestine*, c. 1873. Stereo photograph. The Bert M. Zuckerman Collection

59. Worthington Whittredge, *Graves of Travellers, Fort Kearney, Nebraska*, 1865. 7-5/16 × 23-13/16. © The Cleveland Museum of Art, 1994, Andrew R. and Martha Holden Jennings Fund, 69.29

60. William Holman Hunt, *The Scapegoat*, 1854–55. 33-3/4 × 54-1/2. The Board of Trustees of the National Museums and Galleries on Merseyside [Lady Lever Art Gallery, Port Sunlight, England]

61. Promotional photograph of James Fairman, n.d. Private collection

62. James Fairman, *Alpine Landscape with River*, 1871. 32-1/2 × 45-1.8. Frank S. Schwarz and Son Gallery, Philadelphia

63. James Fairman, *Jerusalem from the Mount of Olives*, 1875. 31-3/4 × 45. Private collection

64. James Fairman, *View of Jerusalem*, n.d. 32 × 45. Private collection

65. James Fairman, *View of Jerusalem*, n.d. 32 × 44. Courtesy Mathaf Gallery, Ltd., London

66. James Fairman, *Jerusalem*, n.d. 31 × 44. Courtesy Museum of Church History and Art of the Church of Jesus Christ of Latter-day Saints, Salt Lake City, Utah

67. James Fairman, *Jaffa*, 1874. 31-3/4 × 35. Private collection

68. James Fairman, *Figures in a Middle Eastern Landscape*, n.d. 30-1/4 × 40-1/8. Private collection

69. Frederic Church, *Heart of the Andes*, as exhibited at the Metropolitan Sanitary Fair, New York, 1864. One half of stereo photograph. Courtesy of the New-York Historical Society, New York

70. Detail of plate 3

71. Frederic Church, *Moses Viewing the Promised Land*, 1846. Oil on academy board, 9-1/2 × 12-1/4 (oval). Collection of Dr. Sheldon and Jessie Stern. Photograph courtesy Kennedy Galleries, Inc., New York

72. Frederic Church, *Hooker and Company Journeying through the Wilderness from Plymouth to Hartford, in 1636*, 1846. 40-1/4 × 60-3/16. Wadsworth Atheneum, Hartford, Connecticut

73. Frederic Church, *West Rock, New Haven*, 1849. 26-1/2 × 40. New Britain Museum of American Art, Connecticut, John B. Talcott Fund

74. Frederic Church, *Cotopaxi*, 1862. 48 × 85. © Detroit Institute of Arts, Founders Society Purchase with funds from Mr. and Mrs. Richard A. Manoogian, Robert H. Tannahill Foundation, Gibbs-Williams Fund, Dexter M. Ferry Jr. Fund, Merrill Fund

75. Frederic Church, *Ruins at Baalbek*, 1868. 21-3/4 × 36-1/4. Private collection

76. Frederic Church, *Anti-Lebanon*, 1869. 21-1/2 × 36. Private collection

77. Théodore Frère, *Jerusalem, View from the Valley of Jehoshaphat*, 1881. 74 × 110.5 cm. Metropolitan Museum of Art, New York. Bequest of Catharine Lorillard Wolfe

78. Frederic Church, *Classical Ruins, Syria*, 1868. Oil on thin creamboard, 7 × 10. Cooper-Hewitt, National Design Museum, Smithsonian Institution, New York. Gift of Louis P. Church

79. A. de Jorio, *Present State of the Temple of Serapis at Pozzuoli*, 1830. Engraving by T. Bradley, from Lyell, *Principles of Geology*

80. Frederic Church, *View from the Mountains toward Damascus, Syria*, 1868. Oil on thin creamboard, 4-1/2 × 8-9/16. Cooper-Hewitt, National Design Museum, Smithsonian Institution, New York. Gift of Louis P. Church

81. Andrew Melrose, *Damascus*, n.d. 30 × 48-1/2. Private collection

82. Detail of plate 5

83. Engraved key to Frederic Church, *Jerusalem*, 1870. The Nelson-Atkins Museum of Art, Kansas City, Missouri

84. Frederic Church, *Mountains of Edom*, 1870. 20 × 30. Private collection

85. Frederic Church, *Two Bedouin*, 1868. Oil on cardboard. 12-1/2 × 17-7/8. Cooper-Hewitt, National Design Museum, Smithsonian Institution, New York. Gift of Louis P. Church

86. Frederic Church, *Tropical Moonlight*, 1874. 30-1/4 × 25-1/4. The Fine Arts Museums of San Francisco. Anonymous loan, L76.12

87. Frederic Church, *Sunrise in Syria*, 1874. 30-1/2 × 25-1/2. Kennedy Galleries, Inc., New York

88. R. E. M. Bain, *Ruins of the Synagogue at Capernaum*, 1894. Photograph. Library of Congress, Washington, D.C.

89. Engraving after Frederic Church, *A Composition*, 1879. From Benjamin, "Fifty Years of American Art"

90. Frederic Church, *Moonrise in Greece*, 1889. 14-1/8 × 20-1/4. Santa Barbara Museum of Art, California. Gift of Mrs. Lockwood de Forest

91. Jasper Cropsey, *The Spirit of Peace*, 1851. 43-3/4 × 67-3/8. Woodmere Art Museum, Philadelphia. Bequest of Charles Knox Smith

92. Frederic Church, *The Aegean Sea*, c. 1877. 54-1/4 × 84-3/8. Metropolitan Museum of Art, New York. Bequest of Mrs. William H. Osborn

93. Frederic Church, *Syria—Ruins by the Sea*, n.d. 10-1/2 × 18. Courtesy of the Reading Public Museum, Pennsylvania

94. Robert and Emily de Forest, *Court Hall, Olana*, 1884, albumen print, 6-1/4 × 8-3/8, David Huntington Archive, New York State Office of Parks, Recreation, and Historic Preservation, Olana State Historic Site, Taconic Region

95. Henry O. Tanner, *The Good Shepherd*, c. 1902–3. 27 × 32. Jane Voorhees Zimmerli Art Museum, Rutgers, The State University of New Jersey, New Brunswick. In memory of the deceased members of the Class of 1954

96. Sanford Gifford, *Jaffa Gate, David's Tower*, 1869. Pencil on paper, 4-7/8 × 8-1/2. Private Collection. Photograph, courtesy Hirschl and Adler Galleries, New York

97. Lockwood de Forest, *Coast Scene*, 1892. 21 × 30. National Academy of Design, New York

98. John Sargent, *The Plains of Esdraelon*, 1905–6. 28 × 43-1/2. Tate Gallery, London

99. John Sargent, *Near the Mount of Olives*, 1905–6. 25-1/2 × 38. Fitzwilliam Museum, Cambridge, England

100. John Sargent, *Palestine*, 1905–6. 22-1/4 × 28-1/2. Private collection

Acknowledgments

It is both a pleasant and a frustrating task to put together the list of names and institutions that conventionally begins a book of this sort. Nothing could be more pleasurable than to offer public thanks to those friends who have, over many years, provided the support, encouragement, and intellectual engagement that enabled me to bring this project to fruition. Yet because the book did develop over an extended period, through several incarnations and within a variety of institutional settings, I know that I risk omission of a number of helpful individuals who have, through acts of kindness small and large, made a difference in the way that I have formulated and pulled together my thoughts on the place of the Holy Land in the visual culture of the United States. For such omissions I apologize, and for the kindnesses shown me, I offer here my sincere thanks.

In a world of shrinking resources and budgets, it is a great privilege to be given the gift of time and material assistance to pursue one's research. I am thus extremely grateful to those institutions that have generously supported this project: the Department of Art History and Archaeology of Columbia University, the Henry Luce Foundation, the Center for Advanced Study in the Visual Arts, the Mrs. Giles Whiting Foundation, and the Committee on Faculty Compensation and Development of Smith College. In the course of my research, I was also fortunate to be hosted and assisted by the helpful staffs of a number of rich archival collections: the Archives of American Art, the British Library, the Jewish National and University Library (Hebrew University), the Cincinnati Historical Society, the Cleveland Museum of Art, the Indiana Historical Society, the National Academy of Design, the National Archives, the National Sporting Library, Olivet College, Bethany College, and Olana State Historic Site.

Many individuals have been equally generous with their time, and with their willingness to share ideas. Those who have read and commented on various portions and versions of this text include my dedicated and inspiring teachers Barbara Novak, Allen Staley, and Richard Brilliant, and my friends and colleagues Gerald Ackerman, Kevin Avery, David Bjelajac, Bruce Dahlberg, Donna Divine, Ella Foshay, Franklin Kelly, Katherine Manthorne, Angela Miller, Jack Salzman, Roger Stein, Greg White, and Karen Zukowsky.

Others who provided aid at crucial moments include Yehoshua Ben-Arieh, Victoria Brewer, Timothy Burgard, the late Martha F. Butler, Gerald Carr, Margaret Conrads, Nancy Davenport, Moshe Davis, Francis E. Fairman, William H. Gerdts (and the William H. Gerdts Reference Library), Randall Griffin, Gail Husch, Alfreda Irwin, Ruth Kark, Dan Kyram, Keith Lewinstein, Mary Lublin, Henry MacAdam, Brian MacDermot, Merl M. Moore, Jr., Christine Oaklander, Kate Nearpass Ogden,

Deborah Rindge, James Ryan, Robert Sandercox, Janice Simon, William Stapp, David Steinberg, Winona Stirling, Joel Sweimler, William Truettner, Elliot Vesell, Lester Vogel, Ila Weiss, and Bert Zuckerman.

Earlier drafts of some of the material presented here appeared in "Frederic Church's 'Sacred Geography,'" *Smithsonian Studies in American Art* 1 (Spring 1987): 78–96, and "Holy Land, Holy People? Photography, Semitic Wannabes, and Chautauqua's Palestine Park," *Prospects* 17 (1992): 341–71. I am grateful to the editors of these publications for their initial support and for permission to publish reworked versions. I also benefited from the thoughtful comments of audience members on the occasions when material from this book was delivered in a lecture format. In particular, I wish to thank the engaged listeners at the Metropolitan Museum of Art, the National Gallery of Art, the National Museum of American Art, and the annual meeting of the College Art Association.

Two groups deserve special mention. The hardworking staff of Princeton University Press—particularly Elizabeth Powers, Timothy Wardell, Elizabeth Johnson, and Jane Lincoln Taylor—made the potentially trying task of book production into a remarkably easy and pleasant experience. Closer to home, my colleagues and students in the Department of Art at Smith College have provided me with an ideal environment, unfailingly warm and supportive, in which to realize this volume. It is a joy to be a part of an institution that values teaching and scholarship so highly, and provides so much encouragement for development in both areas.

Finally, I am profoundly indebted to the members of my family, whose confidence and support have been unflagging throughout the long duration of this project. It is to Jason Heffner, however, that I owe the most. Our years of partnership have given newfound meaning and possibility to all my endeavors, and for that I am more grateful than I can possibly express.

The Landscape of Belief

Religion is first and foremost a way of managing *this* world.
—Margaret R. Miles, *Image As Insight*

Introduction

In a public appeal to the most famous landscape painter of his day, Nathaniel Parker Willis, one of the first American literary figures to travel extensively in the Middle East, gave early voice to the cultural phenomenon that is the subject of this book. "Pray Mr. Cole," he wrote in one of his published letters, "leave things that have been painted so often, as aqueducts and Italian views (though you *do* make delicious pictures, and could never waste time or pencils on *any* thing,) and come to the east for one single book of sketches!"[1] Unlike the artists who are my primary concern in these pages, Thomas Cole never acted on Willis's suggestion, yet to invoke his name is to find ourselves at an appropriate point of departure. Much of Cole's art addressed the same seminal questions—about faith, nature, and national destiny—that framed the experiences of those Americans who did travel east, and in particular, those who sought out the Holy Land.

The special relationship with the lands of the Bible that Americans constructed for themselves was premised on a single metaphor, remarkably potent and synoptic, which explained the United States as a new Israel, a New World promised land reserved for members of a favored nation. The land that had given birth to the Book and the land that was its fulfillment merged in an associational equation of biblical incident and national aspiration. The actual landscape of Palestine and Syria was invoked as a validation, not only of the authenticity of the Bible, but also of the notion of America as heir to the sacred topography. This conflation of gospel and government, far from being a hoary relic of Puritan theocracy, remains with us today, as a line cribbed from the Book of Matthew and worked into the Republican Party platform of 1992 makes abundantly clear: "In choosing hope over fear, Americans raised a beacon, reminding the world that we are a shining city on a hill; the last best hope for man on earth."[2] At issue three hundred years ago, and to an almost equal degree during this more recent national episode, were the most fundamental attempts by the Protestant hierarchy at collective self-definition. The medium for that endeavor, as with so many examples of state mythologizing, was the landscape.

The degree to which a geo-scriptural fusion of writ and region (as well as a wishful, time-transcending imperialism) had come to determine attitudes toward the land is apparent in the optimistic delimitation of the borders of the United States articulated by Arthur Bird at the end of the nineteenth century. Moving well beyond

the domain of the Monroe Doctrine, Bird saw the omnivorous republic as "bounded on the north by the North Pole; on the South by the Antarctic . . . ; on the east by the first chapter of the Book of Genesis and on the west by the Day of Judgment."[3] In this definition, "east" begins with the Mediterranean Bible, rather than the northern European origins of the earliest settlers, for the Holy Land was understood as different from "corrupt" Europe, as Willis had earlier intimated to Cole. The emotional relationship of Americans to Palestine thus transcended their ties to England or the Continent, much like a younger generation that rejects its parents to identify with an (often fictional) image of its grandparents. It was a relationship rooted in the past, and yet it seemed also to hold the key to the future.

That its expression should have occurred through the vehicle of the landscape is not surprising. While the importance of other pictorial modes (such as genre and still life) is gradually coming into focus through recent scholarship, the midcentury dominance of landscape painting in American art is still historically clear. As a carrier of meaning, it played a crucial role in fostering and shoring up national myths, providing normalizing knowledge of new territorial conquests, and creating the comforting sense of an "American" school of art.[4] When artists of the United States found themselves in the Holy Land, then, it was only natural that they turned their attention not to conventional European Orientalist genre scenes, but to depictions of the "pure" landscape, especially as it was popularly believed that figural scenes, even if taken from scripture, would not be tolerated by the market.[5] The author and painter Thomas G. Appleton addressed this crucial issue of the appropriate artistic response to the Holy Land when he wrote:

> But there is another kind of landscape which represents historic sites, wonderful cascades, and lofty mountains, which the artist is learning to go far to represent. As historic landscape, Palestine is full of those suggestive sites, those eloquent battle-fields and homes of kings and prophets, which do not need the help of mere beauty to give them interest. This charm hangs over the whole land, and no artist can fail to feel that his subject is adequate, if, beside the faithful rendering of sacred scenes, he should manage to give with it that sentiment of the place to which no beholder can be indifferent.[6]

The chapters that follow are concerned with these images of the Holy Land terrain and their reception and use by diverse segments of the American populace. This diversity is significant. Although the initial concept of an American Zion—the abstraction structuring the special relationship between "old" and "new" Israel—derived from Puritan efforts at self-justification and remained a rhetorical tool of the dominant New England plutocracy throughout the nineteenth century, the Holy Land (as an idea and as a tangible geographic entity) was a subject of fascination to men and women of various classes, sects, regions, and races. That the majority of American images reflected the perspective of those best able to travel to the Middle East—Protestant men representing (or attempting to speak to) the upper, mercantile classes—is surely an important consideration, but it did not apparently lessen the more general popular appeal of the imagery.

One should not conclude from this that the concept of the Holy Land was spread so thinly that it lost any particular meaning through a weakening process of symbolic dilution. The power of a metaphor and the extent to which it successfully permeates society, in fact, only increases with its mutability. The metaphor of the Holy Land had a supple resilience, easily straddling the fence dividing the realms of the sacred and the secular. It could become both a screen onto which religious ideologies of a remarkable variety were projected, and a convenient lever for boosting nationalistic causes; it was a goal, a means, and an end—a central, absorbing concept that could be made to signify according to the needs of almost any situation.

Though its physical size is minute when compared to the yawning territories of North America, as a landscape of the psyche the Holy Land was expansive and broad, with a complex set of cultural ramifications that demand a variety of interpretive perspectives. Thus there are several lines of inquiry threaded through this study. One of them approaches the problem by acknowledging the primacy of subject in nineteenth-century attempts to contextualize the Holy Land image. It asks why specific sites were depicted, how the works were explained and received, and what can be learned from their manner of execution—from the way in which they construct a Palestinian "reality" on canvas or paper. It seeks insight by examining the beliefs and opinions, largely religious and scientific but also racial and political, of artist, patron, and viewer, and by tracing the debate engendered by these views as it was presented in the contemporary press. It recognizes the impossibility of complete cultural reconstruction but holds that verbal and material evidence can serve as a foundation for interpretation, without ever becoming that interpretation itself. I hope, in short, to provide an initial attempt at filling what Deborah Dash Moore has described as a crucial gap in the scholarly literature on America and Palestine, the exploration of the "cultural landscape" of the Holy Land.[7]

Another, broader endeavor is to investigate the manner by which the representation of a "foreign" land—an act usually grounded as much in the observer's perception of self as in any kind of external reportage—is ultimately turned into commentary, not on the visited place, but on the homeland left behind, as well as the world it occupies and its place within that world. How could the profoundly national enterprise of American landscape painting be divorced from its local context and transported to the Holy Land? The answer is that it was not. Rather, the Holy Land went through a process of localization and *became* American. Its depictions were premised not only on visual and moral possession, but also on its representers' claim (one with immeasurably far-reaching imperial implications) to understand it better than those who inhabited it: "We know far more about the land of the Jews than the degraded Arabs who hold it," asserted one magazine writer in 1855.[8] This "knowledge," objectified and culturally transmitted by the images, allowed their makers to use the land (and occasionally its inhabitants, though they were more often ignored) to validate and elevate their own sense of history, perpetuating important "ancestral" myths of American exceptionalism.

Throughout, I will attempt to remain sensitive to the particular confluence of sensory and cognitive conditions that obtain during the experience of travel, a tem-

poral and physical mode of perception discussed insightfully by John Urry under the rubric of "the tourist gaze."[9] This involves several levels of transformation on the part of the traveler. It begins with the departure—an absolute break in daily routine and a willful separation from familiar social and spatial relationships. The actual journey thus takes place during a heightened, liminal state. It necessarily entails movement through space and often results in intense visual acuity and attention to the landscape. The tourist gaze lingers before sights in a way rarely experienced in the "home" environment. It is both passive and active, unusually open and absorptive, but also controlling and enframing. It is a gaze that is most often constructed of a preexisting series of visual and textual representations, or "enframements," of the place, an index of responses that has, over time, conferred importance and difference on the site. The final stage in this touristic process is that of the return, or reintegration, a culminating experience that is anticipated throughout the journey, never far from the traveler's consciousness.

For artists, this process of reintegration often consists of the production of images, the translation of interior experience into material product. The public reception of such images completes the process of reintegration to the home environment. The driving impetus, though, at any stage of the journey, is the quest for authenticity— "a modern version of the universal human concern with the sacred," in Urry's words.[10] Indeed, the language of travel shares much of its vocabulary with the language of religious pilgrimage. The Holy Land, then, perhaps uniquely for nineteenth-century Americans, fused the two, bridging the proverbial gap in modern life between sacred and secular time and space.

My text is divided into two parts. The first is a broad, but necessarily limited, overview of the pervasiveness of the "idea" of the Holy Land in the pre-twentieth-century culture of the United States. Chapter 1 locates an affective, conceptual identification with the Holy Land in the early coastal colonies and briefly traces it through sermons, poetry, political metaphor, and wartime rhetoric into the first century of the new nation. Chapter 2 examines the concrete ties to the region— missionary endeavors, colonial attempts, archaeological expeditions, travel volumes —that added a perceptual, and even empirical, component to that relationship. It attempts to provide something of the contemporary climate of attitudes toward the eastern Mediterranean, describing and analyzing the historical conditions and events that would have been part of the general reservoir of knowledge brought to Holy Land images by artists and interested nineteenth-century viewers. The next two chapters look at some of these perceptions themselves, as manifested through selected aspects of popular visual culture: panorama paintings, three-dimensional models, stereographs, and books of travel photography. Throughout this section, I lay particular stress on contemporary textual evidence as a way of conveying both the urgency and the surprising currency of the debates surrounding the meaning of the Holy Land. These written sources are also useful in providing some framework for an understanding of works of art no longer extent, most notably the panorama paintings.

The second part of the book focuses attention on four easel painters: Miner Kellogg, Edward Troye, James Fairman, and Frederic Church—all of whom traded in the imagery of the Holy Land. In contrast to the broader, survey approach of part 1, these chapters are conceived as case studies; they range in their concerns, emphases, and methods, and no one of them purports to offer a complete treatment of the given artist or his work. The example of Frederic Church is typical. I am concerned here almost exclusively with his Mediterranean paintings executed in the late 1860s and 1870s, rather than the better-known American wilderness scenes of earlier decades. The point, however, is not to isolate these works as a separate chapter but rather to demonstrate their connection to all that preceded them. Because of the terrible and undeniable trauma of the Civil War, historians of nineteenth-century American art tend to place their subjects chronologically on one side or the other of this brutal conflict. (Most of our college lecture courses, my own included, begin or end with the date 1860.) This creates the false impression that lives and careers were incapable of crossing the great midcentury divide. In fact, some of the most interesting cultural transformations occurred at just this moment, when the artists who lived through the war years as adults "crossed over" into a radically different era in which they were still forced to maintain a professional existence.

To even the casual student of American art history, it will be immediately clear that the four painters of part II occupy widely varying positions in the modern critical estimation, from the clear preeminence of Church, with new books devoted to his art appearing almost yearly, to the utter obscurity of Fairman, all but unrepresented in the scholarly literature. So it was in the nineteenth century as well. One aspect of Holy Land imagery that should be established by the end of this study, however, is its "leveling" property, which made it appropriate and successful subject matter for both a social and professional titan such as Church and a scrambling fringe figure such as Fairman, forever locked out of the New York institutional art establishment. I suspect that there are many James Fairmans still awaiting scholarly disinterment, fascinating individuals with large, regionally diverse audiences who, because of their extensive activities outside the urban Northeast, were never part of the organizations, such as the National Academy of Design, that governed the writing of the first histories of American art. Likewise, Kellogg and Troye offer new perspectives to the standard accounts of American painting. In the context of my own work, they demonstrate the degree to which competing sectarian voices—specifically those of the followers of Swedenborgianism and of the Disciples of Christ—articulated their own visions of the Holy Land, and extracted from them the visual data necessary for specific conditions of belief.

During most of the nineteenth century, much of the eastern Mediterranean region and nearly all of the area that Westerners thought of as the Holy Land was nominally under Ottoman Turkish control. The territory was actually divided into small provincial administrative units (*sanjaks*), and it was the local authority of the governors of these provinces, rather than the central power of Istanbul, that mattered most in the daily affairs of law and commerce. A good many American travelers in the Holy Land, however, felt themselves above any Middle Eastern law, whether local, provin-

cial, or imperial. They often experienced their Palestinian sojourn as if they were traveling into some distant, biblical past, with the contemporary Ottoman realities remaining unacknowledged and ignored. Our historical view must be less blinkered. A brief sketch of some of the most important developments in nineteenth-century Ottoman Palestine will serve as a starting point.[11]

The Palestine encountered by the earliest American travelers at the outset of the nineteenth century was in many ways quite different from that of the turn of the twentieth century. While much certainly remained the same, the nineteenth century is nevertheless seen by historians of the Ottoman Empire as an era of important change and reform. Ottoman Turks (who should not be confused with the indigenous Arab population, always a majority in the region) had been in control of Palestine, or "Greater Syria," since the early sixteenth century. By the nineteenth century, their direct authority had waned considerably in favor of local hierarchies of power, usually religious or clannish. A small military and governmental bureaucracy dominated society but had little direct contact with most inhabitants, especially those who lived outside the cities. Instead, the Ottoman representatives dealt only with the heads or "notables" of the various local communities, creating a highly compartmentalized society, with no clear structure of group interaction. This was particularly true of members of non-Muslim communities—Druze, Jewish, and a large variety of Christian sects—who, although officially second-class citizens, were allowed relative self-determination in internal matters of law, education, and social services. Nevertheless, they were heavily taxed by the central authority.

With the reign of Sultan Selim III (1789–1807), however, a series of sometimes halting governmental reforms commenced, efforts that were enlarged on by his successors Mahmud II (1808–39) and Abd ul-Mejid (1839–61). In general, these reforms can be characterized as federal and secular in nature. Provincial and military corruption began to be addressed, resulting in a strengthening of central authority, to the detriment of local networks. A nonreligious intellectual class grew up and was welcomed into the newly reconstituted Ottoman bureaucracy. Conditions of health and agriculture (the latter the principal source of regional wealth) improved, the population burgeoned (Jerusalem, for example, grew from about nine thousand residents in 1800 to some forty thousand in 1890), and contact with Western nations increased through trade. Midcentury steamboat traffic on the Mediterranean and the opening of the Suez canal were crucial to this economic expansion.

Americans would have been aware of these changes to the extent that they influenced the international political scene. In 1798 Napoleon's occupation of Cairo and his failed conquest of Syria signaled a new era of Western involvement in the region. In response, Great Britain and Russia joined the Ottoman Empire in opposing France's bid for territory. Napoleon's short-term defeat of the existing political system in Egypt, however, allowed Muhammad 'Ali, an Albanian-born Ottoman soldier, to assume the post of Egyptian governor, or "pasha." Western-oriented, with a large and disciplined military force, Muhammad 'Ali invaded Greater Syria following a dispute with the Ottoman sultan; he occupied the Holy Land from 1831 to 1840. This decade of Egyptian rule resulted in swift advances in social and administrative

reform, as well as more favorable treatment of non-Muslims. Although the Turks, with European aid, ultimately succeeded in driving the Egyptians back to Cairo, many of the reforms they had instituted remained behind, to the delight of Western visitors to Palestine, who found the governing structure there increasingly open to the West. The surge in Holy Land tourism during these years may also have influenced Ottoman policy in the region; Istanbul no doubt realized that the ability to visit sacred sites was a major bargaining chip in its Western relations. The province of Palestine thus took on a new strategic importance in the second half of the nineteenth century.

International disputes aside, American attitudes toward the Turks were largely dependent on the treatment of resident Christians. Thus there was particular antipathy toward the Ottomans at moments of domestic and religious crisis: during the Greek war for independence, in the wake of the infamous insurrection at Damascus in 1860 that left thousands of Christians massacred, and at the time of the Christian revolts in Bosnia, Herzegovina, and Bulgaria in the late 1870s. Each of these incidents predisposed Americans against the Turkish Empire and its Arab subjects before they even arrived in the Holy Land; in the case of artists, the events also had repercussions for the public reception of their works.

To a degree, however, visiting Westerners were insulated from these problems while they were touring or living in the Holy Land. American travelers in the nineteenth century would have found there a highly heterogeneous society, particularly in the religiously important city of Jerusalem. It was a polyglot culture, with Arabic serving as the tongue of daily life. Their degree of interaction with this cosmopolitan society, however, was usually quite limited, even in Jerusalem. As a rule, Turkish authorities allowed foreigners exceptional privileges in the spheres of law and lifestyle; essentially they were allowed to keep to themselves. For example, non-Ottoman subjects enjoyed a certain immunity from local judicial systems and were "protected" by their local consular representative. Consuls thus became powerful individuals in Holy Land expatriate communities. They frequently functioned as police officers, lawyers, judges, and juries. They presided over a close-knit community of Western missionaries, archaeologists, colonists, tourists—and at times, artists.

A final note on terminology. Despite its imprecision (but also, I must admit, because of it), I have chosen to use the expression "Holy Land" throughout much of the text. With "Palestine" and "Syria," which I also employ on occasion, "Holy Land" was used fairly interchangeably in the nineteenth-century Western nomenclature for the Ottoman provinces of the eastern Mediterranean. (Depending on the writer's geographic awareness, "Palestine" commonly stood for a southern region encompassing parts of present-day Israel, Jordan, and the Israeli-occupied territories, while "Syria" referred to an area to the north, loosely covering parts of today's nations of Lebanon and Syria.) In reality, though, to nineteenth-century Americans "the Holy Land" meant any part of the Middle East that could be connected with the Bible; it might be used to describe selected areas of present-day Egypt, Turkey, Iraq, and even Saudi Arabia, in addition to the more traditional locations.

The motto of the Jerusalem YMCA proclaims, "Where the feet of Jesus have trod

is the Holy Land."[12] My use of the term, however, is in contrast to this sectarian definition. I write "Holy Land" hoping that despite the vagaries of postcolonial borders and twentieth-century political disputes, it will be remembered that the land remains holy to many faiths and many peoples, no one of which, like the subjects of this study, can claim fully to "possess" it.

PART I

✦

The American Identification
with the Holy Land

Let *Israel* be the evidence of
the *Doctrine*, and our glass
to view our Faces in.

This short imperative, declaimed by John Danforth in the Massachusetts Assembly chamber at the beginning of the eighteenth century, contains within its succinct formulation the sentiments constituting the foundation of the nineteenth-century American fascination with the Holy Land. "Israel," understood as the people of the biblical nation, and by extension the land they inhabited, became a concept repeatedly invoked over three centuries of American cultural development as a justification for the course of history and as a corrective to doubt. Endlessly mutable, it soon became and long remained "the essence of America's motivating mythology," in the words of Conrad Cherry.[1] As "evidence," it supported national and religious beliefs of all varieties. Widely divergent social and spiritual movements turned to the Holy Land—and the events that had taken place there—to find proof, both scriptural and topographical, for specific assertions of dogma and claims of primacy. More directly, however, the Holy Land operated critically in the formation of a variety of discrete American self-definitions. As Danforth's metaphor of the mirror indicates, New World colonists, and many of their descendants, saw their lives as typological reflections of the people and events that constituted the Old World Zion. The history of the Holy Land was at once a guide, a template, and a warning. If the Bible did not provide a complete prescription for the development of the American nation, it nevertheless demonstrated the possibilities and made predictions about its eventual outcome.

While the Puritan roots of this "New Jerusalem" conceit had been present in English dissenting religious communities well before the departure of the earliest American colonists, the typological assertions seemed to be expressed with a new urgency at the time of the Atlantic voyage. Entries in crossing diaries describe the perils of the trip in terms of the miraculous passage of the Israelites through the Red Sea, a geographical image that would repeatedly surface through centuries of New World typological writings.[2] Like the children of Israel, colonists were traversing an

imposing body of water to escape religious persecution. Upon arriving, they contin-
ued to develop the metaphor until it took on a literalness far beyond what had been
seen in Europe. Samuel Wakeman's election-day sermon preached at Hartford in
1685, for example, made a straightforward equation: "*Jerusalem* was, *New England* is,
they were, you are God's own, God's covenant people."[3]

Like its biblical precedent, the New England covenant was interpreted and exe-
cuted by certain chosen individuals. Preeminent among these was Governor John
Winthrop of Massachusetts, called "Governor of Israel" by Cotton Mather. Mather,
in his *Magnalia Christi Americana*, forcefully stressed the parallels between living
colonists and biblical figures. Winthrop was both Nehemiah, rebuilder of the de-
stroyed Jerusalem, and Moses (in later generations, Washington and Lincoln would
take on this role); the early Puritan leaders Edward Hopkins and Francis Higginson
were a latter-day Solomon and Noah, respectively. British kings, from Charles I to
George III, were assigned the roles of Pharaoh or Haman. Such comparisons seemed
all the more apt in the context of the seventeenth century, when many learned
persons knew Hebrew. John Cotton was not being contentious, therefore, when he
made the somewhat brazen declaration that in their relationship to Christ, the
American colonists were equal to the Israelites in "proportion and resemblance of his
life."[4]

It was only natural that the scriptural language the colonists used to describe both
their errand and themselves would be brought to bear on the one great reality that
confronted their every undertaking: the land. The new Massachusetts wilderness was
seen as "desert"—with the biblical capability of becoming a land of milk and honey.
Similar conventions operated in New Netherland, where the seventeenth-century
poet Jacob Steendam seized the same lines to describe the Hudson River valley.
Further south, in Virginia, Robert Beverley was more direct in evoking the Holy
Land: "[Virginia] is very near of the same Latitude with the Land of Promise. Be-
sides, As *Judoea* was full of Rivers . . . So is *Virginia.* . . . All the Countries in the
World, seated in or near the Latitude of *Virginia*, are esteem'd [for
their] . . . Clymates. As for Example, *Canaan, Syria, Persia.*"[5] Native populations,
frequently thought to be descendants of a lost Israelite tribe, provided another pos-
sible link for the land. The Reverend John White speculated that the Indian name
for Salem, "Naumkeag," actually derived from the Hebrew "Nahum Keike," which
he translated as "the bosom of consolation." Much later, in 1825, Mordecai M. Noah,
a powerful Democratic journalist in New York City, attempted to found a Jewish
homeland, "Ararat," on an island in the Niagara River, a plan that included the
optimistic projection of reuniting Native Americans with "their brethren the chosen
people."[6]

After an initial reluctance in New England to name places after holy sites (so as
not to privilege any one location as especially sanctified), the New World topography
became dotted with Canaans, Bethlehems, and Goshens. Such a molding of the
cultural landscape helped lead to the inherited familiarity that later Americans, less
steeped in Puritan metaphor, nevertheless felt for the Holy Land. Nineteenth-
century viewers thus needed little prompting to cast their eyes about New England

and see the same vision of biblical terrain as their colonial forebears had. Often, this power of suggestion came from artistic stimuli. When Mark Hopkins, the president of Williams College, visited a "Panorama of Jerusalem" in Boston, for example, he "remained there till the scene took full possession of his mind." Riding out to the hills of Brookline shortly thereafter, he found that "they were immediately associated in his mind with the Panorama of Jerusalem, and then with the glories of the Jerusalem above. This association was indissoluble, and he would take his friends out to see his 'Mount Zion.'"[7]

The resilience of the American identification with the Holy Land comes not from a desire to emulate or remain within the past, but from the applicability of the concept to a uniquely sanctioned future. Taking his cue from Christ's prophetic Sermon on the Mount, John Winthrop wrote in 1630 of an anticipated American destiny while he was still in transit on the Atlantic voyage: "For wee must Consider that wee shall be as a Citty upon a Hill."[8] His celebrated allusion to the Book of Matthew would have had significance beyond a mere figural simile, for a colonist well versed in biblical geography would have understood a reference to the actual city of Jerusalem, situated high on a rocky ridge. A protean concept at best, "Jerusalem"—or the "New Jerusalem"—stood variously for the historical Israelite capital and its people, the thriving, righteous nation envisioned by American colonists, and the true Protestant church rooted in and predicted by scripture.

The conflation of old and new Israel, however, was not a complete fusion. Rather, the former stood behind the latter, justifying and supporting the quest of God's final chosen people. When it came time to form a new state free of the bonds of England, Americans, in pushing forward, kept one eye always on the scriptural past. Creatively stretching a historical example in his election-day sermon of 1775, Harvard's president, Samuel Langdon, discerned the roots of the budding American democracy not where one might expect them, in ancient Greece, but in the Old Testament Jewish government, which he cited as an appropriate model for a modern state opposed to monarchy. Thirteen years later, on the eve of the ratification of the Constitution, he even less plausibly located the origin of the system of legislative and judicial checks and balances in the Israelite state. "If I am not mistaken, instead of the twelve tribes of Israel, we may substitute the thirteen states of the American union," his listeners were assured.[9]

Even beyond the pulpit, such comparisons were common in the early days of the new nation. In 1776, Benjamin Franklin and Thomas Jefferson both proposed models for the seal of the nation that took themes from the Book of Exodus. For a republic that would become known for its constitution mandating the separation of church and state, Franklin proposed a view of Moses lifting his rod and dividing the waters of the Red Sea; Jefferson countered with a depiction of the children of Israel in the wilderness, led by a cloud by day and a pillar of fire by night.[10] If these nonsecular subjects for a federal emblem seem surprising, it is only because the enduring theocratic origins of the nation, and their grounding in the imagery of the Holy Land, have been relatively forgotten.

In fact, the widespread currency of the Holy Land metaphor in colonial life, only briefly surveyed here, created a foundation of belief that continued well into the succeeding centuries, buttressing a sustained concern with the American relationship to the Palestinian region. Perhaps the most telling aspect of this transoceanic connection (and one with important ramifications for landscape depictions) is the presumed familiarity with the land of the Bible that United States citizens inevitably claimed to possess. The "American" method of raising children, and the Protestant precepts on which that upbringing was based, were thought by writers on religious matters to inculcate a special feeling for and knowledge of the Holy Land. The most celebrated expression of this conceptual intimacy is the oft-quoted passage from Edward Robinson's ground-breaking *Biblical Researches in Palestine, Mount Sinai and Arabia Petraea*:

> As in the case of most of my countrymen, especially in New England, the scenes of the Bible had made a deep impression upon my mind from the earliest childhood; and afterwards in riper years this feeling had grown into a strong desire to visit in person the places so remarkable in the history of the human race. Indeed in no country of the world, perhaps, is such a feeling more widely diffused than in New England; in no country are the Scriptures better known, or more highly prized. From his earliest years the child is there accustomed not only to read the Bible for himself; but he also reads or listens to it in the morning and evening devotions of the family, in the daily village-school, in the Sunday-school and Bible-class, and in the weekly ministrations of the sanctuary. Hence, as he grows up, the names of Sinai, Jerusalem, Bethlehem, the Promised Land, become associated with his earliest recollections and holiest feelings.[11]

Robinson's book was a fact-packed, eminently rational approach to the geography and archaeology of the Holy Land, and he therefore laid stress on what he remembered as the clear didactic reinforcement he received as a child in Connecticut. Yet the very reference to this early chapter of his life compromises the supposedly objective method of his work. It defines his trip as a journey backward and inward, an interior trek associated with the institutions of school, church, and family. The Holy Land thus becomes both personalized and communalized, as well as localized. Throughout the passage, in fact, Robinson's language is most insistent in his repeated, specific invocations of New England; the names of his nominal objects of study, Sinai and Jerusalem, are relegated to the realm of "recollections" and "feelings."

Other American travelers' responses to Palestine, such as that of the Methodist Episcopal bishop Henry White Warren, were even less reasoned, cast largely in a dreamy, atemporal haze of nostalgia:

> This is the first country where I have felt at home. Yet I have been in no country that is so unlike my own. Somehow this seems as if I had lived here long ago in my half-forgotten youth, or possibly in some ante-natal condition, dimly remembered. As I try to clear away the mists, bring forward the distant, and make present what seems prehistoric, I find myself at my mother's side and my early childhood renewed. Now I see

why this strange country seems so natural. Its customs, sights, sounds, and localities were those I lived among in that early time, as shown to me by pictures, explained by word, and funded as a part of my undying property.[12]

Warren's suggestive range of sentiments is symptomatic of the attitudes of many Americans: an ambivalence toward the landscape mediated by an amorphous sense of the past, a need to invoke their cultural roots as a legitimizing tie to the biblical region, and a feeling of possessiveness that prompted repeated assertions of a national "claim" to the Holy Land as patrimony. Indeed, William Gilpin, one of the principal American promoters of western expansionism and Manifest Destiny, went so far as to isolate "the Plateau of Syria" and the Mississippi basin as twin cradles of human civilization, centers of world progress where a favored race of people had in the past, and would soon again, conclude a "divine mission."[13]

An intriguing constant in expressions of familiarity by Warren and others is a reference to their mothers. An anonymous naval officer visiting the Holy Land (almost certainly from the U.S.S. *Delaware*, which stopped at Jaffa in 1834) reflected on the sacred sites he was about to witness, adding, "With these thoughts came dimly up from the past 'the spot where I was born'—the familiar illustrations by my departed mother of the very events I was now contemplating." Much later, a review of a book entitled *Pictures from Bible Lands* in the American *Art Journal* spoke of "lands apart from other lands—sacred from association and early teachings at our mother's knee."[14]

Undoubtedly, the potency of the Holy Land metaphor derived in part from its intertwining with the regressive domestic myth of "home and hearth" and idyllic notions of youth. The excitement of the actual arrival in Palestine probably triggered a particularly forceful wave of nostalgia; childhood associations often arise at such heightened emotional moments, when the intellect strains to make sense of overwhelming mental and visual stimuli. Yet at the other end of the life cycle, the imagery was no less present, as Wilbur Zelinsky's study of American cemetery names makes clear. Among the most common are Mount Calvary, Mount Olivet, Holy Sepulchre, Zion, Mount Sinai, and Mount Lebanon.[15] In the realm of easel painting, Thomas Hovenden's canvas *Jerusalem the Golden* (fig. 1), executed late in the century at a time when many of these cemeteries were flourishing, depicts a pale invalid listening to the comforting hymn of the same title, thus playing on the association of welcome death with the holy city.

The link between past and present in all such references to the Holy Land was thought to be the Bible. As Giles Gunn has expressed it, "The Bible has become America's book not only because Americans like to think that they have read it more assiduously than other people but also because Americans like to think that the Bible is the book that they, more than any other people, have been assiduously read by."[16] Throughout the nineteenth century, individuals and groups continued the Puritan search for reassurance by seeing that their own history fit conveniently into the framework of holy writ. The task became a personal one because of the stress Protestantism laid on the duty of each believer to come to his or her own understanding of

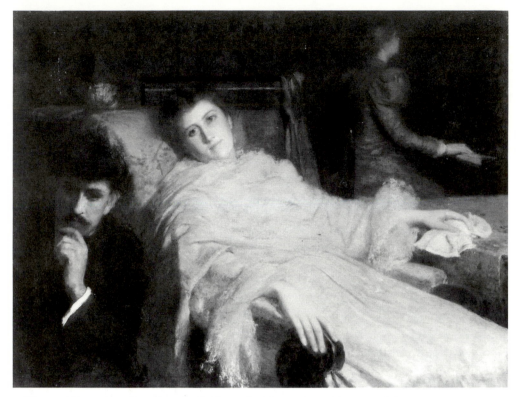

1. Thomas Hovenden, *Jerusalem the Golden*, n.d., Metropolitan Museum of Art

religious truths in the Bible through a process of reading, observation, and reflection. Unlike the Roman and Eastern churches, Americans would maintain, the various Protestant faiths worked for universal knowledge of scripture, not clergy-proclaimed dogma filtered down through priestly interpretations.

As the statements by Robinson and Warren make clear, the intimate acquaintance with the Bible cultivated by American Protestants began in childhood. The very means of instruction often served to create an artificial sense of having experienced the Holy Land terrain. Bishop John Heyl Vincent provides one example. As Sunday-school secretary of the Methodist Episcopal Church, he popularized a teaching program in the mid–nineteenth century that encouraged pupils to take up a fantasy existence in the Holy Land. They would be classed at progressive levels depending on their knowledge of Palestine: "Pilgrim to the Holy Land," "Resident in Palestine," "Dweller in Jerusalem," "Explorer of Bible Lands," or "Templar." His method included asking students to write letters home from their imaginary tours in the Holy Land in order to "secure the vivid realization of actuality in the Bible narratives."[17]

The focus of these and similar programs of study, however, was not always on the same portions of the Bible. Different periods and circumstances saw changing em-

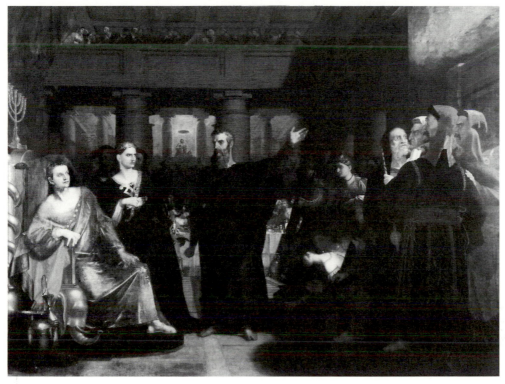

2. Washington Allston, *Belshazzar's Feast*, 1817–43, Detroit Institute of Arts

phases in the study of scripture. Although thinkers in the second half of the nine-teenth century largely concerned themselves with the exegesis of the New Testament, those of the early 1800s concentrated more on the Old Testament and its parallels with America. This "recalcitrant Hebraism," to use Perry Miller's formulation, was a natural legacy of the colonial era, particularly at the time of the Second Great Awakening, when revivalist and typological sentiment took its cue from the enthusiastic piety of the "Israel" of eighteenth-century New England.[18] For an examination of the degree to which antebellum American culture was saturated with this Old Testament imagery, one need look no further than perhaps the most famous painting of its day, Washington Allston's ill-fated project, *Belshazzar's Feast* (fig. 2).[19]

Allston and others of his generation came of age in an era steeped in the examples of the Old Testament. The Massachusetts-based painter's own typological tendencies, though, were given additional nurture by local conditions, for as David Bjelajac tells us, "Nowhere was the Old Testament cited more often as a guide to American history than in the area of Boston."[20] The subject of Allston's unfinished canvas—the dramatic event that triggered the release of the Jews from their Babylonian captivity and made possible their return to Jerusalem—was thus seen by reviewers as

a transparent reference to the American building of a New Jerusalem following the demise of an Old World Babylon. As in previous decades, the biblical roles were assigned to prominent contemporary figures: the prophet Daniel stood for Daniel Webster; Napoleon (or, depending on one's political views, Andrew Jackson—the "American Napoleon" in Whig eyes) was embodied by the ruler, Belshazzar.

At a time of particular millennial fervor, Allston's canvas evoked an American eschatological future predicated on the notion of an elect nation. Yet it was important to determine just who might lay claim to this future. Who could justifiably call themselves "elect"? In a penetrating analysis, Bjelajac has demonstrated the manipulative manner in which nineteenth-century moral and evangelical leaders made use of traditional Puritan religious symbolism in order to advance the cause of a decidedly homogenous nationalism, one that would allow established sects and ethnicities to hold sway. A survey of early-nineteenth-century Congregationalist sermons supports such an assertion. When the new Oxford (Massachusetts) meetinghouse was dedicated in 1829, for example, its pastor Ebenezer Newhall warned, "There is, my friends, a religious patriotism, as well as a civil. You love your country. But do you love Jerusalem? Do you love its temple? Let the energies of your desires be concentrated here, imbibe deeply the sacred patriotism of our text, and your community is safe."[21]

This was largely a partisan argument, with the elitist Federalist/Whigs much more likely than the populist Democrats to invoke the notion of a privileged, monolithic American destiny. Sacvan Bercovitch has isolated the means to this end in his discussion of the nineteenth-century uses of the rhetorical jeremiad, noting that Puritan practice was invoked by later religious nationalists as a "ritual leveling of all sects within the framework of *American* religion."[22] In the process, Christian diversity would be subsumed by the controlling notion of nationality, as defined by those with the power to govern the nation.

It is an important point: A chosen people can be easily exclusive, and marginal groups and outsiders are just as (and often more) easily dismissed for religious dissent as for political or ethnic nonconformity. Indeed, the resonance of all the ideals under discussion here depends on an assumed social collectivity that must in the end be reductive and somewhat artificial. It is significant, then, that the Holy Land metaphor, while always serving a primary function in the rhetoric of the dominant circles of American society, was also used by many culturally peripheral or disenfranchised groups to define themselves. Two salient examples are Mormons and African Americans.

The account of the origins of Mormonism links the pre-Christian Holy Land to the American continent in a concrete way unmatched by other sects. Like the Puritans, the Mormons were a covenant people, but the story of their break from society is quite different. The Book of Mormon recounts the journey of a family that left Jerusalem around 600 B.C.E. and traveled in a ship to the New World. Their descendants became two separate nations, the "good" Nephites—known as "former-" as opposed to "latter-day" saints—and the "bad" Lamanites. (Native Americans were thought to be Lamanite descendants.) Before the Lamanites destroyed their more

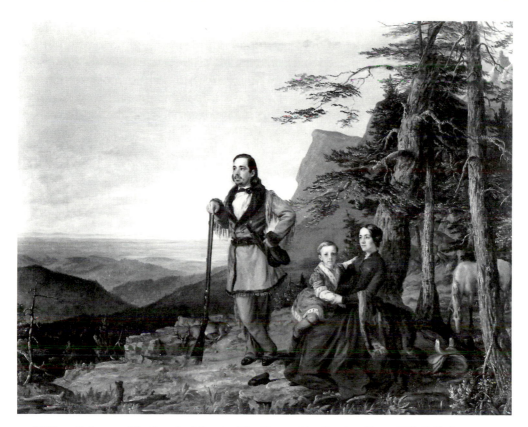

3. William S. Jewett, *The Promised Land—The Grayson Family*, 1850, Berry-Hill Galleries

virtuous brethren, a Nephite prophet, Mormon, inscribed his people's history on gold tablets that were buried by his son, remaining lost until Joseph Smith was divinely guided to them in 1827. Mormons thus considered themselves spiritual descendants of the Israelites (through the Nephites) as well as actual genealogical heirs to the biblical tribe of Ephraim (through their European forebears). Their American wilderness trek to a new Zion was easily viewed as analogous to the Mosaic journey through Sinai and Arabia Petraea, and the singular landscape features surrounding them—such as the Great Salt Lake, with its evocation of the Dead Sea, or the ever present desert, which inspired such town names as Moab, Utah—only reinforced the connection and aided in the creation of their own "sacred" space.

Others who passed through the trans-Mississippi territories were no less likely to view the landscape through a scriptural lens. When California emigrant Andrew Jackson Grayson commissioned William Jewett to memorialize his family's westward journey, for example, the result, *The Promised Land—The Grayson Family* (fig. 3), became as blatantly co-optive of holy writ as any Mormon effort at self-canonization. Just a year earlier, the preface to John C. Frémont's *Exploring Expedition to the Rocky Mountains, Oregon and California* made a claim similar to that advanced by the

Grayson portrait: "In the sunny clime of the south west—in Upper California—
may be found the modern Canaan, a land 'flowing with milk and honey,' its moun-
tains studded and its rivers lined and choked with gold!"[23]

Jewett's canvas asserts itself as a heady, perhaps incongruous amalgam of art-
historical and biblical references, drawing on iconographic formulae evocative of
old-masterish scenes of "Moses on the Mount" and "The Rest on the Flight into
Egypt." The hats of both father and son in this pioneer Holy Family have been
removed, a cue that they stand before sacred ground, and indeed, the slaughtered
deer displayed on the rock ledge recalls Old Testament accounts of sacrifices offered
on hallowed mountaintops. The regally clad boy, however, pulls the layered meta-
phor into the New Testament as he knowingly engages the viewer in the Christlike
manner of a quattrocento *Salvator mundi*. His foreboding gaze hints at a future not
shared by his uncomprehending parents, as does the poignant blue flower isolated
among the weeds in the foreground, a lone bud that is easily identifiable as an iris, a
standard symbol of the Passion. That such an ominous undercurrent could surface
amid the wide-eyed optimism that dominates *The Promised Land* only highlights the
freewheeling nature of the typological associations.

The Mormon epic similarly went a long way toward biblicizing the western fron-
tier, but this did not lessen the church's interest in the historical Bible lands. In
contrast to the Graysons, Mormons were concerned with much more than just Cali-
fornia, or even Utah. Like many dissenting religious sects, they felt that the restora-
tion of the Jews to the Holy Land was a necessary prelude to the return of the
Messiah. While their personal mission was to build a new Zion on the North Ameri-
can continent, they also took on the role of fostering the Jewish revitalization of
Jerusalem, the other heavenly city. Thus, a Mormon representative, Orson Hyde,
crossed the Atlantic to build an altar on the Mount of Olives in 1841, dedicating it to
the gathering of diaspora Jews to a new nation. Even today, the Church of Jesus
Christ of Latter-day Saints is a significant landowning presence outside the walls of
Jerusalem, and church pilgrims on the site are numerous.[24]

In a different set of circumstances, the "transfer of Zion"[25] held obvious meta-
phorical power for African American Christians in the antebellum era, as a means of
addressing the condition of slavery. Egypt, rather than Israel, was the locus of black
interest in Bible lands; enslaved in the manner of Pharaoh's bondsmen and women,
they looked expectantly to the Exodus narrative as the prescription for their future.
For most American slaves, the Promised Land existed tangibly to the north, within
the United States. Their songs, sermons, and folklore had a single-minded focus on
traveling to this Canaan and being delivered from bondage. Meanwhile, their reli-
gious culture attempted to paint a picture of life in free lands. African American
churches invariably took their names from places associated with the Holy Land:
Zion, Bethany, Shiloh, and Calvary are only a few examples. By appropriating the
concept of a chosen people on its way to the New Jerusalem, they succeeded in
elevating their seemingly abject state to that of a "divinely favored people." Although
few African Americans were able to travel to Palestine in the nineteenth century, the
image of Zion was used to promote the return to Africa advocated by some aboli-

tionists and former slaves. As Albert Raboteau has indicated, the later campaign for an African homeland used rhetoric similar to that of the emerging Zionist movement. In an apt turnabout, Americanized descendants of African slaves reversed the direction of the Puritan baptismal water journey and established Liberia as an authentic Canaan.[26]

At no time were the issues of slavery within the United States more topical than during the Civil War era, a period of unprecedented national crisis demanding an inflated metaphorical language that, not unexpectedly, turned to the Holy Land. Resurrected anew was the image of the Red Sea crossing, this time with its troubled waters colored by spilled blood. What is notable once again is the surprising elasticity of the Israelite metaphor, adaptable for use not only by slaves, but also by white Union and Confederate apologists. Abraham Lincoln, in particular, was known for his metaphorical brilliance, and he had frequent recourse to biblical imagery in the important speeches leading up to and during the war years. His "house divided" image, taken from Mark 3:25, is perhaps the most famous, but nearly every Lincoln oration has some biblical allusion, such as the references to the Book of Luke that inform the Gettysburg Address.[27]

In general, the North saw the emergence of opposing views of the implications of the war. Pessimists interpreted the strife as a decisive breaking of the covenant with God. The horrors of modern warfare touched a new nerve in the populace, and it became impossible for some to see scarred and battle-ravaged terrain as part of an anointed New World Zion. Yet others explained the conflict as a moral test; a successful weathering of the trial would leave the Union newly strengthened, purged of sin, and restored as the state of the chosen people. Far from questioning the myth of the elect nation, the war seems to have accelerated the rhetoric, spawning such declarations as that of Hollis Read in his book of 1861, *The Coming Crisis of the World; or, The Great Battle and The Golden Age*: "[God] hath made us his modern Israel—hath seemed to choose us as a peculiar people—hath made his goodness to pass before us as he did to his Israel of old; and yet in many respects, more abundantly."[28]

Whether one anticipated the triumph or the failure of American civilization, the imagery employed was apocalyptic. "I foresee that the country will have to pass through a terrible ordeal, a necessary expiation perhaps for our national sins," predicted Robert E. Lee. With the proliferation of such writings, the Civil War began to be seen as the final struggle between good and evil that would usher in the millennium —what Julia Ward Howe termed "the glory of the coming of the Lord" in her "Battle Hymn of the Republic."[29] In the South, this only cemented the belief in the Confederacy's typological bond to the Israelite nation. White southerners saw themselves as particularly connected to the Old Testament, where the existence of slavery (through Ham, the accursed "dark" son of Noah) is established as a precedent. Noah, in fact, became a southern model for the patriarchal system of plantation life, for a restoration of ancient religion. In an astounding metaphorical reversal, Benjamin M. Palmer, a Presbyterian minister from New Orleans and perhaps the most

celebrated religious theorist for the Confederacy, even assumed the identity of a slave, likening the plight of the eleven seceding states to the captive Israelites and equating Lincoln with Pharaoh: "Eleven tribes sought to go forth in peace from the house of political bondage: but the heart of our modern Pharaoh is hardened, that he will not let Israel go."[30] In general, southern sermons hinted at the important place that a new Confederate state would occupy in world history, continuing the covenantal legacy they traced back to biblical Jerusalem.

Within this context, reference to historical—and apocalyptic—events from the holy city was by no means new, as a poem published decades before the Civil War makes clear. Appearing in 1835 in the *American Monthly Magazine*, "Jerusalem" was a morality tale describing the fall of the overly proud and sinful Hebrew city to the Romans. In a thinly veiled warning to the American people, the author described the bloody slaughter levied on a corrupt nation convinced of its own invincibility:

> Insensate race! Could nought your pride restrain?
> Untaught by woe, blind, fickle, fierce, and vain!
> In vain your city's doom, your abject state,
> Your shrines profaned, your altars desolate.

Throughout the long poem, readers received details of the ruinous state of the once-flourishing metropolis. Until the very end, it was recounted, the Jews clung to the hope "That Israel's God his sacred house would save." Yet it became clear that their special divine bond had been broken. The fallen towers of their capital became for the poet a reflection of their spiritual and moral devastation. Ultimately, all that remained were "marble columns round in ruin strewn."[31]

The many parallels between the imagery of "Jerusalem" and Thomas Cole's *Course of Empire* series, nearing completion at the time of the poem's publication, are striking (figs. 4–5). Although Cole's reference was usually understood to be "pagan" civilization, *The Course of Empire* was also seen as relating to Jerusalem and other biblical cities such as Tyre, Sidon, and Nineveh.[32] His grand colonnaded structures, beset by warring hordes, even bear a resemblance to contemporary recreations of Herod's temple in Jerusalem (see fig. 16). The Hebrew example had thus long underscored the view that a great internal battle or conflict would be the decisive point of reckoning for God's elect; the horrors of the Civil War simply hammered the point home with greater urgency.

Although the South's hopes were certainly dashed, the triumphant North by no means emerged from the war with its confidence intact. The victory was neither swift nor easy, and life would never again be as it was in the antebellum era. While there were inevitable claims that the covenant with God had been reforged and strengthened, it also seemed appropriate to test the nature of that relationship. To some, the assumptions implicit in the American Puritan inheritance seemed less obvious than they once had. One way of verifying the validity of the concept of a New World Zion was to encounter the material presence of the old Israel. For a variety of reasons (many of them external to issues surrounding the national conflict), the three years following the Civil War witnessed the greatest influx of Ameri-

4. Thomas Cole, *The Course of Empire: Destruction*, 1836, New-York Historical Society

5. Thomas Cole, *The Course of Empire: Desolation*, 1836, New-York Historical Society

can travelers that the Holy Land had seen. Indeed, throughout the nineteenth century, the experience of Americans at the actual sites of the biblical events that had structured their national myths added a tangible component to the guiding American metaphor and cannot be considered apart from it. The United States might be the promised land of the New World, but this assumption did not mean that its citizens had forgotten the original Zion. The surge of American exploration, pilgrimage, and ultimately, tourism in the Fertile Crescent indicates that if anything, the opposite was true: the desire to travel to "Bible lands" only grew stronger as the century progressed.

The American Presence
in the Holy Land

The visual culture surrounding the Holy Land is inextricably linked to the artists who produced it, the forces that prompted their efforts, and the reception and use of the images by their audience. A few key concepts, surfacing again and again in the contemporary rhetoric, seem to link these components. Nearly every nineteenth-century attempt to account for this imagery and suggest a reason for its importance, for example, fell back on the twin notions, invoked with wearying regularity, of accuracy and authenticity. The Holy Land was *real*—a viewer standing before a careful depiction of the Palestinian landscape *knew* this simple statement to be true. The proof lay in the experiential act of the artist; the plain fact of localized travel seemed to be all that was necessary to confer an aura of unproblematic authenticity. Thus, while depicting the sacred terrain in no way required a visit to Palestine, the most successful painters owed their popularity to their claim to have actually seen the landscape in question.

But such artists were by no means the only ones capable of making this claim. Of the thousands of Americans who settled in or visited the Holy Land during the nineteenth century, artists, it must be admitted, constitute a rather small, albeit important, group. Fewer than two dozen painters are documented travelers to Palestine and Sinai, although the number of photographers known to have made the trip is greater.[1] Because of this statistical disparity, it is misleading to separate artists into an independent category—however distinctive their visual enterprise might have been—without also considering the main streams of nonartistic American activity in the Holy Land. The work of artists, by its very nature, had an impact on the American public different from that of other travelers' accounts, but the motives and experiences were nearly always the same. Some artists were also missionaries or explorers (or liked to think of themselves as such), some simply tourists. As witnesses to the sacred terrain, they thus became part of the general American presence in the Fertile Crescent, each a link in the chain of pilgrims, archaeologists, colonists, and travel writers. This shared society of temporarily transplanted U.S. citizens bears examination, for without it, there would have been little incentive for the production of a visual record of any kind.

Although each of the groups just mentioned will be considered in turn, the earliest, and perhaps most influential, of those who made the journey were American missionaries. As the first from their country to encounter the lands of the Bible, they wrote letters and memoirs (often published in periodicals and special travel volumes) that were crucial to the shaping of views of the Holy Land back home.[2] Through their writings, lecture tours, and government connections, they not only helped form the popular conception of Palestine and Syria, but also affected diplomatic and commercial policies throughout the century. Naturally their prestige was greatest among Americans who actually made the trip to the Levant. In later years, it was expected that travelers would visit and even lodge with the missionaries. They also served quite often as cicerones for these Protestant "tourists." The artists Miner Kellogg, Albert Rawson, Frederic Church, and Sanford Gifford, for example, all made contact with their missionary communities, and European painters such as David Wilkie were also received by the proselytizing Americans in Beirut and Jerusalem.[3]

Predominance in the missionary field was established early in the century by the American Board of Commissioners for Foreign Missions, a group formed at Andover Theological Seminary in 1810. The organization grew to include operations in many parts of the world, but the mission in the Holy Land had a special significance. It is not surprising that the missionary urge would be greatest in the land of the Bible, where the scriptural and historical connections to the Christian past seemed all but irresistible. But for quite a few Americans, this area was also the locus of a millennial view of the future. Christ's Second Coming, it was thought by some sects, could only occur after the conversion of all the world's peoples. In a departure from Puritan doctrine, most nineteenth-century Protestants began to believe that nonelect groups could be saved. The Jews seemed a logical group to start with, particularly those who were located at the site of the origins of Christ's church.

As the first two American Board missionaries, Pliny Fisk and Levi Parsons, would discover, however, this was not an easy proposition. Entrenched community antipathy (and later in the century, the threat of being denied a portion of the *halukah*, the communal financial fund for resident Jews in Jerusalem) prevented them from gaining Jewish followers. Since the conversion of Muslims was a capital offense under Ottoman law, Islam was off-limits. The Protestant missionaries soon realized that their only areas of opportunity were the Catholic and Orthodox Christian churches, prospects that they pursued avidly, but without much success.

Fisk and Parsons arrived in the Holy Land in 1821. Although Parsons briefly established himself in Jerusalem in February, he did not stay long; he died a short time later in Alexandria. Fisk then went to Jerusalem in 1823 with another comrade, Jonas King, preaching and distributing Bibles. The importance they attached to the dissemination of the printed Word is indicative of the overwhelming American Protestant emphasis on the Book as a means of personal revelation (and of understanding the Holy Land). The very presence, in and of itself, of the Protestant Bible in the holy city was considered a missionary success, one of the few they could claim. Nevertheless, the success was short-lived; several months later, they retreated to Bei-

rut, the city that would become the stronghold of American missionaries.

During the early years of their activities, the missionaries constituted the only sustained American presence in Palestine and Syria. Visits by others from the United States were isolated and infrequent. Nevertheless, the occasional trips of these non-missionary Americans—and the motives behind them—are important to examine, both for the incipient patterns of travel they establish and for the ardor of the individual convictions they often reflect.

The first identifiable tourist seems to have been George B. Rapelje, a New York merchant and lawyer of Dutch descent who in 1824 began a two-year tour of Europe and parts of the Fertile Crescent. Given the exceptional nature of such a trip at this early date, the reasons he gave for leaving home appear curiously matter-of-fact: "to find amusement, and to gain health and information." Although a graduate of Columbia College, he affected to disdain "savans [sic] and literati," employing only "common sense and common honesty," and claiming, "My opinions have been formed from a direct eye-sight and an unbiased understanding."[4] Rapelje's casual and unassuming approach allies him with later nineteenth-century "genteel" tourists whose scientific and religious interests were not characterized by excessive zeal. Nevertheless, like many of his successors, Rapelje felt the need to give a published account of his activities. Appearing several years after his return, his straightforward book located itself within a genre of travel account that would grow exponentially to feed a voracious American market.

The uniqueness of Rapelje's trip, when seen as a whole, lies in his comparative lack of religious engagement with the Holy Land. Most individual travelers in the 1830s arrived with a much greater sense of mission. An early example, remembered by Protestants for what they considered his notorious fate, was Cornelius Bradford, about whom very little is known. A young expatriate, he spent time in Paris before becoming the U.S. consul at Lyons in 1829. Months later, the young Bradford unexpectedly journeyed to Egypt and on to Palestine, writing excited letters about the holy sites he was visiting. In Jerusalem, however, he died at the age of twenty-five, in the care of Roman Catholic monks. His burial in their cemetery and his carved epitaph declaring his abjuration of "Erroribus Lutheri et Calvini" would later scandalize Americans such as Edward Robinson, who, when confronted with Bradford's grave in 1838, accused the monks of converting his former friend after he had already sunk into unconsciousness.[5]

In contrast to the scholar Robinson, with his rational and scientific approach, a number of the earliest American travelers were subject to more visionary proclivities, perhaps none more so than the U.S. artist thought to be the first to reach the Fertile Crescent, John Landis. Born into a devout Lutheran family in 1805, Landis became a printer's apprentice and, briefly, a medical student in central Pennsylvania. As a young adult, he appears to have made a good living as a broker and a printer of a Democratic newspaper espousing Jacksonian ideals. Around 1830, however, his life was changed considerably when he began to experience religious visions during a bout of smallpox. Considering himself called by the Lord to preach, he set out on a

lifelong mission that involved using his developing powers as a poet and painter. In 1833, Landis left to spend several years in the Old World, a trip that seems to have included time in the Holy Land. According to one of his biographers, the artist wandered out alone from Jerusalem and was found several days later, feverish and ill, by a Bedouin group. Taking him to Alexandria, they turned him over to the American consul, who transported him home.[6]

Back in Pennsylvania, Landis made his reputation by publishing lithographs and tracts with such titles as *A Treatise magnifying, lauding, and applauding God! and extolling the Redemption, by the Sister Arts of Poetry and Painting, with Sacred Poetical Effusions* (1843). Becoming a figure of some notoriety, he took to "wearing the garb of the fathers of antiquity, with hair flowing from his head eighteen inches down his breast and a beard of horrific aspect and mammoth magnitude."[7] His paintings were mainly figural compositions with subjects deriving from scripture. It is possible that visits to the actual sites in Palestine could have prompted such works as *Jesus in the Upper Room* and *Madonna and Child Visiting the Family of John the Baptist* (figs. 6–7). Other paintings (which he aggressively hawked at greatly inflated prices to such institutions as the Pennsylvania Academy of the Fine Arts and the Harrisburg legislature) were also situated—at least in title—at specific biblical locations.

Scriptural subjects, however, were already in his repertoire prior to the trip abroad, and many aspects of these scenes, such as the window treatment of the "upper room," are decidedly nineteenth-century in nature. Most telling is the picturesque mix of colonial and Jacksonian architectural fragments glimpsed through the background opening of his *Madonna and Child*. Time and geography collapse in this image, as Pennsylvania becomes the setting for Landis's vivacious New Testament group. This quaint equation, however, is much more than the anachronistic result of a naive pictorial approach. As the artist's striking physical appearance made clear, his paintings were only one part of a complex and significant ordering of time and history—a schema that included his own life—whereby the biblical past and the American present were mutually elevated and authenticated.[8] In the end, however, Landis was unsuccessful in his attempts to sell this type of work, and he seems to have died in a Pennsylvania poorhouse.

To judge from the writings of most of these early travelers to the Holy Land, they all considered themselves vanguard representatives of the United States in a region where their country was yet little known. A more official emissary, however, also appeared in the eastern Mediterranean during this period. The U.S. Navy, after encountering difficulties with pirates along the Barbary Coast, shifted its attentions more toward the Fertile Crescent and established a continual presence along its shores that would be maintained throughout the nineteenth century. During the Greek war for independence, overwhelming American sentiment on the side of the revolutionaries had made it difficult to negotiate with the Ottoman Empire, but the signing of a treaty in 1830 and the increased advisory capacity of U.S. naval officers within the newly modernizing Turkish navy allowed American ships much greater visibility at eastern ports. Also, when the westward-looking Egyptian ruler, Muhammad ʿAli, briefly extended his control to the Holy Land in the 1830s, Americans gained more accessibility than they had enjoyed under the Ottoman sultan.

6. John Landis, *Jesus in the Upper Room*, 1836, Philadelphia Museum of Art

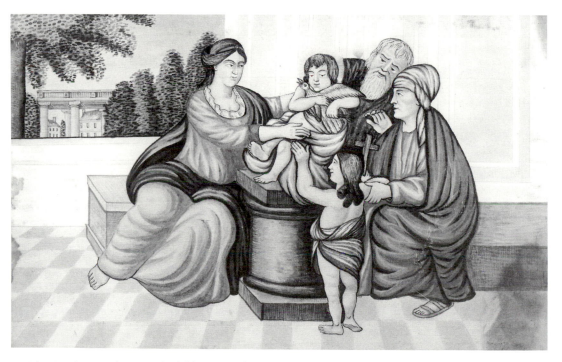

7. John Landis, *Madonna and Child Visiting the Family of John the Baptist*, n.d., National Gallery of Art

It was during this period of Egyptian control that the U.S.S. *Delaware* anchored off the port of Jaffa in August 1834, allowing the crew, the officers, and the captain's family to make two week-long pilgrimages to Jerusalem. Half the ship went in each shift, establishing the pattern later vessels would follow when repeating this unique form of shore leave. Such visits to the holy sites were exceptional in that sailors—presumably of an economic and social class that could not normally contemplate a Palestinian sojourn—were able to experience a journey that would come to be seen as canonically "genteel" in later years. Officers' wives and daughters, likewise, enjoyed an opportunity that, at this early date, would have been otherwise denied women because of the rigors and remoteness of the locale.[9]

The *Delaware*'s port of call was also notable in that it produced at least three Holy Land travel accounts—one by the chaplain, one by "an officer," and one jointly authored by the ship's clerk and a crew member. The officer's sketch, the most enthusiastic of the three, set the tone for future American reactions to the holy topography. Before arriving, he marveled at the connection with Christ that the landscape experience would provide: "I was soon to walk over the very ground which had been pressed by his blessed feet more than eighteen hundred years ago; to see with my own eyes the hills, and streams, and highways, which he ascended, by the sides of which he taught, and along which he walked." Later, at the site of Calvary, he exclaimed, "'How awful is this place!' A few hundred years ago, and the meek Redeemer stood where I now stand, reviled, scourged, spit upon, crucified!"[10] The need to possess tangible evidence of the site and the emotions it produced prompted him to take "some relics of the sacred spot," possibly simple chips of stone. This desire for material testimony of the land is an illuminating thread, one that would run through the entire American Holy Land experience.

The *Delaware* was not the only ship to reach Jaffa in the 1830s. Another memorable visit was that of the U.S.S. *Constitution*, which brought Lewis Cass, minister to France and later secretary of state, on an investigational mission for the government in 1837. It too yielded several travel accounts, including one by Cass. His memoir of the trip, however, was not immediately published as an independent narrative, but rather as a long and glowing review of John Lloyd Stephens's *Incidents of Travel in Egypt, Arabia Petraea, and the Holy Land*.[11] This fact by itself illustrates the popular importance of Stephens's book. Indeed, along with the scholar Edward Robinson, he can be credited with inaugurating a new threshold of American (and international) interest in the Holy Land.

Little in John Lloyd Stephens's early life hinted at the role he would subsequently play in international travel exploration. The son of a prosperous New York City merchant, he graduated from Columbia College in 1822, became a lawyer, and assumed an active role within Manhattan's Tammany Hall Democratic organization. For reasons attributed to ill health, he left New York in 1834 to begin a long European journey that, a year later, would take him to the Middle East. Moving through Egypt, the Sinai desert, and most areas of Palestine, he reached a variety of remote locations (such as the rock-carved city of Petra) that had not previously been

seen by American eyes. Stephens lost no time in writing about his travels, and by 1837, after considerable advance publicity, *Incidents* had appeared to great acclaim and its author had begun to be considered an authority on the East.[12]

The success of his book was unprecedented. Within two years, twenty-one thousand copies had been sold, and the sum of his royalties would eventually reach the unusually high figure of twenty-five thousand dollars. In retrospect, the reasons for its auspicious reception seem clear. As the first serious and comprehensive account of the region published in the United States, it was bound to open a deep vein of interest in a country obsessed with its typological ties to the Holy Land. Stephens's style and method offered further appeal to a general readership. Although interested in the holy sites and the light that the biblical narrative shed on them, he was by no means overly academic in his archaeology; his observations and reasoning were commonsensical and straightforward, and his speculation on the authenticity of specific monuments was marked by a degree of skepticism (particularly in Jerusalem) appreciated by some segments of his public. Rather than overloading his audience with details, he concentrated on creating a general context, describing his approach to a given site and bringing the reader along as he moved closer, until his object came into full view.

There was another aspect of the author that contributed greatly to his success: his "Americanness." Throughout the two volumes, Stephens made frequent reference to the United States, providing homey comparisons that fed the narcissistic nationalism of his reader. Evident was his veneration of the American flag, an object repeatedly waved and promoted by Holy Land travelers with fetishistic zeal. In fact, the carrying of the flag into remote regions was a constant of the American experience in the Middle East. It later flew from every traveler's tent, and even from their backs, as evidenced by William H. Rau's stereograph of his colleague, *E. Wilson Seated atop the Great Pyramid, with American Flag Jacket* (fig. 8). In a published list of the equipment he brought on their photographic expedition, Rau explained, "Last, but not least, we each have a silk American flag, which we wave on all particular occasions."[13]

Other examples were numerous throughout the century. Lieutenant William Lynch of the U.S. Navy moored a large float flying the flag in the middle of the Dead Sea after he had completed his exploration of that body of water in 1848. Years later, J. I. Taylor's sometimes humorous account of his trip to the Holy Land in 1867 lampooned an unnamed painter in his party as callow and overly credulous when it came to biblical sites. Taylor's annoyance almost turned to violence, however, when the artist could not be persuaded to abandon his mission of painting the Stars and Stripes onto a column at Baalbek.[14] Shortly thereafter, Isabel Church, whose artist husband, Frederic, employed the same dragoman as Taylor, complained of "an American maiden lady," Miss Parks, who during their journey from Jaffa to Jerusalem attached the flag to her parasol, "streaming it forth to the winds in all occasions —taking possession as she called it of each place she passed thru."[15] Evident patriotism continued to be a requirement of Americans in the Holy Land well into the twentieth century, even if, like members of the celebrated American Colony in Jerusalem, they had renounced residence in the United States (fig. 9).[16]

8. William Herman Rau, *E. Wilson Seated atop the Great Pyramid, with American Flag Jacket*, 1882, Dan Kyram Collection

In an early contribution to this nationalistic fervor, Stephens signed his book simply "An American Traveler." Whether calculated or not, this device only increased the delight of reviewers. The critic of the *American Quarterly Review* lauded Stephens's *Incidents* for the very fact of its author's nationality:

> It is especially pleasing to us . . . as it is the work of an American. . . . American remarks upon the customs and manners of either Asia or Africa are generally more agreeable than when elicited by kindred European subjects. . . . We confess that we prefer to have the tale [of Idumea and Petra] from one of ourselves, developing, as it does, the tastes and ideas which belong to ourselves, and affixing the circumstances and objects the same estimate which we should doubtless have done, if there.[17]

Such commentary is significant because it indicates a belief in a specifically American perception of the Holy Land. European travel books were certainly read in the United States, but there was a feeling that something was missing; special "tastes and ideas" belonging only to Americans made it desirable that the intermediary between the domestic public and the visited place be a compatriot. The same argument held true for visual depictions of the holy terrain. During the 1850s, for example, reviews of John Banvard's Holy Land panorama often noted that he was an American, perhaps to distinguish his painting from Frederick Catherwood's English-made Jerusalem panorama, exhibited in New York a decade earlier. Likewise, Edward Troye's paintings of the Holy Land were advertised as being painted by the artist "for the American public exclusively. He therefore declined exhibiting them first in England."[18]

Incidents can be credited with raising the popular level of knowledge of Bible lands to new heights. The other early monument of the American Holy Land bibliography, Edward Robinson's *Biblical Researches in Palestine, Mount Sinai and Arabia*

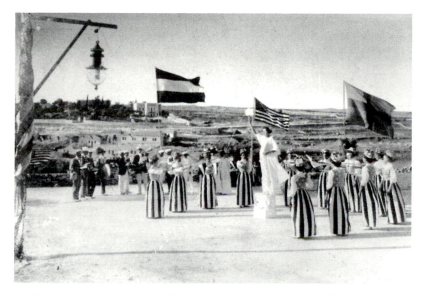

9. *Patriotic Pageant, American Colony, Jerusalem,* n.d., private collection

Petraea, accomplished the same task within a more elite world of professionals. Considered the father of modern Palestinian archaeology and geography, Robinson applied scholarly tools to the study of the landscape and the built environment in a meticulous and incisive manner that revolutionized his field and established it as an area of American predominance.

The son of a Connecticut Congregationalist minister, Robinson first demonstrated his scholarly brilliance at Hamilton College before moving on to the conservative Andover Theological Seminary to master Greek and Hebrew and eventually join the faculty. His choice of Andover was significant, for that institution had been founded early in the nineteenth century by a group of disgruntled New England ministers opposed to the Harvard school of liberal Unitarianism. By his association with Andover, he was making a theological statement, and his scholarship began to be directed toward a pronounced ideological enterprise. Encouraged by others at Andover, Robinson employed his prodigious linguistic and textual skills to counter the growing tide of Cambridge-based revisionism that saw the Bible as a flawed and inconsistent document. Using his partisan academic journal, the *American Biblical Repository,* he set out to demonstrate the absolute authenticity of the Bible.[19]

In his effort to explain vague or misconstrued sections of scripture, Robinson made increasing use of geographical discoveries conveyed by American missionaries. After several years of work, Robinson became convinced that his defense of the Bible could not be fully successful until he, too, had explored the sacred terrain firsthand. His opportunity came in 1837 when the newly organized Union Theological Seminary in New York City offered him its chair in biblical literature. Robinson's condition of acceptance was an immediate three-year leave to enable him to make a

journey to Palestine. Thus in 1838, he and Eli Smith, a missionary and Andover graduate, made a whirlwind tour of the Holy Land. They followed both main routes and tiny secondary roads; when finished, they had seen more scriptural sites than any other modern author.

Prior to arriving in the Middle East, Robinson had mastered the entire ancient and modern bibliography on the Holy Land. This breadth of knowledge, coupled with Smith's fluent Arabic, allowed them to conduct a new type of exploration in the region. Textual accounts gave Robinson notions of where specific sites might be found and what they might look like. Confirmation came from Smith's inquiries of indigenous Arabs. Repeatedly, they found that local residents had preserved the scriptural name of places in an amended, Arabic form. These identifications they invariably accepted, discarding at every opportunity ecclesiastical or "monkish" traditions. Indeed, Robinson's harsh anti-Catholicism glaringly pervaded *Biblical Researches* and, to some critics, compromised it.

Following his grueling journey, Robinson retired to Vienna where he spent two years producing his volumes, published simultaneously in English and German in 1841. *Biblical Researches* changed geographic knowledge of the Holy Land in ways no other book ever did. Lengthy, dense, and learned, it was a massive testimony to Robinson's indefatigable and meticulous nature. His stress on physical geography and the identification of biblical sites resulted in numerous "rediscoveries" of religiously significant locations and clarifications of previously known sites. His attention to the actual landscape led the way to the nineteenth-century obsession with looking to natural history to authenticate the narrative of the Bible.

In this light, Robinson's importance to American artists is seminal. His complete trust in the Bible on one hand, and the evidence of the land on the other, formed the basis for the main justification of American landscape painting in the Holy Land. Until he had experienced the actual topography of the area, Robinson had not felt complete in his understanding of scripture. American Protestants generally boasted that a crucial part of their faith was experiential, and belief was thought by some to owe a great deal to visual perception. Landscape depictions could thus provide the American public with the same reinforcement that Robinson had sought. The perceived tangibility of the landscape would be the key to its power to validate and prove.

The legacy of Robinson's work was great. For the cause of nationalism, his pioneering researches would be repeatedly invoked to claim primacy for biblical archaeology as an "American" science. Years later, when the newly organized American Palestine Exploration Society was seeking contributions, it used an element of guilt "to recall Americans to their duty in a field where their own countrymen were pioneers, and where American scholarship and enterprise have won such distinguished merit."[20] Indeed, American archaeologists still take pride in their responsibility for the formal disciplinary study of the Holy Land. As other historians have noted, the American School of Oriental Research in Jerusalem has frequently been guided by twentieth-century archaeologists who, like Robinson, had clerical or fundamentalist connections, the primary examples being William F. Albright and

Nelson Glueck. Their unabashed desire was to continue Robinson's enterprise of validating the scriptural word. Today, Palestine remains the most actively excavated area on the globe, despite what some have characterized as the relative paucity of continuing important finds.[21]

By the beginning of the 1840s, Stephens's and Robinson's publications had ushered in a new era of American concern with the Holy Land. This increased interest was marked by the federal government in 1844 when the secretary of state, John C. Calhoun, appointed the first fully accredited, American-born consul in Jerusalem. Calhoun's unfortunate choice was a Philadelphia Quaker named Warder Cresson who, it was discovered too late, was a somewhat notorious religious visionary who could scarcely be trusted with representing the interests of the United States. By the time Calhoun revoked the commission, though, Cresson was already on his way to the Levant. Arriving in Jerusalem, he began issuing bogus papers of protection to resident Jews until he was forced to renounce his claim to the consulship.[22]

Cresson decided to remain in Jerusalem, and in 1848 he converted to Judaism, changing his name to Michael Boaz Israel. Returning to Philadelphia, he was detained by his family for several years and subjected to two "lunacy" trials. It was not until 1852 that he was able to return to Palestine. There he conceived the scheme of establishing an agricultural colony in the valley of Rephaim, between Jerusalem and Bethlehem. His enterprise, he believed, would draw the world's Jews back to the Holy Land, thus fulfilling ancient prophecy. In this he was singularly unsuccessful. Nevertheless, he remained in Jerusalem until his death in 1860. His later years were devoted to frustrating the attempts of his countrymen to convert Jews. Although he left no real legacy in the region, his importance lies in his role as perhaps the first nonmissionary American to pursue the idea of taking up residence in the Palestine and living off the sacred land.

The story of Cresson/Israel has several key elements that emerge again in later efforts by Protestant Americans to colonize and "revitalize" Ottoman Palestine: an agricultural focus, an interest in Jews, and a desire to be an instrument of the fulfillment of prophecy. As the second chosen people, they assumed it only natural that they should "inherit" the land of the first favored race, and they meant to hurry the process along. Their settlement schemes shed light on the American fixation on the land, as well as the sometimes overt imperialism that underlies the rhetoric surrounding many verbal and visual evocations of the Holy Land. By casting their designs in a scriptural light, they created an extraworldly justification for their coming. Like the Puritans before them, they believed that they came "not to usurp but to reclaim, not to displace an alien culture but to repossess what was already theirs by promise."[23] At a time when the western frontier of the United States had become the preferred site for flexing the imperial muscle, a few Americans nevertheless set their sights in a decidedly eastern direction.

A series of religious developments in the United States can be credited with creating a focus on the colonization of the Holy Land during the middle decades of the nineteenth century. Under the general umbrella of millennialism (a belief system, as

one scholar has described it, holding that "space and time are bursting with significance")[24] are found a variety of diverse, midcentury American sects and societies whose main emphases were on the apocalypse and the conditions necessary for the second coming of Christ. By the 1830s the revival movement of the Second Great Awakening had rekindled the kind of typological Hebraism common in the colonial era. This interest in ties to the ancient Jewish nation led naturally to a concern for the reestablishment of the children of Israel in the Holy Land, as prophesied in the Bible. The occurrence of the millennium, the thousand years of peace and prosperity that, depending on one's interpretation, would precede or follow the Last Judgment, was believed by many to be dependent on the conversion of the Jews and their return to the Holy Land. Moreover, the role of the United States in this redemption of the world was a given; as an elect nation, it was certainly destined to turn the world to Christ.[25] The question was, when? A New York farmer named William Miller believed he had the answer.

Miller began lecturing in the Northeast in 1831. His message was one of preparation; whether or not the Jews had been converted, the Second Coming, he had elaborately calculated, would occur sometime between 21 March 1843 and the same date in 1844. In the twelve years of his travels through upstate New York and New England, he is believed to have given thousands of lectures, reaching perhaps hundreds of thousands of listeners. Among his fifty thousand close followers—they were called Millerites—many settled their debts and gave away their possessions in anticipation of the great event. When March 1844 came and passed, some followers were initially disheartened, but others were curiously undisturbed. A group of "radical," charismatic Millerites soon stepped forward with a new calculation: Time would come to an end on 22 October 1844. Whole families, some reputedly wearing white "ascension robes," are reported to have waited that night in cemeteries and churches. Once again they were disappointed.[26]

Clorinda S. Minor, a Millerite believer and editor of the periodical *Advent Message to the Daughters of Zion*, was puzzled but not subdued by the apparent failure. After pondering the possible reasons, she decided that the Messiah could not yet return because the Holy Land was not ready. Agriculture, she believed, would be the key improvement necessary for a more accommodating scene for the Second Coming. In 1849 she traveled to Palestine to look into the situation. Convinced that her presence was needed to prepare the way of the Lord, she returned to the United States, raised money, and enlisted prospective colonists. Her appeal was particularly successful among young women, an unusually strong demographic group among radical Millerites.

Minor's desire to assume control of Palestinian land (she called it "natural Israel") was not surprising, given the views of her mentor. Miller's interpretation of scriptural history held that Christianity, as a new spiritual Israel, had inherited the material Israel by default. Rather than necessarily turning the territory over to the Jews, Millerites reserved the right to take the Holy Land for themselves. So although ostensibly acting on their behalf, Minor and her followers appear to have enjoyed little contact with Jews in the region (save one John Meshullum, a London-born hotel-keeper who had previously converted to Christianity), and on-site Jewish re-

10. *George Jones Adams*, n.d.,
Library of Congress

cruitment was almost nonexistent. Initially settling at Artas in 1851, the Minor colony became embroiled in a political dispute, eventually losing the land to the British consul, who had plans for his own settlement of Christianized Jews. They ended up on the Plain of Sharon, near Jaffa, where their colony was dubbed "Mount Hope." During the process of establishing themselves, however, their numbers dwindled considerably, and by the time of Minor's death in 1855, only her son and adopted daughter were left to dispose of her body.[27]

By far the most notorious of the settlements, however, was the Jaffa colony established by George Jones Adams in 1866. The period immediately following the Civil War was a time of greatly increased American activity in the Holy Land. As discussed above, the national conflict, viewed in some camps as the final struggle of worldly good and evil, did much to reincite millenarian fervor. The view that the war would bring on the millennium was buttressed by another chronological calculation that became current at the time. Scripture, it was held, could be interpreted as predicting that the Antichrist would reign on earth for 1,260 years (Rev. 11:3). If the pope was taken to be the Antichrist and his universal rule was dated as beginning in 606, then his reign would end conveniently in 1866.[28] Such a moment, it was felt by many, would be propitiously spent in the Land of Promise.

Adams, a charismatic actor and former convert to Mormonism (in 1845 he had been expelled from the Latter-day Saints because of alcoholism and adultery) had gone to Indian River, Maine, during the Civil War, following a stint as a Millerite preacher in Springfield, Massachusetts (fig. 10). There he founded his Church of the Messiah and published a journal called the *Sword of Truth and the Harbinger of Peace*.

Preaching that the end was near and that the Jews needed to be shown the way to the Holy Land, Adams convinced more than 150 followers to accompany him to Palestine, where they would gain a foothold, introduce modern agriculture, and serve as hosts for the other Westerners who would undoubtedly begin to flock eastward. Knowing of the lack of lumber in the region, these "children of Ephraim" brought along their own prefabricated Yankee houses, as well as an American reaping machine.

The Adams colonists—or the Palestine Emigration Society, as they called themselves—arrived at Jaffa without mishap, but during the first month, while waiting for legal title to a parcel of land, they were forced to camp on the open beach. A dozen of their number did not survive that ordeal. It was only through the illegal use of an Arab front man that they were able to purchase their land and erect their houses in regular rows, mimicking an American town plan. Yet however much their colony might have looked like a "Down East" village, it was most definitely not in Maine. Although crops were soon planted, the harvest was a failure. Ignorant of the region's growing conditions and the accepted ways of interacting with indigenous communities, the colonists soon found themselves isolated, penniless, and starving. They learned that their presence was not welcomed by Ottoman authorities, who maintained, not unexpectedly, that the land belonged to the native people who paid taxes and performed military service. Pressure from U.S. governmental agents in the area was also brought to bear; the officials were growing weary of dealing with the increasingly bizarre and contradictory behavior of Adams and his wife.[29]

Realizing that their prophet was unreliable and frequently incapacitated by drink, a group of dissatisfied members petitioned to be brought back to the United States.[30] In the end, most of them returned home, relying on charitable contributions to pay their fare. Nearly sixty colonists had died, but a few, undaunted, remained to pursue livelihoods as tour guides and carriage drivers. Adams himself stayed for a time, declaring his colony independent of the United States. When Frederic Church and his companion, D. Stuart Dodge, went through Jaffa in March 1868, they met Adams and witnessed the ongoing disintegration of the colony. Dodge, a minister, was troubled by an "extraordinary address" given by Adams, writing home, "Such a tirade of ignorance, coarseness, vulgarity, and well-nigh blasphemy, I never heard. . . . I fear his method of helping forward the restoration of Palestine will have to join the list of failures."[31]

Of the various American colonies in the Holy Land, the Adams settlement was both the largest and the most disastrous. It epitomized the level of American identification with the territory and the intensity of the desire to inhabit it. It also demonstrated, though, the degree to which visitors were capable of blinding themselves to the contemporary realities of Turkish rule and Arab life. Significantly, the Adams colony received considerable attention from the press back home. A concerned public, viewing the episode as a reenactment of the Puritan colonial epic, could follow the changing fortunes of the colony in a series of bulletins published in daily newspapers and specialized journals. Even if all Americans were not universal believers in an impending apocalypse, most nonetheless welcomed a "rebirth" of the Holy Land in their time. However, at least one visiting journalist, Samuel Clemens, questioned

the colonists' logic in inserting themselves into a purely scriptural errand, observing dryly that although the Americans offered a biblical justification for the restoration of the Jews, "they do not make it appear that an immigration of Yankees to the Holy Land was contemplated by the old prophets as part of the programme."[32]

Clemens's series of newspaper articles and, a few years later, his biting satire of both travelers and travel literature, *Innocents Abroad* (1869), appeared at the time of an unparalleled inflow of American visitors to the Holy Land. Earlier, it had required a significant effort for an American to make the trip to the remote area of the Fertile Crescent. The problem of accessibility was solved to a degree in the 1850s when French and Austrian shipping companies began to call at eastern Mediterranean ports with more regularity. Indeed, Clemens's own trip in 1867 aboard the steamer *Quaker City* was the first organized tourist junket to Palestine. As early as 1858, a reviewer of Edward Troye's Holy Land paintings could claim that, "next to England and Italy, Palestine is the favorite goal of American pilgrims."[33]

With an increase in travel came an inevitable by-product: an unprecedented proliferation of Holy Land travel accounts. Although there had always been volumes devoted to the land of Palestine published in the United States, the number of American books on the subject leapt into the hundreds during the decades surrounding the Civil War.[34] Many were repetitious and highly dependent on previously published accounts. In innumerable prefaces and introductions, authors sheepishly admitted to having written just one more in what they themselves considered an overly long series of Holy Land narratives. Yet there was always a justification to be found—a new perspective or an atypical route or an updated archaeological report.

Because of its appeal to a wide audience, travel literature played a role in mass culture denied other prose genres. Authorship of travel books was uncharacteristically heterogeneous, drawing from many levels of society. It followed that their readers would be equally, if not more, diverse. The seemingly insatiable appetite of this large public guaranteed a constant supply of new publications and a lucrative return for the authors. For most Americans, then, the Holy Land had been textualized long before it was experienced as painted or photographed. In essence, the literature (and the frequent lyceum lectures given by travel authors) served as an advertisement for visual depictions of the Holy Land, enhancing an already keen public interest. Artists and writers interacted in other ways as well; a standard method of defending the "truthfulness" of paintings of Palestine was to solicit written attestations of accuracy from celebrated explorers or travelers.

Perhaps the most successful travel writer and lecturer of the midcentury was Bayard Taylor. Although his many books dealt with regions other than the Middle East, it was with the Islamic world that he was most closely associated. Sometimes earning up to five thousand dollars a season, he lectured to his enthusiastic American public in full Arab dress. The popular familiarity with Taylor in this eastern guise was reinforced by the dissemination of such images as Thomas Hicks's portrait of the author in Arab costume, shown at the National Academy of Design in 1856 (fig. 11).

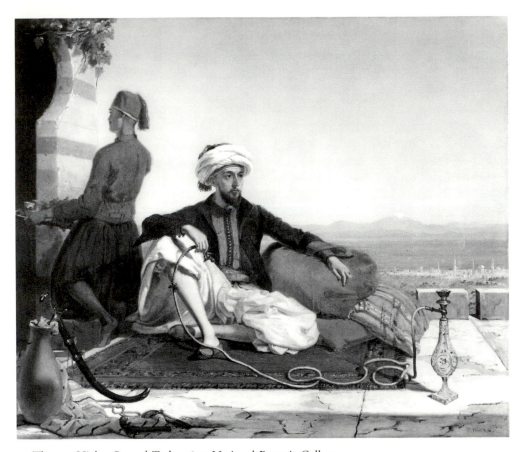

11. Thomas Hicks, *Bayard Taylor*, 1855, National Portrait Gallery

Hicks, known for his attention to props, included such requisite "exotic" elements as the self-conscious display of curving Eastern weapons (a reminder of the dangers that, readers were repeatedly informed, awaited American writers every step of the way), the snaking water pipe, and the marginalized, coffee-serving domestic. Knowledgeable viewers could also have looked beyond the pile of bright cushions to recognize the city of Damascus and its surrounding mountains in the distance, painted by Hicks from drawings executed by Taylor.[35]

Competent as a landscape artist (he was friendly with many painters of the Hudson River school), Taylor used his own travel sketches to illustrate his volumes. It is fitting, then, that his inspiration to go to the Holy Land and the Middle East should have come from an American painter. In 1845, while conducting research in Florence for his first travel book, Taylor was introduced to Miner Kellogg by the sculptor Hiram Powers. Kellogg had passed most of the previous two years in Egypt, Palestine, and Turkey. In the painter's studio, Taylor was shown stacks of drawings and watercolors from these trips (now preserved in the National Museum of American

Art), as well as several paintings being worked up from the studies. Impressed and excited, he wrote soon thereafter, "I met Kellogg, an American painter of very great talent, who has been traveling. . . . I have been to his studio, and looked over some hundreds of sketches which he brought back. He was at Thebes, was thirty days on and around Mount Sinai, and spent nine months in Constantinople. He has set me half crazy to travel there."[36]

Taylor fulfilled his dream in 1851 when he arrived in Egypt for a ten-month stay in the Levant. In an arrangement emulated by many later travelers in the region, he came with a newspaper contract (from the *New York Tribune*) to provide letters describing his journey. These reports eventually formed the core of his book *The Lands of the Saracen.*[37] Although he came to be seen as the classic and pioneering example of the midcentury travel writer in the Middle East, Taylor differed from some Holy Land authors in his lack of emotional attachment to the land of the Bible. He dutifully visited the Dead Sea, the Jordan River, and Jerusalem, but the time spent there was short, and he adopted a general tone of doubt and disappointment. Unlike many of his compatriots, Taylor's interest (as evidenced in his clichéd portrait by Hicks) seemed to lie more in the standard Orientalist subjects of baths, hashish, and the deserts of the Nile.

It is perhaps more accurate to speak of Taylor's disengagement than of his disappointment. In this, he was directly opposed to Herman Melville, whose very personal, intense reaction to the Holy Land was anything but standard. Melville's troubled relationship to Christianity and the Bible has often been pointed out by historians of nineteenth-century American literature, and it was the subject of remark in his own day as well. Shortly before the writer left on his pilgrimage, his friend Nathaniel Hawthorne cogently described him as a man who "can neither believe, nor be comfortable in his unbelief."[38]

A potentially revealing comparative figure within the world of American art is Frederic Church. Both Melville and Church made their reputations introducing Americans to the wonders of the tropics, the former through his early South Seas novels, *Typee* (1846) and *Omoo* (1847), and the latter through the fruits of his South American trips of 1853 and 1857. Subsequently, each made a journey to the Holy Land, occasioned to some extent by unresolved religious questions. It is clear, however, that Melville's obsessive doubt was of a tortured sort that Church's positivistic temperament would have found impossible.

Melville was apparently struck by the Middle East in childhood. His autobiographical *Redburn* (1849) tells of his having had a great Levantine travel writer (usually identified as John Lloyd Stephens) pointed out to him in church when the novelist was a boy. He read the traveler's book on "Stony Arabia," and it greatly affected him. This early interest in Palestine was nuanced in later years by a thorough familiarity with biblical typology. In *White-Jacket* (1850), for example, he wrote, "We Americans are the peculiar, chosen people—the Israel of our time; we bear the ark of the liberties of the world."[39] Such surety, however, even if it truly represented the novelist's views, had deserted him by the time he reached the Holy Land in early

1857. At this troubled point in his life, Melville was ill, practically bankrupt, and experiencing family problems. Depressed, he spent only three weeks in Palestine and Syria.

Although conditioned by his guidebooks to react ecstatically to sublime Palestinian vistas, richly imbued with religious import, Melville could bring himself to see nothing but a barren, hard, despondent wasteland. Prowling around the many tombs in Jerusalem, he found "the city besieged by [an] army of the dead." Christ's anointing stone (see fig. 21) looked like "a butcher's slab," and the wall of the Holy Sepulchre had at its base "an accumulation of the last & least nameable filth of a barbarous city." Other pilgrims seemed to be blind to his dilemma. He met up with one pitiable American, for example: "[an] old Connecticut man wandering about with tracts Etc . . . he maintained that the expression 'Oh Jerusalem!' was an argument." On the Via Dolorosa, he thought not of Christ, but of "women panting under burdens."[40] Everywhere he turned, it seemed, Melville was reminded of hopelessness and mortality. In a remarkable passage in his journal, he composed a corrosive series of bleak associational metaphors to describe the Judean landscape:

> Whitish mildew pervading whole tracts of landscape—bleached—leprosy—encrustation of curses—old cheese—bones of rocks,—crunched, knawed, & mumbled—mere refuse & rubbish of creation . . . you see the anatomy—compares with ordinary regions as skeleton with living & rosy man. . . . *No moss as in other ruins—no grace of decay—no ivy—the unleavened nakedness of desolation*—whitish ashes—lime kilns. . . . Crossed elevated plains, *with snails that* [leave] *tracks of slime.*[41]

The bitterness and devastation revealed here by Melville eventually made its way into his difficult poem, *Clarel,* a five-hundred-page tale of the pilgrimage of an ill-fated divinity student, which has remained unpopular since its publication in 1876 (indeed, its author was ultimately forced to pulp two-thirds of the first edition in exchange for some needed cash from the paper mill).[42] Melville's exposure to the Holy Land took place at a time of intense crisis in bourgeois American society. As Michael Paul Rogin has suggested, the sharp debate surrounding the question of slavery had already begun working its way into the author's fiction, "call[ing] into question the ideal realm of liberal political freedom."[43] Thus his earlier *Moby-Dick* (1851), to cite only the most celebrated example, may be read as a kind of proverb or warning for the United States, played out with borrowed biblical names. Ishmael's trials, however, would continue into the succeeding decades as well.

The trip to the Holy Land shook the author considerably. Between 1857 (the year he completed his journey) and 1866, he published nothing. It was as if the disappointments of the pilgrimage only served to prefigure the devastation of the Civil War years; the parched Palestinian landscape remained with him long after his return. When he finally began writing *Clarel,* probably sometime in the late 1860s, it took years to reach fruition. In the poem, Clarel (the eponymous hero and distressed divinity student) loses his great love, Ruth, a young American Jewish woman who had converted to Christianity, while he is on a pilgrimage to the river Jordan. Her death forces him to acknowledge that during this fruitless quest to find some kind of

meaning for his life, he had paradoxically lost his best hope of order, happiness, and relevance. It is a meditative tale of missed opportunities and failed communication, one that reflects the political and social corruption of his era, the sacrificial position of the self in modern society, and even, as Nina Baym has pointed out, the sexual confusion of the protagonist and narrator.[44] With its tortuous layers of ambiguity and doubt, *Clarel* is difficult to understand without the background of the Civil War crisis, but it is also unthinkable without Melville's prewar journey to the Holy Land. That experience, more than any other, colored his work and precipitated his abandonment of revealed religion during his later years.

Although Melville's extreme response to the Holy Land placed him far outside the circle of conventional American visitors, one suspects that his virulence (and also his need to use travel as a kind of interior journey) was symptomatic of concerns, typically unexpressed, of other travelers as well. He admitted to being "afflicted with the great curse of modern travel—skepticism," and in a milder formulation, the same could be said of most of his fellow Americans, even his sunny contemporary, Frederic Church (whose own predilection for tropical foliage might have made him sympathetic to Melville's wry journal entry: "J[esus]. C[hrist]. should have appeared in Taheiti [*sic*]—Land of palms.")[45] Yet Church eventually overcame any doubts about the continued possibility of natural theophanies in the nineteenth century. For him and his fellow painters, the landscape of Palestine clearly displayed the mark of God. For Melville, however, a reliance on experiential faith could demonstrate little more than the hiddenness of God.[46] His trip to the Holy Land served only as stark confirmation of a crisis of belief.

There was nothing equivalent to Melville's aberrational reaction in the corpus of Holy Land books that followed Bayard Taylor's initial lead. Dozens of volumes appeared, and in large part, they can be seen as moving from Taylor's secular emphasis back to the sacred. This is certainly true of *The Land and the Book*, by the missionary William McClure Thomson, which appeared in 1858. As its title implies, the book successfully combined the prevalent American interest in topography with the Protestant devotion to the Bible as the primary force in Christianity. Although not the first of its genre, Thomson's volume outsold any other and had a singular influence in the United States and England. It eventually appeared in over thirty editions and remained in print well into the twentieth century.

What made Thomson's book stand out in an overpopulated field? A brief look at a few competing volumes is instructive. One earlier publication that also enjoyed a substantial popular response was William Cowper Prime's *Tent Life in the Holy Land*. It stands in illuminating contrast to *The Land and the Book*. Whereas Thomson was patient, knowledgeable, and measured in tone, Prime was prone to fits of temper, wild exaggeration, and general emotional excess. The melodrama of *Tent Life* is conveyed to a degree by Fridolin Schlegel's portrait of its author in Middle Eastern dress, the romantic, haughty, over-the-shoulder glance perfectly matching the quality of his extravagant prose (fig. 12).

Prime was lampooned at a later date by still another popular travel author for his narrational effusion and blustery preoccupation with the spilling of Muslim blood.

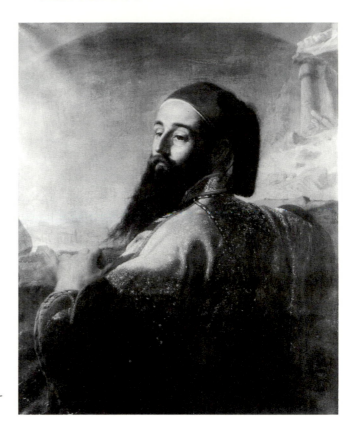

12. Fridolin Schlegel, *Braheem Effendi, Portrait of William C. Prime*, 1857, New-York Historical Society

Samuel Clemens briskly summed up his fellow author in *Innocents Abroad*: "He went through this peaceful land with one hand forever on his revolver, and the other on his pocket-handkerchief. Always, when he was not on the point of crying over a holy place, he was on the point of killing an Arab."[47] Clemens positions himself as the antithesis of the self-aggrandizing Prime, yet his own account is no less exaggerated. The pilgrims of *Innocents Abroad* regularly steal, break through locked gates, disobey quarantine, and scrawl graffiti. Although Prime pushed the Holy Land travel genre to a laughable extreme, he did not violate it. Clemens, on the other hand, indulged in an unprecedentedly savage satire of the pious pilgrimage, ridiculing himself and his companions in the process.

If the caustic irreverence of *Innocents Abroad* pushes the more serious Prime and Thomson back together as kindred spirits, it is nevertheless clear that the latter's *Land and the Book* went far beyond *Tent Life in the Holy Land*. Prime's contribution never approached Thomson's authoritativeness, yet both books still took as their underlying theme the explication of the landscape of the Holy Land. Their assertion that Christians should put their trust in the soil of Palestine rather than the urban sites of Orthodox and Catholic tradition became a fundamental precept of most American activity in the region.

The idea, as any cursory reading of Robinson and a variety of other sources will indicate, was not new. Yet Thomson's clarity of expression, his avoidance of detailed scholarly discussions, and the immediate popularity of his book allowed his voice to dominate in the minds of the interested public. He asserted in his preface that Christ was a lover of landscape. According to the gospel narratives in the Bible (which he said was "not a city book"), the Savior's greatest miracles and his most profound moments of prayer and heavenly communion had taken place in the country. Thomson knew that Americans liked to think of themselves as possessing a unique appreciation of the natural world, so he and other Holy Land writers repeatedly stressed the notion that Christianity was an "open-air" religion. The fact that non-Protestants already controlled the many Christian sites within cities was, no doubt, further encouragement for Americans to turn their backs and appropriate what was left in Palestine: the landscape.[48]

Thomson laid out the rationale for his book in his confident introduction: "The land where the Word made-flesh dwelt with men is, and must ever be, an integral part of the Divine Revelation. Her testimony is essential to the chain of evidences, her aid invaluable in exposition. . . . In a word, Palestine is one vast tablet where-upon God's messages to men have been drawn, and graven deep in living characters by the Great Publisher of glad tidings, to be seen and read of all to the end of time." Thomson sincerely hoped that "all" might have the opportunity to see and read the landscape. He contended that anyone, with the proper coaching, could discern in the holy terrain traces of sacred history and keys to obscure parables. His Presbyterianism emphasized salvation through personal experience, and he agreed that "to describe these things, . . . one must have seen and *felt* them." It is telling that he seized on the metaphor of the artist to convey this thought, assuring his audience that he had amply studied "the originals of which [the] pictures are to be copies" and that his "first impressions" (here he makes an implicit comparison to plein-air sketching) had been corrected and "reproduced for the eye of the public."[49] The style of *The Land and the Book* was therefore one of calculated immediacy, designed to approximate as nearly as possible the author's own trek through the open country.

By the time he published his book, Thomson had already spent twenty-five years in the Holy Land as a missionary with the American Board of Commissioners of Foreign Missions. He was popularly thought to have seen more of the region than any Westerner alive. Yet this authority did not diminish his appeal to the lay reader. Writing often in the present tense, he structured his narrative as a series of conversations between himself and an unnamed boyhood friend, a visitor to the Levant. The reader is asked to be a partner in the enterprise, to ride along and participate in the dialogue. Although artificial, this construct was strangely successful. Even today, the contemporary reader is prey to its seductive pedagogical format (if not to the gratuitous anti-Muslim and anti-Jewish comments that mar this and other texts of the period). Perhaps most impressive to his nineteenth-century audience was Thomson's seeming knowledge of Palestinian flora and the customs of the resident Arabs. Throughout the text, specific plants are described in a manner that illuminates their

use in scriptural parables, while his acquaintance with the living conditions of the indigenous population—unusual among American visitors, who did their best to ignore the realities of Ottoman Palestine—purports to offer insight into the most arcane Bible verses.[50]

The picture of the topographically savvy American promoted by Thomson was one that quickly took hold in the second half of the nineteenth century. In a book on Jerusalem, Albert Rhodes, American consul there for three years during the Civil War, fashioned a gentle satire of a typically resolute "New Englander" who, faced with any sacred site, reduced all discussion to skeptical and stoic considerations "on topographic grounds" of the particular claims. Rhodes complained of these overly practical, "Calvinistic" visitors whose matter-of-fact nature prevented them from being moved by the associations of the region. In contrast, the head of the British Palestine Exploration Fund in Jerusalem, Charles Warren, expressed his admiration of the phenomenon: "I must admit that the manner in which many of the Americans were well grounded in Palestine topography surprised me; they accounted for it by telling me that their clergy make a point of explaining and describing it from the pulpit frequently." By 1892, the popularization had reached the point that Elizabeth Champney (wife of the artist James Wells Champney) could publish a novel for adolescents, *Three Vassar Girls in the Holy Land*, in which the vacationing protagonists decide rather ambitiously to "pass an entire season [in Jerusalem], verifying as nearly as possible all sacred localities."[51]

One result of this currency of language regarding the Holy Land was that interested Americans became convinced that the Palestinian landscape was (or should be) unconditionally "available" to them. Thomson himself assured them that although the Land of Promise was given to the patriarchs, "it is given to me also, and I mean to make it mine from Dan to Beersheba before I leave it." His companion staked a similar claim: "Jerusalem is the common property of the whole Christian world. . . . *I* claim a share in Zion and Moriah, Olivet and Siloah, Gethsemane and Calvary; and I mean to pursue my studies and researches with as much freedom and zest as though no eye but mine had ever scanned these sacred sites."[52] Availability and access, then, were clearly key elements in the increasing assertions of patrimonial privilege. Such sentiments began to be expressed with fresh vigor in the years following the Civil War, when unprecedented numbers of United States citizens set out for the Holy Land.

"You cannot imagine the extent of the American element in travel here! They are as 25 to one English. They go about in dozens & scores—one dragoman to so many— & are a fearful race mostly." So wrote the English painter Edward Lear in 1867 during one of several trips to the Middle East.[53] In the same letter, he mocked the American penchant for listening to as many as three church services in a day and refusing to travel on the Sabbath. Two things caught the artist's attention: the sheer number of Americans and the rigorous piety they professed. Although Lear's correspondence is celebrated for its humorous hyperbole, contemporary witnesses' reports appear to corroborate his observations. By all accounts, the surge of American trav-

elers to the Holy Land in the late 1860s outpaced the visits of any other group of pilgrims. Several historical events can be isolated as contributing factors to this phenomenon.

The most obvious change was the end of the Civil War. After years of focus on the conflict at home, citizens with the inclination and means (at least those in the North) thought themselves in a position to turn their attention across the ocean. A particularly poignant example is that of Abraham Lincoln. On the very day of his assassination, he was reported by his wife to have discussed with pleasure his own anticipated trip to the Holy Land.[54] Another factor was the Universal Exposition taking place in Paris in 1867. Attendance at the fair was often an excuse for United States citizens to continue traveling on to Palestine and Egypt.[55] Locally, their trips were facilitated by improved communication and transportation. The telegraph, for instance, had just reached Jerusalem in 1865, and the first paved road between that city and Jaffa was opened in 1869, the year of the initial Cook's Tour to the Holy Land.

Fiscal considerations ensured that most Western travelers to the Holy Land came from the upper end of the economic spectrum. Charles Warren, a frequent commentator on the American presence, reported that on the ship that took him to Jaffa in February 1867, all of the thirty-five first-class passengers were from the United States.[56] For those who could not afford first-class passage to the Middle East, there were alternative ways to participate in the Holy Land experience. Joseph Inskeep Taylor, a lawyer, took subscriptions from friends and other interested parties before setting off for Palestine. In return, subscribers received a copy of his travel book, *A Gyre Thro' the Orient*. Somewhat idiosyncratic, *Gyre* exhibits the usual racial insensitivity but—rare for an American travel book of the period—is also not above sarcasm at the expense of the Protestant clergy. His reaction to the landscape is no less exceptional. Rather than seeing nature as a confirming agent, he found its very familiarity to be a cause of doubt: A given sacred event "could not have been right here on this spot, for here is the familiar ground,—the earth, and stone, and water, and verdure, and sky, and clouds, and the beautiful harmony of nature in all her workings."[57]

No attitude could be further from the philosophy of Robert Morris, a Holy Land popularizer who arrived a year after Taylor did and staked a career on the notion that the most commonplace chip of stone could indeed elucidate entire biblical passages. His commercial exploitation of the market in Holy Land interest signals perhaps the final and inevitable American reaction to the suggestive landscape. Morris engaged in the sale and distribution of Palestinian realia: bits of stone and wood, pieces of glass, flowers, seeds, coins, shells, and containers of water that threw "rays of light upon 'the mind of the Spirit' as opened in the Divine Narrative."[58] Relics from the Holy Land had long been venerated by European Christians. Even simple earth, brought back by the ton after the medieval crusades, was prized; it was used to create holy burial grounds such as the Camposanto of Pisa. Likewise, returning American colonists from George Adams's ill-fated Jaffa settlement were said to have made money by selling bags of dirt as "genuine Palestinian soil."[59]

An active Freemason, Morris financed his trip to the Holy Land by lecturing in 130 Masonic lodges from New York to Nebraska. The sum of nine thousand dollars was raised, principally from ten-dollar subscriptions for "Holy Land Cabinets," each to be equipped with 150 sacred objects ("less than 7 cents apiece!") accompanied by lengthy descriptions. Masons hold that Solomon and his architect Hiram of Tyre were the first of their brotherhood. They trace their origins, therefore, to Palestine. Morris's itinerary was consequently unusual, emphasizing sites of Masonic importance —such as Hiram's workplaces—rather than the standard points of Christian pilgrimage. He returned in 1868 to report his findings in more than six hundred lodges as well as churches, colleges, and Sunday schools. Morris found that his specimens were also avidly purchased by non-Masons, and by the time of the Chicago fire of 1871 (when his stock was destroyed), he claimed to have distributed one hundred thousand samples. Another hundred thousand were reportedly sold by his organization, the American Holy Land Exploration, after his warehouses were replenished.[60]

This evident American enthusiasm for material specimens of the landscape of the Holy Land bears examination. It bespeaks a trust of the physical, the natural, and the immediate. Once again, Samuel Clemens's parody of the phenomenon serves as an index of its pervasiveness. Throughout *Innocents Abroad*, he delights in mocking the relic-hunting zeal of his companions. In their hunger for proof—not so much of the biblical narrative, but rather of the importance of their own pilgrimage—they ruthlessly chip and hammer away at any building or sculpture remotely invested with a sense of past. Adopting a pseudoscriptural tone, he judged these "image-breakers and tomb-desecraters" in their own pious language: "For behold in them is no reverence for the solemn monuments of the past, and whithersoever they go they destroy and spare not." Earlier in his account, he was more direct in his condemnation: "Heaven protect the Sepulchre when this tribe invades Jerusalem!"[61]

Morris, who might easily have been invented by the author of *Innocents Abroad*, correctly saw this desire for material souvenirs as a crucial component of the Holy Land pilgrimage, yet such a trip was an experience limited to a privileged few. If communion with the sacred terrain was not possible for all Americans, Morris nevertheless saw to it that tangible elements of it could nevertheless be rolled between any citizen's fingers (provided he or she had ten dollars to spare). Individuals back home were thus permitted access to the mix of visual and kinesthetic senses that dominates during the experience of landscape. There was also an appeal to the practical and the scientific. Purchasers were assured by Morris, "I personally vouch for the accuracy of the specimens in this cabinet. *I know them* to have come from the places to which they are respectively accredited."[62] The accompanying texts took pains to break down the chemical components of the water from the Dead Sea and list the mineral content of selected pieces of stone. Seven different bits of Jerusalem marble were included as "object-lessons"; a single example would not have demonstrated the variety of stone from location to location.

Yet by no means were the expressive qualities of the samples neglected. The descriptive leaflet for specimen no. 30, "Earth from the Garden of Gethsemane," suggested, "This . . . is an honest portion of Gethsemane; a portion upon which the

Divine *feet* may have trodden, the Divine knees pressed, the Divine *tears* and *sweat* moistened."[63] Contact with the sacred was thus direct, even osmotic. With the map that Morris included, and references to biblical verses applicable to each object, cabinet owners could essentially recreate, using all of their senses (he even provided extra carob husks for eating), a journey through scripture lands. Above all, Morris's enterprise attested to a kind of thirst for biblical testimony of an experiential type. It is thus characteristic of the desire that also kept visual depictions of the Holy Land constantly before the eyes of Americans.

In its many manifestations, the American devotion to the Holy Land continued to develop and flourish throughout the nineteenth century. This breadth of missionary, exploratory, colonialist, and touristic activity in Palestine provides a starting point for addressing the questions that might frame a discussion of landscape depictions of Bible lands: Why paint the Holy Land in the first place? What was the artistic motivation? Once there, what should be depicted, and how? Who would be the viewers and purchasers, and why should they be interested?

Any consideration of these specific problems must also acknowledge the overlapping pressures exerted by contemporary forces of religion, science, economics, and national identity. Geographically nebulous, the Holy Land was a sometimes contentious, always emotionally charged area of the map—and of the psyche. Its power to provoke, inspire, reassure, and console was widely recognized by Americans, who used its catalytic energy as a means to strengthen arguments, heighten rhetoric, stir up sentiment, and even induce aggression. A history of visual representations of Palestinian lands cannot ignore this social complex surrounding the idea of the Holy Land.

A certain "Holy Land consciousness" permeated most levels of nineteenth-century American society. Indeed, the pervasiveness of the phenomenon was recognized by the observers who lived through it at its peak. One should not assume, however, that even the participants in this celebratory endeavor were unanimous in their confident search for revelation from the land. Thus that most notoriously irreverent of American travelers to the Holy Land, Samuel Clemens, was able to satirize completely the rapturous reaction to the biblical terrain that, by the time of his trip in 1867, had become canonical. Writing of his disappointment in the landscape, he declared with irony, "It is the most hopeless, dreary, heartbroken piece of territory out of Arizona. I think the sun would skip it if he could make schedule time by going around. What Palestine wants is paint. It will never be a beautiful country while it is unpainted. Each detachment of pilgrims ought to give it a coat."[64]

In much the way that his fictional alter ego, Tom Sawyer, might have approached the problem, Clemens is here advocating a whitewashing job. He asks that the landscape be painted over, occluded, rendered opaque—its revelatory content suppressed and concealed. Clemens rejected the Palestinian scenes that greeted his tourist party, yet in his own way he puts forward an "improved" formula that is no less ideal than the hopeful projects he would eviscerate. The difference, perhaps, lies in the level of his self-awareness. Clemens recognized that the key to the meaning of the

Holy Land in the nineteenth century lay in its outward representation. Although his humor and sarcasm might have been lost on the American artists who preceded and followed him, they would have agreed with Clemens on one point: Palestine did, in fact, need to be painted.

Panoramic Imagery in the Early Nineteenth Century

Long before any American artist had the means of travel to the Holy Land, there existed a tradition of vernacular visual representations of its landscape. The popular fascination with Bible lands encouraged a striking succession of entrepreneurial schemes seeking to bring images of the sacred terrain before the eyes of the public. Sparked initially by the widespread interest in Palestine and Syria, the phenomena of panoramas, dioramas, and models of the Holy Land—to name but a few examples—continued to nourish and sustain that same interest, allowing the appeal of the subject matter to grow to truly national proportions. The emergence of these forms of entertainment and edification did more than set a precedent within the circumscribed world of the visual arts. It created the broad structure of an easily adaptable enterprise, a specific market for knowledge that could be quickly exploited by a variety of cultural workers.

The practices that evolved to promote, interpret, and disseminate popular images of the Holy Land are identical with those later employed by academic easel painters. Such a link underscores the virtual universality of the Holy Land as an operative symbol and metaphor, a concept important to groups of varying classes, regions, and religions. Certainly the biblical landscape meant different things to different people. Yet the important point to recognize—as so many did in the nineteenth century— was that it could mean *something* to almost anyone. This factor was crucial to the early success of those artists who employed popular methods to isolate and cultivate a public and shape its understanding of their work.

Like the American concern with biblical typology, the roots of the vogue for visual evocations of the Holy Land can be traced to the colonial era. Eighteenth-century technical constraints placed limitations on what could be offered to an audience, but as in later decades, Holy Land realia, animate or inanimate, often elicited responses that, because of the directness of the experience, were at least as stirring as those generated by even the most elaborate representations. Thus the *Boston Gazette* featured the following advertisement in November 1739: "NOTICE is hereby given to all Persons, that there is come to Town, a very Wonderful and Surprising Creature to all Persons in these Parts of the World; and it is in Scripture the very same Creature

which is there called a CAMMEL. . . . The Creature was brought with great Difficulty from the Deserts of Arabia in that Quarter of the World which is called ASIA, to New England." Admission was charged to see the animal, which was housed at "the Sign of the Cart and Horse."[1]

It is revealing that rather than describing the physical peculiarities of the camel, a ploy that might have been expected to entice the casual reader of the period, the notice was richest in geographical imagery. It fixed Bostonians firmly in New England, while invoking the desert landscape of Arabia and implying that because of its ties to "Scripture," the camel had particular significance for "all persons in these Parts of the World." The *Gazette*'s advertisement suggests both the centrality of the Bible as a point of reference for eighteenth-century American life and the abstract possibility of drawing ties between the old Israel and the new.

In New York a few years later, the suggestion of the holy terrain was much more specific. During the summer of 1764, the *Mercury* publicized a spectacle described as "Jerusalem, A View of that famous City, after the work of Seven Years. To be seen at the house of Tho. Evans, Clock and Watch-Maker. . . . An artful Piece of Statuary, in which every Thing is exhibited in the most natural manner, and worthy to be seen by the Curious."[2] Although it is difficult to know with any certainty, Evans's "Jerusalem" was likely a small, three-dimensional model of the city. According to the *Mercury*, it depicted sites contemporaneous with the Passion of Christ; presumably there would have been someone on hand to point them out and relate the familiar story.

Scaled-down "sculptural" renderings of Jerusalem and the rest of the Holy Land, although not so numerous as two-dimensional representations, were an integral part of the American visual culture surrounding the theme. They continued to be produced throughout the nineteenth century, perhaps because they responded so directly to the mapping instinct that characterized American interest in the region.[3] Topographical accuracy, a prime concern of almost every depiction of the sacred landscape, could be expressed most clearly in three dimensions. Additionally, the models encouraged spectators to make their own spatial connections and intellectual triangulations as they jumped between geographical points on the terrain, allowing the various paths taken by the eye to create narratives (inspired by Bible stories) in time and space.

By far the most important medium for the popular dissemination of views of the Holy Land, however, was the panorama painting. At a time in the early nineteenth century when images in general, and most assuredly images of Palestine, were only rarely available to those who were not members of the cultural elite, panoramas provided "blue-collar" viewers with a rich and comprehensive menu of visual delectation.[4] Their size and their conspicuous presence in a culture where the unceasing bombardment of images of the modern world was yet unknown guaranteed an experience concentrated in content, and of unusual intensity.

Perhaps the first exhibition in the United States advertised as a "panorama" (though it was likely just another three-dimensional model) was a representation of Jerusalem, promoted in the *New York Advertiser* in 1790. It was on view twelve hours a day at the tavern of Laurence Hyers, on Chatham Street, and was described as

"most brilliant by candlelight." Like most panoramas, this particular prospect of Jerusalem remained open to the public, in various locations, for an extended period; it can be followed in the New York newspapers through the 1790s and tentatively identified in advertisements appearing in the early years of the nineteenth century as well.[5]

Within the realm of panoramic subject matter, views of the Holy Land appear to predominate. Although the theme of the Mississippi River, for instance, has received considerable attention from scholars, the number of known panoramas of that subject seems small when compared to the dozens of similar renditions of the Holy Land that existed.[6] In one respect, the Holy Land panorama differed from those of other subjects within the genre. Most of these depended primarily on the novelty of their themes. Eastern Americans could be expected to show an interest, for example, in the scenery along the western rivers, which were only then beginning to be exploited for the purposes of national expansion. The views were new to them, and the paintings helped in the acquisition of controlling knowledge of territories deemed fresh with opportunity. In contrast, Americans already possessed a certain conceptual familiarity with the Holy Land. The appeal of the panoramas depended on their power to invoke that intimacy and on the perceptual component they could add to the viewer's existing understanding of the region. However, this explains only a part of their popularity.

For a subject like the Holy Land, which is notable for its ability to interest a range of social groups, the panorama would appear to be the perfect medium. While aspiring to high-art pretensions through its purported didacticism and moral enlightenment, it nevertheless remained accessible to all classes, thanks to its claims of straightforward naturalism and its elaborate packaging, consisting of interpretive pamphlets, entertaining lectures, and, on occasion, music. John Vanderlyn, a pioneering panoramist in the United States, recognized this aspect of the medium, writing in 1829:

> Panoramic exhibitions possess so much of the magic deception of the art, as irresistably [sic] to captivate all classes of Spectators, and to give them a decided advantage over every other description of pictures; for no study nor a cultivated taste is required fully to appreciate the merits of such representations. They have further the power of conveying much practical and topographical information, such as can in no other manner be supplied, and if instruction and mental gratification be the aim and object of painting no class of pictures have a fairer claim to the public estimation than panoramas.[7]

Vanderlyn hit on a point stressed by nearly every promoter of a Holy Land panorama: Because of its hybrid nature, the panorama offered a unique perception of the region, unmatched by any other experience short of actual travel abroad. Its expanded sense of physical amplitude, whether surrounding the public in a stationary rotunda or moving laterally on rollers behind a wide proscenium, drew viewers into its space, testing the limits of their peripheral vision. With the further addition of aural experiences, the totality was seen as easily surpassing a one-dimensional encounter with, for example, a travel book. This disparaging comparison with "book

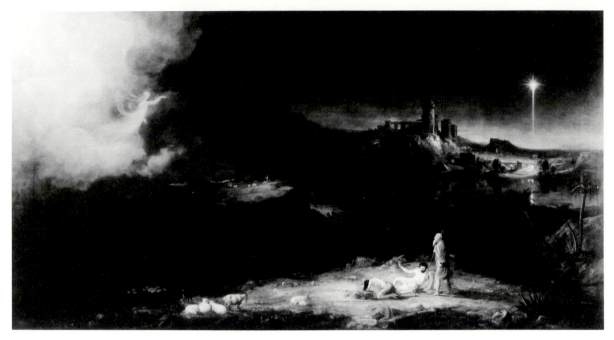

13. Thomas Cole, *The Angel Appearing to the Shepherds*, 1833–34, The Chrysler Museum

learning" was often made, perhaps to emphasize the universal appeal of the panorama, regardless of intellectual preparation. Thus, when Frederick Catherwood brought his panorama of Jerusalem to New York in 1838, the *Mirror* greeted it with the pronouncement, "Neither the most vivid *partial* representations of foreign wonders, nor the most accurate and graphic descriptions of them can so fully bring them before us as a well-chosen and well-painted panorama."[8]

Catherwood's painting, previously exhibited in London, was the most important early panorama with a Holy Land subject in the United States. It arrived at a propitious moment; in a sense, the New York public had recently been "conditioned" to take an interest in visual material related to the Christian narrative in Palestine. Although they were never overly enthusiastic about figural religious paintings, Americans of the early nineteenth century did show an occasional interest in single exhibitions of monumental canvases with biblical subjects. Several such spectacles were offered to the New York public in the years preceding the appearance of Catherwood's work. It was important for the success of these productions that they show effects of astonishing sublimity, and it was important that they be large. Knowledge of the latter criterion no doubt prompted Thomas Cole to execute his most ambitiously scaled painting, *The Angel Appearing to the Shepherds* (fig. 13), which he exhibited in New York, Albany, and Boston.[9]

The Angel Appearing to the Shepherds was first displayed at the American Academy of Fine Arts in April 1834. Essentially bifurcated in composition, this fifteen-foot canvas pairs a gesturing angel (descending at left from a luminous mist) with the

radiance of the star of Bethlehem opposite. In the foreground, a group of three shepherds cowers in yet a third area of bright light, forming another distinct, though static, area of the composition. While the gestures of the shepherds suggest a heightened emotional state, there is little in the way of excited movement or action to bind the competing foci of Cole's canvas. Indeed, the figures have a difficult time filling the grandiose spatial expanse; they seem fixed in place by an exaggerated chiaroscuro that compartmentalizes, rather than unifies, the composition. In the end, Cole lost money on this venture at the American Academy, and when his painting is compared with the more successful works that followed it, some reasons for its lack of popularity can be adduced.

Several months later, a "diorama" called *The Destruction of the City and Temple of Jerusalem* was shown at the same New York location with what was apparently a good deal more success. "We have seldom enjoyed a richer treat," began one enthusiastic account of the exhibition, which identified the "design" of the painting as "from the pencil of our countryman, BENJAMIN WEST." "The clouds—the magnificent architecture—the contending hosts—the countenances of the despairing and helpless,—and the dreadful slaughter 'i' the imminent deadly breach,' are all given with sublime and startling effect," it reported.[10] The dramatic possibilities of grandiloquent architecture, hordes of tiny figures, and thunderous atmospheric effects were what seemed to interest the critic. These qualities had been lacking in Cole's comparatively calm and empty *Angel Appearing to the Shepherds*, and their absence probably contributed to its inability to generate a sizable audience. (Cole, however, soon took the hint and learned on at least one occasion how to satisfy the public's desires, as his much more ecstatic *Course of Empire* clearly demonstrates [see fig. 4].)

Other religious works of great dimensions could be seen in New York during this period, and like the *Destruction* painting, these English productions—enlarged dioramas after David Roberts's *Departure of the Israelites from Egypt* and John Martin's *Belshazzar's Feast*—far surpassed *The Angel Appearing to the Shepherds* in turbulence and bombast (figs. 14–15).[11] Cole may have been happy to let them do so, for the wealthy, upper-class patrons he usually solicited would have likely found much to object to in Roberts's and Martin's violent mob scenes, as several scholars have recently noted.[12] As with Benjamin West's much earlier *Death on a Pale Horse* (1796, Detroit Institute of Arts), such hysterical scenes of biblical tumult were associated with dangerous revolutionary sensibilities, or at least popular vulgarity. Cole probably felt that there were better ways to tell the story.

These dioramic paintings nevertheless remained a part of American popular exhibitions for many years to come. Presentations in the 1840s such as Daguerre and Sébron's dioramas *Jerusalem*, *The Crucifixion*, and *Calvary*, J. Hillyard's "dioramic scene" *The Departure of the Israelites*, and Hanington's "sacred dioramas" *The Creation* and *The Deluge* traded in the same imagery and emotionalism as their prototypes had a decade earlier.[13] One of these, John Whichelo's *Destruction of Jerusalem*, measuring fourteen by twenty-two feet, is still extant. It features swarming Roman armies, burning temples, and a deep, exaggerated perspective. Following the common practice, Whichelo produced an explanatory pamphlet with an engraved key

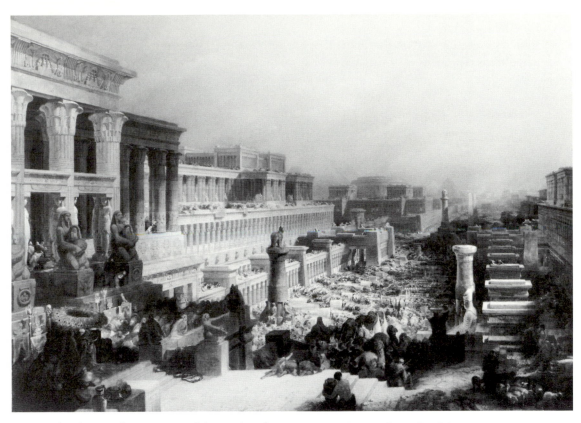

14. David Roberts, *The Departure of the Israelites from Egypt*, 1829, Birmingham City Museums

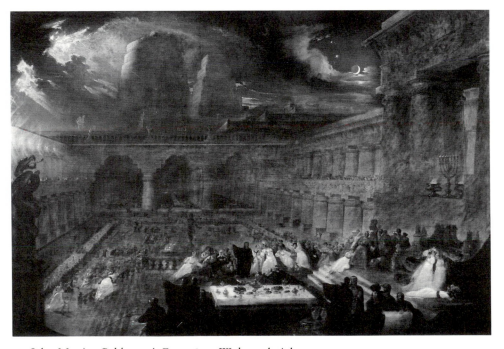

15. John Martin, *Belshazzar's Feast*, 1820, Wadsworth Atheneum

elucidating the complicated setting and identifying the actors in the drama (fig. 16). For those cartographically inclined, he even included a map of the ancient city, coded by numbers to the painting.[14]

Within this succession of highly publicized spectacles, the arrival of Frederick Catherwood's panorama of Jerusalem might have been greeted as just another in the series of sublime biblical recreations. Although it certainly benefited from the interest aroused by the many Martinesque religious tableaux, Catherwood's painting was different in two important respects. As a circular panorama, it provided a spatial experience quite unlike that offered by the other large, flat canvases. Surrounding the public with a continuous horizon line, the panorama appeared to locate viewers within an existing space, uncompromised by an illusion-destroying, lateral frame. In addition, Catherwood's subject matter, though familiar in theme, was distinctive in treatment. He did not conjure a hypothetical, apocalyptic view of Jerusalem from a remote historical period, but rather showed the city as it existed at the time, a nineteenth-century, provincial Ottoman town.

Trained as an architect in London, Catherwood became known as an explorer and archaeological illustrator during his extended travels in Italy, Greece, and Egypt (1821–33). Leaving Cairo in 1833, he crossed the Sinai peninsula and established a residence in Jerusalem for several months. There he produced an exacting set of drawings and measurements of the Islamic Dome of the Rock and surveyed the city for three important maps that he later published.[15] For the American public, though, his most significant activity was the execution of a set of panoramic drawings, with the aid of a camera lucida, from the roof of the structure thought to be the house of Pontius Pilate. These studies became the foundation of his large Jerusalem panorama.

A year later Catherwood returned to England, where he allowed Robert Burford, proprietor of the important Leicester Square Panorama, the use of the Jerusalem drawings. The degree, if any, to which Catherwood participated in the painting of the resulting panorama is unknown. It was always advertised, though, as "Painted by Robert Burford, from Drawings Taken . . . by F. Catherwood."[16] When he moved to the United States in 1836, Catherwood brought the panorama with him, exhibiting it in Boston and building a special home for it in New York, where it debuted in 1838 (fig. 17). Catherwood's panorama building, at Prince and Mercer Streets, was modeled after that of Burford. A large rotunda, it provided space for the exhibition of two panoramas simultaneously, one main attraction below and another, smaller 360-degree view on a higher level above it. The scale, like the format, must have been similar to the Leicester Square building, for Catherwood used several of Burford's actual panoramas (or copies of them), which he purchased in London after the initial success of the Jerusalem painting.[17]

Although it is no longer extant, Catherwood's panorama can be envisioned today by considering the engraving (with its seventy-one labeled points of interest) that folded out of the accompanying pamphlet selling for twelve and a half cents (fig. 18).[18] Guides of this type became standard for panoramas of the Holy Land. Usually,

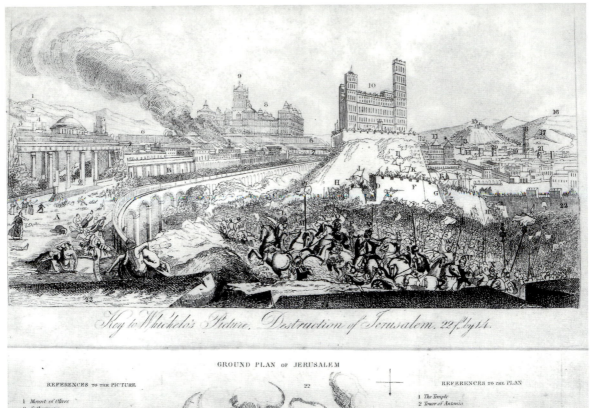

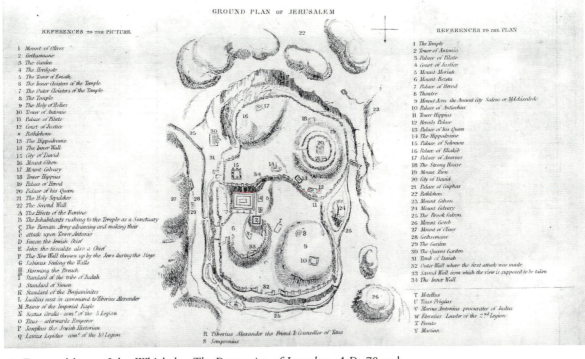

16. Engraved key to John Whichelo, *The Destruction of Jerusalem, A.D. 70*, n.d.

17. Frederick Catherwood broadside (detail), c. 1838

each spot marked on the engraving was laboriously described and discussed in the text, with a liberal scattering of references to Bible verses throughout. These annotated keys were important to spectators, for they allowed them to view the sometimes overwhelming painted surfaces incrementally, providing checkpoints for the eye and a program of visual paths through the complex landscape. It was an interpretive device shared with nonpanoramic paintings, from Whichelo's grand canvas to later, more traditional easel works such as Frederic Church's *Jerusalem from the Mount of Olives* (see plate 5).[19] In essence, such "maps" provided a means for the public to reconnoiter the Palestinian landscape much like the highly publicized American scientific teams that were exploring and excavating the holy terrain during the mid- and late nineteenth century.

At the center of the rotunda, viewers of the panorama were in a position of visual and cognitive power, experiencing what Alan Wallach has called the "panoptic sublime," an exhilarated state induced, in part, by the possibilities of metaphoric dominance and control of the site. Yet like all varieties of the sublime, this situation also came with a measure of discomfort, a sense of self-loss in the face of spatial infinitude and the corresponding desire to confront that loss. Michel Foucault's "sovereign

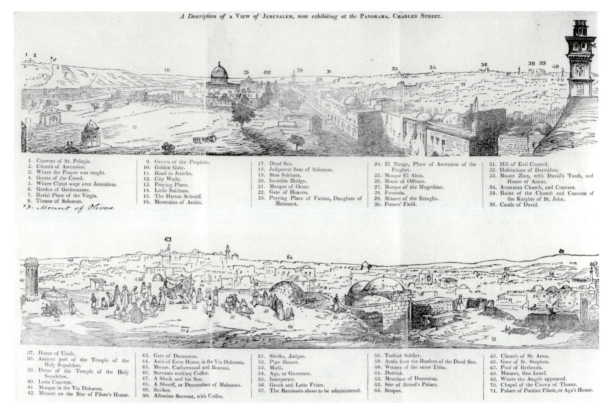

A Description of a View of Jerusalem, now exhibiting at the Panorama, Charles Street.

1. Convent of St. Pelagia.
2. Church of Ascension.
3. Where the Prayer was taught.
4. Grotto of the Creed.
5. Where Christ wept over Jerusalem.
6. Garden of Gethsemane.
7. Burial Place of the Virgin.
8. Throne of Solomon.
*9. Mount of Olives.

9. Graves of the Prophets.
10. Golden Gate.
11. Road to Jericho.
12. City Walls.
13. Praying Place.
14. Little Sakhara.
15. The Harem Scheriff.
16. Mountains of Arabia.

17. Dead Sea.
18. Judgment Seat of Solomon.
19. Stoa Sakhara.
20. Invisible Bridge.
21. Mosque of Omar.
22. Gate of Heaven.
23. Praying Place of Fatima, Daughter of Mahomet.

24. El Mirage, Place of the Ascension of the Prophet.
25. Mosque El Aksa.
26. Mount of Offence.
27. Mosque of the Mogrebins.
28. Fountain.
29. Minaret of the Seraglio.
30. Potters' Field.

31. Hill of Evil Council.
32. Habitations of Dervishes.
33. Mount Zion, with David's Tomb, and House of Annas.
34. Armenian Church, and Convent.
35. Ruins of the Church and Convent of the Knights of St. John.
36. Castle of David.

37. House of Uriah.
38. Ancient part of the Temple of the Holy Sepulchre.
39. Dome of the Temple of the Holy Sepulchre.
40. Latin Convent.
41. Mosque in the Via Dolorosa.
42. Minaret on the Site of Pilate's House.

43. Gate of Damascus.
44. Arch of Ecce Homo, in the Via Dolorosa.
45. Messrs. Catherwood and Bonomi.
46. Servants making Coffee.
47. A Sheik and his Son.
48. A Sheriff, or Descendant of Mahomet.
49. Scribes.
50. Albanian Servant, with Coffee.

51. Sheiks, Judges.
52. Pipe Bearer.
53. Mufti.
54. Aga, or Governor.
55. Interpreter.
56. Greek and Latin Friars.
57. The Bastinado about to be administered.

58. Turkish Soldier.
59. Arabs from the Borders of the Dead Sea.
60. Women of the same Tribe.
61. Dervish.
62. Merchant of Damascus.
63. Site of Herod's Palace.
64. Scopus.

65. Church of St. Anna.
66. Gate of St. Stephen.
67. Pool of Bethesda.
68. Minaret, Ben Israel.
69. Where the Angels appeared.
70. Chapel of the Crown of Thorns.
71. Palace of Pontius Pilate, or Aga's House.

18. Catherwood panorama key, 1837

gaze" cannot be enjoyed unconditionally; it makes its own demands on the viewer.[20] First among these is the need for order; the space *must* be governed by an active eye. The surrounding void of the darkened panorama rotunda thus forced its viewer to make choices, to turn, pivot, and construct a narrative, to marshal the full expanse of a 360-degree prospect. Perhaps realizing the daunting nature of this overwhelming task, panoramists almost always provided their viewers with a buffering package of texts—pamphlets, drawings, and lectures. In this particular case, Catherwood even sold his own oversized map of Jerusalem, based on the survey drawings he had made at the site.

The pamphlet engraving reveals that Catherwood's painting gave a great deal of emphasis to the plazalike space of the Haram al-Sharif, with a clear view of the Islamic Dome of the Rock. This prominence undoubtedly stemmed in part from his unusually extensive researches conducted on the site, an area normally inaccessible to non-Muslims during that period. (His pamphlet provided a great deal of information on the Dome of the Rock; its entry is longer than any other, even that of the Church of the Holy Sepulchre.)[21] The stress on the Dome of the Rock could be justified to Christians who read the Old Testament, however, because the platform of the Haram was also revered as the temple mount of the Jews. Further, Cather-

wood's sketching position at Pontius Pilate's former palace placed him just off the Via Dolorosa, the sacred path where the Passion of Christ is believed to have unfolded. On the other hand, the choice of a high, central pivot point with a close view of the Haram unfortunately left many other important Christian holy places—such as the Mount of Olives and the Church of the Holy Sepulchre—in the distance.

One benefit of the rooftop placement of the spectator was the raised plateau of space in the foreground, where Catherwood displayed a genrelike sampling of contemporary Middle Eastern figures, each identified by religion, political position, ethnicity, gender, or trade. Included were Turks, Greeks, and Bedouins, who fulfilled their artist-assigned roles of clerics, soldiers, functionaries, and servants. Number 57 even depicted the administration of the bastinado, a method of corporal punishment (consisting of beating the soles of the feet) that fascinated many Americans and often found its way into their travel accounts. These incidental episodes of life in the holy city, though undeveloped in the text of the pamphlet, must have provided diverting anecdotes for Catherwood's lectures given before the painting. In fact, to one side of this contrived, encyclopedic figural grouping was a portrait of the artist himself, pictured under an umbrella (number 45). Panoramists frequently included depictions of themselves in their paintings. This practice reinforced the message of authenticity, reminding audiences of the proprietors' claims of firsthand experience of the site.

Catherwood's presence was also important in the New York rotunda itself, where the public heard his lectures and could engage him personally. Earlier, a lack of attention to customers had been seen as a prime reason for the failure of John Vanderlyn's panorama of Versailles in New York City. In 1821, a friend castigated the older artist: "I have never comprehended the prudence of your having quitted yourself & confided such an Exhibition to mere chance success—I should never myself have been satisfied not to have attended myself to the care and circumspection necessary in receiving visitors, and supplying attention and explanation calculated to engage their influence in extending the Celebrity of the Painting."[22] Although he comprehended the power of the panorama to cut across boundaries of class and education, Vanderlyn, unlike Catherwood and his followers, never understood the need for interpretation to viewers. As we shall see, the master of the panoramic lecture (and of the creation of a cult of heroic personality around the panoramist) was to be John Banvard, who pushed both strategies to new limits.

The tenor of Catherwood's own lectures can be known to a degree through the text of his descriptive pamphlet. After situating the reader geographically and historically, the essay became a cautionary tale, stressing the ruinous qualities of contemporary Palestine and the lessons that could be learned from its faded past: "All is loneliness and wilderness, where once was every luxury; the glory is departed from the city, and ruin and desolation alone remain, to mark the tremendous power and righteous judgement that smote and so fearfully laid it to waste." Evoking the solid nineteenth-century belief in the sermons inherent in certain favored stones, it claimed, "Each mouldering ruin recalls a history; and every part, both within and without the walls, has been the scene of some miraculous event, associated with the

great plan of human redemption." Like readers of Edward Robinson's books or purchasers of Robert Morris's Holy Land cabinets, Catherwood's audience was asked to extract biblical and moral truths from the evidence strewn about the landscape of the Holy Land: "How greatly inferior are all other sensations, compared to those which objects so memorable cannot fail to awaken!"[23]

The pamphlet also provided up-to-date information, such as the contemporary population figures for Jerusalem, broken down by faith. This "modern" aspect of the panorama received special attention from some commentators. In a letter to the *New-York Observer* (almost certainly solicited by Catherwood), George B. Whiting, a former missionary with the American Board of Commissioners for Foreign Missions, declared: "I have resided in the Holy City the last four years; and it gives me pleasure to say, after several visits to the Panorama, that it is what it professes to be— *a faithful and true picture of the modern Jerusalem. . . .* Whoever desires to obtain a correct idea of the present appearance of Jerusalem, (and doubtless there are many thousands who do,) should not fail to visit Mr. Catherwood's Panorama."[24] Whiting's testimonial to the painting hit upon a crucial point that distinguished it from most previous large-scale depictions of the Holy Land. For the nineteenth-century viewer, Catherwood provided a glimpse of Jerusalem "as it is" rather than as it was, or as it might have been. Without losing its claims to religious potency and historical interest, the panorama thus gained the qualities of journalistic reportage, topographical accuracy, and ethnographic "color." As a meaningful, moral work of art, it nevertheless remained securely within the category of "real" (versus "ideal") landscapes preferred by many American art theorists and patrons of the day.[25]

Whiting was not the only member of the clergy to contribute to the success of the Jerusalem panorama. Catherwood also made use of a letter written to the *Boston Recorder* by the Reverend Isaac Bird, another American Board missionary. Bird offered predictable encomia, stressing the trompe l'oeil qualities of the experience. He also related his qualifications for "judging of the correctness of the exhibition," which consisted entirely of having once visited the city. Most important, he attested to having been in Syria at the same time as Catherwood, providing the artist with substantiation of his claim to have seen the holy sites in person. This practice of securing statements from members of the clergy or other "experts" became standard for exhibitors of Holy Land panoramas and easel paintings. Some "authenticators," such as William Prime, author of the melodramatic *Tent Life in the Holy Land*, seem to have made it into a veritable cottage industry.

There is little doubt that the panoramists significantly shaped the journalistic reviews of their works; in some cases, the comments appear to be little more than reprinted press releases. Yet these notices are still useful as a barometer of what their authors assumed was most interesting and important to the public. During the course of a long review of Catherwood's work in the *New York Mirror*, the concepts of "accurate imitation," "religious interest," and "glorious associations" appear in quick succession. Another article invoked memories of "those places which we have been taught from our childhood to reverence as the scenes of wonders and miracles." Some adopted a rhetoric of inclusion—"This admirable and correct painting should

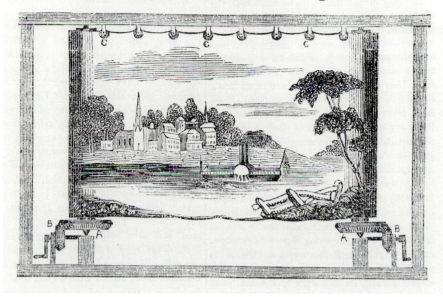

19. *The Machinery for Banvard's Moving Panorama*, 1848, from *Scientific American*

be visited by all religions and all classes"—and others coercively employed the threat of exclusion: "We do not envy the man whose bosom does not glow with enthusiasm while he gazes upon this picture."[26]

Similar reviews accompanied the openings of other Holy Land panoramas throughout the Northeast. With Catherwood's success as a catalyst, the subject became a common one in places of popular entertainment. Over the next several decades, a few panoramists followed his lead in depicting "modern" Palestine. Others simply illustrated stories from the Bible, without much thought given to accuracy of setting.[27] Among the many participants in the popular promulgation of the Holy Land landscape, though, the name of John Banvard was probably repeated more than any other. His relentless campaign of self-promotion successfully placed his own panorama of Bible lands first in the minds of his public. His enterprise lies at the heart of popular imagery of the biblical landscape.

Banvard's panorama of the Holy Land differed from those of Catherwood and his imitators in one important respect. Unlike the earlier stationary panoramas, where the totality of the visual experience was available at all times to the spectator standing in the center of the rotunda, Banvard's painting was displayed section by section as the length of canvas was scrolled across the stage from one huge roller to another (fig. 19). It was thus a landscape that developed over time. This modification, eliminating the fixed point of view, allowed the artist to cover a much greater expanse of terrain. Whereas Catherwood had restricted himself to a static depiction of Jerusa-

lem and its environs, Banvard's panorama roamed across most of Palestine and Syria, lingering at places of historical and topographical interest and even moving inside the buildings housing sacred sites.

Banvard had previously exploited this touristic, narrational aspect of the moving panorama in his more celebrated "three-mile" painting of the Mississippi River. Indeed, before he ever reached the shores of the Holy Land, his career had already been marked by a meteoric rise to fame.[28] His early introduction to the world of art and show business came as a teenager, when he left his native New York City to travel to the Mississippi River valley in search of work. Banvard's upbringing had been staunchly Moravian (the Moravians were a German sect with collectivist and utopian tendencies), with considerable time devoted to Bible study. By 1833, when he was eighteen, however, his life had taken a more worldly turn thanks to work he secured as a theatrical scene painter on a showboat.

For the next several years, he attached himself to a succession of traveling performance troupes that sprang up to service the increasing population of regions west of the coastal states. The first hint of his later activities came in March 1841, when the St. Louis Museum advertised what must have been a variety show, featuring "*Miss Hayden, the accomplished American Sybil*" and two moving panoramas by Banvard, views of Jerusalem and Venice. That he had seen neither of these cities at the time he painted them did not apparently diminish their interest to the public. Long after Banvard had left her act, Hayden was still able to show the two panoramas with seeming success. Six years after their debut, press accounts in St. Louis and Nashville document their continued exhibition during the fall season of 1847.[29]

By that time, however, Banvard had already secured the mantle of dean of panoramists through the unprecedented success of his Mississippi painting. With the tour of this work, the "art" of promoting and presenting panoramas was pushed to new levels of polish and success. Banvard was a lively orator, and his lectures, replete with accounts of his own adventures and accompanied by specially composed music, added considerably to the popularity of the spectacle. Because of the emphasis on his personal exploits, his panoramas became inextricably linked with their creator in the minds of viewers. Aggressively cultivating the press, he was able to establish a certain mythology surrounding his person. His romanticized biography was, to an extent, lived out on the canvas; it became the raw material for the development of a popular cult of heroism. When the Mississippi panorama was sent on tour to Europe, then, Banvard not surprisingly went with it. By 1849, he was explicating "miles" of the river's shore at Windsor Castle before Queen Victoria and the royal family (fig. 20).

The trip abroad is important because it provided Banvard with an opportunity to visit the Holy Land in 1850, or shortly thereafter.[30] Leaving the Mississippi panorama and his family in Paris, he traveled with several friends to Egypt and Palestine. A journal fragment relates that while in England, Banvard had been inspired to go to the East and execute his panorama after hearing the noted British clergyman, Henry Hart Millman, give a sermon on the duty of talented individuals to exert themselves for the good of humankind and the glory of God. (Millman, later Dean of St. Paul's, had earlier published his important and controversial *History of the Jews* [1830], a

20. John Banvard broadside (detail), 1852, Missouri Historical Society

volume notable for its use of "documentary" evidence, rather than miraculous biblical narratives, to locate its subject historically.)[31] The notion of a panorama of sacred sites, though, was not new to Banvard, as the record of the Hayden painting in St. Louis attests. In fact, it may have been a memory of this earlier, no doubt crude attempt at a panorama of Jerusalem that prompted him to try to do better by working from the original locations.

By all accounts, he succeeded. While the Holy Land panorama did not obtain the preeminent place in panoramic lore occupied by his Mississippi painting, it was extraordinarily well received by the press and public. In a medium where size counts, the Holy Land panorama (an "inimitable monster production" according to one critic) was apparently both longer and taller than the Mississippi canvas. An advance review assured readers that it would be "*four times* the size of his celebrated Panorama of the Mississippi." Another thought it was "about six times the size of his famous 'Mississippi,' and exposing at one view two thousand square feet of canvass." Accounts vary, but the height of the roll of canvas seems to have been somewhere between twenty-five and forty-eight feet. A Boston reviewer commented, "In one place, the present actual height of the walls of Jerusalem are given with the exact proportions of the stones of the structure." When it was first shown in New York City in 1852, no conventional building was large enough; Banvard is said to have used a ball court in the New York Racket Club.[32]

The Holy Land canvas was also reported to have been much better painted than most other panoramas of the day, including Banvard's own view of Mississippi,

which even ardent admirers admitted was not a finished work of "high art." The difference, it was maintained, lay in the artist's supposed "years of study among the galleries and the works of the old masters in Europe," which followed the Mississippi panorama but preceded the trip to the Holy Land.[33]

"High-art" aspirations were now working their way more forcibly into Banvard's rhetoric, and as we will see, the sacred subject matter did, in fact, give him an opportunity to make the crossover into easel painting that would signal a different level of professionalism. But in addition to being more carefully painted, the Holy Land panorama also altered the format of the earlier Mississippi painting. There the emphasis had been on length; its most compelling feature was the continuity of the river voyage, an unbroken flow without major, disorienting interruptions. The Holy Land panorama was a good deal taller, and the portion of the canvas on view would have appeared more squarish, less striplike. The possibilities for composition and perspectival development would have thus been greater. The panorama would have likely given an impression of a succession of somewhat discrete scenes, like huge dioramic easel paintings, but related formally and thematically.

Press accounts of the panorama and the interpretive pamphlets published by Banvard confirm this speculation. One Boston reviewer explained, "Mr. B. gives us a capital view by sections of all that is interesting in the different cities, and then he takes us through the valley that surrounds Jerusalem, and thence by the Highways and byways all over and about the land of Palestine."[34] The review gives an idea of a reasonably constant meander through areas of religious interest, with a periodic jump to the next site. This would have allowed Banvard to leave out the depiction of repetitious wandering within important cities, as well as the miles of plain desert roadways between them. Copies of his pamphlets verify this structure, showing the descriptive prose to have been divided into separate entries (Nazareth, Mount Carmel, and so forth), in the manner of Catherwood, with no evidence of transitions between them.

Banvard's longest prose section was devoted to the Church of the Holy Sepulchre, and much of the panorama was taken up by a tour through that complicated edifice.[35] This seems surprising in light of the near-universal distrust of the building by American Protestant writers and explorers. Yet Banvard, his finger always on the pulse of his public, must have been aware of the popular interest in the site, as evidenced by the several Currier and Ives lithographs devoted to the church that were published just before his Middle Eastern trip (fig. 21). Moreover, the ancient discoveries at the Holy Sepulchre of Helena, mother of Emperor Constantine, made for a good story, and perhaps the artist felt that the majority of his viewers, unencumbered by the details of Reformation dogma, would enjoy the tale, as well as glimpses of the purported location of Christ's Passion. Not once in his literature, therefore, did he question the authenticity of the sites within the building.

The usual viewing of the panorama (it was apparently unrolled in both directions on occasion) began with the Syrian seacoast, moved eastward to Galilee, looped down to the Dead Sea, and finally headed back through Bethlehem to Jerusalem. There viewers would explore the surrounding valleys, climb the Mount of Olives to

21. Currier and Ives, *Entrance to the
Holy Sepulchre, Jerusalem,* 1849,
Library of Congress

look down at the Haram, enter the city through the Damascus Gate, and visit the
interesting sites along the streets of Jerusalem. Without being required to move or
turn themselves, they could be carried along by the moving canvas, detached from
their stationary physical selves. Like floating presences, they would be lifted and
conveyed across plains, up hillsides, along roads, and through doorways. This effect
was accentuated by dark fabric draped from the ceiling and fixed near the top edge of
the panorama, thus further purifying the visual experience of the audience.

When compared with the impact of Catherwood's fixed, wraparound view of
Jerusalem, the "viewer's share" of Banvard's panorama was much less demanding.
Banvard coddled his spectators, programmed their voyage, and in so doing, robbed
them of their ocular volition. It was manipulative as well as selective. Comfortably
seated before the moving scenery, the audience trusted the artist to make the choices.
He, not they, had struggled to control the landscape and the space. It remained for it
to be parceled out and served up, bit by bit, as the canvas rolled by. All landscape
painting tries to position its viewer to a certain extent. Banvard, however, situated his
audience with unusual narrowness. His viewers were assigned the roles of passive
tourists, and there was to be no deviation from the scheduled itinerary.

The extended metaphor employed in the panorama was that of a pilgrimage. In
company with his spectators, Banvard set out on a trip that had a clear beginning,

middle, and end. This encouraged the assembled crowd to identify with the artist's experiences, which were conveyed through a biographical addendum to the pamphlet and graphic scenes of adventure in the panorama itself. In addition to sacred geography, viewers learned of Banvard's shipwreck off the coast of Egypt (complete with the "miraculous" saving of his floating Bible and sketchbook), his loss of money at the hands of Arab bandits, and his dangerous trek through a sandstorm.

Such feature stories were only one of many routes to fame employed by Banvard. His publicity apparatus was constantly at work and could be transferred easily from city to city. After opening in 1852 in New York, the panorama went through a sixteen-month run. It was housed for most of that period in the "Georama," a large structure purchased by Banvard. By late 1854, the painting had been taken to Boston, where it remained for over a year. Further venues included Baltimore (1855–56) and Philadelphia (1856). As late as 1863, it could be seen in Brooklyn, at the Lee Avenue Sunday School.[36]

Churches and Sunday schools, in fact, had always been desirable locations to show Holy Land panoramas and easel paintings; promoters realized that such venues elevated their products to an even higher realm of moral culture. Banvard also recognized the powerful influence of the ministers of these churches. Upon arriving in a new city, he would inevitably invite prominent members of the clergy to the opening night of the panorama. Individuals who had actually made the trip to the Holy Land were sought out as well. At the conclusion of the show, they would be asked to stand and attest to the accuracy of the painting. These pronouncements, inevitably favorable to the artist, were immediately reported in the press. As with Catherwood a decade earlier, their testimony was particularly valuable if they could claim to have actually met the artist in Palestine. In Boston the mayor himself was able to perform this function. Both the Boston audience that evening and the opening-night crowd at Philadelphia were induced to prepare resolutions of thanks to the painter, which were dutifully published by journalists.[37]

Newspapers and journals, in fact, provide the clearest indication of the import and effect of Banvard's Holy Land panorama in the various American cities in which it was seen. The artist's personality was crucial to the effect of transportation beyond the exhibition hall. One Boston reviewer reported, "Banvard himself is present, and explains and elucidates the painting in his easy, peculiar style, of which all are cognizant." It soon became part of each Christian's religious obligation to experience the panorama. "We are just returned from 'a pilgrimage to the Holy Land' with an admiring company of Bible Christians," wrote a convert, continuing, "Mahomet enjoined upon his followers the duty of making a pilgrimage to Mecca once, at least, in their lives—we consider it quite as much a duty for every Christian, who has it in his power, to visit an exhibition that they will find far less laborious, but not a whit less interesting, instructive, or binding."[38]

With press notices of such enthusiasm, it is not surprising that Banvard sought to expand his "Holy Land" activities beyond the initial panorama. An author of poems, books, articles, and plays, he came to be seen as an expert on all aspects of the Middle East. His surviving poems (some accounts claim he wrote more than seven-

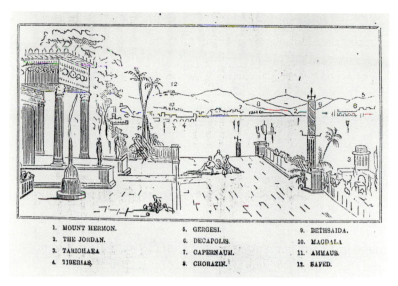

1. MOUNT HERMON.	5. GERGESI.	9. BETHSAIDA.
2. THE JORDAN.	6. DECAPOLIS.	10. MAGDALA
3. TARICHAEA	7. CAPERNAUM.	11. AMMAUS.
4. TIBERIAS.	8. CHORAZIN.	12. SAFED.

22. Key to *Banvard's Historical Landscape*, 1863

teen hundred) are predominately Christian ("An Easter Paean") or archaeological ("The Origins of the Building of Solomon's Temple: An Oriental Tradition"). The novels and plays deal with ancient historical figures such as Jacob, Joshua, and the Egyptian Pharaoh, Amasis.[39]

Banvard's artistic interest in the Holy Land also manifested itself outside his career as a panoramist. Exhibition records indicate that several of his easel paintings of Palestine, Syria, and Egypt were shown at the National Academy of Design and the Boston Athenaeum in 1859 and 1861. That individual paintings by the artist were to be seen within these academic settings undoubtedly elevated his professional standing to a degree. Yet this gambit for recognition by "high-art" critics was short-lived and unsuccessful, if one can judge from the reviews.[40] It was within the community of scientific amateurs and professionals that he received the most encouragement for this final type of endeavor.

On 13 November 1862, Banvard gave an address on the subject of the Sea of Galilee before the American Geographical and Statistical Society of New York. Gathering descriptions of the sea from various ancient and modern sources, he gave a summary of its history and present appearance, with reference to the flora, fauna, and climate surrounding it. For illustrative purposes, he referred to diagrams and an elaborate painting (now lost) that he had executed of the sea as it appeared in the biblical era. At the conclusion of the lecture, the usual resolution of thanks and testimony of accuracy were offered, this time by the ubiquitous William Prime, who had earlier bolstered Catherwood's claims in a similar manner.[41] Others seconded Prime's praise, and with this encouragement, Banvard launched an ambitious public showing of his *Sea of Galilee*.

Using his remarks before the society as a text, he had a pamphlet printed with the requisite engraved key of the painting (fig. 22). While purporting to be a historical

reconstruction, the painting was nevertheless advertised as based on drawings "made personally on the spot," thus guaranteeing an element of contemporary topographical accuracy.[42] The engraving, however, with its framing trees, calm body of water ringed with mountains, and classical terrace slipping across laterally in the foreground, leaves the impression of a work based more on prints after Claude's mythical landscapes or Cole's *Course of Empire*. For his public, though, Banvard probably surmised correctly that it was enough that his subject, the Sea of Galilee, had played such an important role in the life of Christ. These allusions, peppering a text that included stinging criticism of the "rebel," Lieutenant William Lynch, a celebrated American explorer of the region who had subsequently joined the Confederate forces, were no doubt adequate to engage the interest of most northern audiences at the height of the Civil War.

Few cultural phenomena in the United States were left unchanged by the Civil War, and many did not survive it. Like other antebellum tastes, the popularity of the moving panorama had all but played itself out by the beginning of the Reconstruction era.[43] It was perhaps knowledge of this shift that led Banvard to use an easel format for his painting of the Sea of Galilee, his last major Holy Land work. In any event, whether he was pushed out by failure (he is known to have suffered serious financial losses beginning in the late 1860s) or induced by personal reasons to opt for a quieter life after two decades of celebrity, Banvard withdrew from the public eye to concentrate on other activities. American interest in the Holy Land, however, had by no means waned. In step with technology, it simply looked to a new medium for dissemination of popular images of the biblical landscape: photography.

Landscape, Photography, and Spectacle in the Late Nineteenth Century

The amount of American vernacular visual imagery surrounding the Holy Land burgeoned in the second half of the nineteenth century. The relatively new medium of photography, whether experienced through actual photographs, engravings after photographs, or photomechanical reproductions, was soon pressed into service by those who advocated what might be termed universal Holy Land visual literacy—and it performed with undisputed success. Although the popular experience of the Palestinian landscape in the United States included a surprising variety of media—notably landscape architecture and theatrical tableaux—it was photography that best satisfied the public appetite for virtually any scrap of information about the traditional biblical territories. And it was photography, much more than any panorama painting, that could provide the all-important sense of documentary verisimilitude, the unmediated "truth" demanded by a public yearning to be persuaded.

The ties between panoramas and photographs of the Holy Land are greater than one might assume. A link is provided in the person of James T. Barclay, an early American missionary with a penchant for archaeology. While serving as a representative of the Disciples of Christ Church in Jerusalem during the early 1850s, Barclay investigated the holy sites around the city and photographed them using the calotype process. Although not the first American to do so, he was undoubtedly among the pioneers. After returning from the Middle East, he was faced with the problem of making his images known to a wide American audience. To some extent, this was accomplished through the engravings after the photographs that were published in his volume *The City of the Great King* (1858). Another, more unusual solution, though, had greater potential for reaching a larger public. Several years before his book was published, Barclay used his photographs to create a "panorama of Jerusalem and the Holy Land," which he exhibited and explained to audiences in Boston, Providence, and Cleveland in 1856. Details of the format and medium of the spectacle are not known, but its success can be gauged to a degree by the longevity of his concept; as late as 1870, a panorama of Egypt and the Holy Land after photographs by Barclay was on view in Boston.[1]

Barclay's endeavor is an early example of the translation of photographs of the Holy Land into a form that allowed for mass presentation of the images. For the most part, though, Americans had to wait until nearly the last two decades of the nineteenth century to capitalize on this capacity of the camera. It was only after the establishment in the printing industry of reproductive means such as the halftone that photographs of the biblical landscape were widely circulated to the public, making the last quarter of the century the heyday of Holy Land photography. The history of the American contribution to this phenomenon demands its own volume, but within the context of popular visual culture surrounding the sacred terrain, a few distinct uses of photography can be highlighted.[2]

Certainly one category of views that entered the lives of an astounding number of Americans deserves at least passing mention: the stereo photograph. It is estimated that over five million stereographic negatives were produced in the United States, and one of the most enduring subjects, repeatedly featured in numbered sets issued by individual photographers and larger companies alike, was the Holy Land.[3] Stereo photography was developed and perfected in the 1850s, and after the invention of the hand-held stereoscope by Oliver Wendell Holmes in 1861, it became associated with the United States more than any other nation. (England is the only country where its popularity approached the American passion, but the numbers produced there never came close to matching the United States' output.) The boom in stereographs began in the years following the Civil War. In fact, just a year after the cessation of the conflict, a little-known photographer, William James, traveled to the Holy Land and returned with a series of some one hundred images that he perspicaciously marketed to Sunday schools (fig. 23). His was possibly the first major advocacy of the stereograph as a tool to teach biblical geography.

Other Americans followed James, particularly in the early 1870s, when Charles Bierstadt, Benjamin West Kilburn, Mendel John Diness, James Strong, and A. F. Dotterer all executed their Holy Land series.[4] Bierstadt publicized his wares with a much commented-on display of Holy Land stereos at the Philadelphia Centennial Fair, and Kilburn is credited with inaugurating the important practice of selling his cards door-to-door. Through efforts of this kind, collections of mounted stereo photographs of holy sites, often with discursive captions (called "extended legends") glued to their backs, made their way into the homes and schools of hundreds of thousands of Americans.

When viewed in these packaged series, stereos could approximate the narrative structure of a walking tour. In an age when much of Western culture was guided by an imperial, acquisitive drive for knowledge and its attendant power, it was no doubt satisfying (and reassuring) for viewers to be able to experience so much of the world in a small stereoscope safely nestled in the palms of their hands. Their own local surroundings would easily drop away as they pressed their brows to the darkened chamber of the apparatus, obliterating the usual distractions of the periphery and producing a more concentrated, if artificial, type of optical scrutiny. In the first major essay on stereo photography, Holmes stressed this transporting effect, making frequent reference to Holy Land imagery: "I pass, in a moment, from the banks of

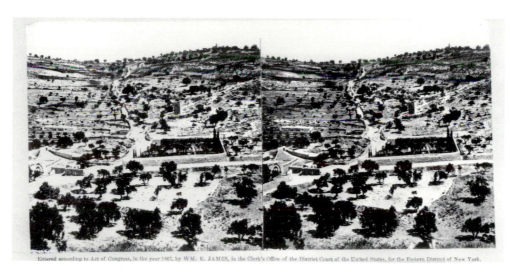

Entered according to Act of Congress, in the year 1867, by WM. E. JAMES, in the Clerk's Office of the District Court of the United States, for the Eastern District of New York.

23. William James, *Mount Olivet*, 1866, Bert M. Zuckerman Collection

the Charles [in his Boston home] to the ford of the Jordan, and leave my outward frame in the arm-chair at my table, while in spirit I am looking down upon Jerusalem from the Mount of Olives."[5]

The ability of stereographs to "capture" space, store it compactly, and recreate it convincingly and repeatedly in the stereoscope had evident interest for teachers of biblical geography, where the actual layout and configuration of sites was often the key to understanding and appreciating scripture. The three-dimensional, binocular visual effect of the stereo photograph soon became a popular nineteenth-century metaphor, used by at least one nature writer to explain the all-important union of the Bible and the land: "It will be found that though the truth of God is one, it has two special aspects, as seen in Nature and in Revelation; and that these two aspects, like the two views of a stereoscopic picture, blend together in the stereoscope of faith into one beautiful and harmonious whole, standing out in clear and glorious perspective."[6]

This three-dimensional effect was also celebrated in stereo advertisements as a uniquely authentic method of experiencing the holy terrain; it was a marketing approach that adopted the tactics of earlier panorama promoters, substituting stereographic "depth" for panoramic "motion." One of the most ingenious exploitations of this feature was patented by the firm of Underwood and Underwood. It consisted of a series of highly detailed maps with numbered spots corresponding to individual stereographs. From each of these points on the diagram, two lines were drawn, forming a V that delimited the peripheral scope of the photographic view, a two-dimensional, Albertian cone of vision showing exactly how much territory on the map was depicted by the stereo card (fig. 24). The crisscrossing lines of the map provided assurance to the home viewer that the faraway landscape had indeed been subjected to a rigorous visual plotting. Its surface had been regularized and triangulated, brought under control by multiple commanding perspectives much like an

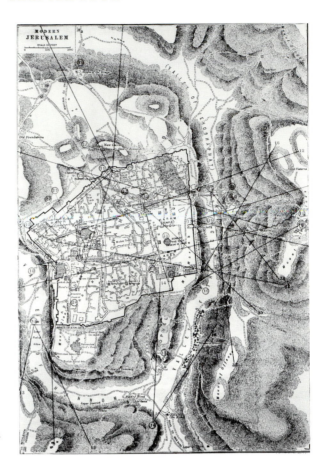

24. "Map of Modern
Jerusalem," 1900

anatomical specimen X-rayed from several different angles. The numbered dot at the
crux of each V thus indicated a visual point of great power, governing its own signifi-
cant scopic field.

The production of packages of stereo cards was often a collaboration between the
photographers (or their agents) and the authors who provided the explanatory cap-
tions. The role of such texts was usually considered subsidiary to the stereographic
prints they elucidated. In other publishing ventures, however, the relationship of
word and image was more complex. Throughout the nineteenth century, photo-
graphs were included in travel or archaeological books as "straightforward," sub-
sidiary illustrative material. The supposedly unimpeachable testimony of the
photographic process was seen as adding moral force to such topographical volumes.
Almost immediately, the power of the photograph to "witness" was established and
accepted; in the very year of its invention (1839), in fact, the daguerreotype camera
had been turned on the landscape of the Holy Land. Shortly thereafter, the first
Bible-affirming book with illustrations from photographs, *Evidence of the Truth of the
Christian Religion* (Edinburgh, 1844), was issued in a new edition by the British
writer Alexander Keith. (British attitudes toward the Palestinian landscape were al-

ways strikingly similar to American notions, an intellectual affinity usually attributed to the common Protestant heritage of the two nations.)

Within decades, travel accounts accompanied by extensive series of photographs (or their engraved reproductions) came to occupy a genre of their own. Late editions of William M. Thomson's *Land and the Book*, for example, were illustrated with engravings after the author's own photographs. Often these books were constructed as personal pilgrimages, retracing the steps of Christ. Sometimes this structure was pushed to include the entire biblical narrative, culminating around the turn of the century in such massive, photographically illustrated Bibles as the four-volume *Historical Library of the Land and the Book*.[7] In the process of being annexed to the holy book, these photographs could almost become objects of veneration in and of themselves. To an increased degree, they were experienced as "cosubstantial" with their sacred subjects.[8]

Of the numerous late-nineteenth-century photo-volumes, one merits extended discussion because of its remarkable content and scope. In 1894, the N. D. Thompson Company, a St. Louis publishing house, released *Earthly Footsteps of the Man of Galilee*, a folio edition of some four hundred halftone reproductions of prints from gelatin dry-plate negatives, all taken by the little-known Robert E. M. Bain. The photographs were arranged in sequence, one per page, in an exhaustive effort to recreate, chronologically and geographically, the experience of following the "footsteps" of Christ, from the time preceding his birth to his crucifixion. The narrative is one driven by images, rather than text. The large photographs occupy most of their oversized pages (when lying open, *Earthly Footsteps* is more than two feet wide), with narrow printed bands functioning as captions below. Bain's reproductions thus serve as more than illustrations; they are not simply visual resting places, islands in a sea of closely set type. Rather, in the aggregate, they approximate a panorama painting, pushing the envelope of their margins as though aspiring toward a single, continuous vision, an unbroken optical survey of the terrain.

Beginning with the journey of Mary and Joseph to Bethlehem, the book traces—at times obsessively—Christ's journeys as fetus, infant, child, and man. Often, according to the volume's lengthy captions, Bain seems to have turned his camera lens to the side of a road being traveled, solely for the purpose of demonstrating what the Holy Family might have seen as they wandered. The producers of the volume made a concerted effort to stress the thoroughness of this method, which provided "an opportunity . . . of making a delightful tour of Palestine and the countries adjacent to it without leaving home."[9]

The original expedition had been organized and financed by the Thompson Company. In early 1894 it sent Robert Bain, a bookkeeper and manager for the International Mercantile Marine in St. Louis and an active figure in local circles of amateur photography, and James W. Lee, a Protestant minister, on a mission of several months' duration. Bain was to take the pictures, and Lee was to provide the extended captions. Lee also contributed an introduction, as did a much more notable clergyman, John Heyl Vincent, the well-known Methodist Episcopal bishop,

promoter of Holy Land studies, and as we will see, founder of the Chautauqua Assembly. *Earthly Footsteps* was aggressively marketed as either a single volume or a subscription of periodic installments, each containing sixteen pictures. The latter format cost twelve dollars annually.

The first paragraph of Lee's introduction explains their effort with a military metaphor: It had been necessary, readers are told, "to actually invade Palestine" in order to follow in the steps of the Savior, but, Lee rationalizes, the invasion was nonetheless benign, conducted "with harmless, scientific instruments." Making assurances that are ambiguous at best, he promises readers that "no bombardment was to be inaugurated, except such as passed through the lens of the camera, and no missile was to be projected deadlier than the thought that passed through a pencil to the pages of a note-book."[10] A short essay by Vincent follows, making standard assertions about the value of viewing the existing biblical terrain and its people:

> In Palestine, the contour of the country remains. . . . The manners and customs of this Eastern country have not been changed. . . . The general scenic features of Palestine render it interpretative of Biblical events and shed light upon difficulties which, but for the perpetuity of its features, would have been unsolvable problems. Every traveler through Palestine discovers and makes report of these features and finds his faith in the Book confirmed.

Vincent leaves his reader with an idea of a landscape and populace, both timeless and willing, that offer themselves to any Western traveler desiring spiritual sustenance and intellectual dominion of the region. In *Earthly Footsteps*, the Bain photographs continue this sense of possibility and possession through open, panoramic views that seem to yield to the camera lens, unfolding to provide confirmation of the scriptural hopes of their viewers. Of the hundreds of images included in *Earthly Footsteps*, a clear majority demonstrate a pronounced topographical emphasis. Many of Bain's most interesting prints, in fact, are severely reduced, allowing the simple, monumental forms of the earth to speak with supposed certainty about the historical events (related in the captions) that they formerly witnessed. In such pictures, the impact of the sometimes stark, elemental land presences is accentuated through a concern with subtleties of texture and composition, as with the massive but gentle swell of Mount Tabor (a possible site of the Transfiguration) as it simultaneously balloons upward and extends its shoulders embracingly toward the viewer along the lateral edges (fig. 25). The rugged materiality and incremental striations of Tabor's richly toned slope—its artificial moundlike rotundity believed to have been shaped by ancient terraced cultivation—provide the "footing" for a visual ascent to the top, while its slow, respirational bulging leaves the impression of a living, breathing body, a continuing landscape witness.

Elsewhere, the sweep of the terrain is used to direct attention toward significant objects, as in *Inn of the Good Samaritan* (fig. 26), where acute angles structure the composition and orthogonal lines converge on the arresting black recess of the building's doorway. As the eye progresses along its prescribed course, it is rocked by the round hills on either side, as though traveling through the trough between low,

25. R. E. M. Bain, *Mt. Tabor*, 1894, from *Earthly Footsteps*

26. R. E. M. Bain, *Inn of the Good Samaritan*, 1894, Library of Congress

27. R. E. M. Bain, *The Arch of the Ecce Homo, Jerusalem*, 1894, from *Earthly Footsteps*

rolling waves. Roadways and paths are often used to such good effect by Bain—to place the viewer's feet squarely on the track to a given monument (fig. 27) or to approximate the pilgrim's experience of passing alongside historic sites at the highway's edge. In images of this type, the slow movement from foreground through middle ground to the ultimate object of interest in the distance answers to documentary photography's need for a clear, legible, pictorial structure.[11] Captions sometimes add to this fiction of moving into the photograph and through the landscape by taking readers beyond the picture frame, describing what could be seen, for example, if a traveler turned to the left or moved further over a hill.

In general, Bain conceives of the landscape as a benignly assertive entity, rising up to a high horizon line and forcing itself and its testimony on the eye in a manner that demands a response. One typical scheme, repeated throughout the volume, consists of adopting a low viewpoint and drawing a stone wall or pile of rubble across the foreground of the photograph. The initial result is a sense of overwhelming natural and archaeological evidence that must be dealt with before addressing any other part of the image. More expansive views, though, without such visual barriers, convey an idea of superabundant physical matter that is no less powerful. *The Lower Pool of Solomon* (fig. 28) includes several groups of tiny figures around the perimeter of the giant cistern. Barely discernible from the viewer's elevated vantage point, they appear

28. R. E. M. Bain, *The Lower Pool of Solomon*, 1894, Library of Congress

completely dwarfed by the immensity of biblical history. Beyond them, a landscape opens up that is littered with geological detritus. Durable and timeless, these rocks seem so numerous as to defy explanation. It becomes easy to imagine that they were purposely pushed up to the earth's crust, knowingly exuded by the hills in an effort by nature to produce a stony carapace of lasting proof.

Bain's celebration of existing sites of biblical interest was particularly successful when the subject was as visually impressive as the Pools of Solomon. When he addressed locations that lacked this degree of monumentality, though, his skills were tested in another way. In and around Jerusalem, there are numerous spots revered primarily for their connection to specific biographical episodes of Christ—even the most insignificant ones. For American Protestants who conceived books like *Earthly Footsteps*, these sometimes unimposing views were nevertheless more important than larger landscape prospects that had nothing to do with the Savior. What could or should be done to enhance their visual appeal?[12] The slightly confessional caption of

29. R. E. M. Bain, *The Spot Where Christ Prayed—Garden of Gethsemane*, 1894, from *Earthly Footsteps*

one photograph entitled *Rock upon Which Jesus Leaned*, a rather unexceptional print taken near the Garden of Gethsemane, indicates that Bain struggled with this dilemma. Lee writes that the stone "was not a scene to witness without tears." Yet "when the suggestion was made that a view of the rock would be interesting, the artist [Bain] replied that it might be interesting from the sacred reverence with which the people regarded it, but as a picture he considered that it would not be attractive at all. . . . All its significance comes from the fact that the loving and fainting Christ stood by it."

The issue of the religious transcendence of otherwise nondescript sites is nowhere more apparent than in Bain's photograph *The Spot where Christ Prayed—Garden of Gethsemane* (fig. 29). This striking print goes to the heart of American attempts to create significant images of the landscape of the Holy Land. The caption makes it clear that the location is more than worthy of contemplation: "Many looking upon this scene do not pretend to conceal the tears which flow down their cheeks. This serves to bring before their imagination the agony and grief of the last hours of our Savior's life, when He uttered that last prayer for his disciples and for the world."

This connection, along with what might be termed, following geographer John Kirkland Wright, a geopietistic fetishism of place—an almost extravagant belief in the numinous power of specific sites—effectively raises such barren views to sanctified spaces of great power.[13] Drastically pared down, *The Spot where Christ Prayed* combines an obsessive emphasis on physical fact with a feeling that something else is there, even if it cannot be seen. A forceful effect of perspective dissolves and then collapses the barrier of the picture plane; the splayed walls advance to embrace all viewers, sliding laterally to surround and include them in the sacralized field. Such an improvised *temenos*, from the Greek *temno*, or "to cut," creates, as Joan R. Branham has suggested in another context, a marked-off space, the singular experience of which is explicitly defined, concentrated, and intensified.[14] The space thus seems elevated and purified, preserved and contained by the familiar and trustworthy stones of Palestine, even as it is visually divorced from the topographical context that ostensibly gives it meaning. Only the teasing top of a tree outside the enclosure and the enigmatic rectangular shadow at right provide any type of spatial fix in this otherwise highly abstracted, capsulated vacuum.

However, the central, darkened blot, difficult to make out at the rounded end of the passage, returns the viewer to the signifying realm of the specific. A rough chink in the wall housing a perpetually burning oil lamp, it recalls the former presence of the agonized Christ and provides the spiritual and associational means by which both the site and the photograph become so powerfully elevated to a timeless *loca sacra*. Thus the charged emptiness of the image successfully substitutes the holiness of the biblical place for the holiness of the biblical person. Subject here becomes infinitely more important than style. The photograph has only to exist, apparently, in order to confer importance on the site. In a transference repeated on some level in nearly every Holy Land image created by Americans, sacred place automatically becomes sacred space.

The absence or suppression of the human figure in such images as *The Spot where Christ Prayed*, however, opens a rift—which widens as one progresses through the book—between the Palestinian land and the people who inhabited it. Up to a point, the locals were embraced by visiting Westerners, for they could also be considered as "evidence" (Lee calls Bedouin nomads "objects of peculiar interest") of a continuing scriptural way of life. Such an approach required that nineteenth-century Arabs and Jews remain safely within the religious past, on the other side of a distancing buffer zone of time. This temporal *cordon sanitaire* effectively filtered out the disconcerting implications of contemporaneous inhabitants, whose very presence asserted an implicit challenge to Western attempts at possession and control. To the degree that they demonstrated the unchanged, biblical way of life, then, indigenous residents were allowed representation as part of the complete organic testimony sought by Americans. Thus a young boy is pictured at left beside a hillside scattered with sheep in a print titled *Flocks Near the Pit into Which Joseph Was Thrown by His Brethren* (fig. 30) in an attempt to evoke an image of the Old Testament hero. The actual site of the biblical incident is not shown; the power of the photograph is wholly allusive,

30. R. E. M. Bain, *Flocks near the Pit into which Joseph was Thrown by His Brethren*, 1894, Library of Congress

as is its caption, which hints rather hopefully that "the flocks are still feeding on the hills of Dothan, and the shepherds watching them are dressed probably in the same costume worn by the sons of Jacob."

Many figures, though, are not so "naturally" inserted into the pictured environment. One strategy, used in *The Tower of Jezreel* (fig. 31), involves treating human bodies as formal adjuncts to the architecture and topography, arranging them into pleasing patterns based on symmetry and tonal values. The caption of *The Tower of Jezreel* makes no mention of any of the figures depicted, and one is left to wonder what, if any, meaning lies behind the lining up of the four huddled children, backs to the wall, displayed and exposed to both the glaring sun and Bain's camera lens. They are pushed to the edge of what looks like an empty stage—almost as if the power of the site has generated its own centrifugal force—but their role cannot, apparently, be subject oriented. Instead, they seem to serve some vague compositional end, formally manipulated and completely ancillary to structural configurations and to the primary point of interest, the elevated tower.

Even close up, such prominent groups of indigenous residents could be completely discounted. The title of another print, *Ancient Bronze Doors, Tiberias* (fig. 32), belies the centrality in the photograph of the group of women and children it does not mention. On one level, it would seem, their purpose is simply to fill a spatial

31. R. E. M. Bain, *The Tower of Jezreel*, 1894, Library of Congress

32. R. E. M. Bain, *Ancient Bronze Doors, Tiberias*, 1894, Library of Congress

33. R. E. M. Bain, *A Woman of Samaria*, 1894, Library of Congress

void, a blank panel in a tripartite composition, maintaining the continuous integrity of the picture plane while not detracting from the more important evidence of the metal doors. On another level, they themselves *become* the void, willfully rendered invisible—despite the obvious vitality of their presence—by the refusal of the picture's title to acknowledge them. Within the ponderous volume of *Earthly Footsteps*, their active gaze, which seems all the more powerful and intensified by the tight squeeze of space, is something of a turnabout. It does not accord well with Lee's *a priori* attitude toward Palestinians, and is probably ignored for just this reason.

When figures assume this degree of conspicuousness, though, an element of confrontation often surfaces. The momentary jerk of eye contact experienced by viewers of *A Woman of Samaria* (fig. 33), for instance, is explained in the caption. Anticipating her objection to being photographed, Bain had quietly turned his apparatus on its tripod, suddenly taking the woman's picture "before she knew what he was doing." (Here is a classic example of the "tourist gaze" in that it shamelessly intrudes into the lives of its subjects, justifying itself in the name of folkloric authenticity.) Reflecting on this anecdote, Lee adds, "One can not help being saddened at the sight of so much ignorance and degradation among the natives of the land of our Lord. How different would have been their condition had they received and continued to act upon the instructions which Christ gave them." The moral, scientific, religious, and—one can certainly posit—sexual superiority of Bain and Lee is thus shown to

triumph: they got their picture, despite the irrational resistance of an unfortunate woman, blind to spiritual truth. In a sense, one can go further with this analysis, to assert that the entire Palestinian landscape, as seen in Bain's views, might be considered a similarly gendered and stereotypically passive subject—one, however, that unlike the Samarian woman is consistently portrayed as receptive to, even caressive of, the active, probing gaze of the viewer.[15]

At least one other American photographer, Edward L. Wilson, demonstrated an analogous reaction to the residents of Samaria, who, in his opinion, seemed unworthy of their hallowed geography. Wilson, editor of the trade journal *Philadelphia Photographer* and author of a series of Holy Land articles for *Century Magazine*, found during an expedition near the Sea of Galilee that his landscape prospect was marred by a group of "repulsive" peasants. "Not a 'good Samaritan' of the old school is discoverable in the whole posse of them," he complained. "*They are entirely out of harmony with the character of the land.*"[16] Such remarks illustrate the degree to which all else could be subordinated to and defined by the experience of landscape. Wilson's disjunctive view of time condemned these Palestinians because, unlike the responsive hills and valleys, they would not remain within his idealized world of the scriptural past.

In *Earthly Footsteps*, the weighing of the respective significance of the people and the land had a result that was no less pronounced. From beginning to end, Lee's captions exhibit a startling range of antipathy toward Bain's human subjects. Turks are derided and Jews pitied, but it is the Arab people who bear the brunt of his scorn. Throughout the hundreds of captions, Arabs are described variously as "fanatical," "rude," "sinister-looking," "predatory," "bigoted," "wretched," "ignorant," "degenerate-looking," "superstitious," "degraded," "lawless," "low," "belligerent," and (perhaps the most grievous sin for the self-satisfied Lee), "conceited enough to imagine themselves superior to all the rest of the world."

Islam, it seems, was the culprit. *Earthly Footsteps* takes pains to demonstrate what it presents as the deleterious excesses of the faith. The caption for one photograph, *Military Mosque, Damascus*, asserts: "Mohammedanism [*sic*] is thought by many who have studied it well to be but organized sensualism. Its subjects move languidly from the harem to the bath and from the bath to the mosque." A few pages earlier, Lee explains another print entitled *Dervish Beggars* (fig. 34) by ridiculing the two holy men it offers up for scrutiny: "They are supposed to devote themselves to the contemplation of God," but by the calculated effect of "their shabby appearance," "they have reduced begging to a science." Seemingly stunted, pressed to the bottom of the frame, the dervishes appear small, passive, and weak in Bain's image. Closed, shaded eyes prevent them from returning the judgmental gaze of the viewer. Even the crumbling rubble wall, its cumbrous stones looming above their heads, functions as a blind commentary on their abject state, just as elsewhere, Lee's caption to a photograph entitled *Wall of Tiberias* equates the ruinous condition of the structure with that of the Jews who lived around it.

The men in *Dervish Beggars* have been trapped between two confining planes—the unyielding barrier of rock and the even more relentless "wall" of vision directed at them by the Western readers of *Earthly Footsteps*. Their ability to penetrate either

34. R. E. M. Bain, *Dervish Beggars*, 1894, from *Earthly Footsteps*

boundary has been held in check by Bain's maneuvering; his large camera (we can imagine it set on its tripod directly before the pair) confronts and constrains them, daring them to test the limits of the slice of space into which they have been forced, all the time confident that they will not. With such images, it becomes easier to understand Lee's fervent belief in the ultimate triumph of Christians ("the true children of God") in the Holy Land. Elsewhere in the volume he writes, "It is only a question of time when Western civilization that has grown out of the Christian religion is destined to take the place of the civilization of Mohammed."[17]

This, then, was the real problem with the people of the Holy Land: they were the most obvious threat to its possession by Christian civilization. It was a long-standing dilemma, one encountered by a seemingly unending series of American Protestants

who concerned themselves with Palestine. Thousands of miles westward, however, a solution of sorts was worked out in the late nineteenth century when the creators of perhaps the greatest propagator of Holy Land "consciousness," the Chautauqua Assembly, decided that if American knowledge and power could not be made to dominate in faraway Palestine, then the answer was simple: Palestine would be brought to America. With the creation of "Palestine Park," vernacular imagery of the Holy Land moved decidedly beyond the panorama rotunda, the stereoscope, and the scriptural textbook. Passive observation gave way to participatory interaction as Chautauquans reacted to the problem of contemporary Palestine by enfolding themselves in the ancient cloak of Bible life and Bible land.

Called by Theodore Roosevelt "the most American thing in America," the Chautauqua Assembly got its start in 1874 as a two-week meeting for Sunday-school teachers convened by John Heyl Vincent, the *Earthly Footsteps* essayist, beside a lake in western New York.[18] Only a few years later, Chautauqua had become a year-round educational enterprise touching the lives of thousands of Americans through its permanent summer community, home reading circles, and satellite camps and meetings. From the start, Chautauqua was conceived of as a place where the rational study of the Bible, nature, and science went hand in hand. Because of Vincent's personal interest in teaching sacred geography, the early years included exhibitions of panorama paintings, stereo photographs, and lantern slides of Palestine, as well as lectures on life in the Holy Land, symposia on Darwinian science and the Bible, language instruction in Hebrew, Arabic, and Aramaic, and the purchase of plaster casts from archaeological digs at Nineveh and elsewhere. Soon, Chautauqua developed a reputation as a center of Holy Land teaching. As evidence of that commitment, a major thoroughfare in the community was even named Palestine Avenue.

It is this aspect of the Chautauqua community, the desire to refashion its own living space into a kind of surrogate, transplanted Holy Land, that provides the most illuminating demonstration of the extent of American identification with the region. During the first summer at Chautauqua, a Pennsylvanian named W. W. Wythe created a landscape environment, at Vincent's suggestion, that became known as Palestine Park.[19] Constructed of tree stumps, sawdust, and sod, it was 170 feet long, a scale model of the hills, cities, and bodies of water of the central, most religiously significant portion of the Holy Land. Using Chautauqua Lake as his Mediterranean, Wythe situated Palestine Park next to the pier where ferryboats unloaded summer arrivals, ensuring that their first steps at Chautauqua would take place on sacred ground.

Palestine Park was an immediate success. During subsequent seasons it underwent several reconstructions, notably in 1879, when William Henry Perrine, a minister and professor at Albion College, who was celebrated for his Holy Land panorama paintings and his widely distributed chromolithograph of Palestine, introduced more durable materials and increased the accuracy of the three-dimensional map. In the end, the tiny plaster houses of the earliest version of Palestine Park were replaced with entire cast-metal cities, and the composition grew to its ultimate length of some 350 feet (fig. 35). Gradually, it became known outside the community, and visitors to

35. *Palestine Park*, after 1888, Chautauqua Institution Archives

the resort asked to see it before any other feature of the camp. Branch Chautauqua assemblies, such as those at Round Lake, New York, and Lakeside, Ohio, also made their own models, sometimes on a scale still larger than the original park.

The most fascinating aspect of Palestine Park, however, is not its popularity, but the way it was used by the people of Chautauqua—the part it played in their daily mental and physical lives. First and foremost, it was a teaching instrument. Regular lectures were given by biblical scholars as their listeners gathered around miniature mountains and cities or watched the water stream down the Jordan from the Sea of Galilee into the Dead Sea. The special heuristic power of the grassy model that these speakers used to their advantage was described by Isabella Alden (writing under the pseudonym "Pansy") in her popular novel *Four Girls at Chautauqua*.

Ruth, one of the skeptics among the eponymous protagonists, finds herself at Palestine Park one day and muses, "What silly child's play all this was! How absurd to suppose that people were going to get new ideas by *playing* at cities with bits of painted board and piles of sand!" Yet soon "it began to dawn upon her, that it was useless to deny the fact that even such listless and disdainful staring as she had vouchsafed to this make-believe city had located it, as it had not been located before, in her brain." The girls take to passing time at the park, moving their camp chairs about as they study different sections (cf. fig. 36). Sometimes the direct connections to the Bible seem overwhelming, as when Flossy, tracing the path of Christ, becomes excited, exclaiming, "Then he went this way, this very road, Eurie, where you are sitting!" Even Eurie, a doubter throughout the novel, becomes convinced in the end.

36. *Palestine Park*, n.d., Chautauqua Institution Archives

Shortly before leaving Chautauqua at the end of the summer, she suggests to the group, "I say, girls, let's go to Palestine," as though she were preparing to embark on an actual ocean voyage.[20]

Such a total melding of the topographical reality with its scaled representation does not seem to have been unusual, as evidenced by this note in the Chautauqua daily newspaper:

> Saturday morning the members of the Children's Class made the third attempt at a journey through the Holy Land. . . . They marched from the Temple down through the Auditorium making a beautiful appearance with flags and banners flying . . . gave three hearty cheers . . . and sang "Shall we gather at the river" with all the sweetness of children's voices. They then proceeded to Palestine, where they formed a semi-circle extending from the Mediterranean Sea to the Valley of Jordan. Rev. Vincent ascended Mount Hermon and explained to his young, but attentive, hearers the places most prominently connected with Bible history.[21]

The fiction that this group of children was actually "in" Palestine, that their lecturer had actually climbed up the famous peak of Hermon, was of course just that: a fiction. With Palestine Park, any realities were left far outside Chautauqua's tightly controlled gates. The Chautauquan Holy Land was purified and miniaturized, rid of the problematic elements that compromised a visit to the actual Holy Land. Like the stereo photographs used in Sunday schools, Palestine Park

provided a packaged experience that was safe, manageable, and ready to be invoked on demand. And as with the stereoscope, the disruption of scale between viewer and viewed also worked in favor of the beholders of the miniaturized park. Towering above the tiny landscape, their artificially panoramic gaze rendered it easily graspable and digestible. Gaston Bachelard has observed that miniature worlds are necessarily "dominated worlds," adding, "and how restful this exercise on a dominated world can be!" The exaggerated scope of vision afforded visitors to Palestine Park similarly convinced them of the ease with which all that they saw could be understood and possessed.[22]

This they did literally. As one witness reported, "A few would even pluck and preserve a spear of grass, carefully enshrining it in an envelope duly marked." Such an intense, material focus on the physical minutiae of the park helped blur the distinction between artificial and real. Vincent wrote that he envisioned a day when "returning merchant ships from the Levant will have brought quantities of rock, earth, and timber from Syria itself; these will be transferred to Chautauqua, become a part of our own model of Palestine, and people may tread the sacred soil without crossing the sea."[23] Indeed, it was popularly (and falsely) believed in the nineteenth century that Palestine Park had already been constructed of soil specially transported from the Middle East, thus giving it even more of a claim to the title of "Holy" Land.

However potent its physical features, though, the park necessarily remained inanimate. Its carefully plotted hills, valleys, and bodies of water meant nothing unless they were engaged by the humans who viewed and walked through them. Who were these visitors? Contrary to the impression given by Alden's *Four Girls at Chautauqua* and the newspaper account quoted above, Palestine Park was by no means the unique province of children. Adults also frequented the site. What is remarkable, and potentially revealing, however, is that these adults often arrived dressed in "Oriental" garb (figs. 37–38). Chautauqua residents, in fact, consistently indulged in such costuming, both within and without the confines of Palestine Park.

This practice assumed several forms. One early Chautauqua chronicler describes the daily lectures of a certain Rev. J. S. Ostrander, who spoke before a model of the Jewish "Tabernacle in the Wilderness" while wearing "the miter, robe, and breastplate of the high priest." Another Chautauqua regular was A. O. Van Lennep, a pioneer salesman of Holy Land stereographs to Sunday schools who was also known for his lectures delivered in Arab dress. Each day he climbed to the top of Chautauqua's "Oriental House," a two-story recreation of a Jerusalem dwelling, to sound the call to prayer of the Islamic muezzin.[24] Groups could also participate in this fiction, as in the "Oriental Funeral Service" recounted in 1876 by the *Chautauqua Assembly Daily Herald*: "Rev. J. S. Ostrander appeared upon the platform, followed by a company of women throwing their arms wildly. Next came the bier, carried by three men, and after this the widow and child of the deceased, followed by other women, smiting on their breasts. The procession marched around the stage three or four times in the most impressive manner."[25] Such playacting bespeaks more than an obvious insensitivity to cultural difference. Its very outlandishness indicates an ap-

37. *Chautauqua Men in Middle Eastern Dress*, n.d., Chautauqua Institution Archives

ORIENTAL GROUP IN PALESTINE PARK.

38. *Oriental Group in Palestine Park*, 1879, from *Harper's*

parently sincere attempt to "become" the people of the Bible, to move, if only temporarily, from their American status as a metaphorical chosen race in the New World to the actual favored nation of the Old. In this ahistorical conflation of Jewish and Islamic culture, religious and present time, and Semitic and Nordic civilization, the "chosen people" with which they identified became an indistinct Middle Eastern amalgam, a "Bible people" rather than a kingdom of Jews, a nebulous merging of separate cultures almost entirely divorced from contemporary, or even scriptural, "reality."

This blurring of racial boundaries found expression in the late nineteenth century through the revival of the theory of Anglo-Israelism, the belief that the Anglo-Saxon peoples had their origins in the Ten Lost Tribes of Israel. (The philological argument was that "Saxons" equaled "Isaac's Sons.") Initially advanced by a group of religious nationalists in England, the concept of Anglo-Israel was embraced by a minority of American ministers at a time when the Anglo-Saxon "purity" of the American populace seemed threatened by rising immigration. Locating hidden biblical references to the lost tribes in the American flag and the seal of the United States, preachers such as William Poole of Brooklyn, New York, and Morton Spencer of St. Augustine, Florida, assured their followers that people of good American stock (English-derived, but purified by the democratic experience) were the ultimate chosen race. They were described as "Hebrew" but not "Jewish," a bit of skewed biblical ethnography that allowed Americans to become a kind of dominant, Darwinian strain of the original holy people while relegating Jews to the status of a weaker, Semitic branch, slowly withering over the years.[26]

Here, in fact, the focus can be widened beyond such fringe religious thinkers, and even beyond the Chautauqua community, for the desire to remake oneself, to "self-project" beyond local limits of time and geography, was a hallmark of fin de siècle culture in the United States. As T. J. Jackson Lears has demonstrated, the antimodern impulse of the Gilded Age frequently resulted in a longing for the intensity of premodern, instinctive experience. One possible recourse was the appropriation of "primitive" cultures as a means of invigorating bourgeois lifestyles felt to be sterile and overcivilized.[27] The modern self thus became fragmented, susceptible to primal, nonrational urges. Regenerative role-playing developed as an acceptable and desired method of tapping into this lost side of the human condition; it restored an element of "authenticity" to a fatigued, industrial society, troubled by a loss of belief in itself.

One telling illustration of the phenomenon—but certainly not the only one—is the vogue of *tableaux vivants* and pageants.[28] In nearly the same way that stereo photographs were used to encapsulate the globe and make it available to viewers in the comfort of their own homes, parlor tableaux domesticated global life and history and served it up to a titillated audience. And as might be expected, most books on the subject did not fail to provide Americans with instructions about how to invoke their Semitic antecedents. The title page of *Hill's Book of Tableaux*, for example, advertised its "Series Presenting in an Attractive Form THE GREAT TRUTHS OF RELI-GION, As Drawn from the BIBLE; together with Curious Marriage Ceremonies Of Nations, arranged as Tableaux." These ceremonies were celebrated for "seeming to

39. H. C. White Co., *Walls of Jerusalem and the Ferris Wheel Looking from West Restaurant Pavilion*, 1904, Library of Congress

us so peculiar, outre and frequently very ludicrous," yet like the Chautauqua funeral service, they were also "attractive, affording both amusement and instruction."[29]

The people of Chautauqua, who could never be accused of lacking in seriousness, would doubtless have stressed instruction over amusement, but others were not so punctilious, as the case of the Louisiana Purchase Exposition makes clear. When the world's fair opened in St. Louis in 1904, there were two main sections, the official buildings and the Pike, a commercial endeavor devoted to "concessions and amusements" that had, nonetheless, "a meaning just as definite as the high motive which inspired the Exposition." Along the Pike were small exhibits purporting to depict international regions and sites such as "Mysterious Asia" and "Schloss Charlottenberg." On a scale that left these modest efforts far behind, however, the Jerusalem Exhibition Company spent seven hundred thousand dollars to put together a reproduction of the Holy City that became the hit of the fair (fig. 39). In a separate compound covering more than eleven acres, "Jerusalem" opened its doors to the crowds, with its twenty-two streets, three hundred buildings, and one thousand actual inhabitants "being conveyed to the Exposition by chartered steamer, sailing from Jaffa." Dwarfing many of the official structures, the Jerusalem exhibit was given highly favorable placement, off the grand Basin and between the Fine Arts and Machinery buildings. Fair-goers could explore the Church of the Holy Sepulchre, the Wailing Wall, and the Dome of the Rock while being surrounded by imported "Turkish cavalry, Rabbis, dealers of Assyria, Arabia, Jews, Moslems, Christians, and the hoi polloi of that life."[30]

While the display of living persons in ethnic villages was nothing new to world's fairs, the Louisiana Purchase Exposition was exceptional for its devotion to theories of social Darwinism and evolution, with the varying degrees of human development

supposedly demonstrated by its succession of racial exemplars.[31] But even here, "Jerusalem" was an exhibit in a category by itself, both for its unique size, exceeding anything else at the fair, and its enhanced ability to absorb visitors into its environment. The possibilities for spatial and social interaction were almost limitless; viewers moved into roles that were much more complex than the passive observer status common to most of the other ethnic sideshows.

The "Jerusalem" of St. Louis took the concept of Palestine Park and expanded it far beyond the abilities and resources of the inhabitants of Chautauqua. Yet it sought to provide a similar experience, one made even more intense by the totalizing quality of its environment. All aspects of the visit to the St. Louis "Jerusalem" were regulated—including the transported Semitic "types," who, customers were assured, had been forbidden to beg. This issue of organization and control is central to the Chautauqua experience as well. Bain's *Earthly Footsteps* photographs had problematized the *people* it chose to depict, but it had delivered up the *land* in all its vastness—at times perhaps too much of its vastness. The makers of Palestine Park solved both problems by telescoping the land down to a more convenient size, getting rid of the indigenous people, and substituting themselves in their place. Instead of objectifying the people of Palestine through the camera lens, they became them through a willful process of self-transformation. It might seem surprising that in an era of overt expression of racism, anti-Semitism, and a general fear of all but Nordic ethnicity, these members of the cultural elite should try to be anything other than Anglo-Saxon Protestants. But this would be forgetting the artificiality of the situation.

Palestine Park was successful because it provided a safe place, cloaked and sanctified by the aura of religion, for Americans to assume another, temporary identity, one that had deep implications for their national mythology and their own sense of self. By donning Semitic clothing, they used the medium of their bodies to reshape their social and historical identities, much as the sod and tree stumps of Palestine Park had been molded and shaped into meaningful space, or the stark masonry in Bain's *Spot Where Christ Prayed* had been made into a reassuring container for Protestant aspiration and proof. The experience was limited, however—and necessarily so. Chautauquans were "going primitive," in a biblical sense, but only with the knowledge that the transformation would be brief. They would soon return to their proper world, armed with spiritual ammunition to defend American cultural authority and destiny. In the late nineteenth century, then, the pastoral redoubt of Chautauqua functioned as a corrective to the urban environment of chaos and sin—with its population of *real* immigrant Jews—to which so many of the "inhabitants" of Palestine Park would return from their vacations. The jealousy with which they guarded their safety and privacy behind the walls of their community simply underscores their desperation. Their synthesized piety, so blatant in its fiction, and yet so apparently heartfelt, was a response to a rapidly changing world in which faith, social and political prepotency, and the Middle East were no longer fixed and immutable quantities.

The American desire to enter the Holy Land was rarely so adequately fulfilled, short of an actual trip overseas, as in Palestine Park. While there might be something slightly irreverent about tramping on holy sites and leaping in a single stride from one bank of the Dead Sea to the other, the park nevertheless provided a pleasing sense of territory and travel. As one moved through it, end to end, one traveled through familiar terrain and familiar history. The two were united in an imaginative, associational melding of landscape and scripture.

This was the same ideal to which most American easel painters in the Holy Land aspired. These artists stated repeatedly that their works were based primarily on a belief in the revelatory role of the land, particularly land hallowed by sacred incident, and more often than not they were taken at their word. Beyond such outward expressions of Christian positivism, however, their visual imagery also became subject to the same ideological pulls that operated on the *Earthly Footsteps* volume or Chautauqua's Palestine Park. Thus, the success of the four painters who will be considered in part II did not so much depend on their aptitude as explorers, archaeologists, or even artists as on their ability to navigate the complex cultural topography of religious faith, scientific doubt, colonial desire, and contemporary aesthetics that awaited them back home. In this, the early pathfinders had been the panoramists, who mined the first nuggets of interest in visual evocations of the sacred terrain. Their lessons were not lost on the easel painters who followed them, for at midcentury, when most of them left for the Middle East, American fascination with the Holy Land was still providing artists with a social, spiritual, and intellectual mother lode that showed no signs of exhaustion.

Part II

◆

Miner Kellogg, Mount Sinai, and the New Jerusalem Church

When Miner Kilbourne Kellogg arrived in the United States on a summer day shortly after the close of the Civil War, the little-known painter was bringing two decades of sometimes difficult expatriation to an end with a final, hopeful return to his native land. Kellogg had first gone abroad in 1841, returning six years later to oversee the wildly successful American tour of his friend Hiram Powers's *Greek Slave*. The magnitude of that undertaking, his able management of the crowds of paying viewers, and his concerted manipulation of the press in favor of the absent sculptor had convinced him that what he had earlier done for Powers he could now do for himself. Disembarking in 1865, several months after the Confederate surrender and in a climate of fatigued relief and expectant renewal, the artist was confident that the time was finally right for his assumption of a leading role within the high circles of his country's cultural establishment. Kellogg believed that his years of study and travel in North Africa, the Fertile Crescent, Greece, Turkey, and the major capitals of Europe had equipped him—uniquely—to open the eyes of his compatriots to the splendors of Western civilization lying beyond their provincial borders. Most Americans, he was sure, were sadly ignorant of this sweeping historical legacy. He offered himself as a corrective, a cosmopolitan agent of cultural enlightenment.

Kellogg (fig. 40) returned with much more than years of accumulated international experience, however. He was accompanied by crates and trunks stuffed with the tangible evidence of his wanderings: European books and prints, gifts from friends in the Middle East, personal journals and manuscripts, a prized collection of Old Master pictures, and perhaps most important, hundreds of his own drawings, watercolors, and oil sketches—a resource of subjects to work up into exhibition pieces that would consume his remaining years of professional activity. He immediately set about reestablishing his reputation as a painter, and one of the first fruits of the mining of his sketchbooks was a large canvas entitled *Mount Sinai and the Valley of Es-Seba'îyeh*. Today known only through photographs (see fig. 47), the painting had become by the time of Kellogg's return the central obsession of years of personal engagement with the Middle East and its associated biblical themes. Heark-

40. Miner Kellogg, *Self-Portrait*, n.d., Cincinnati Art Museum

ening back several decades to his youthful Sinaitic journey of 1844 but coming at a critical later point in the middle-aged artist's life, this single work functioned effectively as a summation of his formative experiences as a painter and explorer. A locus of scientific, religious, and artistic concerns, *Mount Sinai* provided a late focus for a diverse career that set a precedent of intellectual commitment to the elucidation of the Holy Land through visual means.

Kellogg was the first American painter to engage in systematic travel and study throughout Egypt and Palestine, and in many ways his life serves as a generic profile of a number of artists who followed him. Like most delineators of the holy topography, his career unfolded largely outside the entrenched academic mainstream that dominated artistic life on the East Coast of the United States.[1] He thus relied almost completely on his popular reputation. Not trusting the various juried exhibitions to accept his paintings and hang them favorably, he took personal responsibility for local presentations of his work. Without the benefit of an institutionalized support structure, he was forced to solicit his own patronage—a constant concern throughout his unceasingly peripatetic existence. Kellogg's earliest modern biographer seized on these enterprising aspects of his personality, describing him as "one of those

clever, restless, versatile men who can always attract notice and make their way in the world, shifting easily from one kind of activity to another, or practicing several careers at once."[2]

In order to understand the multiple (and perhaps conflicting) ramifications of a canvas like *Mount Sinai*, the unique experiences of Kellogg's childhood and youth must be considered. Although born in upstate New York, Kellogg grew up in Cincinnati, where his unusual upbringing was largely determined by the progressive social and religious views of his father Charles, a tailor. As described by his son, Charles Kellogg was "a victim of emotion" who, after becoming dissatisfied with the strictness of his parents' New England Presbyterianism, passed successively through the Episcopalian, Universalist, and Unitarian churches.[3] Uncomfortable with the concept of the Trinity and the doctrine of eternal damnation for sinners, he finally found what he was searching for when Adam Hurdus, an ordained minister in the New Jerusalem Church, introduced him to the prophetic writings of the eighteenth-century engineer, philosopher, and mystic Emanuel Swedenborg.

Hurdus, a former British soldier who had discovered both Swedenborg and the New Jerusalem Church before immigrating to the United States in 1804, was instrumental in making Cincinnati an important early center of Swedenborgian worship. With the help of Charles Kellogg and other recent converts, Hurdus erected a small frame church, the initial home of the First New Jerusalem Society of Cincinnati. Their efforts were met with some resistance, for while adherents to the Swedenborgian faith enthusiastically celebrated its rational approach to scripture and its carefully articulated theory of the relationship of God, humanity, and the natural world, the church's detractors denounced it as blasphemous. They accused its followers variously of denying the divinity of Christ, calling into question the reliability of the Bible, and engaging in questionable sexual practices (Swedenborg saw the conjugal act as a symbol of the eternal spiritual union one would find after death and even described a kind of heavenly wife-swapping for those who had been paired with the wrong partner on earth).[4]

In the face of such adversity, the Cincinnati Swedenborgians were nevertheless able to establish a vibrant religious community, including Sunday school classes taught by Hurdus, which young Miner Kellogg attended. As he remembered more than fifty years later in his notes for an autobiography, "In this little Sunday School I received the first impulse to inquire into and respect the writings of the Prophets and Evangelists in the Bible." Such early exposure would have been reinforced by his contact with other significant adult "receivers" (as baptized members of the New Jerusalem Church called themselves): Kellogg's schoolteacher, Milo Williams, and one of his first instructors in art, German-born Frederick Eckstein, were both followers of Swedenborg. The latter's influence in particular forged an associative link between Kellogg's art and his faith, a connection that remained with the painter for the rest of his life. Eckstein, a sculptor who founded Cincinnati's first academy of fine arts, was also instrumental in the Swedenborgian education of another local art student, Kellogg's friend Hiram Powers. In fact, despite their small numbers within the general American population, followers of the New Jerusalem Church were

strongly represented in the ranks of artists, where their numbers were disproportionately high during the nineteenth century.[5]

Kellogg's education was liberal in other respects, for he attended a primary school based on the philosophy of Johann Pestalozzi, a Swiss reformer whose pedagogic method included training in drawing, mapmaking, and close visual observation, skills that would later be used extensively by the artist in the Middle East. But his most radical immersion in an experimental system came in 1825, when the Kellogg family, along with other Cincinnati Swedenborgians, joined the utopian community of New Harmony, Indiana, a communal village founded by the English labor visionary Robert Owen.

Although he was a professed atheist, Owen welcomed all manner of liberal religious sects, and this acceptance was a strong attraction for the sometimes assailed members of the New Jerusalem Church. New Harmony's philosophy of tolerance, freedom, and socialism was never clearly articulated and its mechanisms of government were changeable and controversial, but for over a year Kellogg's family participated in the experiment. In keeping with the program, the eleven-year-old schoolboy was separated from his family, housed in a dormitory, made to wear a uniform, denied shoes, and restricted to a vegetarian diet, yet he was also given drawing lessons twice a day and permitted to make landscape sketches on Sundays. In the end, New Harmony failed to live up to its announced principles, and after a brief attempt to start a new colony in Jeffersonville, Indiana, the Kellogg family eventually returned to Cincinnati. This short episode, while convincing Kellogg that New Harmony's communal precepts had been flawed, remained a formative experience for the child. He later wrote that "all the steps taken in these changes were witnessed by me, and being of a novel kind had a lasting effect upon my youthful mind and character."[6]

Kellogg's voluminous personal writings make it clear that the exceptional experiences of his youth left him permanently marked and favorably disposed to religious and social ideas residing well outside the nineteenth-century status quo. (He is known, for instance, to have sought instruction in an Ohio Shaker community and to have attended services there, which impressed him with their simplicity and liberality.)[7] Yet soon after leaving Cincinnati in the early 1830s, he began a lifetime of striving for public acceptance and success within the most orthodox echelons of the artistic, political, and cultural establishment. After engaging in semi-itinerant portrait work in Ohio, New York, New Jersey, and Massachusetts (where he met Washington Allston), Kellogg was able to ingratiate himself with key figures of the Democratic Party, resulting in an appointment to West Point to study art under Robert W. Weir, commissions to paint portraits of such luminaries as Andrew Jackson, Martin Van Buren, and James K. Polk, and free passage to Europe in 1841 as a diplomatic courier carrying dispatches to Naples.

The departure for the Old World began the most significant chapter of Kellogg's development as an artist. Throwing himself with ardor into the expatriate life of the American community in Italy, he set about visiting historic collections, copying Old Masters, sketching the *campagna*, and establishing working relationships with such fellow visiting artists as Asher B. Durand, John Vanderlyn, Henry Kirke Brown, and

Shobal Vail Clevinger. His home base became Florence, where he reforged an inti-
mate friendship with his old Swedenborgian companion from Cincinnati, Hiram
Powers.

It was to Powers that Kellogg confided his most personal thoughts during the
course of his seminal five-month trip to Egypt and Palestine, begun two years after
his arrival in Europe. As his steamer entered the port of Alexandria on Christmas Eve
day, 1843, he wrote excitedly to his friend in Florence, "My heart flutters with delight
at the prospect of putting foot on the shores of Egypt! Who would have thought that
such a joy would have fallen to the lot of this poor son of a tailor!" Kellogg's strong
emotions are understandable, given the relative infrequency of travel by Westerners
in these Middle Eastern regions during the early 1840s. His expectations were little
different from those of other early American pilgrims: "I anticipate great improve-
ments in many ways in sojourning awhile in this land of the most wonderful of
human events, in meditating upon its ruins and studying the singular character of its
people. It will make the Bible an every day book, and help me to appreciate some of
its most interesting historical passages."[8]

A little over a month later, however, Kellogg found himself subject to thoughts
that were far less common among those who made the same journey. While sailing
slowly down the Nile, he had the opportunity to study and sketch the many ancient
Egyptian temples and tombs that dot the riverbanks of upper Egypt. Pondering the
dates of the ruins, he wrote Powers, "Now according to the Old Church calculations
of the age of the earth these things are more than miracles, for from chaos to the
time of the execution of these wonderful and *extensive* works only 15 or 1800 years
have intervened. Can *you* believe this, knowing the slow progress of the human mind
in such acquirements?" Kellogg felt that the remarkable accomplishments of the
Egyptians necessitated many more centuries of development than the biblical ac-
count of time allowed. As he explained to Powers in the same letter, this theory
called into question the veracity of the chronology given in Genesis:

> Be assured that when the hieroglyphics are properly understood, an entire new face will
> be put upon the Mosaic account of the creation. If the Deluge took place *literally*, and
> was universal, and that too in [the] 2256th year of the world, then these remains were
> *covered with water* if they existed between 3 & 4 thousand years ago, taking the world to
> be 5000 years old! How will this agree with what now is seen in the tombs of Thebes![9]

The issue of the universality of the deluge was an important one for Kellogg, who
noted that the bright colors of Egyptian wall paintings were water soluble and could
be easily wiped off. If the entire earth had at one time been covered with water, how
could these fresh colors still be present? He found his answer in Swedenborg,
through the vehicle of a book, Benjamin Fiske Barrett's *Course of Lectures on the
Doctrines of the New Jerusalem Church*, a gift from a fellow passenger on the boat to
Egypt.

A primary goal of Swedenborgianism is to articulate the link between the finite
and the infinite. This is largely accomplished through a system of what Swedenborg
called "correspondences," a broad but intricate ordering of all things seen and un-

seen that renders the entire universe intelligible to the initiated. The basic theory holds that material objects and natural phenomena are symbols of internal, spiritual principles. Barrett's lectures, which Kellogg described to Powers as "clear, argumentative, and fearless—showing all the hideous errors of the fallen church by the light of the Heavenly doctrines of the New Dispensation," maintained that specific scriptural incidents such as the deluge must be understood "symbolically," corresponding to a higher, spiritual meaning. Thus, wrote Kellogg to Powers, "Mr. Barrett . . . says that our doctrines *deny* the *existence* of the Flood in a literal sense. This will be satisfactory information to you, we used so often to talk upon the question."[10]

Kellogg was by no means the first to suspect that the Mosaic account of time needed to be amended; in recent years, articles had been appearing in popular American journals that argued for a greater compromise between science and scripture, or even an elevation of science above scripture.[11] But among Holy Land travelers, such views were rare. Thomson's authoritative *Land and the Book* explained the lack of fossil evidence of the deluge by speculating that the waters had remained universal for a short time only, adding somewhat gratuitously that miraculous events were not especially known for leaving their traces behind. Even as late as the 1880s, an American book on biblical archaeology could criticize "a class of skeptics called men of science" for "trying to discredit revelation"—remarks indicating the extent to which the recalcitrant public lagged behind the scientific community's embrace of what historians of science refer to as "deep time."[12] Kellogg was not part of that general resistance, and although the problem surrounding the deluge and the age of Egyptian antiquities was only one of the many questions considered by him during his trip, it serves as an important demonstration of his propensity to turn to Swedenborg for help in interpreting his observations while still giving credence to the scientific findings of his day.

Early in his trip, Kellogg wrote Powers that he expected to find "great feasts for the pencil" during his travels, and the evidence of hundreds of existing drawings and watercolors demonstrates that he was not disappointed.[13] Initially fascinated with the changing views from the deck of his boat on the Nile, he drew dozens of light, careful, panoramic strips of shoreline, sometimes stacked one above another on the same page (fig. 41). With a finely sharpened pencil, he made exacting observations of topographic contours and textures, paying close attention to the varying rock faces of the uncomposed bands of riverbank. At least once, though, he broke from this straightforward, planar format to execute a more arresting composition, where a sleek jet of Theban mountains appears to float on the pristine paper, seemingly pulled across the empty page by a rapidly vanishing perspective point, like the tail of an arcing comet (fig. 42). Other works explored more complex compositional techniques or emphasized more recognizable monuments such as the Great Sphinx (fig. 43).

The sites of the Nile valley occupied him for about two months, but the more important segments of his trip were yet to come. Although he is known to have kept a journal during his entire sojourn in the Middle East, that manuscript has not been located. Through his correspondence with Powers, however, and through a series of

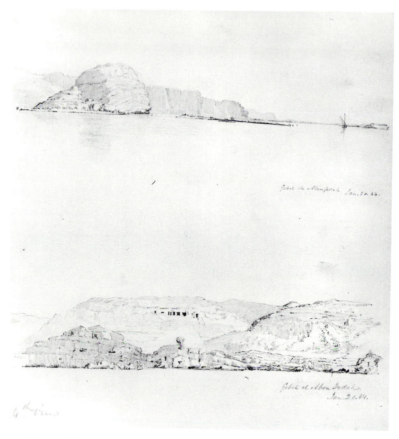

41. Miner Kellogg, *Nile, 3rd and 4th Views*, 1844, National Museum of American Art

letters to his brother Sheldon published in the Cincinnati *Western General Advertiser*, the basic itinerary of his journey can be reconstructed.[14] (Kellogg was to use the publicity tactic of reprinting letters written to him and by him throughout his career.)

Leaving Cairo in late February, the artist set out on camel for a grueling thirty-day crossing of the Sinai peninsula. Using the Exodus narrative as a guide, he and his several companions charted the wanderings of the Israelites, spending an important five days at the Monastery of Saint Catherine at the foot of Mount Sinai. As he moved into this desolate region, with its great looming cliffs of solid rock rising precipitously from the desert, Kellogg's sense of petrological fact became even more acute. His sketching also took on new intellectual purpose in the vicinity of Mount Sinai when he began to formulate his ideas regarding the true scenes of the Old Testament events involving the wandering Israelites. In particular, the problem of the actual location of the sacred Mount Sinai would become a lifelong obsession. Already thinking ahead to their eventual use for purposes of demonstration, he selected his views of crucial valleys and peaks to indicate the possibilities of the

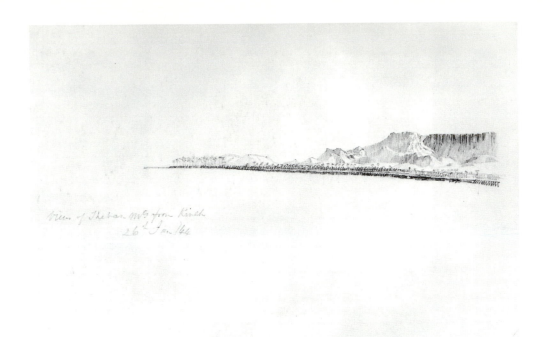

42. Miner Kellogg, *View of Theban Mountains*, 1844, National Museum of American Art

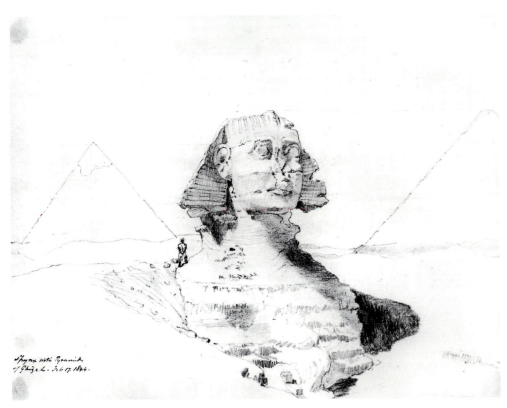

43. Miner Kellogg, *Sphynx with Pyramids of Ghizeh*, 1844, National Museum of American Art

44. Miner Kellogg, *Jerusalem*, 1844, National Museum of American Art

massive movement and encampment of the Jews fleeing Egypt. For these studies, he reasoned, rigorous accuracy would ultimately be necessary if he was to convince biblical geographers of his developing theories.

Crossing into Palestine from Sinai, the party then made its way to Jerusalem, where Kellogg was forced to spend three days in quarantine. After attending a meeting of resident missionaries and examining the scriptural points of interest surrounding the holy city, he began a monthlong series of short but thorough visits to the other principal sites and cities of Palestine and Syria. Included were Bethlehem, Hebron, Jericho, the Jordan River, the Dead Sea, Jacob's Well, Nablus, Mount Tabor, Nazareth, Endor, the Sea of Galilee, Safed, Tyre, Sidon, Beirut, Damascus, and Baalbek.

In addition to his pencil drawings, Kellogg worked extensively in watercolor, particularly after crossing into the region of Palestine. At Jerusalem, he made loose sketches of significant ruins on the perimeter of the city as well as wide panoramic brush studies of what would become the standard nineteenth-century prospect from the height of the Mount of Olives. More inventive was a low view of rooftops taken from an opposite corner of the city (fig. 44). The large, moist sky is convincingly handled here, with a degree of sensitivity and attention unusual in these studies. On a sunny rooftop in the foreground, a tiny woman hanging laundry to dry provides an element of anecdotal interest, while beyond her the crowded street grid of the walled city spreads out diagonally in patterned, squarish blocks of wash. Kellogg provides here a rare American view of Jerusalem as a contemporary, lived-in city, rather than a fossilized tomb.

45. Miner Kellogg, *Sketch of the Artist Camped outside Jerusalem*, n.d.,
Cincinnati Art Museum

Many of the Palestinian drawings include views of Kellogg's own tents and be-
longings worked into the landscape vistas. Like the panorama painters who felt a
need to furnish their audiences with visual evidence of their personal trips to the
Holy Land, he seems to have sought the documentary authority that such self-
insertions were seen to provide. There are several Middle Eastern paintings by Kel-
logg known to include his image, and one oil sketch set outside the walls of Jerusa-
lem has the artist's initials autobiographically marked on a box strapped to a kneeling
camel (fig. 45). Freely and thickly brushed with warm, glowing paint, this small work
depicts a few groups of conversing figures in Middle Eastern dress. Off to one side,
the Mamluk walls of Jerusalem supply a specific element of place. Internal and
external evidence suggests that this fragmentary view was once part of a larger work
that depicted the artist before the ancient city. Certainly the unbalanced composi-
tion and unresolved lateral edges—with the arbitrary slicing of the important walls
of Jerusalem and the glance of the youth at left unexplainably directed beyond the

picture frame—argue for the painting having been altered at some point. Such a modification would have been entirely in keeping with Kellogg's practice of using and reusing his Holy Land material over the course of several decades.[15]

Within months of returning to Italy from the Fertile Crescent, Kellogg had again decided to journey east, this time to Constantinople and the surrounding regions of northwestern Asia Minor. Although the second trip did not bring him near any sites of specific scriptural importance, the experiences and contacts proved significant in shaping his views of biblical interpretation and publicly connecting his name with the issue. Leaving Italy in December 1844 and traveling by way of Malta and Greece, he accepted the invitation of Dabney Carr, the United States minister to Turkey, for an extended visit in Constantinople, where he hoped to receive portrait commissions from residents of the city. While there, he also spent time with the British ambassador, Stratford Canning, and became quite close to Canning's assistant, the budding archaeologist Austen Henry Layard.

Kellogg was impressed by Layard, becoming ardently devoted to him to a degree rivaled only by his friendship with Powers (and he remained on good terms with Layard for the rest of his life, though the same could not be said of his relationship with the sculptor). The two took to roaming Constantinople together, in search of genre subjects for Kellogg to sketch. Both men had already explored areas of the Holy Land, so it is not surprising that in the midsummer of 1845 they set out on an expedition to visit ancient cities east of the Ottoman capital city. Accompanied by a Prussian diplomat, they wanted to study the architectural remains found at such sites as Bursa and Aezani. As Kellogg later remembered it, "Layard was engaged in copying the old inscriptions on the ruins whilst I employed my time in sketching the scenery and making very careful drawings of important edifices—temples—amphitheatre—bridges Etc. Etc. Every thing was new to us, and we worked like beavers to be *the first* to make known the details and value of ruins until this time only hinted at by some former travellers."[16]

Kellogg's greatest efforts at promoting Turkish archaeological discoveries, however, were devoted to the spectacular Assyrian finds Layard subsequently unearthed at Nimrud (which he believed was the biblical Nineveh). Although he had returned to Europe shortly before Layard began his most important excavations, Kellogg was kept informed of the progress through continued correspondence with his British friend. It is clear that Kellogg was profoundly affected by news of the remarkable reliefs from palaces of rulers believed to be contemporaneous with the ancient Hebrews. "You can scarcely *dream* of the importance which your solitary labors may have upon the right understanding of the Historical and Prophetical parts of the Holy Word," he wrote Layard in 1846. "Every image which you uncover, may add a link in that chain of interpretation which is now being unfolded in regard to the signification of those hitherto inexplicable and I may say, apparently *absurd* passages which abound in the word of the Old Testament."[17]

Specifically, Kellogg saw the grotesque animal forms of the Assyrian reliefs as having much to do with descriptions of similar creatures in the Book of Revelation.

Although he avoided invoking the name of Swedenborg—he was perhaps embar-
rassed by the opinion, current throughout the nineteenth century, that the seer of
the New Jerusalem Church had been insane—the artist boldly put forward a
Swedenborgian interpretation of the finds, writing in the same letter: "That the
Prophets spoke agreeably to a settled system of *correspondences*, seems beyond any
question in the present day by all who are not blinded by some sectarian doctrine in
religious matters. Your researches have been amongst the buried records of this an-
cient correspondence between spiritual and natural things—for what else are those
strange images which you probably surmise to have belonged to the religion of the
Ninevites?" In what is likely the longest and clearest expression of his beliefs, he went
on to confess to Layard his faith in "the Christian doctrine,"

> which doctrine is to be fully revealed in the *Second* Coming of the Lord, that is, when
> the *internal meaning* of His word will be manifest to every eye. And this last and
> glorious state of things is to be brought about only by a knowledge of the *true meaning*
> of the Sacred Scriptures, through this Doctrine of correspondences, agreeably to which
> they were written, and agreeably to which they must be understood, not only in a
> general manner, but in every particular, "jot and tittle." To this end John was com-
> manded not to "*seal* the words of the prophecy of this Book," for the "time (or state of
> the world) was at hand," when it would be necessary that it should be opened for the
> good of mankind. I believe that state *has arrived*, and this is one great reason for the
> interest I take in what you are doing.[18]

In this concise credo, Kellogg plainly set down his acceptance of two primary
Swedenborgian precepts: that the apocalypse had already occurred through John's
(and Swedenborg's) revelations, and that the "science" of correspondences, which
had made this "Second Coming" possible, provided the exacting prescriptions
needed for an understanding of God's final truths.

Near the end of this extended letter to Layard, Kellogg announced his intention of
alerting the American press to the new Assyrian discoveries, and in what was to be a
recurrent pattern of successful media manipulation, he was indeed able to foster an
early and avid fascination with the Nineveh excavations and their biblical ramifica-
tions. By offering Layard's letters to periodicals of general interest, Kellogg not only
introduced Nineveh as a relevant topic for Christians, but also advanced his own
name as a commentator on biblical archaeology. In 1847, for example, he took center
stage when he read his friend's letters before the American Ethnological Society of
New York, securing an honorary, corresponding membership for the archaeologist in
that organization. The press did, in fact, remember Kellogg's name in connection
with the Nineveh discoveries; when the *Home Journal* published a notice of a new
archaeological book by Layard, it reminded its readers, "We first heard of Mr. LAY-
ARD . . . from Mr. KELLOGG, the artist."[19]

Layard's published correspondence made it clear to Americans that his work of-
fered solutions to even the most vexing problems of scriptural interpretation; "I have
been continually struck with the curious illustrations of little understood passages in
the Bible which these records afford," he wrote.[20] Yet the evidence could also be

applied to the larger religious and national issues of the day. In a sermon on Nine-veh, preached in New York in 1849 and "suggested by the recent discovery of the ruins of that city," the Reverend J. P. Thompson saw the remains not merely as a verification of the biblical version of history, but as "a lesson of the vanity of human pride and power."[21] Using phrases reminiscent of the many explications of Cole's *Course of Empire* a decade earlier, he warned of the demise of civilizations such as Nineveh that forsook God for material gain.

Thompson's seizing of the phenomenon of Nineveh, moreover, was by no means an isolated occurrence. The contemporary press soon became flooded with notices and essays devoted to the celebrated site in Asia Minor. This reaction was apparent to Layard as early as 1848, when he predicted to Kellogg that his forthcoming book on Nineveh would "be attractive—particularly in America where there are so many scripture readers." A friend of the archaeologist was more blunt about the appeal of the subject, offering this bit of sardonic advice (most of which would have applied equally well to artists): "Write a whopper with lots of plates . . . fish up old legends and anecdotes, and if you can by any means humbug people into the belief that you have established any points in the Bible, you are a made man."[22]

The degree of enthusiasm with which the discoveries in Asia Minor were received must have been encouraging to Kellogg; it may have provided an impetus for his own sustained attempt to contribute to the scientific study of the Holy Land. This initially occurred in 1847, during his first trip back to the United States to manage the tour of Hiram Powers's *Greek Slave.* In masterminding perhaps the most success-ful promotion of a work of art to a popular audience that America had seen, he created a national cultural episode of singular scope and endurance. Several histo-rians have estimated that under Kellogg's supervision, *The Greek Slave* was seen or known by more nineteenth-century Americans than any other work of art.[23] In the process, he was able to hone his skills (later used to good effect on behalf of his own painting) in advertising, pamphlet writing, and lecturing. While in New York in December 1847, however, he made one public appearance that had nothing to do with the tour of *The Greek Slave.* Ever since his desert trek to Mount Sinai, Kellogg had been troubled by a debate, then current, as to which peak in the area surround-ing the Monastery of St. Catherine could correctly be singled out as the holy summit spoken of in Exodus. Putting his thoughts in written form, he appeared before the Ethnological Society and read a paper that was published two months later in the *Literary World.*

In the several years prior to Kellogg's trip to the Holy Land, experts in biblical geography, led by the dean of the discipline, Edward Robinson, had rejected the mount traditionally identified as the site of the giving of the laws to Moses. Robin-son favored a neighboring mountain, called Horeb, which fulfilled the crucial condi-tion of having a plain (Er-Rahah) before it large enough to accommodate the encamped nation of Israelites. In addition, Horeb was plainly visible from this open area, just as the biblical account indicated that the peak must be. Kellogg, however, believed that he had discovered an even larger, hitherto overlooked valley ("Es-Seba'îyeh") which could have served as a place of encampment and which com-

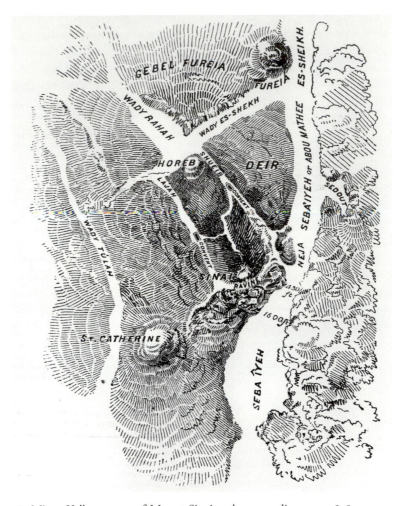

46. Miner Kellogg, map of Mount Sinai and surrounding area, 1848

manded a view of the traditional Sinai, thus restoring it to its original place of honor. He drew a map (fig. 46) to illustrate his theory and published it with his *Literary World* article.

Most of the article is devoted to transcriptions of Kellogg's journal entries in which he describes the process by which he first came on his alternate site while sketching. Es-Seba'îyeh had been missed by previous observers, he explained, because of a low, intervening mountain between it and the peak of Sinai, a ridge that blocked views of the valley from most vantage points. As justification for his interest in the topic, he stressed the importance of a proper understanding of the desert trek of the children of Israel: "That all the circumstances, even to the most minute, attending these journeyings, were intended as so many spiritual lessons to all mankind, we may learn from many passages of the Holy Word; anything, therefore, calculated to elucidate any of the localities through which they passed, and give them reality in the mind, is deserving of consideration."[24]

The eminent Robinson, who later claimed that Kellogg's map was exaggerated, was likely present when the artist addressed the Ethnological Society, and other luminaries in the field of biblical geography soon became aware of his short article in the *Literary World*. John Kitto, for example, gave extensive coverage to Kellogg's theory in his *Scripture Lands*, ending with this admission: "Thus it seems that the question as to the camping ground of the Israelites, which seemed to have been settled by the researches of Dr. Robinson and others, must now be regarded as reopened for further investigations."[25] Yet despite this initial scholarly splash, more than fifteen years would pass before the artist again aggressively took up the issue of the true Mount Sinai.

After completing his obligation to Powers, Kellogg returned to Florence in 1851 and began a second, but less well documented European residency. Moving his studio to Paris in the mid-1850s, and to London by 1860, he devoted much of his time to amassing a collection of Old Master pictures, which he believed to contain works by Leonardo and Raphael. In an effort to prove the authorship of these paintings, he published several pamphlets that, although contested during his lifetime, demonstrate considerable art historical research skills.[26] His work as a painter also continued, with particular emphasis on ideal pictures of Middle Eastern ethnographic "types," mainly female, which he marketed as "national representative portraits." When he was able to, Kellogg also indulged his interest in the landscape of the Holy Land. There is documentation, for instance, of two such paintings (now unlocated): *Beirout and Mt. Lebanon* and *An American Gentleman, in the Costume of a Bedouin Sheikh—Mount Sinai in the Background.*[27]

In his own mind, however, the degree of Kellogg's artistic success and fame was still unsatisfactory, despite the long years he had spent establishing his name in Europe. It was with renewed hope, then, that he finally sailed again for American shores in 1865, arriving equipped with all that he thought necessary to guarantee his success. Although he settled initially in Baltimore, during the succeeding years Kellogg often moved back and forth to other cities, opening studios in Washington, New York, Cleveland, and Toledo and announcing in every city his intention to take up permanent residence as an important contributor to the local art scene. At each location, he displayed his portfolios of Middle Eastern sketches, publicized his paintings, and saw that his name appeared constantly in newspapers and magazines. Kellogg also tried, never successfully, to obtain a more secure position in the art world. He was considered for the position of director of two newly formed art schools in Washington and Cleveland, for instance, and in New York he lent his collection of old masters to the Metropolitan Museum, lobbying to become its curator.[28]

A constant in this campaign for fame was a focus on the large canvas depicting Mount Sinai, presented to the public about a year after his return (fig. 47).[29] Deprived of Kellogg's accompanying lecture, the image now seems to make its topographical point with less clarity and power than the nineteenth-century sources would indicate, but the most important feature of the view is unmistakable: Seen from the east, the jagged profile of the traditional Mount Sinai rises at the far right

47. Miner Kellogg, *Mount Sinai and the Valley of Es-Seba'iyeh*, n.d., present whereabouts unknown

edge, high above and slightly distant from the other rocky forms. In the middle ground of the picture, the lower half of Sinai is blocked by an intervening scalloped ridge of lower peaks (the mountainous "finger" visible on the map, fig. 46, just to the left of the legends "430 ft" and "1600 ft"). It was this visual barrier that Kellogg maintained had hidden his valley of Seba'iyeh from earlier explorers, who never ventured all the way around the ridge. In the foreground of his painting, stretching from edge to edge of the canvas (that is, roughly along a north-south axis), was this crucial valley, the purported site of the Israelite encampment in which viewers of the image, along with several traditionally dressed figures and their camels, find themselves situated.

Although *Mount Sinai* was possibly begun in Europe, it seems to have been completed in the United States and unveiled at Baltimore's Peabody Institute during a two-part lecture series, "The Traditional Mount Sinai," delivered by Kellogg in January and February 1867. Versions of the talks were delivered again in Washington in 1868, and in New York in 1870, the latter before the American Geographical and Statistical Society. In addition, the painting was prominently displayed (prior to its sale) in Kellogg's various studios, where it was noticed repeatedly by visiting critics, and called "a great and valuable acquisition to the world of art."[30]

The American interest in the Exodus account and the area surrounding Mount Sinai was long-standing; even the characteristically unemotional Edward Robinson

48. Henry Cheever Pratt, *Moses on the Mount*, 1828–29, Shelburne Museum

reported that he had burst into tears upon arriving at Mount Sinai, so intense were the associations he brought to it.[31] In this heightened climate, Kellogg's picture became only one of a series of related images that spanned several decades. Although lacking the later painting's geological precision, Henry Cheever Pratt's *Moses on the Mount* (fig. 48), for example, depicts the actual topographical circumstances that Kellogg argued were possible with the discovery of his valley of Seba'îyeh: The encamped Israelites, worshipping the golden calf at right, are situated so as to have an unobstructed view of the stormy summit of Sinai, from which Moses has just descended at left. Like most artists who did not personally make the trip to the Holy Land, Pratt focused on recreating the exciting biblical tale.[32] Kellogg, in contrast, adopted the approach of the earlier panoramists, providing a comparatively straightforward, contemporary view of the peak, one that eschewed an elaborate and eventful narrative.

Although he stressed the measured, "scientific" aspects of his topic, Kellogg also allowed a bit of bombast to charge his formal presentation. Preserved manuscript fragments, which probably served as his lecture notes, reveal a high rhetorical style and a lengthy justification for his obsession with Sinai: "Savans [*sic*] will write whole tomes of learned quibbles as to the birthplace of Homer, or the exact height of a Pyramid, whilst they are content to remain in total ignorance of either the position

or appearance of that mountain from whose summit issued those decrees which are to govern the world and ultimately bring all people into a state of Heavenly order and peace." Targeting the previous U.S. naval exploration of the Dead Sea, he continued:

> The most enlightened Christian nations send forth costly expeditions . . . to explore the rocky, sterile, and pestilential borders of the Dead Sea, *and* search for doomed cities long sunk beneath its stagnant and dirty waters, problems which, if satisfactorily solved, would teach no good to man, . . . yet the wilderness of Sinai . . . is only pictured out by the imagination from the scanty and uncertain material furnished by a few enthusiastic travellers, and by monkish and arabic traditions.[33]

In these lectures, just as in those of the panorama painters, ministers and other community figures were occasionally asked to stand and testify to the correctness of Kellogg's works. In addition to the large *Mount Sinai*, this body of illustrated material included a similar painting of Mount Horeb, sectional drawings and diagrams, and "a faithful portrait of the lecturer's guide and Monk (Pierre)." Still, journalists always seemed to come back to *Mount Sinai* and the force of Kellogg's hypothesis and presentation. The *Baltimore Sun* rather effusively celebrated the painting as "an ocular demonstration in the only picture ever made of it, the force of which, as an illustration of his argument, it will be impossible to resist, and the grandeur of which, as a work of art, ought to make the name of its author as lasting as the granite rocks which his pencil has portrayed." Reviewers also made much of Kellogg having actually visited the spot. After a trip to his studio, a reporter from the *Washington Evening Express* wrote, "The Chief painting is that of Mount Sinai and the Plain of Sebaiyeh. This is a masterpiece, and possesses special interest to the Biblical students as its accuracy cannot be doubted, it being from sketches made by the artist while travelling in Eastern climes."[34]

Surprisingly, the painting was praised most consistently for its plainness of composition and absolute lack of foliage. The majority of commentators recognized the somewhat unprepossessing image as a demonstration piece and thus addressed themselves to its message, rather than its forms. The *National Republican* even saw its barrenness as a strength: "For a scene where so little material exists to make it attractive to the eye, other than by 'fancy touches,' which to carry out would be violating the truth of nature and history, [it] will challenge the test of criticism and add a glow of pleasure to the admiring eye." Swept away by Kellogg's argument, a writer for the *Washington Daily Chronicle* thought his scene of barren grandeur "the place, above all others, that Moses would have doubtless selected that his followers could be most effectually impressed with the spiritual truths which he was chosen by the Grand Architect of the Universe to communicate to them." And in contrast to the exaggerated expression of a work such as Pratt's painting, *Mount Sinai* contained for another critic "the oppressive silence which overwhelms the spirit of the pilgrim. Silence and solitude here triumph over all outward nature and conquer at last even the turbulent passions of the human soul."[35]

Although the last comment suggests a reaction based in part on religious emotion, the larger journalistic record clearly indicates a preoccupation with the "scientific"

aspects of *Mount Sinai*. Although he did devote a considerable amount of time to this rational side of the painting, Kellogg nevertheless approached his work as an ardent Swedenborgian New Churchman as well. In this, however, there was a possible conflict. If an overly literal reading of the Bible was seen by Swedenborg as a misguided strategy (as Barrett's *Course of Lectures* had made clear to the artist), then how could Kellogg's public concern for exact topographical details be reconciled with the doctrine of his personal faith? To a degree, his promotion of the precise location of the traditional mount can be ascribed to his accurate gauging of what would "sell" to an interested public. But there is also evidence that he was able to work out for himself a harmonious accord between the positivistic cartography of the painting and his seemingly contradictory religious beliefs.

When Kellogg gave his address on the traditional Mount Sinai to the American Geographical and Statistical Society in 1870, he ended the lecture by announcing his intention "to say a few words upon the religious prejudice which . . . has had much to do in originating this whole dispute." The prejudice he described was that of the scriptural literalists who refused to acknowledge less stringent methods of understanding the Sacred Word. Carefully reserving a special category for Sinai, he asserted,

> Beyond the general landmarks, such as Egypt, the Red Sea, the Wilderness, Sinai and Palestine (to which a spiritual significance is attributed by all religious denominations), there is much recorded in the memorable march of the Israelites that cannot, it seems to me, be reconciled to the law governing the human senses, nor with those of time and space. . . . May it not be that the numbering of the tribes and other incidents of the Mosaic record involved another and more important sense [than] the literal, just as the chronology of the earlier books of the great lawgiver are now admitted to do.[36]

In essence, Kellogg was able to make Mount Sinai all things to all people. Because of its fundamental importance, he exempted it from what he saw as the nonliteral elements of the narrative while still claiming for it "a spiritual significance," opening the door to a deeper interpretation of the site. The physical mountain could reliably be considered the same "Sinai" as that spoken of in scripture, yet it also remained subject to the less tangible system of correspondences. Further blurring these boundaries, he weakly concluded, "To my mind, no compromise is necessary; the spirit and the letter are one, and when their unity is unseen, it is because we do not comprehend the nature of their union."[37]

Kellogg was not alone in seeing Mount Sinai, and mountains in general, as expressive of a higher realm. In nineteenth-century natural typology, mountains, thanks perhaps to the consecrating power of height, had always been considered a sign of the divine presence. And Mount Sinai, where God had actually come down to earth and met with humanity, was a traditional location where this notion of heavenly contact was greatly intensified. As a contemporary writer on art and nature explained, "From Sinai to Tabor and the Mount of Olives—everywhere and always the High Places of the physical world have led to spiritual elevations."[38] That Sinai (and Kellogg's depiction of it) consisted of a monumental mass of rising, solid rock and little else added greatly to this mystique. Writing generally of religious belief, Mircea

Eliade has suggested that this notion of the utterness of stone is common to most faiths: "In its grandeur, its hardness, its shape and its colour, man is faced with a reality and a force that belong to some world other than the profane world of which he is himself a part."[39]

Eliade's formulation of "some world other than the profane" is reminiscent of the Swedenborgian higher level of correspondence, and it is Kellogg's understanding of this doctrine of the New Jerusalem Church that provides a key to larger meaning in *Mount Sinai*. His correspondence with Powers indicates that New Church theology occupied him constantly during his trip through Egypt and the Holy Land. Writing from Jerusalem, for example, he thanked his friend for a gift of a Swedenborgian tract: "Your little book—'Summary Expositions' has proved of *infinite* service to me in reading the Bible. It is a most valuable *brief* of our doctrines, or rather of the internal meaning of the Prophets." To underscore his point, he indulged in disparaging remarks about the non-Swedenborgian company he was forced to keep during his travels, complaining, "An Old Churchman is no *internal* companion at all. Everything with them is of such an external character that the truth is made dim whenever they open their mouths." Sarcastically repeating the "old church" line of interpretation, he paraphrased: "Where Scripture says 'stone' of course it means stone literally, and so on with all the host of representations with which the Scriptures are filled. But I cannot say here what I want to tell you on this subject. Every day[']s travel has served to confirm . . . that our author was commissioned to write for the use of the *New Jerusalem* of the Apocalypse."[40]

Kellogg's reference to the Apocalypse is instructive in that it comes in the same letter as his acknowledgment and analysis of Powers's gift, a book entitled *A Summary Exposition of the Creed of the New Jerusalem Church*. In that volume, the painter would have read a quotation from the twenty-first chapter of the Book of Revelation describing John's apocalyptic vision of the descent of the New Jerusalem. "This beautiful description," the author of the book explained, "has been seen, by the most learned and eminent commentators, to refer to a future glorious state of the church."[41] Indeed, these crucial biblical verses were the very foundation of the Swedenborgian church, for not only did John's vision serve as the prototype for the entire system of correspondences (with the revealed New Jerusalem representing the truths to be fulfilled by the establishment of the church), but it was also seen as inaugurating the new order of the millennium. It is not surprising, then, that tucked among Kellogg's Holy Land studies was a pencil work labeled in the artist's hand, "St. John—Descent of the New Jerusalem" (fig. 49). Nearly unique in his oeuvre, this scriptural figure drawing shows John, pen in hand much like an artist, ready to transcribe the internal truths to which he is witness.[42]

The connection between the apperception of correspondences and the artistic process was one that Swedenborgian thinkers also highlighted. Barrett's *Course of Lectures*, for example, would have reinforced Kellogg's sense of the importance of his Holy Land endeavor: "The foundation of all excellence in the arts of painting and sculpture, is based upon the Science of Correspondences, a portion of which the artist received by influx. For it is the great aim of those who cultivate these arts in

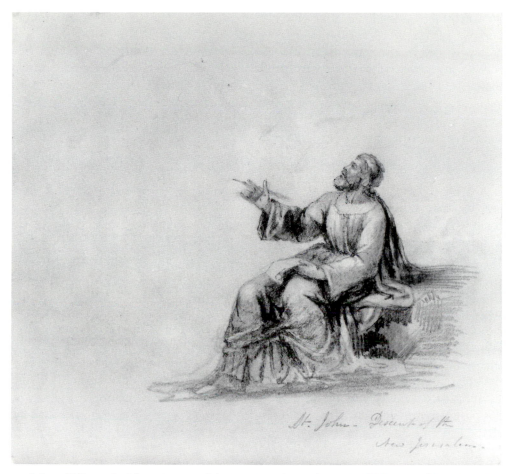

49. Miner Kellogg, *St. John—Descent of the New Jerusalem*, n.d., National Museum of American Art

their higher departments, to represent by sensible colors, and to embody under material forms, certain ideas or principles which appertain to the mind, and which are therefore spiritual." As a Swedenborgian "receiver," Kellogg saw the special benefits of travel through sacred lands. To Powers he confided, "To be enabled to tread upon the same ground, and visit the scenes where our Savior appeared & taught and was crucified, is certainly a great blessing to any believer in His Divinity, and to a New Churchman and a painter the blessing is increased."[43]

On the summit of Sinai, at the place where the laws were revealed to Moses, Kellogg surely stopped to ponder the ways in which divinity manifests itself to humanity. Through his advocacy of the traditional peak as the true Sinai and through its powerfully redolent religious associations, the site came to have profound personal meaning for him. It was this connection that no doubt prompted the artist to execute a painting of himself seated on the mount. Although probably painted years after his trip, *The Top of Mount Sinai with the Chapel of Elijah* (pl. 1) is a work that stems from original studies made on the spot in 1844.

As befits a painting by an artist who prided himself on his topographical accuracy, *The Top of Mount Sinai* exhibits a great deal of attention (with both brush and palette knife) to the rocks that form the summit. A dazzling mix of blue, pink, yellow, and green strokes has been blended, layered, slathered, and dragged across the faces of the cliffs—almost like a pastel frosting—to form the convincingly broken surface. Rocks loom and rise wherever one looks, and Kellogg has clearly reveled in their tactility, particularly in the foreground where the heaping and smoothing of the dense paint appears as if worked in tinted clay. If material evidence of Eliade's pleasing "utterness" of stone is wanted, it is here in abundance. Other features of the scene, however, are no less carefully described. In fact, each element of the view, such as the "three-headed cypress" and the mountaintop chapel, was considered important by Kellogg; the contents of the painting were virtually catalogued for his audiences whenever he lectured on the subject.[44] Yet after surveying the scene, the viewer ultimately returns from the luminous surrounding vista to the more reserved figure of Kellogg, an element of the composition, like any other, that seems to demand cataloguing and explanation.

Although he has depicted himself with the Arab guide who accompanied him on the climb, the artist appears emotionally and intellectually alone—seated, focused, and observant (like his St. John) as he ponders a drawing or map in silence. This is perhaps a commemoration of the moment of inspiration when he began to form his theory of the Israelite encampment at Es-Seba'iyeh. Kellogg seems mentally withdrawn in any event, as his neglected, though melodramatically prominent, sword testifies (to say nothing of the unceremonious and distracted manner in which he has plopped himself down on the bare summit). His bold self-insertion, as well as his state of intense absorption, place him squarely within the field of his investigation. Unlike the majority of visiting artists to the Holy Land, Kellogg does not practice here the disembodied tourist gaze, directed at the subject from without.

Instead, his nearly solitary presence at the site calls to mind the Old Testament figure of Moses, who also climbed Mount Sinai to seek enlightenment and knowledge. He can, in fact, be seen as something of a link between the Old and New Testaments, between the figures of Moses and St. John, both important receivers of revealed religion. Kellogg's presence on the mount adds a third, Swedenborgian level to this scriptural typology of vision and prophecy. The central focus on the cypress, silhouetted against the lighter, burnished cliffs beyond, may also be connected to this theme, for the theory of correspondences held that a tree signified or stood for humanity, as well as for the concepts of perception and understanding. Thus the poignantly isolated tree, almost miraculously alive in its inhospitable setting, becomes a natural, typological foil for the lonely human seer who, like Kellogg and Moses, is subject to mountaintop revelations, whether they are welcome or not.[45]

A similar identification with Moses and his Sinaitic exploits occurred in the work of another in the group of American Swedenborgian painters. According to Joshua Taylor, William Page actually used his own likeness for the figure of Moses in his large painting *Moses, Aaron, and Hur on Mount Horeb* (1857, National Museum of American Art). Taylor interprets Page's audacious self-portrait as an expression of the

50. Miner Kellogg, *The Sphinx*, 1858, Gallier House, Tulane University

importance of the artist's role in sustaining spirituality in the modern world.[46] For both Kellogg and Page, though, the act of including themselves in the guise (more or less) of Old Testament patriarchs at a scene made sacred by miraculous biblical incidents adds not only an element of spirituality, but also one of wishful heroism. It is not far removed, in fact, from the type of costumed enactment that would be performed several decades later at Chautauqua's Palestine Park.

This too is part of the pattern of Kellogg's engagement with the Middle East. In another painting executed years after the trip, here depicting the Sphinx and pyramids at Giza and obviously dependent on the earlier drawing (fig. 50; see also fig. 43), the painter—wearing the same stockings, Turkish pants, sash, fez, beard, and sword as in *The Top of Mount Sinai*—once again takes center stage as he casts his knowing gaze on the huge sculpted head. The requisite Eastern attendants merely watch this familiar Orientalizing process from a slight distance. But Kellogg is also unmistakably engaged in another type of process: his intense observation mimics the pose seen earlier in his St. John drawing. Like the saint, he tilts his head back considerably, his right hand holds a drawing implement, and his left clasps a waiting sketchbook. If there are any truths to be dispensed, he stands ready to receive them.

Despite these heady associations, both *The Sphinx* and *The Top of Mount Sinai* seem to be "about" very little other than the fortuitous intersection of artistic presence and physical place. They somewhat blandly document Kellogg's experience of the sites, but like their kindred panorama paintings, they appear to require external exegesis in order to make their point. *The Top of Mount Sinai* is somewhat passively composed, not quite capable of bringing together its bits of data meaningfully.

Something is lacking; a missing piece prevents the statement from being complete. Part of the problem is that Kellogg's painting goes blatantly against type. The reward of a climb to the top of a mountain is almost always the panoramic prospect of the valley below. Kellogg (both as the maker of the image and the subject within it) turns his back on this expected view, focusing on other matters. The viewer is privy here only to the fact of the painter's presence on the mount. The actual revelation engendered by this visit must wait for the larger, distant view of the site (see fig. 47).

Yet in Kellogg's greatest canvas with a Holy Land theme, the large *Mount Sinai and the Valley of Es-Seba'iyeh*, there is hardly a trace of Moses, St. John, or any other heroic or heavenly vision. (The standing Arab figure facing the tiny camels in the foreground of *Mount Sinai* was occasionally identified in reviews as Moses, but nowhere in Kellogg's own writings is there an indication that the prophet is depicted in his painting, which was usually understood to show the mountain as it appeared in the nineteenth century.) Where then, if it is to be found at all, is the Swedenborgian content?

Answers can be found in the copy of Barrett's *Course of Lectures* that Kellogg carried with him in the Holy Land. In the discussion of correspondences in this book, the author makes many equations of natural objects to "internal" concepts, asserting that "according to this doctrine all things around us are significant. All material things, and all natural phenomena, are symbols of certain spiritual principles and their operation in the mind of man." Applying Barrett's specific discussions to some of the features depicted in *Mount Sinai*, the reader learns that:

> Wilderness corresponds to the state of material man, destitute of good and of truth.
>
> Mountains correspond to the Lord and his spiritual truth.
>
> Clouds correspond to scripture understood only in its literal sense, a mask covering the underlying meaning of the Word.[47]

With these and other relevant "significations," a Swedenborgian interpretation of Kellogg's painting can be constructed. While not the only possible translation from the textual sources, one plausible New Church explication of *Mount Sinai* might read something like this: "God, the monolithic mountain of rock, the place where earth reaches to touch heaven, and the finite intersects with the infinite, rears up above the wilderness of material man, his divine solidity and permanence transcending the precariousness of humanity at his feet. As the clouds move away and the veil of a mere literal reading of scripture is pulled back, the spiritual inner truth of the Lord is revealed."

For a Swedenborgian mind like Kellogg's, such a reading would have been by no means farfetched. Even at the late point in his career when *Mount Sinai* was first exhibited in the United States, his devotion to the New Jerusalem Church was undiminished. His daughter Virginia, for example, was baptized into the faith in 1861, and six years later he wrote a long newspaper article defending Swedenborg from charges of insanity.[48] Swedenborgian receivers like Kellogg, it must be stressed, lived in a different world and followed a different calendar than other Christians.

1. Miner Kellogg, *The Top of Mount Sinai with the Chapel of Elijah*, n.d., National Museum of American Art

2. Edward Troye, *The Dead Sea*, c. 1856, Bethany College

3. James Fairman, *The Mussulman's Call to Prayer*, 1876, private collection

4. James Fairman, *Sunset*, n.d., Graham Company

5. Frederic Church, *Jerusalem from the Mount of Olives*, 1870, Nelson-Atkins Museum of Art

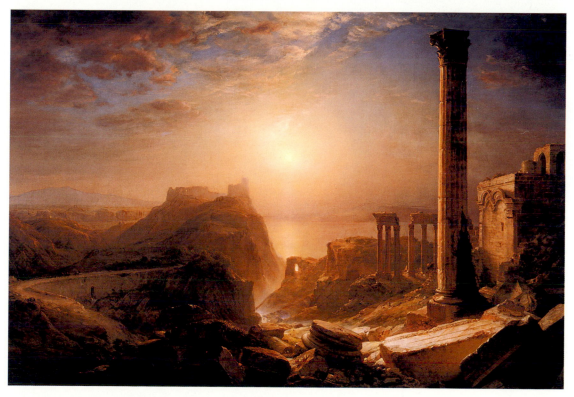

6. Frederic Church, *Syria by the Sea*, 1873, Detroit Institute of Arts

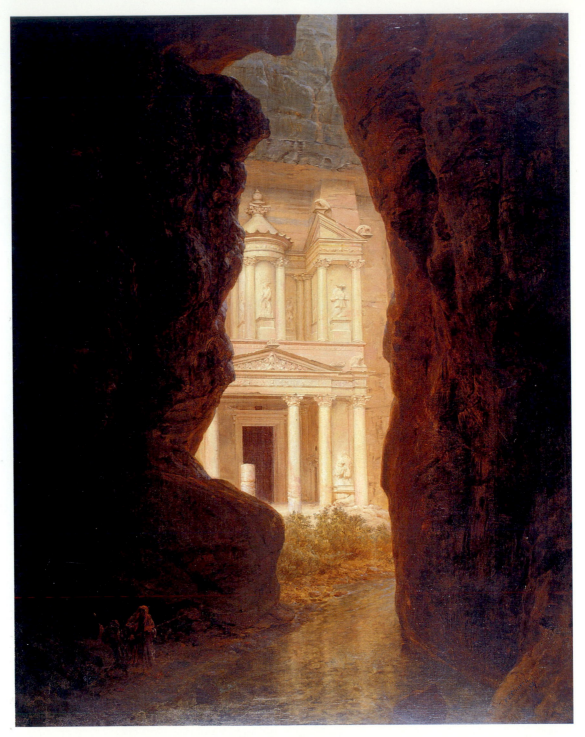

7. Frederic Church, *El Khasné, Petra*, 1874, Olana State Historic Site

Unlike most Christian sects, they believed the Second Coming had already occurred when their Swedish prophet formulated his final eschatological pronouncements. Their postmillennial world has thus been redeemed; its laws, meanings, and physical appearance are not necessarily those of the profane sphere of the unconverted.

One need not, moreover, confine the discussion to Swedenborg. There are many books on the natural world published in the United States during the nineteenth century that support anagogic interpretations of this type. Hugh Macmillan, for example, in his *Bible Teachings in Nature*, wrote, "The whole face of nature, to him who can read it aright, is covered with celestial types and hieroglyphics, marked, like the dial-plate of a watch, with significant intimations of the objects and processes of world unseen. . . . All the objects of nature have but a symbolical or concealed meaning."[49]

If *Mount Sinai* can be seen as possessing such intimations of the "world unseen," then it would have been a manifest answer to the artistic call put forward in 1841 by a fellow landscape painter and member of Kellogg's New Jerusalem Church. Joseph Ropes, in his "Lecture on Painting," published in the official organ of the Swedenborgian church in the United States, the *New Jerusalem Magazine*, asked, "What shall hinder when the science of correspondences is understood, the construction of pictures . . . so arranged, as, while to the unenlightened observer, they would form an ordinary picture, to him who should look at it with spiritual desire, its secrets would be unveiled, and it would be to him the medium of heavenly instruction?"[50] Like the Bible, then, a painting such as Kellogg's *Mount Sinai* would signify on two levels, one for the casual viewer that is literally descriptive, and the other more potently (and even covertly) emblematic for those with eyes to see it.

Unfortunately, the lost *Mount Sinai* was one of the few large-scale works from his Holy Land trip that Kellogg was able to execute after returning to the United States. Wounded financially and emotionally by domestic strife (his wife, a writer whom he had married in Europe, deserted and apparently sued him shortly after he arrived in Baltimore), he was never able to turn his life around and achieve the professional recognition he sought. After exhausting the possibilities on the East Coast, he finally moved back to Ohio, where members of his family still lived. For nearly ten years until his death in 1889, he attempted to gain support in the fledgling artistic community of Cleveland. While continuing to produce portraits in his last years, he also appears to have adapted to the changing late-century aesthetics by moving from straight topographical Middle Eastern landscapes to a more genrelike model of religious figure painting, with such scriptural subjects as "Christ and the Woman of Samaria" and "Hagar Expelled."

Most of these paintings, however, attracted little attention and have not apparently survived. Embittered and defeated, Kellogg often wrote in his later years of a yearning for his younger days in the Middle East and of his disappointment in what had followed them. In a wrenching two-page manuscript headed "Personal to Myself," penned in the late 1880s, he acknowledged what he perceived as his failed and difficult life, copying at one point a reputed quotation from Ruskin almost as an

epitaph: "Life is really too disgustingly short, one has only got one's materials to-
gether by the time one can no more use them."[51]

As the first American painter to survey the territories of Sinai and Palestine, Kel-
logg brought back materials—drawings, watercolors, and written observations—
adequate for an extensive series of paintings of the Holy Land. In the hands of a less
capricious artist, this might have resulted in a comprehensive body of work that
would have penetrated the higher levels of the profession and made a more resound-
ing cultural statement. In the end, however, Kellogg was able to execute only a few of
the many paintings he envisioned. Although he had inaugurated the American artis-
tic exploration of the Holy Land, by the time of his death his primacy had been
firmly supplanted by the several painters who followed him in his pilgrimage. For a
time at least, these other artists would be able to transcend Kellogg's personal limita-
tions, successfully translating their Middle Eastern experiences into meaningful cul-
tural products for their American audiences.

Edward Troye's Holy Land Series

THE FLOW OF SACRED WATERS

In its broad outlines, the career of Edward Troye would appear to have little to do with nineteenth-century American visual culture surrounding the Holy Land. Born into a Swiss family of artists, taken to London as a boy, and trained there as an animal painter, he came to the United States by way of Jamaica in 1831, thereafter considering himself an American painter. (He eventually became a naturalized United States citizen.) Over the ensuing four decades, Troye became known almost exclusively as a painter of horse and cattle portraits (fig. 51), catering particularly to the Thoroughbred-racing community.[1]

The one great anomaly of his professional life, however, a series of large Holy Land pictures, stands apart from his achievement in sporting art. Considered by the artist to be the summit of his oeuvre, this group offers itself as a nexus of contemporary intellectual and cultural issues relating to the sacred landscape. Deceptively unassuming in design and execution, the five paintings are nonetheless structured to make a unified statement of forceful conviction, using pictorial means somewhat outside traditional academic practice. Yet as energetically promoted works, launched by the artist on a national tour, they also situate themselves well within the mainstream of Holy Land imagery, presenting evidence not only of the popularity of exhibitions of Middle Eastern easel paintings throughout the United States, but also of a specific southern interest in Palestine and Syria. Perhaps most important, the Troye series highlights the ability of American religious sects and institutions, in this case Alexander Campbell's Disciples of Christ and Bethany College, to use such landscape scenes pedagogically, to illustrate and reinforce church doctrine.

Although Troye's specialty required an itinerant lifestyle, subject to the seasonal and geographical limitations of the turf sports, he was able to establish reasonably solid roots in Scott County, Kentucky, where he was married in 1839. It was there that he met one of his most important patrons, Alexander Keene Richards, scion of a wealthy southern family whose estate, Blue Grass Park, was located in nearby Georgetown, Kentucky. Though he did not officially inherit the family's landholdings until 1857, Richards was given ready access to as much money as he needed to develop a superior line of Thoroughbred racehorses while he awaited control of the

51. Edward Troye, *John Bascombe*, n.d., Yale University Art Gallery

properties. His resources were considerable, for they included the large "Transylvania" plantation in East Carroll Parish, Louisiana, said to have provided the family with $250,000 a year.[2]

In 1851, Richards embarked on a trip through Europe, North Africa, and the Fertile Crescent with the purpose of studying and comparing various breeds of horses. He was accompanied by Professor Joseph Desha Pickett from his alma mater, Bethany College, in West Virginia (then still part of Virginia). Richards had been an early graduate of this institution, founded in 1840 by Alexander Campbell for the Disciples of Christ, an indigenous American denomination with roots in the Presbyterian and Baptist churches. The Middle Eastern wanderings of the teacher and his former student were extensive; they visited the principal cities of Palestine and Syria, as well as the ancient site of Petra, at that time rarely seen by Westerners. One result of this trip was the importation of several Arabian horses, purchased from their Bedouin owners in Palestine. Richards began breeding the horses with American animals, and by 1855, he had decided to return to the Holy Land and purchase more Arabians to infuse the bloodlines of his racing stock.

During the previous year, Troye had painted two highly regarded portraits of the Arabian stallions brought back by Richards on the first trip. Pleased with the paint-

ings and confident of the artist's reputation as one of the most discerning judges of horseflesh in the country, Richards asked Troye to join him on his second visit to the Middle East. Although he is known to have taken a personal interest in the holy sites, Richards's motive, as he explained in a letter to the *Spirit of the Times*, was actually "one of business more than of pleasure."[3]

This does not seem to have been the case with Troye. Certainly, he owed his trip to Richards's mercenary interest in horses, and as expected, he played an active role in selecting the animals that were ultimately purchased, but judging from his journal and later published reports, his main preoccupation while traveling was the surrounding landscape and its sacred associations. Troye seems to have had an idea of the potential importance to an American audience of paintings he might bring back from the Holy Land, and the trip was organized to permit him considerable time to work out his canvases *sur place*. Indeed, his ability to paint rapidly, a skill no doubt developed as a result of the demands placed on him as a constantly itinerant painter, allowed him to finish all five pictures of the series during the months he spent in Syria and Palestine in late 1855 and early 1856.[4]

Richards's party arrived in Beirut on 1 October, after spending part of July in England, visiting the world's fair in Paris, and sojourning briefly in Constantinople. Soon thereafter, Troye traveled to Damascus, where he began to execute commissions for his patron. There is no evidence of work on the Holy Land paintings, however, until the following February, when he indicated in his journal that the first canvas, *Bazaar in Damascus* (fig. 52), was progressing. At the same time, he prepared to embark on a tour to the south, through the biblical regions of Palestine. Over the next six weeks, he and Richards visited the territories surrounding Jerusalem, the Dead Sea, and the Sea of Galilee (also known as the Sea of Tiberias). During this period, *The Sea of Tiberias, River Jordan—Bethabara,* and *The Dead Sea* were largely completed (figs. 53–54, pl. 2). Returning to Damascus after the journey, he finished the last of the five works, *Syrian Ploughman* (fig. 55), in the final weeks of his Middle Eastern stay.

Although his journal entries were matter-of-fact, free of the rhapsodic tone that characterizes other contemporary accounts, Troye, a devout Presbyterian, was fully cognizant of the religious implications of the landscape. Occasionally, though, his experience of a particular site would indeed prompt a small burst of enthusiasm, as at Capernaum on the Sea of Galilee, a location important to the New Testament narrative: "Nothing can be more impressive than the associations that crowds [*sic*] upon your notice at every step. Here our Saviour commenced his ministration; the doomed city heard his melodious voice warning them of their approaching danger; the lake and its shores was the scene of miracles."[5] Like other Americans, he endeavored to possess some tangible evidence of these "associations," ultimately breaking off a piece of the marble fort at Caesarea and an antique column fragment at Bethshean as tokens of the region.

After passing through Galilee, Troye spent an intense two-week period in mid-March camped by the Dead Sea, where his large picture of the same name was executed. Despite its unwieldy size (it was over ten feet wide), *The Dead Sea* was apparently painted directly from nature at the water's edge. At the time, it was

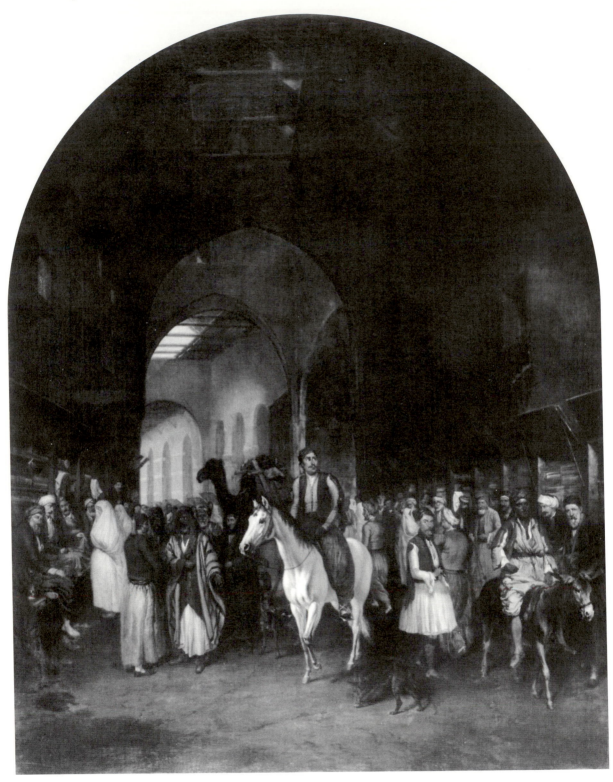

52. Edward Troye, *Bazaar in Damascus*, c. 1856, Bethany College

53. Edward Troye, *The Sea of Tiberias*, c. 1856, Bethany College

54. Edward Troye, *River Jordan—Bethabara*, c. 1856, Bethany College

55. Edward Troye, *Syrian Ploughman*, c. 1856, Bethany College

unusual for Westerners to spend more than six hours in that severe and taxing valley, and although his health was said to have suffered from the ordeal, Troye was proud of the indisputable accuracy that his uncommonly long stay was thought to have guaranteed. His journal gives an indication of the extent to which the scenery was impressed on his senses: "Desolation holds her empire over for miles from the site of the cities of the plains. The ground is sunk for miles. . . . The air is strongly impregnated with minarel [*sic*] exhalations. Salt is found in great quantity on the shores . . . and nothing that has life is found in its waters. A deathlike silence prevails that is only interrupted at night fall by the [shrieks] of unclean birds and the cry of [the] jackel [*sic*]." A page later, he added this almost humorous understatement: "My stay at the Sea would have been very tedious, had it not been that my time was fully taken up in painting."[6]

While the logistical difficulties of working in such an inhospitable environment on a stretched canvas of the size of *The Dead Sea* would seem daunting, there is reason to believe Troye's claim of having executed his painting on the spot. In the first place, the artist had planned this series long before arriving in the Holy Land, and there is evidence that he provisioned himself with all the necessary canvas materials while still in England. Additionally, several other parties support the story of Troye having worked from nature. In Richards's letter to the *Spirit of the Times* (written shortly after he left the artist in Syria), for example, he described "several pictures on a large scale," including *The Dead Sea*, as having already been completed

in the Holy Land. On another occasion, he related that Troye had "found himself upon the shores of the Dead Sea, determined to mix his colors on the spot, and place on canvass that awfully sublime scene, even though he died in the attempt." Henry Wood, the United States Consul in Beirut, had also seen the Holy Land paintings before Troye left the Middle East, as he related in a dispatch to the *Journal of Commerce*, a letter that was later reprinted as a broadside by Troye. Finally, the sheer number of horse portraits that the artist is known to have been able to produce in a single seasonal painting trip argues strongly for his ability to fill a large canvas during the short time he camped at the Dead Sea.[7]

Even after finishing the Holy Land series, though, Troye's painting tasks were not complete. Leaving the Middle East, he sailed for Europe with the intention of visiting family members. In Antwerp, while staying for several months with his artist brother, Charles de Troy, he used a borrowed studio to execute a replica set of the five paintings. When he returned to New York in January 1857, then, he brought with him two similar sets of paintings, both of which were purchased by Richards.

One of the Holy Land series probably went immediately to Blue Grass Park (where it was likely destroyed by fire in 1875), but the other was sent out on a multicity tour, promoted and managed by the artist. Troye began in New Orleans in April 1857, where the five paintings were shown at the Odd Fellows' Hall from ten in the morning to ten at night, with admission set at fifty cents. A year later, they could be seen at the Apollo Rooms in New York City, and by the spring of 1859, Bostonians were viewing them at the Melodion, along with copies, executed by Troye's brother, of paintings by Rubens depicting episodes of the Passion.[8]

Troye's series, perhaps more than any other easel production with a Holy Land subject, had direct links to the American popular imagery surrounding the sacred landscape, especially in the way it was presented to the public. Following the lead of previous panorama painters, he adopted their familiar promotional methods for his exhibition. Like Banvard, he personally delivered explanatory lectures before the paintings, occasionally charging extra for this service. In addition, it was announced in the press that "Clergymen, Superintendents and Teachers of Sunday Schools can make their own terms for the admission of children under their charge."[9]

Several versions of a pamphlet were also printed, some with letters of attestation from the usual "experts" on Holy Land matters. William Lynch, who had been head of the American naval exploration of the Dead Sea, called Troye's view of that body of water "perfectly accurate in the delineation of the scenery, the appearance of the sky, and the aspect of the Sea with the peculiar haze above its surface," and William C. Prime stretched credibility to relate not only that he had camped at each of the exact spots depicted by Troye ("That very drift-wood on the shore of the Dead Sea lay there when I saw it a week before you painted it"), but also that he had met the artist in Jerusalem and that he even recognized the white horse (purchased by Richards) in the foreground of *Bazaar in Damascus*.[10]

Public comment also stressed the spiritually salutary effects that would result from experiencing the paintings. One argument, invoking the notion of "Christian duty," was used in New Orleans, where readers were told that "every Christian must feel a

deep and abiding interest" in the works and "everybody should see them."[11] It is not surprising that Troye's series would have received an enthusiastic reception in Louisiana, where the huge family plantation of the owner of the paintings, Alexander Keene Richards, was located. However, the artist also had strong personal ties to the Deep South, having taught at Spring Hill College, near Mobile, Alabama, for a number of years before his Middle Eastern trip. During the late 1850s, when the slavery controversy was forcing a more pronounced and defensive regional identity on southerners, newspaper writers would no doubt have been anxious to promote the cultural fruits of such local talent. This would have been especially true in New Orleans, where the fiery preacher Benjamin M. Palmer had already begun his zealous campaign to legitimize slaveholders by connecting them to the Hebrew nation. As early as 1845, Palmer had advanced his argument that because of their preservation of the "ancient" ways of the Bible, the southern states were the true embodiment of the landscape of Zion. Troye's paintings would have fit easily into this schema.[12]

Both artist and patron, in fact, were directly connected to the issue of slavery, the preeminent southern concern at the time. The Richards fortune had been built on the backs of the hundreds of slaves owned by the family, and Troye's own history was also intertwined with the "peculiar institution." One of his traveling companions in the Holy Land was the overseer of Richards's Louisiana plantation, and there is evidence that the artist himself served in that notorious capacity when he "had charge of" a sugar plantation in Jamaica for several years before coming to the United States. Troye left the country for Europe during part of the Civil War, but there is no question as to where his sympathies lay. His will written in 1870 specified that if there were no familial heirs, his property should be sold to benefit "Orphan children of Confederate Soldiers" and "the Sisters of Charity, provided their sphere of operation is confined to the Southern States."[13]

Such strong associations might have precluded a warm welcome in the North, but it appears that the special properties of Troye's subject matter exempted him from such sectional bias. Both northern and southern writers at midcentury could make the landscape of the Holy Land their own, shaping it to meet specific cultural and political needs, and this probably accounts for Troye's equally enthusiastic reception in the North, where southern landscape imagery was usually anathema.[14] Abolitionists might even have found in Troye's large landscape *The Dead Sea* a covert rebuke of the southern states, which were seen as moving toward their own desolate wasteland, tempting God's wrath in much the same way as did the sinners of the Old Testament cities of Sodom and Gomorrah. Northern newspaper reviews, in any event, did not differ markedly from those in the South. In Massachusetts, for example, the *Boston Transcript* referred to the series in 1859 as a "rich intellectual treat," perhaps emphasizing conceptual, subject-oriented qualities because of a certain embarrassment (expressed by the same paper a year earlier) before Troye's quirky, sometimes naive style: "As works of art, their merit is not of the highest order, according to the modern refinements of landscape art; but when to respectable executive skill is added the testimony of Eastern travellers to the *fidelity* of the representations, it is easy to understand why these pictures attract so many gratified visitors."[15]

As though echoing this view, Troye's pamphlet began by asserting what many felt

to be the paintings' greatest credential, that "they were executed upon the locations which they represent" and, hence, were not "creations of his own imagination."[16] The bulk of the prose was then devoted to separate essays on each painting—short discussions that related stories of scripture, identified contemporary objects depicted, and stressed the "unchanged" aspects of the Palestinian scene. The order in which the paintings were invariably listed (in press accounts and in Troye's publications) indicates that they were probably hung side by side in the exhibitions, alternating according to size and format and probably claiming more than one wall of the space, unless it were very large. Thus, *Bazaar in Damascus* (no. 3 in the pamphlet and the only vertical composition) would have been placed in the middle, with the other large works, *Syrian Ploughman* and *The Dead Sea* (nos. 1 and 5, each about six by ten feet), likely anchoring the beginning and end of the series, left and right. Interspersed would have been the smaller views, *The Sea of Tiberias* and *River Jordan— Bethabara* (nos. 2 and 4).

Of the five, *Bazaar in Damascus*, the first painting undertaken by Troye, is the only subject without a conventional landscape element. Although the pamphlet text attempted to relate the work loosely to Christian history (the scene was described as near the entrance to the Great Mosque of Damascus, "in early times a Christian Church")[17] and although there was a popular tradition linking Damascus with the site of the Garden of Eden, these concerns were not stressed by Troye and do not assert themselves in the painting. Rather, *Bazaar in Damascus* functions as a compendium of animal and figural types, with center stage and favorable illumination given to Lulie, the mare purchased by Richards, as she breaks from the crowd and moves into the empty foreground with her Albanian rider.

The formal complexity of this work, with its crush of variously clad, moving figures, its uneven lighting, and its powerfully assertive perspective, was entirely new to Troye. For a model he may have turned to François Marius Granet's influential *Choir of the Capuchin Church of Santa Maria della Concezione in Rome* (fig. 56), a widely exhibited and much copied painting that had caused something of a sensation in the United States earlier in the century. Both works make use of an arched format with blind spandrels, creating a forcefully punched-out space receding from the picture plane through a series of echoing arcs. Each composition also features lofty but cavelike pockets of darkness—a mysterious effect in keeping with their unique subjects, which to American Protestants would have seemed equally "exotic," despite their obvious differences.

Previously, Troye had spent a career executing a succession of flat, fairly indistinguishable landscapes, usually serving as a background for a single, lateral horse portrait and sometimes framed by a human attendant or two, with little or no overlap of the figures. *John Bascombe* (see fig. 51) is a typical example of the Troye formula, with the monumental stallion seizing up into hard, compact form, his profile etched against the pale, yielding shapes of the landscape. There is little to suggest that the horse occupies the same space as the slackly brushed trees in the background, or that they are subject to common laws of perspective and optics. Even in the artist's most ambitious efforts, such as his *Self-Portrait in a Carriage* (fig. 57)— in which the harnessed horse is allowed to pivot and shift away from the picture

56. François Marius Granet,
*The Choir of the Capuchin
Church of Santa Maria della
Concezione in Rome*, 1815,
Metropolitan Museum
of Art

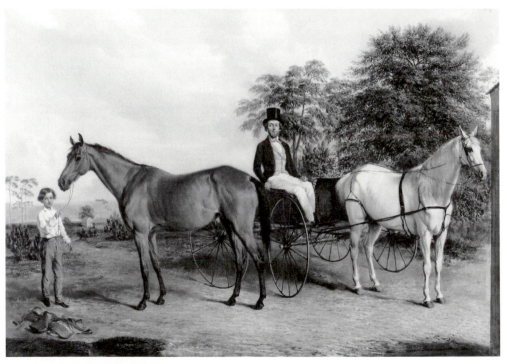

57. Edward Troye, *Self-Portrait in a Carriage*, 1852, Yale University Art Gallery

surface, breaking out of Troye's standard conceptualized sandwich of confining par-
allel planes—the problems of spatial relationships do not approach those posed by
the entangled bazaar scene.

In each of the five Holy Land paintings, in fact, he stretched himself a good deal
beyond his normal format in scale, composition, and subject. Yet Troye found it
difficult to stray too far from a rather obvious planarity; the packed crowd in *Bazaar
in Damascus* appears pushed up to an invisible barrier wall more or less parallel to
the picture plane, so that from edge to edge, an almost archival sequence of racial
exemplars, most of them turned outward and some actually mugging for the viewer,
is highlighted and lined up squarely for inspection. One by one, they are neatly
catalogued in the text of the pamphlet: Bedouins, Albanians, Turks, and Greeks;
merchants, buyers, soldiers, and guides.

Because of this profusion of genre detail, *Bazaar in Damascus* stands alone in
Troye's series; the majority of the paintings exemplify "pure" landscape, notable for
the complete lack of human figures. The two smallest (and least original) works, *The
Sea of Tiberias* and *River Jordan—Bethabara*, for example, exhibit almost identical,
conventional landscape compositions, with artificially darkened foreground bands
heaped with rocks and scrub foliage, meandering coastlines curving gently through
middle ground to background, continuous mountain ridges providing a sense of
visual closure and boundary, and (in *River Jordan—Bethabara*) framing trees focus-
ing on a privileged, vignetted view telescoped through the center. In broad outlines,
they differ little from the many engravings of the same subjects that appeared in
popular travel books of the period.

Yet these two views occupy an important place in a four-part thematic and topo-
graphical chain of paintings, the genesis of which can probably be traced to the
student days of Troye's patron at Bethany College. In a letter to a former professor,
Richards explained how his interest in this section of the Holy Land had been
awakened by Bethany's Alexander Campbell:

> The beautiful and intensely interesting morning lectures of Mr. Campbell, upon Sa-
> cred History, and more particularly his graphic descriptions of and typical allusions to
> the sacred river Jordan, from its source in the melting snows of Hermon to the desolate
> plains of Jericho, and lastly the flowing of its pure and limpid stream (typical of life)
> into the mysterious and desolate waters of the Dead Sea, greatly interested me; and
> created in me an intense desire to witness these sacred scenes.[18]

In this light, it is easy to imagine that, at Richards's urging, Troye sited his four
landscape paintings so as to trace the actual course of the sacred water of the river
Jordan, from its origin at Mount Hermon (featured at right in *Syrian Ploughman*),
into the Sea of Tiberias, past the ford at Bethabara, and down to the Dead Sea,
where, through evaporation, the pure flow of the river would ultimately be liberated
from the stagnant waters of the sea, transubstantiated into ascendant vapor.[19] This
continuous cartographic movement (north to south) would have thus been approxi-
mated in the exhibition hall by the careful sequencing of the paintings (left to right).

The tale of the "life" of this water (which, as Richards wrote, *itself* typified life)
had the added advantage of passing through perhaps the most scripturally significant

area of Palestine. Many commentators felt that the sea and territory of Galilee were more important to Christians than even the city of Jerusalem, a sentiment that might account for the somewhat surprising omission of a view of that city in Troye's series. Just a few years after the artist's trip, William Thomson summarized the Christian significance of Galilee and Tiberias in his canonical *Land and the Book*, which reiterates Troye's own journal comments:

> Here he preached in a ship, slept in the storm, walked on the waves, rebuked the winds, and calmed the sea. . . . Here he opened his mouth, and taught, with authority, that divine sermon on the mount; and on one of these solitary summits Moses and Elias, in shining robes, came down from heaven to converse with him in the glory of his transfiguration. And not least, from this shore he selected those wonderful men who were to erect his kingdom, and carry his gospel to the ends of the earth.[20]

The Sea of Tiberias is an odd painting, denuded in form, irresolute in color, and fraught with small tensions created by an uneasy emphasis on isolated elements of the landscape. As it nears the shore, for instance, the sea becomes unaccountably assertive in a scene otherwise notable for its deadly calm. Worked up into impastoed whitecaps out of scale with the mountains around it, the water calls attention to itself through textured, open brushwork and unblended white pigment, possibly evoking the famous storm located here by the New Testament narrative. Further to the left, dark mountain forms loom up in almost anthropomorphic, undulating configurations, leaving the impression of an active, sinuous landscape, expressive by the very fact of its conspicuous physical presence. Across the sea, geological layers and striations are visible in the hills, perhaps evidence of the volcanic activity mentioned in Troye's pamphlet. (The petrological testimony of such primeval convulsions would also prove important to the interpretation the artist brought to *The Dead Sea*.) The buildings depicted, the baths of Emmaus in the foreground and the city of Tiberias beyond it, imply an unseen race of indigenous inhabitants. Yet these structures are severely reduced in shape and surface, almost devoid of apertures; their blocky, unyielding solidity only intensifies the feeling of blank and arid timelessness, exclusive of the region's vibrant nineteenth-century population (see fig. 32).

The pendant to this spare work, *River Jordan—Bethabara*, offers a luxuriant, reposeful counterpart to the hardness of *The Sea of Tiberias*. The variety and complexity of the foliage lining the banks of the river showcase an ability to render naturalistic texture and layered volume seen only occasionally in Troye's animal works. It is not surprising, though, that his emphasis should be on this profusion of verdure. The standard travel accounts never failed to celebrate the Jordan as a scene of dense plant growth in an otherwise barren region.[21] Troye further dramatized the fecundity of the trees and undergrowth through a close juxtaposition with the barren, sheer face of the pink background hills, where the Eden-like band of greenery ends abruptly. Although the exhibition text stressed the identification of this site, called Bethabara, with the location of the baptism of Christ and the crossing of Joshua, the painting shows no modern pilgrims entering the baptismal waters. The much-described sight of white-robed Christians in the river was fairly common in

the nineteenth century, but here Troye relies entirely on the uncharacteristic lushness of the landscape to convey its singularity.

This is not the case with the first work in the series, *Syrian Ploughman*, where the protagonist and his oxen loom surprisingly large in the brownish foreground. The degree of importance that Troye ascribed to this painting, and even more to its similarly outsized companion, *The Dead Sea*, is apparent from their disproportionate physical scale and the amount of pamphlet text accorded them. A reading of the essay for *Syrian Ploughman* leaves one with the impression that the view was intended as a catalogue of the region's flora, fauna, geological configurations, and architecture—with the human figures treated merely as representative elements of local natural history. Described in quick succession are goats, sheep, and a camel; walnut, olive, almond, apricot, palm, and cypress trees; oat and barley fields; a "sheik" and a "fellah"; the city of Damascus and several mosques; and snowy Mount Hermon.

In the picture, however, most of this is entirely subservient to the plowman and his team. Following a habitual compositional tic that had become standard for Troye's portraits of horses, he allows relative scale to decrease precipitously and unnaturally as the eye moves away from the central figures. "Fields" of grain barely rise to the camel's ankles, goats are diminished to nearly half their expected size, and the line of trees along the overly flat horizon is all but indistinguishable, despite the text's explicit enumeration of type. In many ways the painting does not live up to its prose exegesis. It is as though Troye sensed that for his audience, listing these many elements in his guide was enough. It provided the information to interested viewers and dispensed it in a comforting system of classification. Any caviling about what, exactly, was depicted in the painting could be answered with the pamphlet's insistent reminder: "This picture was painted on the spot, and there is nothing imaginary introduced, from the smallest thistle to the soft shadows falling upon Hermon's lofty peaks."[22]

The visual focus, then, was not on the surrounding detail inventoried in the text, but on the dioramic plowman and his cattle, presented on a meticulously (even obsessively) delineated patch of ground. The pamphlet maintained that "the Ploughman is just in the attitude of turning his cattle, to pass around a small stream of water, which is used for irrigating the fields."[23] It seems clear, though, that the figure is not oriented toward any particular field awaiting his plow; rather, the team has been placed here artificially, on a kind of bare landscape "pedestal" where it can be easily studied for purposes of demonstration. In fact, more than a paragraph of text is used simply to examine the technical features of the plow and its use. Why this grand treatment for such a seemingly mundane subject?

For nineteenth-century American Protestants, the image of traditional plowing in the Holy Land was by no means mundane. It evoked familiar scriptural references, was useful as a spiritual metaphor, and addressed the relationship of the past, present, and future states of the promised land. Troye himself was pleased to come across this sight on his wanderings: "On our way to Jerusalem, after leaving Sychem, we entered into a valley, el-Mukna, where a number of ploughs were seen at one

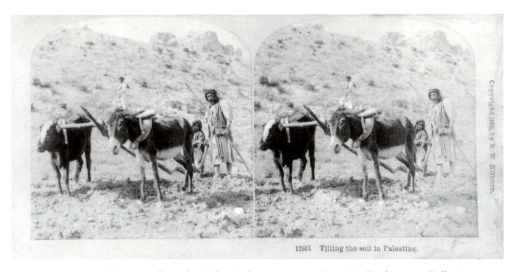

58. Benjamin W. Kilburn, *Tilling the Soil in Palestine*, c. 1873, Bert M. Zuckerman Collection

sight, I believe over sixty, each drawn by oxen. . . . The sight of these and other customs of the people found upon my mind the parable of our Saviour." It is not clear which biblical passage he had in mind here, but there is no dearth of verses in both the New and Old Testaments that use plowing as a significant narrative or symbolic element.[24]

Troye was not alone in his desire to secure a view of a plow in action. Photographers seem also to have found this subject a necessity (fig. 58), and American travel accounts invariably included a section on tilling practices, often as an occasion for mocking the perceived backwardness of the Arabs. Thomson, for example, devoted several pages to plowing, with remarks on the frailty and inefficiency of Arab plows. Robert Morris, the purveyor of Holy Land realia, was even less charitable, observing, "The native plow is the simplest and crudest of instruments. . . . In the United States more than a thousand patents have been issued for improvements in plows. Father used to say, 'Show me a farmer's plow and I can describe the man.' It is so here; the absurd plow is the emblem of the miserable farmer."[25]

However, what was thought to be primitive could also be seen as authentically ancient, a living example of the continuity and truth of the Bible—no matter how fictitious the sense of "authenticity" imposed by the Western observer. Troye's pamphlet remarked that the plow depicted had been "used in Palestine for centuries" and that even the oxen were "peculiar to the country, and are doubtless of the same species as the Bulls of Bashan, mentioned in the Bible."[26] It was also important for Christians to demonstrate that although the nineteenth-century Fertile Crescent did not appear to live up to its name, the *possibility* of a rich agricultural Holy Land was still there. Indeed, the sorry attempts by Americans to colonize Palestine were invariably grounded in the mission of revitalizing the agriculture of the Holy Land, to the point that the Adams colony brought along a modern, American-made reaping machine more or less as an instrument of the apocalypse.

Apocalyptic notions were also bound up in the last and most important of Troye's Holy Land paintings, *The Dead Sea*. The attention that the artist devoted to this work far exceeded that of any other view in the series. The picture was the only one mentioned in the introduction of his general pamphlet, where the scene was called "an imperishable monument of the truth of the Mosaic history." In addition to its lengthy entry in that publication, *The Dead Sea* received a twenty-page explication in a separate booklet entitled *The Dead Sea and the Ruins of Sodom and Gomorrah; including also a Description of Troye's Painting of the Dead Sea*. In a testimonial letter published by Troye, William Prime also focused on this bleak landscape: "But while all the views are perfect, I confess to you that I turned constantly to the Dead Sea, and sat longest before it. . . . Closing out the frame and the room, I could easily imagine that I was once more on that desolate shore looking at the hills of Moab beyond, and far down the hazy air to the gloom that covers the cities of the plain."[27]

Prime's invocation of the "cities of the plain" is a reference to the group of accursed Old Testament localities—notably Sodom and Gomorrah—that were believed to have once occupied the site of the Dead Sea. According to the biblical account, these abject and wicked communities were destroyed by God in a cataclysmic, fiery upheaval of the earth. In Troye's literature, this was seen as a lesson of "the power of God's anger," relevant to the nineteenth-century crisis of faith: "Even to this day the waste land that smoketh is a testimony which will ever put to silence the sceptic." The longer pamphlet, which treated *The Dead Sea* specifically (and in which Troye surely had a hand, even if he was not the author), considered the body of water and its story in much greater detail, using geological observations and Latin quotations to prove that the Dead Sea was actually a volcanic crater, the result of an eruption that, at God's command, had swallowed up the sinful cities. The discussion took the middle road of nineteenth-century moral scientism, explaining the phenomenon through rational, natural law but maintaining that the impetus for the destruction nonetheless came directly from "the Lord in heaven."[28]

This American interest in the Dead Sea was deep-seated. It was also tinged with overtones of nationalism. The earliest American "hero" of Holy Land exploration, Edward Robinson, had visited the site with enthusiasm in 1838. In his *Biblical Researches*, he came to much the same conclusion as Troye: The waters of the sea must certainly cover the destroyed cities of the plain. A decade after Robinson's visit, William F. Lynch's official naval expedition to the Dead Sea cemented the proprietary American identification with the region. In contrast to the many private American endeavors in the region, Lynch's reconnaissance mission to the Dead Sea is a startling example of governmental involvement in schemes to explore the Holy Land, lay claim to its promise, and placate religious doubt by locating scripture-affirming evidence. At the time of Troye's national tour, the story of the Dead Sea survey was well known to the general public, with tales of Lynch's resourceful persistence having essentially passed into national lore. It, more than anything, became associated in the popular press with *The Dead Sea*; a brief account of it is thus important to any understanding of Troye's canvas.

Before beginning his expedition, Lynch was required to petition for a firman (or permit) from the Ottoman sultan. This he obtained in Constantinople, after being granted an unusual audience with the ruler and presenting him with examples of George Catlin's depictions of Native Americans. Using camels to drag his boats over the desert, he launched them in the Sea of Galilee and proceeded down the cataract-choked Jordan River. Finally arriving at the desolate shore of the Dead Sea, he circumvented the shallow body, collecting geological, meteorological, zoological, and archaeological data. Upon his return, Lynch was gratified by an enthusiastic public response to his mission and near-celebrity status, particularly in his native South. By the time his official report had been presented to Washington in 1852, a long preliminary account had already gone through seven American and two English editions.[29]

The primary results of his trip were a careful map of the entire waterway and a new series of climatic and topographical measurements taken at regularly spaced intervals. More significant, however, is the series of observations and speculations that Lynch inserted into his prose account. From the outset, it is clear that the enlightenment he sought, like that described by Troye, was both rational and spiritual. He began by declaring that the "extent, configuration, and depression" of the Dead Sea were "as much desiderata to science as its miraculous formation, its mysterious existence, and the wondrous traditions respecting it, are of thrilling interest to the Christian." Lynch claimed with satisfaction, "Everything said in the Bible about the sea and the Jordan, we believe to be fully verified by our observations," concluding: "We entered upon this sea with conflicting opinions. One of the party was skeptical, and another, I think, a professed unbeliever of the Mosaic account. After twenty-two days' close investigation, if I am not mistaken, we are unanimous in the conviction of the truth of the Scriptural account of the destruction of the cities of the plain."[30]

Articles with such titles as "The Dead Sea, Sodom, and Gomorrah" followed Lynch's survey, replete with possessive threats and nationalistic boasts: "If we fancy such a change in the world's face as would exclude us from the shores of the Holy Land, . . . such events as . . . the equipment of fresh armies of crusaders, would by no means seem impossible." Lynch himself understood the implications of his exploration, as his lecture, published in 1860 under the title *Commerce and the Holy Land*, makes clear. Hinting at the likelihood of gold being found in Palestine, he advocated the creation of trading routes to exploit the country and its links to Asia. The Arabs, he assured his audience, could be "guided like children." Further, "The highland east of the Jordan, with its park-like scenery and deserted cities, would seem . . . to invite colonization on a large scale." Arguing that God had decreed that ruinous cities be rediscovered just at the time that a capable nation was arriving to develop them, he interwove American designs with those of Providence. Isaiah, he asserted, had predicted that a Western naval power would come to Palestine to aid the Jews. "Shall we be true to ourselves and accelerate that event?" he challenged. "Or, shall we supinely wait, while France and England quarrel, each for its almost exclusive route?"[31] Such was the charged rhetoric surrounding the Dead Sea at the time that Troye's painting was unveiled.

In all discussions of this singular body of water, including Lynch's, evidence of the destruction of Sodom and Gomorrah was assumed to be clearly imprinted on the country surrounding it. Such sentiments must in large part account for the singular visual character of Troye's image. Very little in the history of American art prepares one for this astonishingly empty painting. Lurid in color, as though still hot and glowing from a recent searing blast, and relentless in its unmitigated horizontality, it is a work that bears down heavily on the viewer. The lines of the mountains, un-softened by foliage and unregulated by framing elements, are compressed and desic-cated. The entire landscape appears flattened, passive, and exhausted, unable to exert itself and rise above the pressure of the horizon. It is as though the space of the sky has been weighted and forced down heavily to the surface of the planet, where it slowly spreads laterally as far as the eye can see.

This quality of resignation also struck other American visitors to the site. At the Dead Sea, the photographer Edward Wilson described a scene of extreme lassitude, "where active force has been suspended and the whole petrified by the sudden grip of a dreadful power all unseen—as though some purgatorial air had blown across it and scorched out its life while the dramatic changes were going on." In his schematic journal, Melville characteristically had one of the most vehement reactions to the area: "Ride over mouldy plain to Dead Sea . . . foam on beach & pebbles like slaver of a mad dog—smarting bitter of the water,—carried the bitter in my mouth all day—bitterness of life—thought of all bitter things—Bitter is it to be poor & bitter to be reviled, & Oh bitter are these waters of Death, thought I . . . nought to eat but bitumen & ashes with desert of Sodom apples washed down with water of Dead Sea."[32]

Intense reactions to the remarkable terrain of the Moabite region abound, but the discomfort experienced by Americans may also have resulted from the contradictory associations engendered by the site. Geographically, as Troye noted in his journal, the Dead Sea was the lowest area on earth and thus the farthest point from heaven. Yet it sat in the middle of the country revered by Christians as the holiest on the globe. It appeared to exist as a paradox, refuting the validity of the phrase "the waters of life," and rendering stagnant the sacred flow of the Jordan as soon as that river emptied into its salty basin.

Throughout Palestine, water was associated with sustenance and baptismal youth; wells and springs were repeatedly endowed with symbolic significance. But this body of water seemed to have little of the sacred about it. In Troye's prostrate landscape, there is nothing aspiring to the vertical; there is no psychic or visual "irruption," no opening or break in plane—elements isolated by Mircea Eliade as necessary for the manifestation of the divine and the creation of transcendent, sacred space.[33] The bleak emotional associations of the profoundly horizontal format become unavoid-able, even unbearable. Other American artists also found ways to use it to such arresting effect, as in Worthington Whittredge's remarkable *Graves of Travellers, Fort Kearney, Nebraska* (fig. 59), where the extruded canvas takes on the proportions of a grave, eloquently expressing the final immobility of the freshly interred corpse. The Palestinian desert was often compared to the American plains, and the same funereal

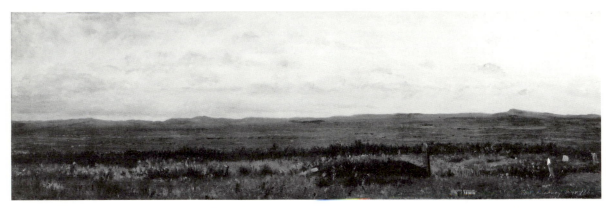

59. Worthington Whittredge, *Graves of Travellers, Fort Kearney, Nebraska*, 1865, Cleveland Museum of Art

air undoubtedly contributes to the uneasy quality pervading the Troye painting, with its emphatic lateral composition and overwrought color and scale.

As unusual as Troye's Dead Sea project was, he was neither the first nor the only artist to camp for several weeks on the sea's barren shores in order to work up a finished landscape from nature. There is, in fact, one close contemporary parallel to his endeavor. Two years earlier, the English painter William Holman Hunt had put himself through a nearly identical trial, remaining near the Dead Sea for approximately the same period of two weeks. His motives were similar to Troye's, and so, to an extent, was his product. Within the context of mid-nineteenth-century art, Hunt's *Scapegoat* (fig. 60) and Troye's *Dead Sea* are in a class by themselves for their strident intensity of vision and concerted devotion to the revelatory power of a desolate bit of landscape.[34]

Devout and unyielding in his faith, Hunt made an extended trip to the Holy Land in an effort to find authentic models for the biblical subjects he wished to paint. Taking as his text a verse from Leviticus, Hunt sought in *The Scapegoat* to illustrate the ancient Jewish practice of driving a goat into the wilderness each year, the belief being that it would carry away the community's sin and iniquity. From his supremely scriptural point of view, the most apt place to picture his sin-laden goat was near the ruins of Sodom—hence his trip into the desert.[35]

What is notable about *The Scapegoat* is that in England it met with near-universal incomprehension and disgust, a critical controversy followed by readers of the American periodical, the *Crayon*, where the letters of the Pre-Raphaelite chronicler William Michael Rossetti appeared. Most English writers apparently felt that Hunt had no business painting, first, an ugly, dying goat, and second, as repellent a landscape as that surrounding the Dead Sea. John Ruskin was one of the few to see value in the canvas. Making a now familiar point, he wrote defensively, "Of all the scenes in the Holy Land, there are none whose present aspect tends so distinctly to confirm the statements of Scripture, as this condemned shore. It is therefore exactly the scene of which it might seem most desirable to give a perfect idea to those who cannot see it for themselves."[36]

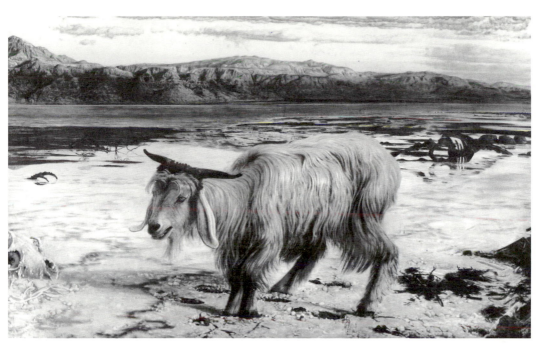

60. William Holman Hunt, *The Scapegoat*, 1854–55, Lady Lever Art Gallery

Ruskin aside, the popular British rejection of *The Scapegoat* provides an illuminating contrast to the praise heaped on Troye's *Dead Sea* by critics in American cities. One can speculate that it had much to do with the American acceptance and celebration of landscape painting as a genre equal in importance to any other. Hunt himself was somewhat apologetic about turning to a landscape subject in the Holy Land; he only took it up when he failed to obtain the services of any Jewish models for his figural works.[37] Thus, while English writers found *The Scapegoat* not a true subject for a painting, Americans greeted Troye's crushed and far emptier landscape —without even the benefit of an implied biblical narrative or a central animal protagonist—as full of meaning and value. (More than anything else, in fact, *The Dead Sea* looks simply like a blown-up version of one of Troye's planar horse portraits, but with the horse removed.) Hunt's critics also condemned his colors— which are remarkably close to Troye's—as fanciful and pointless, while the American audience saw the intense hues as potent evidence of the ravages of divine fire.

In contrast to the *Scapegoat* canvas, which remained in private hands throughout the nineteenth century, one of the Troye Holy Land series was given an institutional setting almost immediately after the national touring exhibition had ended. In 1860, Troye's patron Richards donated the five views to his alma mater, Bethany College, where they began an institutional afterlife that continues to the present. In a letter explaining his gift, Richards made particular reference to his memories of the scriptural lectures of Alexander Campbell, founder of the college. The elderly Campbell responded by recognizing "this most appropriate and acceptable expression of an interest excited in years gone by, by my own humble but sincere efforts to implant in

the minds and the hearts of my young friends a veneration for the Bible, its history, its sacred scenes, and the sublime significance of its monumental symbols and types."[38] Richards requested that Troye travel to Bethany to install the paintings in the college's newly constructed Old Main Hall; they were placed in the very room where Campbell lectured. For a complete consideration of the reception and visual use of the series, then, the activities and intellectual milieu of Campbell and his Disciples of Christ bear examination.

The church of the Disciples of Christ was formed principally by Alexander Campbell in the 1820s, although the religious movement he initiated predates the formation of the sect by more than a decade. It soon grew to be the largest indigenous American denomination, numbering some two hundred thousand members at mid-century.[39] The church was particularly popular in the border states, probably because of its (and Campbell's) ambivalent, compromising attitude regarding slavery. This accounts in part for the location—neither in the North nor fully in the South—of Bethany College, which Campbell founded in 1840 in a relatively unsettled portion of northwestern Virginia. He immediately became the leader of the institution.

Born in Ireland, Campbell came to prominence in East Coast circles of Protestant reform soon after immigrating in 1809. The dominant strand of his theology was a desire to bring the church back to what he called "primitive" Christianity. This, he asserted, would eradicate sectarian disputes by "restoring" the purity of the New Testament, which would again become the sole guiding text of all Christians. Only Americans, he felt, could sufficiently shed the debased skin of the standard European churches to rediscover the original simplicity of the early Christian church. The movement was thus a form of American exceptionalism, with Campbell and his followers stepping squarely outside time and history.

The Disciples of Christ were seen not as starting anew, but as "picking up the threads" of this New Testament Christianity and carrying on the mission of Christ's original disciples. The result, once again, was the forging of a spiritual bond between American Protestants and their progenitors, the ancient (Christian) residents of Palestine. Campbell's revitalized Christianity, undivided by denominational barriers, could thus take up the sacred landscape and propose it as a common ground, in much the same way that Troye's painted depictions of the same topography had earlier bridged the disturbing political gap between North and South. His was a movement away from splintering sectarianism toward a more national faith, even if other southern ministers, such as Benjamin Palmer, were using a similar theological argument to separate the "infidel" North from an authentically "pure" southern faith.[40]

There was also a millennial aspect to the Disciples' return to the roots of the church. Campbell preached that until the purity of the faith was restored, there could be no Second Coming. His words had a profound effect on at least one member of the Disciples of Christ, James T. Barclay. In keeping with his church's teaching, Barclay volunteered to travel to Jerusalem in 1851 as a representative of its affiliated American Christian Missionary Society, of which Campbell was president.

There, by converting the Jews, Barclay would bring about the desired revitalization of "primeval" Christianity. In particular, he sought to expose the "hypocrisy" of the Catholic and Orthodox Christian churches, which he vehemently scorned. At the time, Campbell's adherents were divided on the issue of slavery, and Barclay, a slaveholder, was thus a somewhat controversial figure. In the end, however, he prevailed, moving his entire family to Jerusalem for nearly four years.

Although he was signally unsuccessful in his attempts at land acquisition and conversion, Barclay nevertheless made several contributions to the archaeological study of the Holy Land, rediscovering an important walled-up gate from the Jewish temple, locating the entrance to "Solomon's Quarries" under the city, and publishing a number of other finds relating to ancient Jerusalem and its water supply.[41] More to the point, his sojourn in Jerusalem serves to indicate the degree to which Campbell and his followers could take a proprietary interest in the state of Palestine. (Barclay sent regular reports to Campbell, which were read with interest at Bethany.) Indeed, for several years, Barclay and his family were the only American residents of Jerusalem, giving the Disciples of Christ an unusually high profile in the city. And certainly his presence in the Holy Land suggests the heightened level of awareness with which Troye's paintings would have been viewed several years later at Bethany College.

As an educator, Campbell saw his mission as one of popularization. His significantly named periodical, the *Millennial Harbinger*, was written for a general audience, and Bethany College was established as a school of arts and sciences, not a seminary for would-be clerics (though students were still required to attend daily lessons in "sacred history"). What role, then, might the works by Troye have played in Campbell's pedagogic system? On a basic level, his views (expressed in voluminous writings in several Disciples of Christ periodicals) that American students should undergo a more rigorous training of "the eye" and should be more thoroughly grounded in geography would have prompted him to take up the painted scenes as straightforward visual aids for such instruction.[42] In particular, Troye's focus on Galilee, the site of the earliest ("primitive") works by Christ's disciples, would have carried meaningful resonance for Campbell and his students. But the Holy Land paintings also dovetailed in a more profound way with his most basic religious and philosophical beliefs.

Known for his stress on Newtonian and Lockean rationalism, Campbell constantly preached a strong alliance of reason and faith. With a bow toward science and a certain privileging of the sense organs (particularly the eyes), his theology stressed the extent to which knowledge and belief must be dependent on the reports of others, beginning with the authors of the books of the Bible. He emphasized "the primacy of observational methods" and their possible application to the biblical narrative: "Faith is the simple belief of testimony, of confidence in the word of another."[43] Essentially, he urged his followers to take the "facts" of the Bible and, through inductive reasoning, process them into belief. It was a philosophy that easily accommodated modern scientific discoveries. Thus, like Troye, Campbell explained scriptural miracles through a combination of faith and rational inquiry, divine will and natural law. This binary concept, he believed, would be readily embraced by his

ideal Christian, whom he described as "an animal, intellectual, and moral being. *Sense* is his guide in nature, *faith* in religion, *reason* in both."[44]

Following Campbell's line of thought, students, through Troye's trusted eyes and brush, could gain a great deal from study of the landscapes hung in the second-floor lecture room of Old Main Hall.[45] The visual presence of the history-laden terrain was Christian testimony in and of itself, much like the verbal accounts of the evangelists. Both were "reports" that transmitted experiences and presented narratives useful to contemporary believers attempting to examine the sources of their own faith. The very fact of the existence of the Palestinian topography, and the artist's witnessing of it, could lead indirectly to confirmation of the events narrated in the Bible, an idea only reinforced by students' daily contact with the images.

Images of the Holy Land were always used by Americans as "proof" of some sort, but Campbell's observational rationalism made this process the foundation of a belief system. The facts of nature and the facts of revelation could, in effect, be subjected to the same type of analysis. Campbell was always careful to warn, however, against deistic worship of the landscape; in stark contrast to other nineteenth-century American philosophers, he equated the propensity to "look up through nature to nature's God" with the practice of atheism.[46] Thus, the proscribed experience of the paintings would have been to some degree empirical; with a proper clear-eyed approach, biblical traditions could be reconciled with the latest scientific and artistic observations of the land.

Calculated explanations such as these conjure the vision of a dispassionate scholar, magnifying glass in hand, subjecting Troye's paintings to minute inspection and scriptural correlation. Yet it is evident that appreciation of the pictures was not limited to any purely academic realm. The reviews of the series during its national tour indicate that viewers possessing a completely intuitive faith, based entirely on revealed religion, could respond favorably and effusively to the landscapes as well. What is most striking is the widespread appeal—national, regional, and sectarian—that images of this type were able to command. The paintings were more than a simple expedition report; they could function as an exteriorized reliving of a personal, interior pilgrimage, regardless of whether the viewers had actually made the physical trip to Palestine.[47]

In the case of Troye, his Holy Land series, unique in his predominantly equine oeuvre, carried his name to parts of the country and segments of society that would otherwise never have heard of him. The enthusiasm with which the American populace received virtually any type of Holy Land imagery provided the key to a level of public acknowledgment and critical attention far beyond the possibilities of his own circumscribed world of the turf sports. It was the subject matter, meaningful and applicable to a variety of social and religious groups, that was apparently universal—so much so that it allowed Troye to transcend stylistic and experiential limitations, as well as the boundaries of genre, to cross over into decidedly more diverse circles of viewers. And as the legacy of Bethany College demonstrates, the paintings continued to support and function within a specific didactic and cultural matrix long after they passed from the control of the man whose experiences they document.

James Fairman

THE VIEW FROM OUTSIDE

Had the tour of Edward Troye's Holy Land paintings been unsuccessful, it would probably not have affected his career adversely, for at the time he could have fallen back on his booming business in portraits of Thoroughbred horses. The artist James Fairman had no such safety net. A figure who resists categorization and easy placement into the standard narratives of nineteenth-century landscape painting, Fairman led a professional existence of extreme independence. His ultimate success at cultivating a nationwide patronage base, however, suggests that at least one benefit of his professional marginality was a more supple adaptability to the market, an autonomy unavailable, perhaps, to those with rigid ties to the hierarchical elite. A consummate outsider, Fairman desperately sought the level of acceptance and recognition accorded the more prominent painters of his day, but when it became clear that he would not get it, he spent a lifetime circumventing the barriers of an obdurate art world and railing against the institutional entrenchment that the better-known artists epitomized.

Closed out of the ranks of the academies and social clubs, Fairman (fig. 61), like his predecessor Miner Kellogg, responded by organizing his own extensive network of patronage and promotion. His forceful personality helped him create a separate niche in the market, often placing him in opposition to the rest of the art establishment. Fairman's achievement, which in its methods and manners harks back to those of the early panoramists, was made possible in no small part by the popular appeal of one of his main landscape categories: views of the Holy Land. Indeed, although his repertoire of subjects varied considerably over the years, he became the preeminent painter of Jerusalem in the United States, executing, at a minimum, some twenty documented paintings of the holy city. More than any other easel painter, he took the production of Holy Land imagery to its limits. In this, as we shall see, Fairman can be revealingly compared to the much more renowned artist Frederic Church, who also executed Middle Eastern subjects in the 1870s. In the end, it is a testament to the protean appeal of their shared imagery that it proved flexible enough to be successfully exploited by two such antithetical painters.

The son of a refugee Swedish army officer and his Scottish wife, James Fairman

61. Promotional photograph of James
Fairman, n.d., private collection.

was born in Glasgow. Following his father's death, his mother left Scotland, moving
to New York City with her six-year-old son in about 1832. While still a teenager,
Fairman was hired as a bookbinder by Harper's Publishing Company. For a time, he
also devoted his evenings to classes in drawing at the National Academy of Design,
an institution he would later come to vilify. Aside from some additional local train-
ing in portrait painting and a visit to the Great Exposition of 1851 in London, little is
known of the earliest years of Fairman's artistic development.[1]

 It was in the sphere of politics, rather than art, that Fairman first came into the
public eye. The biographical material he distributed later in his career recalled of the
1850s: "The anti-slavery agitation brought him prominently forward as a platform
speaker, and, to make himself more effective in this work, he took a thorough course
in law under E. Delafield Smith, of New York. In connection with these legal studies
he pursued a course in Latin, and later, acquired a good knowledge of New Testa-
ment Greek, from a profound interest in religious and theological truth."[2] This
"profound interest" manifested itself publicly in May 1858, when New York City
erupted in a controversy over the reading of the Bible in public schools. A group of
Protestant citizens, spurred on by the orations and sermons of George B. Cheever,

the dogmatic and contentious pastor of the New York Church of the Puritans, demanded that the Board of Education mandate the reading of scripture each day in the classrooms of public schools; it was understood that the King James version, rather than the Roman Catholic text, would be used. Citing an existing policy against school-sanctioned religious instruction, the Board of Education elected not to succumb to pressure on the issue.

It was a decision that cost the seats of many members of the board. By the November elections, a highly visible, single-issue campaign had been mounted to replace incumbent members with candidates who would vote to "maintain" the Bible. Fueled by anti-Catholic, nativist sentiment and encouraged by periodic warnings in the pages of the *New York Times* against creeping "Romanism" and growing numbers of Irish immigrants, the movement was successful in stacking the board in favor of the pro-Bible faction. One of these new members was James Fairman, who ran on the unofficial Bible ticket with the endorsement of the *Times* and the announced backing of the "Americans, Republicans and People's Parties." (The American Party was a vestige of the anti-immigrant Know-Nothing movement.)[3] This seemingly pluralistic support, though, is misleading, for his fortunes were largely tied to those of the dominant Republican Party, in which he was already quite active. He had earlier been put forward as a Republican candidate for Congress, for example, but had withdrawn in favor of a stronger contender. In addition to linking his name with a reverence for the Bible, then, his activities on the school board helped establish his reputation among Republican officials, a connection that would later be important to his patronage. His embrace of nativist political tactics looked forward to his artistic career in one other respect: it set the tone of the promotional literature for his Holy Land paintings, in which faiths outside the Protestant norm were attacked and ridiculed as a matter of course.

With the advent of the Civil War, Fairman, a long-standing member of the New York militia, volunteered to serve in the Union forces. His connections with a close Republican friend, William Maxwell Evarts, chair of New York's Union Defense Committee, resulted in his commission as an officer and his command of several successive regiments. He ultimately led the New York Ninety-sixth Regiment as a colonel, but left that unit, as well as the Union army, in 1863 after suffering an unspecified wound.[4] He retained his military title for the rest of his life.

Fairman dated the real beginning of his artistic career to the moment he left the army. His characteristically acerbic promotional literature explained: "Coming out of the service, Mr. Fairman took a studio in New York, and gave himself for two years to the practice of his art with the view of becoming a professional artist. He soon discovered how little could be taught by the leading landscape painters in the city, and became satisfied that, like Haydon, he must pursue his own curriculum, in order to be thorough, and must avoid the indolent and unscientific methods in vogue around him."[5] Fairman could hardly have chosen a more appropriate artist with whom to compare himself than the English painter Benjamin Robert Haydon, an opinionated outcast who had also cultivated a martyr complex. Both men feuded

with their colleagues, accused the professional academies of their day of plotting against them, claimed to base their art on "scientific" principles ignored by their competitors, and worked obsessively on a few specific themes, which they repeated in dozens of similar versions.

Haydon committed suicide in 1846 after years of simmering resentment, but the American artist's estrangement came much later; initially he attempted to enter his profession through the usual channels. Thus in May 1863, Fairman saw three of his landscape and marine subjects hung in the National Academy's annual exhibition. His works were shown regularly at the Academy throughout the 1860s, although at some point his relationship with the organization soured. Fairman named as the source of the animosity a series of articles he published in 1867 that criticized with "severe strictures" the "New York coteries of artists." He also began feuding with a number of individual painters at this time, particularly a fellow Scottish immigrant, William Hart. There were apparently disputes about the placement of his exhibited works as well. Catalogues of the American Society of Painters in Water Colors and the National Academy, the two organizations he criticized most consistently, show that during the years from 1868 to 1871, his works, though accepted, were sometimes subsequently withdrawn, presumably because the artist was dissatisfied with the way they were hung by the jury.[6]

Thereafter, Fairman's poison pen ensured that he would never be welcome in the inner circles of artists who controlled the exhibitions in New York. In letters and articles throughout his life, he described these men as "shameless adventurers" and "stagnating obstructionists"; their organizations were variously termed a "peddling, plotting junta," a "mercenary clique," an "unscrupulous ring," and a "monstrous, unclean zoophite." He accused dealers of "cupidity," denounced members of the established social clubs for promoting and buying only the work of their fellow members, and in particularly distasteful language ascribed "Israelitish guile" and "womanly indolence" to the presidents of the leading art organizations.[7] Taking a position that was anathema to most professional painters, he advocated exhibition juries composed exclusively of laypersons, rather than the artists he thought incapable of rising above jealousy and rivalry.

To underscore his low opinion of the National Academy, he usually referred to it as the "New York Academy," or even as the still more circumscribed "Twenty-third Street Academy," maintaining that its scope and interests were far from nationwide. There was a good deal of truth to Fairman's assertion that, contrary to the New York Academicians' all-embracing claims, American art did actually exist beyond the Hudson. Certainly when Fairman took his paintings to towns with less highly developed systems of patronage and exhibitions, he received a much warmer welcome. In the years before his trip to the Old World, he successfully sent his work to Chicago, Montreal, Pittsburgh, Cincinnati, St. Louis, Buffalo, Philadelphia, and Utica. At an early stage in his career, then, he decided to take his art directly to "the great tribunal of the people," bypassing traditional intermediaries.[8]

Offering himself as a lecturer wherever he traveled, Fairman assumed the role of provincial preceptor in the arts. (He was also a poet and a playwright, and he played

and collected fine violins.) His career as an art lecturer can probably be traced to 1867, when he gave three discourses treating the profession of the artist at the Cooper Union. During the same year, he spoke at the Brooklyn Academy of Design on aesthetics and the interrelationship of the arts, receiving the honor of an introduction by Henry Ward Beecher. To supplement these *conversazioni*, as his addresses were called, he took to organizing local "art circles," which read and discussed texts of art history and aesthetics.[9] This cultivation of the layperson, he correctly surmised, would ultimately result in sales of his paintings.

Before 1871, Fairman's output had consisted of American landscapes and marines, with an emphasis on views of New York Harbor and subjects from Maine and New Hampshire. In that year, he left for Europe and the Holy Land, already having secured commissions for a new range of pictures. The consular records of the United States office in Jerusalem indicate that Fairman registered there on 19 December 1871, during a period of stepped-up American travel in Palestine.[10] No other documentary evidence of his Middle Eastern trip has surfaced, but the titles of paintings he produced suggest that he visited Jaffa, the Plains of Sharon, the Sea of Galilee, and the region of Judea. The sheer number and variety of his views of Jerusalem make it clear, however, that the historic city held the greatest interest for him.

While the trip provided him with virtually unlimited subject matter for the rest of his career, his stay in Palestine does not appear to have been overly long; Fairman soon returned to Europe. His biographical pamphlet claims that he intended "to remain eight months, and after a rapid survey of the chief modern schools of European art, to return home." His expatriation, though, was to be greatly extended. John Henry Barrows, author of the pamphlet, explains, "At once, however, there unfolded the startling necessity of a protracted residence abroad, with a careful, thorough, and, in many respects, *de novo* study of his profession. This led to his deliberately adopting the plan of a ten years' exile from America, with study in the German, French and English schools, and incidentally in those of Belgium and Norway."[11]

There is some exaggeration here. The "exile" did not last the full ten years, and there is evidence during this time of at least four trips back to the United States, opportunities used by Fairman to lecture and vend his paintings in places as far inland as Springfield, Illinois and St. Louis, Missouri. He also moved about frequently within Europe but appears to have spent most of his time in three cities: Düsseldorf (during the initial period of his sojourn), Paris (during the middle years of the 1870s), and London (at the end of the decade). In Paris his work was sufficiently notable to be praised, albeit lukewarmly, by Henry James, who pronounced the paintings exhibited by Fairman at the Durand-Ruel Gallery in 1876 to be "the best things" among those that had been rejected by the Salon.[12] Such ambivalent criticism notwithstanding, Fairman, like Miner Kellogg before him, put the cachet of his long study and residence in Europe to good use. It always formed part of his publicity, setting him apart from other American landscapists of his generation and lending credence to his claims of broad artistic knowledge.

Fairman worked with surprising rapidity. By the summer of 1872 he was back in New York, exhibiting at least nine finished paintings of Old World subjects.[13] In-

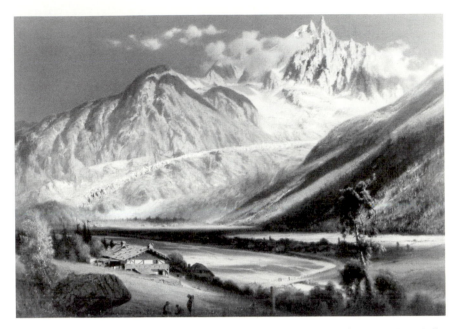

62. James Fairman, *Alpine Landscape with River*, 1871, Frank S. Schwarz & Son Gallery

cluded were European landscapes, such as his *Wetterhorn, Switzerland* (probably identifiable as a recently located painting, fig. 62), and five Middle Eastern works, among which were three views of Jerusalem and a Jaffa beach scene. The titles of the Jerusalem paintings (*The Valley of Jehosaphat*, *View of Aceldama*, and *The Damascus Gate, Jerusalem*) indicate that they were taken from three different directions, respectively the east, south, and north sides of the city. Fairman made a point of changing his perspective, even if only slightly, each time he began a new Jerusalem canvas. Taken as a whole, the corpus of views of the Palestinian capital—the most frequently painted subject of his career—forms a panoramic portrait of the city, a series of varying prospects that assigns importance to disparate topographic sites as the cone of vision pivots around the periphery of the walls.

By far his favorite view, however, was the prospect from the Mount of Olives (figs. 63–66). Together forming a cohesive series of slightly permuted images, each of these homologous scenes is bifurcated by the horizontal axis of the city's eastern wall, with the ponderous silhouette of the Dome of the Rock and an occasional minaret serving as its mensural coordinates. In successive canvases, the great dome shifts slightly to the left or right, reflecting the movement of the spectator's viewpoint along Olivet's ridge. Likewise, landmarks such as the walled Garden of Gethsemane and the funnel-like spire of the Tomb of Absalom reappear at various points in the middle ground of the paintings; in each case, the relative position of the spectator on the flank of the mount is easily determined by lining up these elements with points in the background. The totality of the set of images constitutes a catalogue of discrete views, organized and unified by a sweeping field of vision and a reassuring system of fixed, signifying objects.

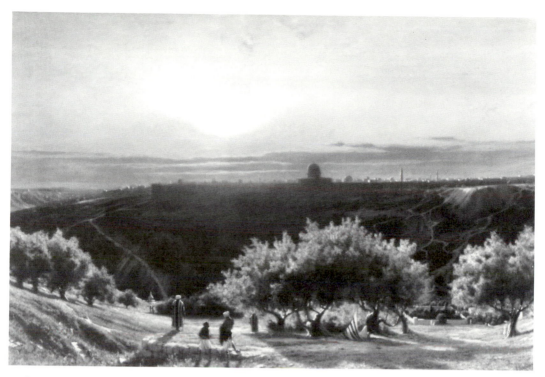

63. James Fairman, *Jerusalem from the Mount of Olives*, 1875, private collection

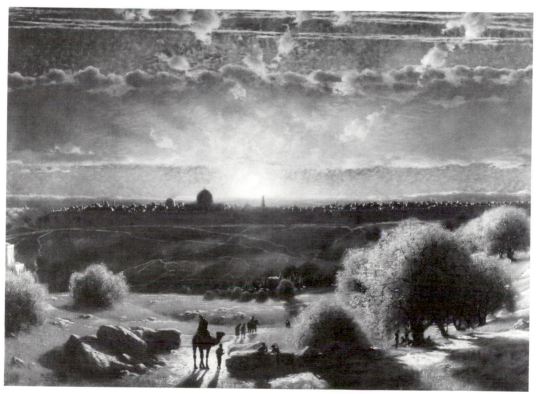

64. James Fairman, *View of Jerusalem*, n.d., private collection

65. James Fairman, *View of Jerusalem*, n.d., Mathaf Gallery

66. James Fairman, *Jerusalem*, n.d., Church of Jesus Christ of Latter-day Saints

67. James Fairman, *Jaffa*, 1874, private collection

Fairman, though, despite his apparent interest in the placement and situation of the viewer, does not climb high enough on the Mount of Olives to gain the maplike command of other contemporary images of the city (see pl. 5); he never looks over the wall. Instead, it always remains a visual barrier, strategically placed at eye level like a narrow blindfold. Information on the layout of the city is thus withheld, making its contents appear less knowable, more difficult to explain. Fairman's Jerusalem—distant, shut up, and impenetrable—seems to exclude its audience. The glare of the sun renders its skyline darkly opaque. The light glances off the rooftops without revealing details. An opposition of values is set up, with the glowing disk of the sun hovering like an ever-present, divine sentinel near the shadowed blot of the Dome of the Rock. In the course of his many views from Olivet, these two orbs (light and dark, implicitly Christian and Islamic) dodge and parry like positive and negative forces, challenging one another as they shift their positions along the horizon.

This head-on view of the centrally placed, setting sun (Barrows described it as "the 'solar look'") was not limited to depictions of Jerusalem. Fairman delighted in the challenge, making it the hallmark of most of his other Middle Eastern landscapes such as *Jaffa* (fig. 67), *Figures in a Middle Eastern Landscape* (fig. 68), and *The Holy Land* (n.d., Museum of Church History and Art, Salt Lake City).[14] His pronounced meteorological effects are often startling: heavy, plaster-of-paris clouds drooping ominously around the burning sun (see fig. 67), mottled leopard patterns spread across the entire sky (see fig. 64), and expansive areas of cool blue unexpectedly juxtaposed with torrid bars of orange strati set low on the horizon (see fig. 63). This direct light creates ambivalent, theatrically dim silhouettes. It drenches parts of the landscape with strong, sulfurous color, while the peripheral sections are pulled toward lower,

68. James Fairman, *Figures in a Middle Eastern Landscape*, n.d., private collection

grayer values. The resulting olive and dingy mustard tones are unsettling and irresolute, seemingly straining (without success) to become pure greens and yellows. This sense of internal combat prompted one critic to note, "Col. Fairman is a bold and original artist; he produces effects, and uses a palette which would frighten most artists."[15]

Fairman acknowledged the singularity of his extreme effects, explaining them as one more aspect of the unique position he held within the lagging, moribund world of American painting. While in Europe, he claimed to have studied the optical researches of the Heidelberg chemist Robert Wilhelm Bunsen, as well as the work of other prominent German scientists. Thus his promotional literature hinted at new methods of painting that were "based on the principles of light scientifically determined" and "the absolute application of the prismatic theory." This led to some grandiose boasting. Several of Fairman's pamphlets stated confidently that "scientific knowledge has opened to Fairman the secret of the sunbeam which Turner never fully discovered," and a newspaper writer in Cleveland apparently took it on faith that "through the science of chemistry, the artist has been enabled to place upon the canvas a body of paint possessing by actual test of the photoscope a luminous power one-fourth greater than ever before secured." Lest any reader be put off by this daunting empiricism, there were careful reminders that Fairman's remarkable illumination, though scientifically analyzed, remained "the light of Christian tenderness and hope."[16]

This combination of scientific knowledge and adherence to "the Christian school of truth and goodness" gave rise to an illusive promotional construct, "the Eclectic

School of Art." At about the time of his definitive return to the United States, Fairman began corresponding on stationery emblazoned with this affiliation. Using information no doubt provided by the artist, the *Newburyport Herald* explained that "the lecturer represents the eclectic school of art, lately formally organized in London, which is very thorough in its system, requiring that its members shall possess a wide general education, and have obtained a diploma as Master of Arts."[17] This last requirement Fairman had conveniently fulfilled in 1879, when Olivet College, a religious school in Michigan, conferred an honorary degree on him. Not surprisingly, no other "members" of the Eclectic School were ever mentioned.

In cities without a developed professional tradition of art making, his lectures and exhibitions were apparently received as important cultural milestones. "No event in the annals of the art interest in this city has been fraught with such significance as the sojourn here of Col. James Fairman," his pamphlet quoted the *Cleveland Daily Sunday Voice*. Fairman reinforced his appeal to the layperson by stressing such newspaper commentary, rather than reviews from the more insular art press. As he explained in 1882, "The best art thought, developed in journalism, is found not in the columns of the affected specialists, who speak in the name of art, but in the incidental notice of the daily papers."[18]

The manner of showing his paintings, like his lecture style, was highly theatrical and integrally tied to popular methods. The *Chicago Tribune* provided details of his practice: "In exhibiting the pictures, Col. Fairman uses the panoramic style. A large frame, heavily draped with maroon velvet, is placed on the line, and in this the pictures are shown one after another."[19] As the notice points out, there are obvious ties here to the circumstances of display developed by panoramists such as John Banvard (see fig. 20), as well as by the easel painter Frederic Church (fig. 69), whose elaborate cabinetwork for his *Heart of the Andes* similarly exploited the Albertian principle of frame-as-window.[20]

Fairman took Church's draped shadow box, however, and went one step closer to the panorama by adding motion to his performance; while lecturing, he actually changed the canvases that were inserted, one by one, into the proscenium of his stationary frame. In essence, he was bringing into reality the worst nightmares of cosmopolitan critic James Jackson Jarves, who had previously lampooned Albert Bierstadt by writing hypothetically of "the countryman that mistook the *Rocky Mountains* [1863, Metropolitan Museum of Art] for a panorama, and after waiting a while asked when the thing was going to move." Unlike Bierstadt's picture, Fairman's canvases did in fact move, appearing and disappearing as the evening wore on. The censure levied on him for this affinity with the "low" panoramic art form was therefore even more vehement than Jarves's humorous indictment of Bierstadt. Thus, the *Boston Daily Evening Transcript*, in reprinting a description of Fairman's curtained, versatile frame, could make the unusually harsh comment that to refined persons, the ingenious setup must "suggest violence and bad language."[21]

Such reactions against Fairman's inflated claims, cantankerous manner, and peremptory dismissal of the high-art establishment were not at all unusual, and the artist, or one of his nonprofessional allies, could often be counted on to provide a

69. Frederic Church, *Heart of the Andes*, as exhibited at the Metro-
politan Sanitary Fair, New York, 1864, New-York Historical Society

reply. When the *New York Times* mocked him for allegedly writing his own biogra-
phy, for example, a Fairman son soon sent a letter of vindication on his father's
behalf. The artist was apparently less successful at countering a devastatingly sarcas-
tic article, "A Crichton of the Brush," which appeared in the *Art Amateur* in 1882.
"Some, indeed, may be so ignorant that they never heard of Col. James Fairman,
M.A.," it began. "We ourselves confess to such ignorance until this distinguished
man honored us with a call and supplemented his personal narrative by handing us
his printed biography, which establishes beyond dispute that Col. James Fairman,
M.A., is no ordinary person." In the paragraphs that followed, the article effectively
allowed the artist to dig his own grave, quoting ironically from the more fustian
sections of his pamphlet, lamenting with tongue in cheek that "the Dictionary of
Artists of the Nineteenth Century . . . has shamefully omitted even to mention his
name," and declining to subject his paintings to the usual critical commentary, for,
"the Colonel having reached perfection, what remains to be said?"[22]

That such a condemnation, expressed in a biting, derisive tone that is extraordin-
ary for the period, should appear in a respectable art journal, especially one like the
Art Amateur, which was directed toward potential picture buyers, only indicates the
degree to which Fairman's maverick tactics must have been seen as a real threat by

the East Coast art establishment. A favorite means of responding to this hostility, though, was to draw attention to his commercial success. An anonymous letter to the *Boston Journal* observed, "It need not be said that an artist who in these times receives so many orders for pictures, no one of which is sold for less than a thousand dollars, merits exceptional attention." The price tag of a thousand dollars was placed on his "crown size" picture, thirty-two by forty-five inches, and there is indeed evidence to suggest that he sold quite a few of them. Barrows explained, "He has been greatly prospered in his professional career, and his success is partly attributable to the fact that he deals directly with his patrons, and relies on the manifest merit of his work, rather that on the reputation manufactured by picture dealers and cliques of mediocre artists."[23] Here there is no exaggeration; it is clear that one of Fairman's greatest achievements was the successful personal solicitation of scores of picture buyers, a network stretching from Maine to California.

Investigations into Fairman's patronage are largely possible because of a singular brochure produced by the artist, *Pictures Painted by James Fairman, A.M., with the Names of Possessors*. Although it applies only to the first part of his career (it was probably published around 1879), the pamphlet provides important information—name, place of residence, and business affiliation—for the buyers of more than 140 Fairman paintings, of which some three dozen are views of the Holy Land. While more than a third of his private patrons lived in the New York metropolitan area, most were spread throughout the mid-Atlantic, Midwest, and Plains states, with particular concentrations in St. Louis, Detroit, Chicago, and the Minneapolis–St. Paul area. (No southern patrons are mentioned.)

An understanding of Fairman's itinerant sales efforts adds significantly to our knowledge of the means by which provincial buyers, many of whom did not regularly attend the major East Coast exhibitions, formed their collections. The artist traveled to lecture and socialize in almost all the cities where his pictures were owned, an unusual and laborious undertaking for the period, and it is certain that his sales depended to a degree on his dynamic personal presence. Several such visits to Minneapolis in the early 1880s resulted in over half a dozen eager patrons, including the important collector James J. Hill. This wealthy railroad industrialist seems to have been introduced to picture buying by Fairman, whose *Cows in a Pasture* constituted the first entry in his collection inventory.[24] Fairman was evidently widely known in Minneapolis, but at other locations he seems to have relied on a single, primary contact. In St. Louis, for instance, he corresponded with S. A. Coale, Jr., a collector who specialized in small, cabinet-sized American landscape paintings and contemporary European art. Coale had already purchased Fairman's work in the 1860s, and by the time the artist was living abroad, had evidently put him in touch with other wealthy patrons in St. Louis.[25]

Word of Fairman's paintings apparently passed through local business associations as well. James L. Edson, a Detroit dry-goods merchant who owned two works, one of which was *The Plains of Sharon*, worked in his firm with an associate named Charles Buncher who, according to Fairman's brochure, also patronized the artist. In

Kansas City, the partners in another dry-goods company, Bullen, Moore, and Emory, owned three paintings among them, one of which was entitled *Mount Moriah, Jerusalem.* Another group well represented on the list of patrons is journalists, with works by the artist in the possession of the editors of the *Wilkesbarre Record of the Times*, the *Minneapolis Tribune*, the *Scranton Republican*, and the *Art Journal* (London). Fairman's long-standing use and manipulation of the media would suggest that he hoped for some benefit from this cultivation of the press. In at least one case, he seems to have received it. S. C. Hall, the editor of the *Art Journal*, was likely responsible for a decidedly positive review of a Fairman exhibition, which the artist reprinted on several occasions.[26]

Although not all of the patrons listed by Fairman are traceable, a sample survey of thirty buyers (almost a third of the total) from twelve different cities suggests a few biographical constants. A small but significant number were either born in Scotland or of Scottish descent. Fairman made a point of stressing his own "Scotch ruggedness," and over two dozen of his listed paintings depict scenes in Scotland.[27] Presbyterianism, a faith traditionally associated with Scotland, was the dominant religious affiliation (when such affiliation is known). Presbyterian buyers—of both Holy Land and other scenes—outnumbered those of every other denomination, four to one. The artist also seems to have capitalized on his political connections. As might be expected in a predominantly northern region, his clientele was overwhelmingly Republican. But Fairman, a onetime congressional candidate himself, sold to purchasers who were unusually active in the party. His list included the New York City politicians Henry Smith and Salem H. Wales (the latter was the Republican mayoral candidate in 1874) and the families of two Republican senators in the Midwest, James McMillan and Zachariah Chandler.[28]

Several of Fairman's paintings, like Troye's earlier Holy Land series, found their way into religious institutions. The case of Olivet College is instructive. The college, located in tiny Olivet, Michigan, was founded as a Congregationalist school in 1844. After it had evolved from a general "institute" into a degree-granting college in 1859, one of its first undergraduates was John Henry Barrows, Fairman's obliging biographer, whose father was employed there as a professor of natural sciences. Barrows left Olivet in 1867 and met the artist six years later in Paris. It was doubtless Fairman's connection to this former student of the college that secured him an invitation to give two lectures on the fine arts in 1878. Following these addresses, an impressed faculty recommended to the college trustees that an honorary degree be conferred on the lecturer. This was the prized "A.M." he appended to his name thereafter. In addition, the artist was asked to become a part-time lecturer at the college; he remained on the faculty until 1886. The relationship between painter and college was mutually beneficial, for Fairman also served as a consultant on the erection of a new art gallery and the purchase of a collection to fill it.[29]

The first painting to enter the collection, in fact, was by Fairman: his unusually large *Mount of Olives from Mount Zion* (1879). The painting has hung for decades over the mantel of the fireplace in the main reading room of Olivet's library, and continued exposure to roaring fires and steam heat has severely compromised the

surface of the canvas. Still, the general outlines of the composition are readily dis-
cernible. Within the canon of nineteenth-century views of Jerusalem, the Olivet
canvas depicts the city from an unusual perspective. The viewer is positioned near
the southwest corner of Jerusalem looking across only a corner of the Haram al-
Sharif. The mosque of al-Aqsa is prominent in the middle ground, but the more
recognizable Dome of the Rock is cut out by the picture's left edge. Dominating the
composition at right and across the entire background is the broad Mount of Olives,
the perch normally chosen by artists, including Fairman on many occasions, to look
back at the city.

Why this reversal of the usual point of view? For Fairman, the image of Jerusalem
was a malleable entity, easily adaptable to a variety of market conditions. It seems likely,
then, that the artist, ever sensitive to what might please a patron, gave prominence
—and a good degree of celebratory, warm afternoon light—to the Mount of Olives,
also known as Olivet, because of its connection to the Michigan community that
would be the painting's home. The founders of the town of Olivet took their name
seriously—its nearby stream was called Kedron, after the brook that flows at the base
of the original Mount of Olives—and Fairman apparently accommodated local
pride by selecting an unusual prospect that maximized the view of the college's
topographic antecedent.

The view from the south, though not his most frequent compositional choice, was
used by Fairman in several other canvases. A second Midwestern religious insti-
tution, the Baptist Theological Seminary in Chicago, owned his *Jerusalem from
Aceldama*, for example. Although this painting is no longer owned by that institu-
tion, what is likely a very similar work, possibly originally titled *The Mussulman's
Call to Prayer* (pl. 3), is still extant. It is one of Fairman's most striking Middle
Eastern works.[30]

Across the intervening Valley of Hinnom, the southern walls of Jerusalem are
shown here to follow the gradual slope of land toward the Mount of Olives to the
east. The long procession of clustered, glinting domes catches the raked afternoon
light from the sun, uncharacteristically edited by the picture's left border. Above, the
city seems crowned by an aerial series of vibrant pentecostal flames. Like solar flares,
twisting, dancing strokes of orange and yellow rise from the horizon in a viscous
impasto. Shifting in hue, they ultimately move through an evanescent band of soft
lime to blend with the blue sky overhead. Closer to the viewer, the focus is on an
unusually prominent figure perched on a projecting brow of rock. Around him, the
forms of the landscape convey a pleasantly tactile sense of brushwork, alternating
between a saturated, claylike fusion of pigment and medium and a more waxy trans-
lucence of stroke. The increased palpability of paint in this lower region of the
painting encourages viewers to follow the sweeping line of the soft, dusty valley up
through the more solidly constructed promontory, where this wavelike momentum
of coalescing brushwork crests with the brightly tangible human figure.

Indeed, the emphatic singularity of the lone Arab (fig. 70) makes him the key to
the work. Conspicuous in his spatial isolation, he is further highlighted by the bright
sun glancing off his turbaned head, its compact, rounded form echoing the salient



70. Detail of plate 3

Islamic domes in the distance. This evocation of faith seems appropriate as the figure is actually shown engaged in an act of prayer. His red shoes removed and his staff left behind, he bows his head, assuming a position—inclined upper body, lowered hands—identifiable as part of the devotions performed five times daily by practicing Muslims. Such prayers are inevitably directed toward the holy city of Mecca, as is every mosque, each provided with a wall oriented toward the *qibla*, the direction leading to Mecca.

In Fairman's picture, one of the most celebrated and venerated of all mosques, al-Aqsa, is in view at the corner of the city. Its qibla wall, pointing south to Mecca, faces the northward-looking viewer of the painting—a simple geographical observation that would have been apparent to many nineteenth-century spectators. Yet the praying figure is not facing south, as al-Aqsa's qibla indicates that he should. Instead, he is turned ninety degrees toward the east to face the Mount of Olives, the site most closely associated by Protestants with Christ's Passion. (The Garden of Gethsemane can be made out at the right edge of the work.) For the viewer, Fairman's figure functions as an ethnic and religious type. Through a visual telescoping from the turbaned head in the foreground to the distant rounded domes, the single Islamic believer comes to stand for the institutions of his faith, a shorthand summation of a vast culture. The artist therefore manipulates this praying manikin so that he performs theatrically, paying deference through his nature worship to a major landscape icon of Christianity while implicitly snubbing the holiest site of Islam. Like the deified, centrally placed "Christian" sun that repeatedly sublates the Dome of the Rock in Fairman's series of Jerusalem paintings, the natural world of *The Mussulman's Call to Prayer* is brought into complicity in a subtle act of religious degradation.

The artist's views were actually quite clear on this subject, and he made a point of calling attention to the anti-Arab and anti-Turk elements in his paintings. As with his earlier embrace of nativist politics, Fairman seems here to be in step with definite shifts in prevailing public opinion, for the decade of the 1870s saw a general reassessment of the moderately favorable American attitude toward the Ottoman Empire that had theretofore prevailed. As the Turks lost a measure of their global clout (through the Balkan revolts in 1875, the internal power struggles of the sultanate in 1876, and the Western dismemberment of the empire's outlying provinces at the Congress of Berlin in 1878), American sympathy for Islamic rule diminished considerably while concern for Christian minorities began to be expressed more openly. In this climate, Fairman was anxious to demonstrate evidence of Turkish misdeeds. In a broadside used to advertise a view of Jerusalem, he wrote (one presumes he is the author): "The figures and accessories are careful local studies made on the spot: such as the blind man, with his hand upon the shoulder of his boy guide, a sight too sadly familiar, in a land where the mother by crude method destroys the right eye of her boy child, lest he be conscripted into the Turkish army when he became a man, frequently leading to total blindness of both."[31]

The particular work addressed by this text has apparently not survived, but in other paintings (pl. 4; see also figs. 66, 68), the same intergenerational pair is inserted into the foreground of each scene. Fairman has taken a standard Orientalist accusation—that indigenous peoples were "blind" to the historical glories that surrounded them—and made it a literal reality. Because this blindness is revealed in his broadside to be more or less self-induced, the consequent ignorance of the figures becomes willful, and thus worthy of scorn rather than pity. Like *The Mussulman's Call to Prayer*, Fairman's landscapes conspire to extend the metaphor of sightlessness still further, for several of the paintings featuring the paired boy and old man induce a kind of compositional blindness of their own. In *Sunset* and *Figures in a Middle Eastern Landscape* (see pl. 4, fig. 68), huge masses of unusually shaped stone rise up to create visual blockages that deny the full view to the figures circling them. The only omniscient "eye" is the one represented by the elevated sun. With the long, curving scallop of the foreground edges of his paintings repeatedly suggesting the bottom of a lenticular oculus and the solar disk approximating its fiery pupil, Fairman's landscapes mock their painted figures by staring back with such eagle-eyed, Cyclopean intensity that normal vision is overpowered by the brilliant, central glare. Once again, natural forces are shown to rule in the Holy Land, at the expense of its human inhabitants.

The repeated inclusion of the blind man is a conscious censure of what was described in the same broadside as "the rapacity and cruelty of Turkish rule." This condemnation ended with the ominous words, "Jerusalem, the Crescent is thy Cross." Taken as a whole, Fairman's Holy Land views can be seen as a continuous effort, through structural and iconographic means, to separate the crescent from the cross, to restrict the access of indigenous Muslim figures to the topographic glories celebrated in the central territories of his canvases. Nearly every painting operates through this centrifugal opposition of distinct sectors of landscape: an internal bowl

of warm, glowing space and an elevated, peripheral rim populated with an array of notably passive figures—the profane encircling the sacred. The central areas appear devoid of inhabitants, unsullied by any infidel human presence. Like the closed-off, walled city of Jerusalem, these favored valleys become sacral by virtue of their unobtainable status. Foreground figures are left to gaze into the misty center, their entrance into the scoop of space interdicted by the pronounced edge and sudden drop of their foreground perch as it pulls back from the middle ground. This bowed, "fish-eye" stretching of the landscape along the edges leaves the impression that the figures are located outside some protective glass globe, or perhaps are placed as passive spectators high up in a natural amphitheater. Here, however, elevation of viewpoint does not denote visual command, but rather removal from a more privileged sphere.

Fairman's figures suffer from a universal lassitude. Curiously inert, they recline, gather in the shade, rest on camels' backs, and lean against rocks and trees (see figs. 63–65, 68). They quietly observe, but rarely converse. The characteristically low placement of the sun throws them into silhouette; they cast long, ponderous afternoon shadows that seem to fix them in place, increasing the sense of psychological and physical weight. When they do move, it is along the certain, timeworn trails around the valleys' edges. Trudging and stooped, in single-file, creeping lines, they slowly work their way along the foregrounds of such scenes as *Sunset* with all the deliberation of two-dimensional tin targets in a shooting gallery (see pl. 4). The single, curving path of *Sunset* implies a certain circularity, both spatial and temporal. It is as though the figures are engaged in a ritual reliving of a predictable past: cyclical, ongoing, and inevitable—unbroken by contemporary events. Even the overall golden tonality of the canvas contributes to the effect of suspended time; the entire visual field, and everything within, appears as if preserved in amber.

Other compositional elements, however, interrupt this comforting impression of stasis. The tracks of the figures in many compositions are threaded through enormous boulders that dwarf the bent bodies and order their progress. These huge masses of rock assert themselves as looming, alternate protagonists of stone, thrusting confrontationally through the earth's crust (see pl. 4) or teetering dangerously on hillside slopes (see fig. 68). Belying their expected immobility and appearing somehow more fanciful than their measured human counterparts, Fairman's reigning megaliths give his pictures some of their few elements of drama, just as they reinforce the passivity of the neighboring Arab figures.

Fairman thus creates a field in which these human occupants are allowed to exist but with which they are not permitted a dialectical interaction. The same might be said of the viewer of the artist's Holy Land paintings. In their postures and their quiet focus on the scene before them, in fact, his foreground figures often approximate the poses of pensive visitors to a genteel art gallery: spectators receptive to visual impressions but without a forum to act on them (see fig. 63).

The irony of the repeated restriction of the Arab inhabitants to a decontextualized periphery is that although Fairman has objectified his faceless figures to the point

that they are forever subordinate to his painterly gaze, he is forced to share their point of view. As with the contemporary American visitors to Chautauqua's Palestine Park, the line between objectification and identification becomes thin indeed. Fairman's ability to penetrate the holy city of Jerusalem or the inviting plains expanding toward the horizon remains nearly as limited as those of his stock characters. That he should have used the Holy Land to create a landscape construct with a place for himself only in the margins is not, however, surprising. His professional career had always been conducted from the outside, and until the end he used the popular subject matter of the Holy Land as a means of turning his exteriority into a positive, even lucrative, attribute.

At the close of his career, Fairman made a late attempt to market his Holy Land imagery, an effort as remarkable for its belief in the importance of his work as it is for the ignorance of the contemporary art world it displays. Writing in 1899 to William Macbeth, a New York dealer specializing in American art, he proposed the exhibition and reproduction "in color" of a recently completed painting, *Sunset over the City of Jerusalem*, measuring nine by six feet.[32] At this point in his career, Macbeth specialized in small, intimate landscape paintings by such artists as the Barbizon-inspired Homer D. Martin and J. Francis Murphy or the protomodernists Arthur B. Davies and Maurice B. Prendergast.[33] Macbeth's reply to the proposition is unknown, but it is a safe bet that he would no more have exhibited Fairman's large, pedantic work to his turn-of-the-century, cosmopolitan clientele than he would have presented John Banvard's Holy Land panorama accompanied by pianoforte music.

Fairman, who had never marched in step with the New York art establishment, was now even more hopelessly out of sync with the professional world around him. Yet he apparently remained committed to his mission of taking his message to "the people." Just days before his death in 1904, for example, he is reported to have delivered a lecture on art before the Brooklyn Board of Education.[34] At a time when his inflated romantic grandeur and didactic specificity of time and place had become anathema to most American landscape painters, Fairman, opinionated and unswerving, maintained his devotion to the painted views of Palestine he had been producing for a quarter of a century. His was an idiosyncratic and lonely voice until the end, just as it had been throughout his exceptional life.

Frederic Church's Late Career

THE LANDSCAPE OF HISTORY

While Frederic Edwin Church was by no means the first American artist to travel to the Holy Land in the nineteenth century, he was certainly the best known. In contrast to Kellogg, Troye, and Fairman, Church left for the Fertile Crescent with an established reputation (in both popular and professional circles) as the nation's leading landscape painter. His previous commercial successes virtually guaranteed that critics, patrons, and general viewers would show a keen interest in the painted results of his trip, whatever form they took. Anticipating this reception, his slightly envious colleague Jervis McEntee, who shared an interest in the biblical landscape, complained that "any humble individual like myself who goes there hereafter will be playing second fiddle."[1]

McEntee was accurate in his assessment of the level of public interest that Church's paintings of the Holy Land would generate. Before he had even left Beirut (his base of operations while in the Middle East), the artist had received several commissions for "Syrian" landscapes of various sizes and subjects. Yet in the decade following his trip, when most of his Eastern works were painted and exhibited, Church also saw a swift erosion of the celebratory critical consensus that, for the most part, had greeted his earlier New World paintings. While there was often unquestioned enthusiasm for these later works, more confused and mixed reactions became increasingly common as well. The questions he now asked of his material, the demands he made of his imagery, were no longer necessarily those of his audience. With the evolution of taste toward intimate, Barbizon-derived landscapes that were evocative rather than explanatory (or in Church's case, declaratory and even hortatory), a certain cooling toward his rigorous style was inevitable.

But if the taste of his time was changing, so was Church's subject matter, in fundamental and unanticipated ways. After years of seeking the wild, the new, and the "virginal" in South America, Maine, Jamaica, and the Arctic, he embarked in 1868 on a seemingly anomalous exploration of what was then considered the most aged, history-laden part of the world. Still, Church's trip to Palestine and Syria (and, more important, the products of that trip) can be linked to his earlier devotion to such subjects as Andean volcanoes and preindustrial New England forests. They are

all aspects of the relatively conservative search for continuity and origins that marked his entire career. Throughout this quest, his constant referents were the twin pillars of science and faith. Perhaps more than any other American artist in the Holy Land, then, Church would have been challenged profoundly by the controversies of biblical and terrestrial chronology and teleology. It was in the enduring, sacred landscape that he sought his reconciliation.

The sudden shift in interest from natural history to human history was, for Church, a return to themes first investigated at the beginning of his career. As a student of Thomas Cole, he was introduced quite early to an emblematic, epic view of the nation's Protestant heritage (which, for the younger painter, if not for his teacher, meant the Puritan-derived cultural legacy common to his family's established rank within Connecticut society). While serving his apprenticeship at Cole's home in Catskill, New York, for example, he might have watched the older man plan his powerful, unfinished Bunyanesque series, *The Cross and the World*, with its twin protagonists roaming through morally unequivocal landscapes of good and evil. Such exposure manifested itself in Church's initial efforts to find his own means of expression through landscape painting, as recent scholarship has demonstrated.[2]

The year 1846 was pivotal for Church. It not only marked the end of his period of study with Cole, but also saw the completion of two thematically important paintings that prefigure his work in the Holy Land two decades later. While they were never intended as physical pendants, *Moses Viewing the Promised Land* and *Hooker and Company Journeying through the Wilderness from Plymouth to Hartford, in 1636* (figs. 71–72), when considered together, provide a clear typological commentary on the relationship of the New World nation to its Hebraic antecedent and, in addition, posit a prophetic role for Church himself within this parallel construction.

The celebrated story of Thomas Hooker's trek into the wilds of Connecticut had added personal relevance for the artist: his ancestor Richard Church had been among the dissidents who, in defiance of the ruling Massachusetts theocracy, left with Hooker in search of new grazing lands.[3] The connections between the Hooker story and the Exodus narrative are obvious—to the point that the New England ford depicted in the painting can even be seen as hinting at the parting of the Red Sea. Hooker himself, as much as any member of his community, acknowledged the tie, writing that the apocalyptic mission of his own generation was "typified in the passage of the Children of Israel towards the promised Land," and Church's contemporaries two centuries later continued to see the episode in terms of "the foundations for a chosen Israel."[4]

With *Moses Viewing the Promised Land*, Church also made implicit reference to the continuing Puritan errand. The tiny figure of Moses looking down on a vast Edenic plain can easily function as a stand-in for such American seers as Cotton Mather, who wrote, "I may Sigh over *this* Wilderness as Moses did over *his*." And with his panoramic command of the favored terrain, the artist himself, by virtue of his connection to his forebear Richard Church, could assume the position, alongside Mather, of colonial prophet above the landscape, a position consequently shared

71. Frederic Church, *Moses Viewing the Promised Land*, 1846, Dr. Sheldon and Jessie Stern

72. Frederic Church, *Hooker and Company Journeying through the Wilderness from Plymouth to Hartford, in 1636*, 1846, Wadsworth Atheneum

73. Frederic Church, *West Rock, New Haven*, 1849, New Britain Museum of American Art

with his viewers. As David Huntington has written about Church's art, "Before his canvas the spectator, as one of the Chosen People of God's nation, becomes protagonist."[5] This place at the top was a favorite of most American painters with biblical tendencies, as William Jewett's *Grayson Family*, painted several years later, reminds us (see fig. 3).

Within Church's oeuvre, *Moses Viewing the Promised Land* and *Hooker and Company* share another trait: they both approach the landscape in ways eventually rejected by the artist as he moved beyond the early, exploratory years of his career. There would be several other biblical pictures, but ultimately he found that reconstructive illustrations of scriptural narratives were not to his taste. *Hooker and Company* would remain something of an aberration; while the themes of the colonial past were ever present in his art, he never again attempted to express them so literally. Arriving at a kind of compromise, he solved, for himself at least, the dilemma of the real and the ideal that had so troubled his teacher.

West Rock, New Haven (fig. 73) is an example of that solution. Although the scene depicts a specific, recognizable geological landmark, the anonymous haying vignette in the foreground generalizes the view, locating the spectator of Church's time in the approximate present. For many viewers this undoubtedly was, and is, enough. Those

well versed in Connecticut history, however, could bring more to the picture. West Rock was traditionally thought to have served as the hiding place for two seventeenth-century enemies of the British crown who were said to have been helped by nearby colonists. Thus, for the select audience with this knowledge, the painting also carried the associations of a significant bit of "national" history, without ever invoking it specifically.[6]

With *West Rock*, Church satisfied his need to produce an actual view of a particular site while still alluding to the "story" attached to the physical place. It was a way of acknowledging history and carrying it through to the present without ever giving up a tangible hold on the contemporary, topographical "reality" as he had experienced it. Arrived at early in his career, this strategy was easily transferred to the terrain of the Holy Land twenty years later. Indeed, it was the perfect method for a journey of exploration in a country where, more than any place Church had previously encountered, the specifics of place and the exactitude of visual transcription were necessary components of a meaningful depiction of the historicized landscape.

The year 1867 marked another turning point for Church. The period following the resolution of the Civil War was a time of reassessment for the artist, as it was for many Americans. He no doubt shared the ambivalent attitude of most of his fellow northerners toward the deadly outcome of the conflict, an attitude reflecting both a devastating loss of personal faith and a desperate search for some kind of affirmation to replace it. Church's public landscape style had all but foundered on the shoals of American nationalism, and he, like many postbellum artists, was now moving toward a more searching, subjective experience, one not necessarily grounded on familiar turf. In his art, it is clear that Church felt a need for change. Two important series of paintings with South and North American subjects—the Andean volcano Cotopaxi and of the falls of Niagara—were brought to a close in 1867. His small canvas *View of Cotopaxi* (Yale University Art Gallery) was completed that year, the last of a group of depictions of the mountain that had supplied him with remarkably constant inspiration for over a decade. Similarly, with the large but nevertheless vacant and inflated *Niagara Falls, from the American Side* (National Gallery of Scotland), he concluded his sequence of at least three major oils of the famous cataract on a searching and unresolved note.[7]

It was thus with a sense of opening a new chapter that Church began his first and only trip to the Old World in the autumn of 1867. From the start, it was clear that despite the traditional artistic temptations of Europe, his strongest desire was to reach the Middle East. With his wife, mother-in-law, and infant son, he raced through England and France on his way south to Marseilles, where they boarded a steamer for Alexandria. In London and Paris, he made obligatory but quick trips to the major museums, but in general he passed through the cities only "glancing at the famous things," as he wrote to his colleague, Martin Johnson Heade.[8] Although the family was delayed in the French capital by Isabel Church's temporary illness, the party was soon on its way to Egypt, arriving during the first week of 1868. Church found little to interest him in Alexandria, and fearing for the well-being of his family

if left alone, he relinquished with disappointment his planned trip to Cairo and the pyramids. Within a few days, he and his entourage had boarded another ship bound for Palestine; after landing in Jaffa, they waited only a few hours before moving on to Beirut, their home for the next four months.

Church disembarked in the Holy Land at a time when American tourism had reached unprecedented levels. He recorded in several letters his surprise at the numbers of fellow citizens he encountered, writing to his close friend and patron William Osborn, "There are Americans innumerable in Syria. All landlords look to them for their profits. The few Englishmen here stand with their hands in their pockets and exclaim 'Most extraordinary—these Americans.'"[9] Among these compatriots, he had the opportunity to meet several who played significant roles in popularizing knowledge of the region, including Robert Morris, the Masonic leader and vendor of thousands of "Holy Land cabinets," and William Thomson, the missionary author of *The Land and the Book*.[10]

Thomson was a leader of the Beirut missionary community into which the Churches were immediately welcomed; they became particularly close to the Reverend D. Stuart Dodge and his wife, Ellen Ada (Phelps) Dodge, who had arrived several years earlier to help found the Syrian Protestant College (later the American University of Beirut). The artist wholeheartedly supported the missionaries' endeavors, writing appreciatively to Heade of their efforts and likely contributing to their nascent scholarship fund.[11] Perhaps of more importance, however, was the fact that the missionaries provided a familiar religious and social environment for the pious Churches, one that aided in their enjoyment of the surrounding sacred sites. Church received topographical instruction from Dodge, for example, and his wife's diary is filled with accounts of attending church services and participating in evening hymn-singing and scripture-reading sessions with their new friends.[12]

At the outset of his Middle Eastern trip, Church had written excitedly to Osborn, "Just think of a series of studies in oil presenting the great features of Thebes, Etc., Sinai, Petra, Palmyra, Damascus, Baalbec, Lebanon, Jerusalem, Etc., Etc.!!!"[13] With his family settled in Beirut, he could now begin to seek out some, if not all, of the places on his list. Carrying materials for work in pencil, gouache, and oil, he sailed back to Jaffa on 6 February and began the overland journey that would take him through Jerusalem to the spectacular rock-carved city of Petra. With his traveling companions (Dodge and a Scotsman named Alexander Fowler), Church spent a week in Jerusalem preparing for the ten-day camel ride to Petra. After successfully securing a large portfolio of sketches and visiting a number of biblical sites on the way to and from the abandoned city, he returned, by a similar route, to Beirut by 13 March. Two weeks later, he was once more in Jerusalem to draw and paint, this time with his wife. In late April and early May, they left Beirut again and traveled to Damascus and Baalbek, where Church spent several days exploring the famous ruins. By the end of May, the family was sailing through the Aegean, making a week-long stop in the Ottoman capital of Constantinople before returning to Europe.

Although Church spent most of the next year in Rome (his wife was pregnant and presumably required an environment more stable than that of Beirut), he disliked

the city and compared its architecture unfavorably to the older ruins he had encountered in the eastern Mediterranean. In fact, Europe in general failed to move him while his memories of the Middle East were still fresh. "In all Europe I have seen nothing to equal the Syrian landscape for the brightest qualities. . . . Syria, with its barren mountains and parched valleys possesses the magic key which unlocks our innermost heart," he wrote to Osborn from Perugia. Even in the Alps, he had to confess, "Magnificent and stupendous as the scenery is here—yet I look back with particular favor to the sad-parched-forsaken Syria. There is poetry—not here."[14]

Why was his visit to Syria (or the Holy Land—the terms were used interchangeably) of such importance to Church? And how can his sudden interest in a previously ignored part of the world be reconciled with earlier phases of his career? The glue that bound these seemingly disparate spheres of interest was science. In the past, pundits had often looked at his paintings with an eye toward the scientific principles they were seen to exemplify. Perhaps the most salient earlier instance was the reception of his monumental *Heart of the Andes* (see fig. 69). The contemporaries of Church who took on the task of explicating this complex work attempted to reveal the profound depths of scientific knowledge—geological, botanical, and meteorological—with which it was imbued. What is also significant is the degree to which *Heart of the Andes* was publicly explained as an enlightened illustration of prevailing theories of creation. The artist's friends Theodore Winthrop and Louis Noble wrote exhaustive pamphlets detailing the ways in which *Heart of the Andes* affirmed a post-Lyellian but pre-Darwinian view of the world, with the mountainous rock forms offering up evidence of a gradual yet convulsive story of formation and change.[15]

Interpreted correctly, the visual data that Church provided in such South American canvases as *Heart of the Andes* and the cataclysmic *Cotopaxi* (fig. 74) could remain in step with accepted scientific principles without seriously questioning the truth of sacred writ. Indeed, volcanic upheavals and other momentous natural occurrences were even used as a "bridge" to understanding the biblical accounts of miracles; scientific precepts were applied to the wonders of scripture. In the year of Church's departure for the Old World, one American writer went so far as to describe God as a kind of scientist, conducting laboratory exercises for the benefit of humanity: "The miracles of the Bible are not only emblems of power in the spiritual world, but also exponents of the miracles of nature—experiments, as it were, made by the Great Teacher in person, on a small scale and within a limited time, to illustrate to mankind the phenomena that are taking place over longer periods throughout the universe."[16]

As a central figure within the orthodox cultural circles where this type of thought was unquestioned, Church would have certainly been predisposed to apply it to the landscape of the Holy Land as well. A fellow artist wrote of him just a year after his return, "[Church] is the only landscape-painter living who has anything cosmical in aim and idea."[17] It would have been surprising, then, if he had been anything but active in the promotion of a scientifico-scriptural interpretation of the sacred terrain. That this was the case is due in no small part to the bibliographic inspiration with

74. Frederic Church, *Cotopaxi*, 1862, Detroit Institute of Arts

which he provided himself. Church's extraordinary library (still virtually intact at his home, Olana) stands as a testament not only to his struggle with the religious ramifications of post-Darwinian science, but also to his willingness to turn to the Holy Land for a way out of his dilemma.

As Stephen Jay Gould pointed out, it is as telling to note which scientific books Church did *not* have as it is to list those he did, in fact, possess.[18] Although Charles Darwin is represented by several volumes (including Allen Grant's biography of the scientist), his *Origin of Species* and *Descent of Man* are notably missing from the library. It is as though the relentlessly undirected, numbingly long process of change that Darwin described was too painful for the artist to contemplate in his own home. It must have appeared to destroy his ideal world view, which had been derived from the writings of the natural philosopher Alexander von Humboldt, a view that embodied a prearranged union of science, religion, nature, and art. It was a union based above all on an underlying belief in the reassuring principle of "design."

Instead, Church surrounded himself with scientific treatises that were firmly grounded in Protestant spirituality (or, alternatively, spiritual tracts suffused with an optimistic scientism). Books such as Horace Bushnell's *Sermons for the New Life* and James McCosh and George Dickie's *Typical Forms and Special Ends in Creation*, for example, confidently sought God in natural history and the stories of the Bible in the crust of the earth. Cunningham Geikie's *Hours with the Bible; or, The Scriptures in the Light of Modern Discovery and Knowledge* also had relevance for the artist. His copy at Olana has this passage conspicuously marked: "Nothing can be more certain

than that the truths proclaimed, on sufficient evidence, in nature, are as much a revelation, in their sphere, of the ways of God, as the higher disclosures of the Bible."[19]

In addition to these general works, Church's library was rich in volumes that specifically addressed the regions of Palestine and Syria. By the end of his life, he had amassed some forty Middle Eastern guides and descriptive accounts. Many of these showcased the empirical method of biblical archaeology pioneered by Robinson in 1838 (or often, a less rigorous, "popular" equivalent of it). Among them are William C. Prime's *Tent Life in the Holy Land*, W. H. Bartlett's *Jerusalem Revisited*, and Arthur Penrhyn Stanley's *Sinai and Palestine in Connection with Their History*. Church's Petra diary indicates that he was also familiar with other standard books on the subject, such as J. T. Barclay's *City of the Great King*, which the artist specifically cited. There is much in these volumes that must have appealed to him: their search for historical continuity running from Genesis to the present, their Protestant bias against Catholic-venerated sites, and their reliance on landscape as the ultimate trustworthy "witness." Most of all, though, they were attempting to find a half-way point between modern faith and modern science, and Church was probably sympathetic to the notion that, like the artist, they were not always able to reconcile the two.

Perhaps because he needed time to assess his own reactions to the Middle East, Church did not immediately begin any large views of scripturally significant sites. Almost as soon as he arrived in Beirut, however, he set up a "painting room" in his rented house, and during the course of his stay he applied himself to several smaller works. It might be expected that as he brought back dozens of "Syrian" sketches from his outdoor ramblings he would begin to transfer them to his easel, but in fact the first painting he commenced was a South American subject, a commission for an English patron. This is less surprising than it would first appear, for the artist had earlier demonstrated a similar propensity to work with familiar subject matter while still digesting newer impressions. After returning from his first South American trip in 1853, for example, he had occupied himself primarily with North American scenes, and upon completing his voyage to view icebergs off Newfoundland, the first picture he painted was tropical.[20]

By the end of his Middle Eastern sojourn, however, he appears to have become sufficiently acclimated to his surroundings to begin a "3 footer" with a local subject.[21] The man behind this commission was a New York lawyer and historian, Edward Floyd de Lancey, whom Church had met earlier on the Eastern trip. De Lancey wrote to his new acquaintance in April, when Church was in Damascus, and placed an order for a fifteen-hundred-dollar picture "suited to a modest man's house," for as he admitted, "I am not 'a collector' and aspire to no 'gallery.'" His motivation was of a more personal and religious bent (de Lancey was the son of a well-known Episcopal bishop), as he went on to explain: "Subject and size I would wish to leave entirely to yourself, only asking that the former be of an *oriental* character—as a memento of my visit to these ancient and sacred lands."[22]

75. Frederic Church, *Ruins at Baalbek*, 1868, private collection

De Lancey's painting was completed in Rome the following November and sent on to his agent in London. It can be identified as a work now known (probably incorrectly) as *Ruins at Baalbek* (fig. 75).[23] As an initial attempt to flesh out a type of subject completely new to Church, the painting exhibits a surprising number of pictorial features that would be used again and again by the artist. He seems to have hit immediately on some favorite motifs: a small but conspicuous Arab figure, a herd of goats, and several toppled column-cylinders juxtaposed with other standing shafts, a lone group connected by a segment of broken entablature and silhouetted against the sky. What is perhaps most unexpected is the unusual haziness of the background, a misty range of topographic form utterly lacking in Church's habitual attention to mountain detail. A possible explanation for the change in approach is found in a letter to Osborn—written while *Ruins at Baalbek* was yet unfinished—in which the artist made this pronouncement: "Syrian subjects in the main must be distinguished by paucity of detail so far as landscape is concerned. The sentiment of them should be highly poetical and with a tone of sadness." To his patron, he confided that *Ruins at Baalbek* possessed, in fact, "more sentiment" than any other work he had yet painted.[24]

At Church's request, de Lancey (certainly one of his most accommodating patrons, if one can judge from the correspondence) agreed to allow his painting to be shown in New York. No matter how enthusiastic Church might have been about

76. Frederic Church, *Anti-Lebanon*, 1869, private collection

Ruins at Baalbek, though, it was a work that was already sold and thus not in need of great publicity. It was never promoted, therefore, as aggressively as Church's next Syrian three-footer, *Anti-Lebanon* (fig. 76), a painting exhibited in the United States on four different occasions within a year of its arrival.[25] Although he ultimately sold the canvas to a Chicagoan, J. M. Walker, who was so pleased with it that he later purchased more work from Church, *Anti-Lebanon* initially caused the artist no small amount of distress when he and another prospective patron found that they had divergent views on how best to paint Middle Eastern scenes.

The details of the controversy were reported by Church in a series of letters to Osborn, for his friend had been instrumental in putting the patron, an Englishman named Cunningham Borthwick, in touch with the artist.[26] Borthwick was initially sent the small South American scene painted in Beirut, but in September 1868, when Church was in Italy, he was informed that the Englishman did not care for the work and wanted a Middle Eastern view. To Osborn Church confided, "He [Borthwick] speaks as if he wanted a picture like one of Frere's. I have nothing to do with Frere's Egyptian scenes—I can only paint my own subjects." The following January, he was still working on the picture, but not without worries: "I confess that I am much puzzled by his bringing up Edward Frere's works as examples of what he likes. My pictures must necessarily be in every respect different from these."[27] In the end, Borthwick rejected the second painting as well, and *Anti-Lebanon* was sent on to New York.

These emphatic comments on the work of another artist are revealing coming

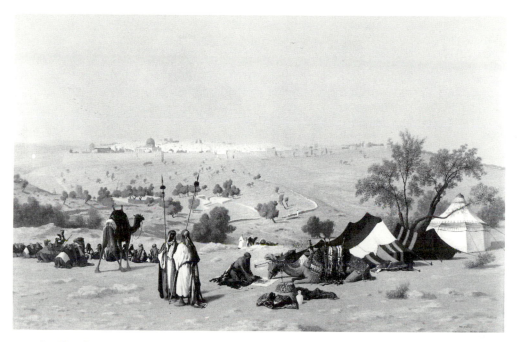

77. Théodore Frère, *Jerusalem, View from the Valley of Jehoshaphat*, 1881, Metropolitan Museum of Art

from the normally tight-lipped Church, who over the course of a long career had little to say about his own or other people's art. He mistakenly referred to Edouard Frère in his letter, but the painter in question was actually his brother, Théodore Frère, a French artist known for Orientalist genre and landscape subjects. From the early 1860s, Frère's work was promoted in the United States by the dealer George Lucas. This was a period when American artists were becoming increasingly vocal about being displaced in their own market by foreign painters, but Church's hostile reaction can probably be ascribed to more than a knee-jerk feeling of nationalist competitiveness.[28]

Many of Frère's Egyptian scenes are small panel paintings depicting close-up incidents of genre. The color is usually bright, even, and matte, without the darker, richer, golden tonalities and occasional sparkle of impasto that Church gave to his small Syrian works—paintings that, despite the usual Arab figures, could never be mistaken for genre. Even when Frère approached Church's panoramic landscape style, as in his *Jerusalem, View from the Valley of Jehoshaphat* (fig. 77), the result is flatly descriptive and nonchalant, without the ideologically passionate cues that characterize Church's own view of the city (pl. 5). In his larger Holy Land works, Church provides his spectators with guidance and direction and seems to turn and manipulate them until they are forced into seeing what he sees and feeling what he feels. Although his small generic works do not have the powerful content of specific subjects such as the city of Jerusalem, they share in the strong feeling of "sentiment" that Church claimed to bring to them. To a degree, this sentiment first became

78. Frederic Church, *Classical Ruins, Syria*, 1868, Cooper-Hewitt Museum

apparent in his work in the Holy Land. Critics saw it as a change toward richer, resonant color, a more ruminant stroke, and an ambiguous nostalgia—a sense of extratemporal longing.

It may seem strange to discuss Church, an artist usually celebrated for a clinician's approach to nature, in terms of his allusive poeticism, but that is exactly the way works such as *Anti-Lebanon* were received. Writing from New York, a correspondent for the *Chicago Tribune* called it "a scene so lonely and so sad, that but for the glow of its evening sky, 'twould have called no color from the palette, save sombre grays; and no emotion beyond sighs." *Anti-Lebanon* seemed to induce an unfocused mental state in the critic, prompting nostalgic dreams of "never to be recalled departures." Yet the rapturous account also took more particular notice of a specific and significant compositional element: "the three crumbling columns that overlook the plain."[29]

Seen previously in *Ruins at Baalbek*, this piece of architectural shorthand became something of a leitmotif for Church; he used it in varying formats in at least seven finished compositions. Several times during his trip, he made studies of poignantly isolated column rows, notably in the rapid and brushy oil sketch that provided the compositional germ for *Anti-Lebanon* (fig. 78). Here, the last remaining bit of architecture appears miraculously solid and stable, surrounded by a flurry of long, wandering strokes sliding across the contours of the hills and by quick hatch marks, jostling to form the faceted, agitated heap of stones in the foreground. Within this visual tumult and disintegration, the columns seem like a small grid of

79. A. de Jorio, *Present State of the
Temple of Serapis at Pozzuoli*, 1830

permanence—iconic, frontal, and glowing. They defy the vicissitudes of time while
nevertheless invoking a familiar, readable past, still contiguous with the present.

It was not unusual in the nineteenth century for erect columns to be compared to
standing trees, and toppled column shafts to fallen trunks; Thomas Cole's poem
"The Lament of the Forest" is only one salient example. Interpreters of Church's
paintings have drawn this parallel as well, and in examining his depictions of trees,
have pointed out their frequent appearance in prominent clusters of three, a group-
ing that, depending on the type of tree and on the painting (for example, *To the
Memory of Cole* [1848, Des Moines Women's Club], *Heart of the Andes* [fig. 69], and
Twilight in the Wilderness [1860, Cleveland Museum of Art]), has varying symbolic
significance. Church's fascination with sets of three columns can perhaps be traced to
these earlier uses of suggestive trios.[30]

The erect column, as Angela Miller has noted, was also a recognized symbol of the
classical roots of the American republican structure of government, and of the sus-
taining, masculine strength that preserved it. Yet despite such associations, Church's
use of this architectural fragment was probably closer to that of Charles Lyell, who
reproduced an engraving of three columns of the Temple of Serapis at Pozzuoli as the
frontispiece of his *Principles of Geology* of 1830 (fig. 79). This illustration of the

columns was included in the text, according to Ellwood Parry, because of their "usefulness as a record or calendar of change on the earth's surface."[31]

Like Lyell, Church did not deny change; he simply sought to keep it within reasonable bounds. This desire explains his newfound attraction to the human relics of the Holy Land. Ruins provided a visual lesson concerning the final omnipotence of God and nature, but it was a lesson that was centered on and told through the story of humanity. His own identification with the durable stones of previous civilizations becomes clear in *Anti-Lebanon*, where a huge chunk of corbeled cornice, out of scale with the rest of the painting and in considerably sharper focus, is highlighted in the lower left corner. This overwhelming, tangible mass, unexpectedly lifted into the composition from another oil sketch taken at Baalbek, is where Church chose to inscribe his signature, autographically conjoining himself with the reassuring remnants.[32] His onomastic identification with ruins is, in fact, remarkably consistent. Many of the Mediterranean paintings are signed on some type of architectural fragment in the foreground (sometimes mimicking carving, so as to seem part of the stone itself), though few examples are as prominent as that of *Anti-Lebanon*.

For Church, *Ruins at Baalbek* and *Anti-Lebanon* were personally expressive in a way relatively new to his painting, even if the general subject of columnar ruins was, by the late 1860s, a familiar standby in landscape art. (Church's pair, for example, is quite similar to several of Turner's Roman views.) The dreamy indeterminateness of these works allowed the artist a gradual initiation into Middle Eastern themes, without the rigor needed for depictions of the actualities of specific sites. As the correspondence and reviews demonstrate, however, this did not prevent them from also being appreciated by owners and critics for their significant allusions to the sacredness of the Holy Land. Such a connection would be made much more directly, though, in Church's next project, *Damascus from the Heights of Salchiyeh* (1869, destroyed).[33]

Church and his family delighted in the beauties of Beirut, but when it came to choosing an ancient city for the subject of a large painting, he probably discounted his temporary home on the Mediterranean coast because of its principal drawback: Beirut is not mentioned in the Bible. Damascus, on the other hand, appears in both the Old and New Testaments, and plays an important role in the story of Saul/Paul. The city, moreover, had received unwonted notoriety several years earlier, when thousands of Christians were reportedly massacred by Turks. Nevertheless, lingering fears seemed to have no effect on Western visitors. As Church reported to Osborn, "Every steamer brings a troop of Americans who troop off to Damascus."[34]

One of these Americans was Samuel Clemens, whose trip to the Holy Land preceded Church's by a year. In *Innocents Abroad*, he discusses Damascus at some length, paying special attention to one important aspect: Damascus was popularly thought to be the oldest city in the world. It thus could be seen as a kind of barometer of the centuries, having existed as a witness throughout almost all measured time. Clemens wrote of Damascus: "She saw the Israelitish empire exalted, and she saw it annihilated. She saw Greece rise, and flourish two thousand years, and die. In her old age she saw Rome built, she saw it overshadow the world with its power; she saw it

80. Frederic Church, *View from the Mountains toward Damascus, Syria*, 1868, Cooper-Hewitt Museum

perish. . . . Damascus has seen all that has ever occurred on earth, and still she lives." These last words in particular would have been significant for Church. Here, before his eyes, was a living metropolitan relic of nearly all that he believed had transpired in history. Its material presence allowed for an unbroken flow of demarcated time, to which he could consider himself connected. As Clemens reported, "Here you feel all the time just as if you were living about the year 1200 before Christ—or back to the patriarchs—or forward to the New Era."[35]

The Churches went to Damascus in April 1868. Although they spent several weeks in and around the city, they were most impressed by their first view of it, from the top of the bare rock mountains surrounding its lush valley. The artist wrote to a friend in Philadelphia: "The view of Damascus from an adjoining mountain is strangely beautiful. The contrast between the dry, desolate mountains, treeless and verdureless, of an arid, sandy color, and the dazzlingly green plain, in which rises the city, is remarkable."[36] The luxuriant, oasislike quality of the valley undoubtedly took on added religious significance because Damascus was traditionally thought to occupy the site of the Garden of Eden.

Church made good use of the laws of contrast in *Damascus*, as existing drawings and oil studies make clear (fig. 80). Using the rising cliffs on either side as a shallow, sloping frame focusing inward on the main area of interest, he appears to have set the dazzling, faraway valley within a blazing pool of light, revealing scattered canals and gleaming white buildings below. An idea of the appearance of the composition may perhaps be found in a painting, also titled *Damascus* (fig. 81), by Andrew Melrose, a little-known artist who, on several occasions, produced variations of major works by celebrated American painters.[37]

Church may have struggled with his own painting, for it took five months to complete in Rome, a period much longer than he had originally anticipated—

81. Andrew Melrose, *Damascus*, n.d., private collection

perhaps a result of his simultaneous work on *Anti-Lebanon* and other Italian projects. By April 1869, however, the picture was on its way to London, where the dealer L. M. McLean was anxious to show it. *Damascus* opened in June, with an accompanying printed flier. The English reception of his first large work from the Holy Land proved extremely enthusiastic, albeit in occasionally contradictory ways.

In Rome during the preceding January, the visiting poet Henry Wadsworth Longfellow had called the emerging painting "highly poetical," and six months later, London reviewers wrote their assessments using similar adjectives. The account in the *London Morning Post* proclaimed Church "the most imaginative landscape artist since Gaspar Poussin—Turner alone excepted." However, in beauty, and especially coloring, he had surpassed even Turner (who, it was explained, was prone in his Venetian works to "loading," "opacity," and "offensive whiteness").[38] Yet alongside these appreciative aesthetic comments were remarks of a more scientific bent, acknowledging the topographic value of the work as a careful geographical transcript. Despite the primary attention to the broader visionary qualities of landscape art, it seems the writer felt obliged to discuss the canvas in more empirical terms as well.

In the *Art Journal*, a similar dichotomy arose. Comparing *Damascus* to the paintings Church had previously exhibited in England, the critic wrote, "The artist has seen all that he ever saw before, but has felt much more deeply. . . . Mr. Church has produced works of much excellence, but '*Damascus*' far transcends any that have preceded it." This comment takes on considerable force when it is remembered that his *Niagara*, *Heart of the Andes*, *Icebergs*, *Cotopaxi*, *Chimborazo*, and *Aurora Borealis* had all appeared previously in London, some relatively recently. Yet once again, these

rhapsodic observations occurred alongside more "factual" considerations: "Above all," it was lamented with some fussiness, "we should have desired to know the time of the year intended to be represented." There was also an intimation in the review that it might have been preferable to make the sites of Christian importance a bit more "discernible."[39]

There is ample evidence that the ultimate owner of *Damascus*, William Walter Phelps, brother of the Churchs' missionary friend Ellen Dodge, shared the English writer's interest in the elaboration of Christian sites. Phelps publicly and materially expressed his support for the work of his sister and brother-in-law, visiting the Beirut college in the 1880s. What is more, he is recorded as having sentiments similar to Church's regarding the compatibility of science and faith and the fallacy of substituting one for the other. "Equally logical are the processes of science and religion," he wrote later in life. "The premises of the Christian are certainly as well founded in reason as those of science."[40]

Phelps, a graduate of Yale, was no doubt responsible for the several exhibitions of *Damascus* at that institution's School of Fine Arts in the early 1870s, but the primary showing of the painting was arranged by Church in late 1869 and early 1870 at Goupil's, his favorite New York gallery at the time. While the *New York Tribune* could only call it "disappointing," the New York correspondent of the *Chicago Tribune* hailed "the production of Church's pictures of the Orient and the Holy Land" as "the promised art event of the season." The Chicago paper devoted many paragraphs of impassioned description to the painting, but the most telling comments came later:

> If you have turned away disappointed from pictures that have vainly sought to spiritualize the canvas with some celestial vision, especially if you have seen Martin's time-labored and whimsical paintings of "The Resurrection," and "The Heavenly Glory," or Leutze's "Paradise and the Peri," or Cole's sacredly suggestive but unfinished "Cross and the World," or Innis' [*sic*] awkward endeavor to precipitate an iron-blue New Jerusalem, of Hottentotish architecture, upon an unprepared and unsuspecting New England farming land, you will prize very dearly Church's picture.[41]

Here, the writer cut immediately to the ideological core of Church's approach to the sacred terrain. It was apparently the belief of both critic and painter that the pure landscape of the Holy Land was already profoundly "spiritualized" and needed no additional narrative, real or imagined, to move it into the celestial realm. It is telling that this same reviewer, as if to reinforce the argument for a "straightforward" reading of the Palestinian topography, did not end his column with a review of *Damascus*, but went on to notice the recent appearance of a book by Nathaniel Clark Burt. Its title, not insignificantly, was *The Land and Its Story; or, The Sacred Historical Geography of Palestine.*

"Sacred geography," the rational study of the holy landscape with the aim of revealing the conformity of the physical and scriptural accounts, was to assume even greater importance in Church's next major undertaking, *Jerusalem from the Mount of*

Olives (pl. 5). In many ways, *Jerusalem* and *Damascus* were kindred paintings: large, panoramic depictions of specific Levantine cities, both completed in the two years following his trip. As early as 1868, Church's first patron for a Middle Eastern subject, de Lancey, suggested that the two projected views should be considered companion pictures, and there is evidence that the artist sought to exhibit them together.[42] In one important respect, they were unlike any major canvas previously executed by Church. While his "great pictures" of the 1850s and 1860s had been understood to be "compositions"—that is, studio arrangements of representative aspects of a given region or location—*Damascus* and, especially, *Jerusalem* were assumed to be unedited transcriptions of fixed, actual views. It was this aspect of *Jerusalem* that gave it its significance, but it was also the quality that made the painting problematic in the eyes of a number of critics.

In the course of his several trips to Jerusalem, Church allowed himself ample time to survey the old city. Although he dutifully visited the traditional sites within the walls, such as the Church of the Holy Sepulchre, his Protestant bias against these Catholic-tended shrines led him to conduct his own explorations in the surrounding areas outside the city gates. His diary tells of visits to the tombs and ruins that dot the hills on the city's perimeter, and he made a point of visiting "Solomon's Quarries," the underground stone caverns discovered by the Disciples of Christ missionary James T. Barclay. In this search for "old" Jerusalem, he found himself offended by the recent erection of the Russian and Prussian pilgrim hospices, the "appearance of newness" of which had "destroyed" his first view of the city.[43]

Two days after his arrival, however, Church had a rare opportunity to leave behind these modern impositions and view the most ancient parts of Jerusalem. Charles Warren, the head of the field operation of the British Palestine Exploration Fund, was in the habit of conducting visiting Westerners through his excavation shafts just outside the walls. Most of the travelers who eventually made this descent were from the United States. As Warren wrote in early 1868 at the time of Church's visit, "Jerusalem is beginning to fill with visitors, mostly from America, who are greatly interested in our work."[44] After meeting Warren, Church was lowered into the hundred-foot shaft, where he was impressed by the arched limestone passages and ashlar remains believed to be part of Herod's temple. This experience was undoubtedly the seed of his later involvement in the fund's sibling organization in the United States, the American Palestine Exploration Society.

The British fund had been created in 1865 with the goal of providing a detailed, accurate map of Palestine. By studying the archaeology, geography, and natural history of the Holy Land, its organizers hoped, once and for all, to establish the biblical sites through scientific means. Their efforts were closely followed in the United States, with financial support coming particularly from Chicago and New York. By 1871, the increasing interest was sufficient to found a separate American group, the Palestine Exploration Society. It was decided that the Americans would take responsibility for mapping the territory east of the Jordan, while the British would concentrate on the (much more biblically important) western portion of Palestine. Contributions were sought from across the United States, and two American expeditions were sent out in the mid-1870s.[45]

82. Detail of plate 5

The "Members" of the American Palestine Exploration Society (its board of directors) consisted of fifty distinguished American men: ministers, missionaries, industrial giants, explorers—and one artist, Frederic Church.[46] It would be difficult to overestimate the significance of Church's involvement with this organization; it is perhaps the most concrete tie known to exist between the acquisitive, ideologically charged enterprise of Palestinian exploration and the painted depictions of its landscape. In the publications of the society, covert and overt appeals were repeatedly made to racist, imperialist, or nationalist sentiments. It was common knowledge, as Church's outspoken friend Thomas G. Appleton recognized, that the maps created by the British and American archaeologists, for example, could later be used for a Western conquest of Ottoman territories.

For the most part, though, a more palatable face was put forward, with the official rhetoric couched entirely in the language of faith. The chairman of the society was unequivocal in describing its work: "Its supreme importance is for the illustration and defense of the Bible. Modern skepticism assails the Bible at the point of reality, the question of fact. Hence whatever goes to verify the Bible history as real, in time, place, and circumstances, is a refutation of unbelief." These words were written at approximately the same time that *Jerusalem* was on view in New York, and although the painting is much more than a simple answer to a call to arms against religious doubt, it is easy to imagine Church's meticulous canvas (fig. 82) as just the kind of illustration of "the Bible as a Book of realities" that the society would have welcomed.[47]

By choosing his vantage point high on the Mount of Olives, looking down on the walled city, Church was following the advice of several of the biblical geographers whose books he owned. They made the point that Olivet was an authentically "safe" haven from the newness of Ottoman Jerusalem and the suspected charlatanry of the non-Protestant churches. Unlike the sites within the city walls, the untainted mount had not been covered by centuries of building and refuse; it was the one place where a pilgrim could be certain that Christ had actually walked. Stanley wrote, "It is useless to seek for traces of His presence in the streets of the since ten times captured city. It is impossible not to find them in the free space of the Mount of Olives."[48] Such thoughts apparently inspired the Churches to leave their hotel for a night and camp on Olivet, where, according to Isabel Church, they "read appropriate portions of the New Testament." Her reflections on the Mount parallel Stanley's: "And as you wind your way thru the *very* dirty . . . streets you are still disappointed[,] but from Olivet—at sunset—all your expectations are realized and Jerusalem is Beautiful."[49]

If the number of studies produced is any indication, Church would have seconded his wife's preference of the Mount of Olives to the rest of Jerusalem. Despite a streak of bad weather, he spent much of his time sketching on the mount, and there are extant a number of drawings and oil studies taken from Olivet's heights. With this portfolio in hand, and some additional photographs he purchased, he was confident of having secured "all material sufficient for an elaborate view of Jerusalem."[50] Perhaps because it already had a buyer, however, the Damascus canvas was given priority over his view of the holy city; it was not until his return to the United States that he was able to work in earnest on *Jerusalem*.

It took Church at least a year to paint *Jerusalem from the Mount of Olives*. That it required so many months to complete is not surprising, for during its genesis he was also preoccupied with a bout of family sickness, the birth of a son, and simultaneous work on at least four paintings: the large *Parthenon* (1871, Metropolitan Museum of Art) and a group of South American views. Throughout this period, though, Church was looking forward to his planned exhibition of *Jerusalem* at Goupil's (where *Damascus* had earlier been unveiled). As early as 1868, the proprietor of the gallery had written Church, encouraging him to execute a painting of the holy city, and during the spring season of 1871 it finally went on view.[51]

The practice of organizing a private exhibition for important new pictures was not new to Church; it had been more than a decade since any of his major paintings had debuted at the National Academy of Design alongside the work of his fellow artists. As a result, resentment was increasingly apparent among those who felt that the Academy's annuals were suffering from neglect by its senior members. Several years later, for example, Jervis McEntee wrote bitterly of Church: "He is an Academician. He does nothing for the Academy but criticise it. Won't accept any office, won't exhibit his pictures but each year while the Academy exhibition is going on brings out a picture at Goupil's. I wonder what policy he would call that. I am getting pretty sick of this sort of thing and hope he won't present me with an opportunity to say what I think of it."[52]

However much such sentiment was in the air in 1871, Church was probably still shocked by the stinging criticism he received from at least one writer on this count. The *New York Evening Mail* devoted almost a third of a substantial review of *Jerusalem* to a harsh chastisement of the artist for his "unholy leaven of self." Alluding to the religious subject matter of the painting, the critic charged, "Surely it must be difficult to others, as it is to us, to give the artist credit for true greatness of soul, who, over mindful of himself, over eager for the glorification to be obtained by special exhibition of this character, thus isolates himself and his work."[53] Such remarks were unusual, a rare public acknowledgment of the possibility of venal motives in placing images of the Holy Land before American viewers. They also underscore the critical bias against the "low" type of self-promotion that was still associated with panorama painters.

Surprisingly, after registering its complaints, the *Mail*'s review went on to offer perhaps the most favorable consideration of the painting that Church received. It termed *Jerusalem* "the best of his large canvases," elevating it specifically above *Heart of the Andes, Damascus,* and both large Niagara paintings. Almost universally, however, other critics dismissed the "artistic" qualities of the work—except to comment on the remarkable treatment of the sky—and concentrated on the "facts" of the image: "It presents an excellent topographic panorama of the site and surroundings of the Holy City, but has few of the merits which make a really fine work of art," opined *Appleton's Journal.* A year later, the *Hartford Evening Post* found it full of "intellectual vigor," but added, "It does not address itself to the imagination or sympathies of the beholder. It is cold, logical, true. A mathematical proposition in art, rationally solved."[54]

While the critical consensus found aesthetic fault with what the *New York Tribune* called Church's "painfully elaborated" picture, the same writers recognized that this was exactly the quality that drew the crowds. The *New York World* made it plain that "the interest evinced by the throngs of visitors to the gallery is in the topographic details rather than in the creative wholeness of the work." This popular phenomenon was tied to Warren's timely archaeological work in the *New York Times* review of the painting: "At no period during many past centuries has greater interest been felt in the cities of the East, especially of Jerusalem, than at present, when as is believed, the secrets hidden beneath its soil for near upon 2,000 years are about to be disclosed, and we of this later generation may, thanks to the researches of Lieut. WARREN, be able to behold the very spots made sacred by our Lord's travail and crucifixion." Acceptance of the connection of Church's *Jerusalem* to the contemporary Protestant surveys of Palestinian lands even seemed to affect the language used to describe the canvas: "It is, in a certain sense, a map of Jerusalem and its suburbs," observed the *New York Tribune.* "The eye is at first confused and misled. It must go roving about and learning its lesson, like an engineer officer reconnoitering a difficult field."[55]

The vast scope of the painting (itself a kind of personal expedition report) made this "reconnoitering" process a slow one; the scene was not easily comprehensible at first glance. Viewers were first required to negotiate twisting paths, a myriad of rich

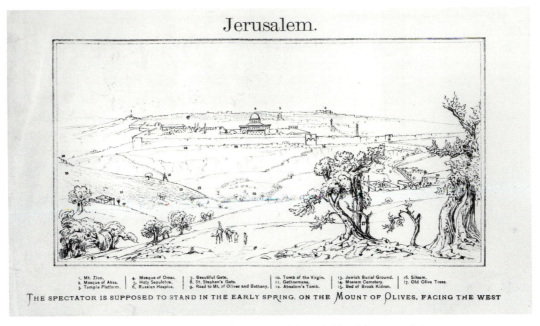

Jerusalem.

1. Mt. Zion. 4. Mosque of Omar. 7. Beautiful Gate. 10. Tomb of the Virgin. 13. Jewish Burial Ground. 16. Siloam.
2. Mosque of Aksa. 5. Holy Sepulchre. 8. St. Stephen's Gate. 11. Gethsemane. 14. Moslem Cemetery. 17. Old Olive Trees.
3. Temple Platform. 6. Russian Hospice. 9. Road to Mt. of Olives and Bethany. 12. Absalom's Tomb. 15. Bed of Brook Kidron.

THE SPECTATOR IS SUPPOSED TO STAND IN THE EARLY SPRING, ON THE MOUNT OF OLIVES, FACING THE WEST

83. Engraved key to Frederic Church, *Jerusalem*, 1870, Nelson-Atkins Museum of Art

textures, and abrupt changes in distance before arriving at a synthetic understanding of the work. As an aid, Church provided the Goupil's Gallery visitors with a printed key (fig. 83), its numbers designating such important sites as the Tomb of the Virgin, the Holy Sepulchre, and the Jewish temple platform. He even pointed out the distant Russian hospice on the horizon (no. 6); though he had resented its modern appearance, his sense of fidelity to the view did not allow him to edit its darkened silhouette.

The vista that the artist laid before his viewers is an impressive one. As with *Damascus*, the point of view is from above the city, providing a reassuring visual command of the scene. Church takes possession of the space, dominating, organizing, and clarifying it, seemingly paving the city across the measured, flat hilltop as if to display it with maximum clarity above the overly dark Valley of Jehoshaphat. The work's intricacy of detail is immediately apparent, although the paint application is surprisingly thin, with the canvas weave barely covered through such translucent passages as the walled Garden of Gethsemane in the shadowed right middle ground. In addition, there are areas of relatively unrestrained brushwork. The Jewish cemetery, for example, seemingly shimmering on Olivet's left flank, is largely composed of single, quick dashes of white paint, each stroke approximating an individual tombstone.

The view had more than purely formal interest, however. Isabel Church's speculation in her journal that Christ had taken "those very paths and looked upon those same lovely views" was shared by others who had experienced the sight of Jerusalem

from the Mount of Olives. One review of the painting drew attention to the foreground path, "down which we may well permit ourselves to fancy the Saviour passed on his first entry into Jerusalem."[56] In fact, it was often pointed out in travel volumes that Christ would have seen this exact springtime view each day near the end of his life as he rounded the ridge on his morning walk from his lodgings in the town of Bethany to Jerusalem. At the bottom of the key to *Jerusalem* was printed: "The Spectator is supposed to stand in the early spring, on the Mount of Olives, facing the West." The American viewer was thus invited to enter the painting and follow in the footsteps of Christ, beholding the "same" vision of the ancient landscape and walled city.

The need for the engraved key stemmed from the special character of *Jerusalem*, so different from Church's other major works. The artist no doubt realized that programmatically, his painting was not easily readable; his landscape, that is, did not rely on a few dominant, clearly emphasized forms, and its most significant compositional elements were tiny and likely to be missed by the casual viewer. In *Jerusalem*, then, light becomes the principal effect, breaking through the great cloud mass to guide the spectator to the warmly illuminated temple platform and the spotlighted promontory of Olivet. With their surroundings remaining in shadow, these two pools of golden sunlight encourage the formation of a personal link between the viewer in the foreground and the most ancient section of the old city across the valley.

An even greater bond is forged, however, when the radiance of the sun at the top of the canvas is added to this pair of highlighted areas, a dramatic, heavenly effect carefully studied in the artist's plein-air sketches. The glowing foreground is thus matched above the bisecting line of the city by a corresponding burst of warm, aerial luminescence. In the flat plane of the finished canvas, the result is read as a connecting axis of light, an *axis mundi* creating Mircea Eliade's important "irruption" at the center, with its consequent aura of sacred space. Indeed, the introduction of a vertical element is crucial for Church's rapturous effect of transcendence, just as the lack thereof was the defining feature of Edward Troye's sullen *Dead Sea*. Its location in Jerusalem accords well with the medieval idea of the holy city as the navel of the world, and more specifically with the ninth-century theologian Rodolph of Fulda's notion of the *universalis columna*, or "column of the universe," passing through that navel—an architectural image, as we have seen, with its own interest for Church.

This refulgent shaft at the center of *Jerusalem* forms a luminous "break in plane" in an otherwise uninterrupted horizon, a connecting of the celestial and the terrestrial. Viewers standing before the huge painting experience a "lift" that could almost be described as physical—the very structure of the image seems to induce an ascendant state. In this it could not form a greater contrast to James Fairman's many images of the same city, where spectators rarely find themselves swept up in such a divine and miraculous unfolding. Fairman is fixed and controlled; Church is engaging and interactive. Church gives his viewers more, but also assumes that they will be able to make more of it. In words used by Henry Tuckerman to describe another

painting by the artist, the city before them "beams with glory like a sublime psalm of light."[57]

As is often the case with Church, the entire landscape is encoded with formal cues—"dialectically charged spots," to use Ann Bermingham's suggestive terminology—that are designed to reinforce and support the primary visual statement.[58] The artist's representational energies intensify in the center of the canvas, for example, where detail becomes almost unbearably insistent (see fig. 82). Just as the holy light dissipates at the painting's edges, this need to communicate through significantly emphasized minutiae becomes centrifugally less obsessive at the margins. Yet the more broadly painted peripheral areas are no less carefully arranged to underscore the brilliant central effect. In the sky at left, the clouds, light breaking at their edges, appear to roll back off the city of their own volition. Like a curtain being pulled away, they help form the image of an opening, a revelation in process. On the opposite side of the canvas, anthropomorphized olive trees also participate in this presentation. A single smaller tree, in particular, seems to turn and regard the illuminated spectacle, its torsolike trunk bent in acknowledgment and its branches gesturing.

That Church identified with these stately, aged behemoths (the largest forms in the entire composition), rather than with the tiny Arab figures who converse among themselves and fail to exhibit the same degree of awareness as their arboreal neighbors, is indicated by his signature, inscribed on the face of the hillside in the midst of the dominating grove of olives. Like the surrounding trees, the artist has become rooted in the authentic soil. Perhaps as a result of this associational communion with the mount, its illuminated plateau of land appears to rise up assertively in the foreground, tipping toward the viewer as if to corroborate scripture solely by virtue of its material presence.

Every part of the canvas, in short, performs its assigned role in bringing the viewer to a private experience of spiritual redemption. It is important to remember that this personal engagement with the image is in direct contrast to the powerfully nationalistic iconography of his American-themed canvases of previous decades, where a more collective, public identity was stressed. That this shared sense of "nature's nation" should be on the wane in the years following the devastation of the Civil War is not surprising. In its place, Church now celebrated the wonders of human agency—through both the material witness of the stones of Jerusalem and the individual pilgrim's epiphany before them.

In the end, though, despite the attention focused on the city, Jerusalem seems strangely distant and far away. It is an effect that probably is inevitable, given the monumental scale of the work. If Jerusalem seems removed, quiet, and passive, however, it is because it is simply fulfilling its role as the physical evidence of larger phenomena, such as the heavenly proclamation of cloud and sun above it. This elevated meteorological drama sets the composition in motion, uniting its disparate parts with strategic mounds of cumuli and shafts of light. It leaves an impression of a city and countryside being acted upon below, and there is little question of the identity of the actor.

While Church was in the early stages of work on *Jerusalem*, a much smaller picture had been quietly on view in New York, first at the Century Club and then at Goupil's Gallery. In many ways, this painting, *Mountains of Edom* (fig. 84), was the antithesis of the great public spectacle of *Jerusalem* that it preceded. Comparatively empty, lacking in historical ruins, and of a somewhat indeterminate location, it was painted without a patron's commission—a personal work that appears to have been executed with little concern for the market. It shares this characteristic with a larger, thematically related canvas, *El Khasné, Petra* (pl. 7). Both paintings were likely conceived as fond recollections of one of the most remarkable features of Church's trip to the Holy Land, his trek to Petra.

As he explained to his colleague Erastus Dow Palmer, Petra, an ancient secluded city of tombs and caves cut from living rock, was identified as biblical Edom (or Idumea), "the inheritance of Esau," "the object of terrible prophecies," and "the strangest scene of desolation I ever saw." For Church, however, the long camel ride in the desert and the gradual approach to the startling mountains that rise up around Petra were as impressive as the ancient city itself. Responding to the flat, barren plain, so different from any landscape he had previously experienced, he described his surroundings in a diary entry as "a terrible waste, stony and bleak and very thinly scattered with tufts of vegetation." Yet its bare sterility seemed to appeal to him;

84. Frederic Church, *Mountains of Edom*, 1870, private collection

"The desert of Arabia impressed me much," he admitted to a friend after returning from Edom. It was the range of mountains, however, that drew the strongest and most sublime language from the artist, prompting exclamations of amazement in his letter to Palmer about the "terrible crags," "yawning chasms," and "jagged black rocks piled up in awful grandeur."[59]

This transition from the rock-strewn horizontal wasteland of southern Judea to the looming vertical peaks of Idumea became the principal focus of *Mountains of Edom*. The only additional elements are several Bedouin figures and their camels moving forward across the plain. Their mode of transport evokes Church's own journey through the region, the sole episode of his trip that he took the time to describe extensively in his letters and diary. His writings appear to reflect a need to advertise the fact of his unusual trek, just as his signature, moved into the center from its accustomed corner position, proclaims his former presence on the nearly empty plain, now occupied by only a few Arabs. By leaving his mark so conspicuously, though, he was also identifying with the Hebrew nation, for as he noted of this level expanse of hard-packed earth in his diary, "Here passed the Israelites and were turned back." His thoughts the next day was also directed toward this association: "We read and discussed passages of Scripture which relate to Edom and to the wanderings of the Israelites—from the natural advantages of the ground where we are encamped and the fact that it lies before the easiest entrance to Petra we felt justified in supposing that the Israelites may have encamped just here." The combination of scriptural association and personal experience apparently led Church to place special value on the unusual *Mountains of Edom*, for on three separate occasions in letters to Osborn he called it "the best small picture I ever painted."[60] He demonstrated similar affection for the other token of his trip to Edom, *El Khasné, Petra*, the only large painting he never sold, a gift to his wife that remained at Olana.

El Khasné, Petra documents a striking personal experience, the emerging vision of the most impressive of the rock-cut edifices—known as El Khasné—from the mouth of the Sîk, a long, narrow passage with precipitous cliff walls rising hundreds of feet on either side. (This near-tunnel of rock was traditionally thought to be a cleft opened by the rod of Moses.) Through research conducted before arriving in the Middle East, Church had known of the celebrated Khasné, but his reading had done little to prepare him for its forceful appearance: "Imagine the effect of this shining temple after a long tramp through the narrow, gloomy gorge in front. Of course I was too astounded to do anything but stare at the temple for some time. When I came to my senses, I selected my view point—took my portfolio from the Arab who carried it, opened it and dashed at the subject with all fury."[61]

When, six years later, he presented his finished work to the public at the National Academy of Design annual exhibition, viewers were no less struck by the startling scene, so uncharacteristic of Church's landscapes.[62] Tantalizing in its fragmentariness, disarmingly planar, and lacking in conventional "escapes" for the eye, such as even a hint of sky, *El Khasné, Petra* surprised and confounded the critics. The *New York Times* wrote admiringly, "There are few artists who would have attempted to cover so large a canvas with such very simple elements, but Mr. Church has made the essay, and can have no reason to repent of his temerity." The *World*, however,

85. Frederic Church, *Two Bedouin*, 1868, Cooper-Hewitt Museum

criticized the painting's "easy effectiveness," dismissing *El Khasné* as a "'sensation' picture." The *Sun* matched the *World*'s critique, predicting that the "theatrical" painting would "add nothing to his extended reputation."[63]

El Khasné, Petra, though, was more than just a dazzling formal display. Replete with biblical associations, it was also interpreted by critics as a moralistic lesson, "a living bit of the old Scriptures" reminding viewers of the fate of the cave-dwelling, corrupted Edomites, whose destruction by God is recounted in chapter 49 of the Book of Jeremiah. As Frank DeHass—who, as a fellow participant in the American Palestine Exploration Society, had explored some of the same territory as Church— stated with confidence, "In the present desolate condition of Petra we see how literally the judgements of God denounced against it have been executed." Such sentiments led the *New York Herald* to write of Church and his painting, "It is perhaps well that we have some one to preach to us amid our feverish life the sermons that lie hidden in stones."[64]

According to the *Chicago Evening Journal*, this was the key to moving beyond the picture's overly plain design. "As the painting is studied with knowledge of the [scriptural] associations," the article asserted, "it fixes more and more the attention." The same high-minded reviewer nevertheless had some difficulty moving beyond the two small Arab figures in the lower left corner. Constructing an assumed and hyperbolic narrative, the author related how the "swarthy Bedouin, in picturesque costume, springs forward and raises his long gun to forbid all approach until his extortionate demands have been met, his companion in ruffianism crouching behind him." Indeed, nearly every commentary devoted its attention to these tiny figures, whose overall compositional role is, at first glance, quite minor (see fig. 85). As Arabs,

they were linked to the doomed Edomites—or even compared unfavorably to these decadent "ancestors": "This is . . . a type of the insignificant humanity which puerile as it seems when placed in proximity to these grand works of Nature, is still a type, if a poor one, of those who at least brought her ruggedness under subjection, and tore from her bosom this wondrous temple."[65]

Such racial and religious denigration served an important ideological end in the reception of Orientalist landscape painting. In the Holy Land, it was a strategy used years earlier by the first American writers to travel through the region. The novelist John William De Forest is a salient example. Musing on his memories of "lonely, forgotten old tombs," he defended his own interest in the ancient stones by remarking that "the half-savages, who wander and abide under their shadow, understand not their broken teachings of history, and have no sympathy for their solemn passion of desolateness."[66] The repeated public expression of sentiments of this type allowed Church's two staffage figures—and their analogues in countless similar Western images—to be used as an intellectual foil, their "ignorance" before the ruins contrasted with the often panoramic omniscience of the viewer of the painting.

Yet Church's composition is anything but panoramic, and it is probably this denial to his audience of the expected full view that forces the otherwise negligible Arab figures into the contentious narrative of the image. The long, claustrophobic Sîk inevitably induced a feeling of nervous vulnerability in Western travelers. Here was where they feared meeting the resident Arabs; here was where they also knew a sublime spectacle awaited them around the final turn. Indeed, the widespread accounts of local hostility and the tension induced by the threatening closure of the valley of Petra prompted some of the most scandalous recorded acts of violence by visiting Westerners, such as when the Philadelphia photographer Edward Wilson ordered his servants to shoot a Bedouin attempting to detain his party, leaving the dying man bound, bleeding, and unconscious at the roadside, a few dollars (stolen from another Arab prisoner) thrust in his hand as recompense.[67]

The structure of *El Khasné, Petra* replicates this state of anxiety and anticipation. The glowing temple offers itself as a kind of visual escape, the need to move forward to the light becoming all but irresistible. Yet just as this final goal seems attainable, viewers (at least those conditioned by the nineteenth-century Petra legends) find themselves challenged by the foreground figures. The desired projection and release into the freedom of the teasing distance is withheld, with the frustrated viewer confined to the dark, frictional space of the Sîk. The inherent analogy here of an unreachable sexual climax becomes even more meaningful when the character of the narrow tunnel as a contested, male proving ground is remembered. In this respect, and in others, *El Khasné, Petra* is a highly personal image, its constricted and intimate verticality demanding a much more solitary interaction than the expansive *Jerusalem.*[68]

Although Church's letters and diary amply demonstrate his own lack of sympathy for the indigenous residents of the valley he temporarily occupied, it is nevertheless unlikely that he would have professed as heightened a concern for the Arab figures as that of his newspaper critics. The great majority of his recorded comments lack such

bravado and refer only to the temple itself. He was fascinated by its "salmon," "clove," and "tea-rose" tints, and he repeatedly marveled at its "internal light" blazing forth from the envelope of black rocks. This optimistic effect of sudden, revealing illumination bursting upon the middle ground, in stark contrast to the shadowed areas before it, was important to many of his Holy Land works, including *Damascus*, *Jerusalem*, and *Mountains of Edom*.

Like these paintings, *El Khasné, Petra* can also be experienced as an opening, an ongoing revelation, rather than as a disputed and blocked route of escape. In this light, it becomes a somewhat differently charged emotional image, structured so as to seize the momentary process of understanding it and suspend that instant, never fully divulging itself to the viewer. As with so much in Church's art, the earth itself becomes the ultimate agent of this act of enlightenment. Through the convenient mountainous fissure, his audience is given its window to the biblical past, though the view will always remain partial and uncertain.

El Khasné, Petra marked an endpoint of sorts, for it was the last large Middle Eastern canvas executed by Church that depicted a specific site in the Holy Land. There are indications that by 1874 he had begun considering the Eastern material less as a separate category, with its distinctive subjects demanding a special mode of treatment, and more as an integrated part of his global landscape vision. In that year, he completed a pair of paintings for William Osborn, *Tropical Moonlight* and *Sunrise in Syria* (figs. 86–87), that set up a binary construction, a new interpretive framework for the Old and New Worlds.[69]

Tropical Moonlight clearly shows the effects of Church's work on the Petra painting, which had been finished several months earlier. Also a vertical composition (and thus atypical for the artist), it is similarly organized around a forceful "keyhole" view through a dark, enveloping *repoussoir*, leading to a glowing source of light beyond. His experience in the Middle East was evidently affecting his South American landscapes, and *Tropical Moonlight* serves as an early indication of the more elegiac equatorial mood that his later *Morning in the Tropics* (1877, National Gallery of Art) would epitomize. When coupled with its Syrian pendant, the changing attitude toward the New World in Osborn's picture becomes even more apparent. Church has allowed the sun to set on *Tropical Moonlight*. It is as though the previously celebrated vitality of lush jungle growth has dimmed in comparison to the bright orange, green, and blue hues that dominate in *Sunrise in Syria*; the spotlight has shifted. The familiar architectural unit of three-columns-plus-entablature now makes a soaring, almost heroic reappearance, and as if to lay even greater stress on this relic, Church depicts its structural members with the same uncomfortably high resolution that characterized the emphatic piece of cornice in the lower corner of the earlier *Anti-Lebanon*.[70]

In actuality, Church had already made an attempt to resolve the differing qualities seen in the two Osborn pictures with his large *Syria by the Sea* of 1873 (pl. 6). This work relates to the South American paintings as well, for like his earlier panoramic "machines," it brings together an assortment of "typical" vignettes for an artificial

86. Frederic Church, *Tropical Moonlight*, 1874, private collection

composition that in no way purports to represent an actual scene. Curiously, although this generalized pictorial method had been employed for years by Church—with critics commenting favorably on the benefits of the approach—there were always some objections when the liberty was taken with the Holy Land. Even at this late date in the waning era of the Hudson River school, the reviewer at *Appleton's* complained, "It is debated by amateurs whether it was a sound principle in art that prompted him in this picture to place imaginary ruins on a coast where we know there are no real ones, like those depicted." More astute was a writer in the *New York Daily Tribune*, who subtly shifted the critical focus from the final visual results to the motive behind them: "It represents no scene in nature, but shows how men of genius would group their hills and their ruins if history would give them the chance."[71]

87. Frederic Church, *Sunrise in Syria*, 1874, Kennedy Galleries

Church's groupings, his landscape manipulations in *Syria by the Sea*, are indeed crucial to an understanding of his reactionary attitude to the course of recent history, especially natural history. His own historical "moment" had occurred during the wildly successful decade leading up to his trip abroad, and in some respects it was to the pictorial formulae of those years that he now returned. Awkwardly bifurcated like his *Cotopaxi* (see fig. 74), and subject to the same potent, corrosive light boring through its center as *The Andes of Ecuador* (1855, Reynolda House), *Syria by the Sea* is celebratory, but reflective and mellow, tinged with a copper-plated nostalgia. Its deified source of illumination appears to dissolve matter much like one of Turner's sun disks, fusing with the surrounding forms as though regressing to the primal, miasmic state of the first day of Creation—or perhaps, moving forward to a final

transubstantiation. Here, the insistent tangibility of the center of his *Jerusalem* has essentially been replaced by a vaporous void. At right, an abstracted grouping of ruins—broken column rows, blind arches, tumbled walls—meanders haphazardly down the slope. Towering above this burned-out detritus is the strangely isolated Corinthian column. Overly large and seemingly unrelated to any surrounding structure, it is conceptualized, a massive, three-dimensional glyph of civilization providing the only energetic, confrontational element of the composition.

Almost as striking as the column, though, is the foreground of *Syria by the Sea*. Church paid unusual attention to the bottom edges of his Holy Land canvases; the rising, highlighted promontory of the Mount of Olives in *Jerusalem* is only one such example. This was not his customary practice, however. The most important paintings with New World subjects (see fig. 69) consistently adopt a disembodied, suspended viewpoint, with no apparent earthly foundation for the viewer.[72] In contrast, such works as *Jerusalem*, *Damascus*, and the smaller Syrian paintings were composed with a strong reliance on a solid, material foreground that serves conceptually to root the feet of the viewer. While spectators before *Cotopaxi* (see fig. 74), for example, are thrust forcefully into the picture's space, they are not made aware of how they have arrived at such a hovering, helicopter's-eye view. The Middle Eastern paintings provide a more gradual, knowable entrance into the scene, and the result is a reassuring sense of stability.

In *Syria by the Sea*, Church makes his assurances to viewers through the heap of solid matter pushed up to the picture plane. He seems intent here on piling as much petrological evidence in front of his scene as the composition can bear, even if it becomes, ironically, a visual impediment. It was a tendency he shared with photographers such as R. E. M. Bain (fig. 88), who similarly offered historically significant architectural refuse and durable, natural rock as a physical refutation of modern challenges to the chronological narrative of the Bible. Church, who owned an armchair made from the wood of the famous Charter Oak of his hometown, Hartford, was certainly sensitive to the associative "lessons" inherent in such natural relics.[73] His materialist focus privileged any tangible contact with objects invested with even a nebulous sense of pastness. Like the purchasers of Robert Morris's Holy Land cabinets, he became subject to the acquisitive need to obtain Palestinian realia. Still preserved at Olana is a barrel filled with dozens of rock specimens picked up during his travels in the Fertile Crescent. Many are individually wrapped and labeled, as though the very inscription—"Mt. Hor" or "Askelon" or "Solomon's Temple"—was enough to establish with certainty the existence and pedigree of these biblical places. For Church, the landmarks of the past could indeed speak to the present.

One of the most telling of the stone trophies brought back to Olana is a large piece of an antique column shaft, a synecdochic fragment of Church's favorite structural member—an architectural component that was, itself, emblematic of a greater and more meaningful whole. That component, the column, was assuming increasing prominence in such works as *Syria by the Sea*. Its appearance can be explained in part by a comment Church made late in his life: "If I were permitted to select from among all the landscapes I have ever seen, I should certainly choose for one of them

88. R. E. M. Bain, *Ruins of the Synagogue at Capernaum*, 1894, Library of Congress

'Desolation' the last of the five paintings by Cole entitled 'The Course of Empire.' . . . It is a striking picture, possessing as much poetic feeling as I ever saw in Landscape art." This veneration for Cole's *Desolation* (see fig. 5), with its formal and narrational culmination on the single column, is apparent in other Church works as well, such as his unlocated sketch entitled *A Composition* (fig. 89).[74]

Church's late focus on ruins indicates a certain shift in his attitude toward landscape and human history. There is some truth to Martin Christadler's remark that in the artist's Mediterranean views of the 1870s, "the synthesis of the naturalistic code and the religious code has finally fallen apart."[75] That all-important breach, though, had already been opened before Church arrived on Syrian shores. Rather than exemplifying the dissolution of his deistic synthesis, works such as *Syria by the Sea* demonstrate his final attempt to repair the breach. Church was becoming increasingly desperate, clinging to remnants of culture that, even more than the purely natural forms he had spent his life celebrating, seemed to guarantee an account of time inclusive of human achievement and divine direction. Their visible age told a story, affirming that although the earth was old, humanity was ancient, too. As Thomson had written, "Broken columns, and prostrate temples, and cities in ruin, must bear testimony to the inspiration of prophecy." Ruins appeared to partake of an eternal absolute, a temporal axis on which Church and his immutable world could safely turn. As late as the 1880s, when significant portions of the scientific community had

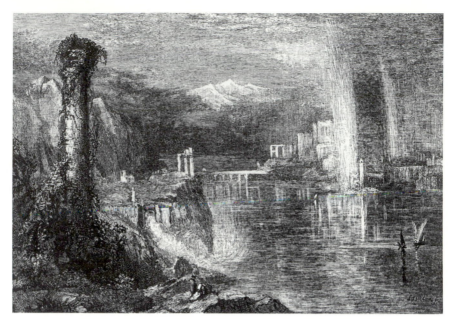

89. Engraving after Frederic Church, *A Composition*, 1879

already accepted the precepts of Darwinism, individuals within this fixed and lim-
ited orbit adamantly maintained that it had not been compromised. "Thus far, no
discovery has been made that conflicts with Revelation. These disentombed cities are
not composed of dead-walls, but *living* stones, witnessing to the truth of Scripture,"
declared archaeologist Frank DeHass in 1887.[76]

There are indications that Church was not so sure. Cole's *Desolation*, to which he
felt himself so powerfully drawn, was actually a canvas suffused with ambiguity.
Certainly it might be interpreted optimistically as the beginning of a cycle of re-
newal, with nature reclaiming the failed refuse of human civilization. Verdant ivy
takes possession of the abandoned column, for example, just as it does in *Syria by the
Sea*. The absence of human figures, however, calls this hopeful outcome into ques-
tion. The depopulation of Cole's ideal world also seems to have had an effect on his
pupil.

In a late reprise of his *Anti-Lebanon*, Church executed a similar composition (fig.
90) that changes the time depicted from day to dusk, lovingly bathing the repeated
three-column unit in the warm glow of the setting sun.[77] More important, perhaps,
it fails to include the human figures of the earlier canvas (see fig. 76). Like *Desola-
tion*,x it looks forward only to a deserted, twilit landscape of decay, unredeemed by a
new generation of inhabitants. Both works are in stark contrast to other, less melan-
cholic prognostications by American painters, such as Jasper Cropsey's idyllic *Spirit
of Peace* (fig. 91), with its carefree inhabitants dancing amid palm trees and ruined
chunks of masonry. Cropsey, in many ways a connecting individual—a kind of
intellectual and artistic suspension bridge, swaying and hanging dependently be-

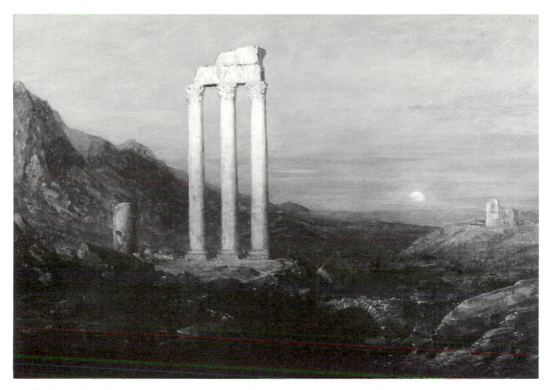

90. Frederic Church, *Moonrise in Greece*, 1889, Santa Barbara Museum of Art

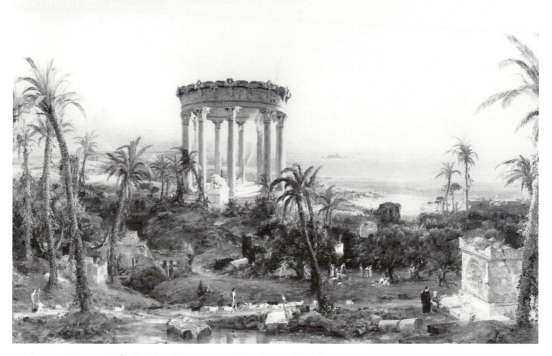

91. Jasper Cropsey, *The Spirit of Peace*, 1851, Woodmere Art Museum

tween the towering figures of Cole and Church—does not succumb here to the deeper ruminations of the other men, although he is obviously conversant with their themes. Unlike his colleagues, Cropsey painted during a period of intensified millennial fervor. His vision, as Gail Husch has pointed out, was one that looked forward prophetically to an untroubled future.[78] Thus his ruins, while no less battered than Church's, are repeopled, surrounded by thriving Arcadian (but also Christian) families who faithfully maintain burning altars within the temples and gesture knowingly toward reliefs holding the lessons of the past.

The *Course of Empire* made it clear, however, that ruins did not always offer themselves up as symbols of progress. As Church might have read in his copy of Bushnell's *Sermons for the New Life*, the shattered temples and cities of the past could be seen alternatively as a type for the final apocalyptic ruin warned of by Christ.[79] For Church, his favored column may have also had a darker side. Through its historical associations it could be consoling and familiar, offering durable proof of the existence of previous civilizations. But standing alone, untended by humans, it became pointless and irrelevant, a useless vestige that, with nothing to support, was left stripped of its initial raison d'être. Ridiculous and somewhat pitiable, it nevertheless continued to stand resolutely, surrounded by the decaying remains of the culture with which it had formerly been intimately bound.

For many commentators in the final decades of the nineteenth century, these last lines also aptly characterized Church's place within the evolving world of American culture. By his own admission, the science of his day had passed him by; "Would that science rested for ten years," he joked despairingly in 1883. He was also well aware that his artistic primacy in landscape had long since been supplanted by the hazy, evocative, and bucolic forms of the Barbizon-inspired painters; "Mr. Church feels that his country has not known his value," confided a visitor to Olana in 1889.[80]

In this light, *The Aegean Sea* (fig. 92), his final large-scale picture (also purchased by Osborn), can be seen as a last attempt to adapt to a New York art world that no longer knelt in astonishment before his yards of canvas. With this strikingly ideal work, Church went out in a burst of light. His double rainbow, seemingly burned into the picture surface, provides an impossible glow, illuminating the great expanse of sea and shore with a warm, palpable radiance. No longer restricted to a focus on the Holy Land, the painting united, as one critic wrote, various "interesting archaeological photographs" from all his Mediterranean stops: Petra, Baalbek, Constantinople, Athens—even the majestic olive trees of Jerusalem are set down in the foreground. In essence, he was reverting to his original Humboldtian vision of *Heart of the Andes*, providing a typified portrait of a region, rather than a more space-specific view of, say, Damascus or El Khasné. Such meticulous visual documents had passed from favor. Here, the stroke is relatively broad; detail is subordinated in order to celebrate a comforting melding of all that he had seen in the East. It was a parting stylistic transformation that succeeded in capturing his critics' hearts. *The Aegean Sea* was universally received as an unexpected, imaginative wonder, the most important picture of the season, a work that "may well hold its own by the side of some of the superb Italian canvases of Turner," as S. G. W. Benjamin predicted.[81]

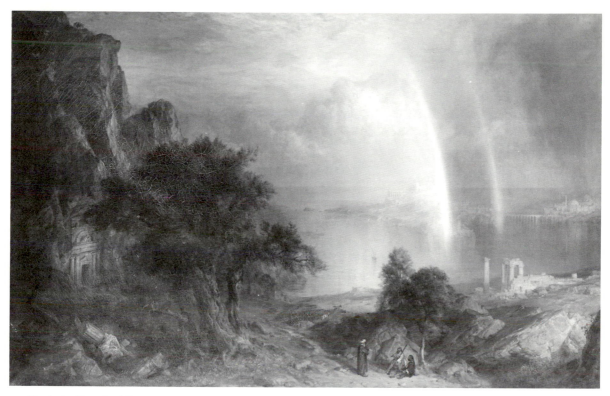

92. Frederic Church, *The Aegean Sea*, c. 1877, Metropolitan Museum of Art

Yet in the same essay, Benjamin made it clear that the painter's time had passed. Summarizing key elements of Church's art and the disintegrating school he typified, the critic saw his paintings as representing "the restless, unsatisfied genius of our people during this period, ever reaching out and beyond, and yearning, Venice-like, to draw to itself the spoils, the riches, the splendors, of the whole round globe."[82] Church's had indeed been an acquisitive art, but despite the virtual catalogue of the spoils of his Mediterranean trip that *The Aegean Sea* documents, it is difficult not to see it, and much of his late work, as "unsatisfied"; in light of his former devotion to accurate archaeological evidence, the almost promiscuous shuffling of ruins about the surface of Osborn's picture can only appear as something of a loss, an intellectual resignation.

Church was bowing out of the public light, and the late paintings related to *The Aegean Sea* (fig. 93), otherwise unaccountable for their flimsy staginess and Old Masterish patina, are part of his search for a more personal means of expression, far from the inhospitable exhibition halls of the National Academy of Design. Church's own Venice had become his remarkably eclectic home, Olana (fig. 94). This Hudson River fortress was also his Ecuador, his Jamaica, his Maine, and his Holy Land. Much like *The Aegean Sea*, the artist's home was a calculated compendium of auto-biographical artifacts and impressions.[83] Similarly decontextualized and divorced

93. Frederic Church, *Syria—Ruins by the Sea*, n.d., Reading Public Museum

94. Robert and Emily de Forest, *Court Hall, Olana*, 1884, Olana State Historic Site

from history, these aesthetic souvenirs were willfully reshaped into an interior land-
scape as fraught with the resonances of the past as any of his Mediterranean canvases.
Surrounded by carpets, furniture, natural curiosities, and thousands of drawings and
sketches from around the world, Church took his memories of the earth's riches and
beat a retreat. His decades of toil had provided him with the means of creating a
private, artificial universe, untouched by the distressing changes that had followed
the Civil War. By refusing to recognize and engage these changes, he made certain
that his own world view, emphatically endorsed by his paintings, would, if only for
himself, always remain intact.

Epilogue

Painters of the Holy Land, it would appear, had a clearly limited shelf life, particularly in the late nineteenth century. It is striking how many of the artists discussed here—Miner Kellogg, Frederic Church, James Fairman, even the panoramist John Banvard—seemed to have outlived their era in later life, their work unappreciated, the values of their formative years no longer paralleling those of the Gilded Age. Painted presentations of the Holy Land, one might conclude, could not respond to the increased cultural fragmentation and secularization of these late decades: the pervasive tendency to doubt one's faith, the crumbling of the consensual Protestant edifice that had formerly dominated civic matters, and the retreat of the world of art into an ideal realm that was at least nominally divorced from any notion of history or nationhood.

Technological developments also transformed the late nineteenth century, and here it is tempting to cast photography in the villain's role. As a kind of mechanical usurper, the camera could be seen as supplanting midcentury landscape painters by removing their major determinant of quality and success, faithfulness to nature, from the critical discourse. Holy Land imagery, however, had a set of needs peculiar to it. The heightened concern surrounding the identification and depiction of specific elements of the landscape and the irrepressible Protestant desire to manipulate such data into an unequivocal form of visual rhetoric seems to have extended the viability of a pronounced stylistic naturalism in Palestinian landscape painting. This is surely why Frederic Church's final frontier became the Middle East, the last canvas that could support his obsessive teleological labors. And, as we have seen, it was not so much the introduction of photography as the later development of cheap means of photomechanical reproduction that made the photograph the medium of choice for Palestinian views at the end of the century. These fundamental changes in the printing industry ushered in new forms of panoramic compendia, such as the encyclopedic volumes of the type exemplified by Bain's *Earthly Footsteps of the Man of Galilee.*

The assumption that it was either fin de siècle crassness or the invention of the halftone screen that sounded the death knell for painting in the Holy Land, however, is belied by the career of Henry Ossawa Tanner. At about the same time that James Fairman was making a futile effort at the end of his life to sell his view of Jerusalem

to the dealer William Macbeth, Tanner was discovering the associational richness of the sacred topography, an experience that would lead to a monumental series of biblical paintings as well as his later appellation, "Poet-Painter of Palestine."[1] In many ways, the preparation for Tanner's trip was at least as intensive as that of the typical traveling artist of the previous generation. Raised in the pious and intellectual household of his father, the African Methodist Episcopal bishop Benjamin Tucker Tanner (a prodigious scholar who read the Bible in its original Greek and Hebrew), he was well equipped to filter his observations and experiences through a profound understanding not only of scripture, but of the needs and demands of modern Christianity and aesthetics.

Tanner's paintings, as a result, are different from the transcriptive travelogues of the midcentury artists, despite the months he spent carefully touring Palestine in 1897 and 1898–99. He painted few pure landscapes of the Holy Land. Rather, he soaked up the qualities he found most moving in the terrain—its tragic emptiness, its majestic hugeness—and used them to provide his figural biblical canvases with authentic, emotionally resonant backdrops. Unlike his predecessors, Tanner did not dwell on the materiality of the existing landscape but instead used it to conjure images of the scriptural events he hoped to illustrate. Riding to Bethlehem on Christmas, he later recalled, "Dark clouds swept the moonlit skies and it took little imagination to close one's eyes to the flight of time and see in those hurrying travelers the crowds that hurried Bethlehemward on the memorable night of the Nativity, or to transpose the scene and see in each hurrying group a 'Flight into Egypt.'"[2]

Tanner's tendency in this recollection to move immediately from the natural impetus of the Nazarene sky to a recreated vision of a particular figural group from scripture is as characteristic of his generation's attitude toward religious art as the relaxed sense of geography that enabled him in the same passage to make the quick mental transposition from the Nativity to the Flight into Egypt. In the process, he retreats to an inner landscape only vaguely suggestive of topographic actualities. In such typical works as *The Good Shepherd* (fig. 95), figure and ground are fused into an undulating, tremulous exhalation of the spirit, richly composed of tractable, yielding paint rather than petrological fact. His glowing surface conveys an almost kinesthetic depth of feeling, eschewing prosaic description in favor of the expressive, loaded stroke. To a degree, this stylistic retreat from the specific was forced on the artist by the era in which he worked. It is thus a tribute to his convictions and to his understanding of changing aesthetics that he was able to craft a meaningful statement from his trip to the Holy Land at a time when this kind of local landscape "fieldwork" was viewed with a good deal of suspicion.

Tanner's interactive experience of the Palestinian landscape was, in fact, something of an exception, for at the turn of the century, *genius loci* had come to be understood as residing in the artist's head rather than in any particular regional terrain. As early as the 1860s, there were American painters who traveled through the Holy Land without producing a single celebratory or testimonial work of art. Changes in attitude on the part of the artists who moved through the region were actually quite fluid and overlapping. Their goals and reactions depended not so

95. Henry O. Tanner, *The Good Shepherd*, c. 1902–3, Zimmerli Art Museum

much on when they arrived as on the cultural and religious beliefs they carried with them as they stepped off the boat. Thus, while Fairman could continue producing outmoded "portraits" of the city of Jerusalem until the turn of the century and Tanner could find inspiration at the same spot for several decades of protomodernist religious nocturnes, an artist like Sanford R. Gifford, who preceded both men in his trip to the Holy Land, remained uninterested in a similar enterprise. Indeed, what most distinguishes Gifford's stay in Palestine (unlike his visits to nearly every other place on his itinerary, including Upper Egypt, Constantinople, Greece, Venice, and the Italian lake district) is the absolute absence of any oil sketches or finished paintings from the region. His lack of engagement would be the harbinger of a new artistic attitude toward the sacred localities.

Gifford claimed that the thirty-two days he spent in Palestine and Syria in 1869 (just a year after Church's visit) were not sufficient to enable him to work up the many Holy Land subjects he encountered. "It is useless for me to attempt such things without plenty of time," he wrote home. "I have long since given up the expectation of making anything of the East."[3] In light of the works that did eventually result from his trip, however, his excuse appears somewhat flimsy. Much shorter

96. Sanford Gifford, *Jaffa Gate, David's Tower*, 1869, private collection

periods of time spent at such sites as the Athenian acropolis eventually gave rise to monumental paintings (*Ruins of the Parthenon*, 1880, Corcoran Gallery of Art) that far outshine the handful of drawings constituting the sole product of the artist's month in the Holy Land (fig. 96). What is more, it was only the overtly "sacred" portions of the eastern Mediterranean that failed to interest Gifford. The nonbiblical region of the Nile, in contrast, provided him with some of his most memorable desert canvases. What Gifford seems to have been reluctant to admit was that he simply was not interested in the sites of scriptural importance.

This somewhat aberrational nonchalance in the presence of the sacred landmarks of Christianity can perhaps be accounted for by Gifford's equally atypical religious outlook. Unlike most American artists who visited Palestine, Gifford's faith was extremely liberal, nonsectarian, and tolerant. He was a member of a radical New York City Unitarian church, later known as the Free Religious Association, that tested the boundaries of nineteenth-century eclecticism by welcoming both Jews and atheists. Evolution and natural selection were unconditionally accepted in this circle, and Gifford is even known to have attended a lecture addressing God's possible role in watching over life on other planets.[4] As a pilgrim and as an artist, therefore, he had very little at stake in the Holy Land; with nothing to prove, he found the landscape oddly silent.

Gifford's ideological openness, however, resulted in an unusual sensitivity to the modern realities of the Holy Land. Untroubled by the usual topographic fever, he paid greater attention to the Muslim society surrounding him. He made a point of securing Ottoman permission to visit mosques, for example, and he was conversant with the ritual aspects of Islamic architecture. While in the Middle East, he also read

the Qur'an and several biographies of Muhammad, explaining, "They help one very much to understand these Eastern people."[5] Finding himself in Jerusalem on Easter Sunday, he made a pilgrimage not to the Church of the Holy Sepulchre, but to the Dome of the Rock, a remarkably casual act for an American Protestant of his era, one that would probably have drawn the censure of his friend Frederic Church.

Gifford's actions in the Holy Land, and indeed throughout most of his career, bespeak an engagement with the present and a relative lack of interest in the past. During a European sojourn early in his career he is said to have proclaimed, "No historical or legendary interest attached to the landscape could help the landscape painter."[6] In the context of midcentury landscape painting, this is a remarkable statement for a young artist to have made. American nature writers had long paid lip service to the concept of the New World tabula rasa, but in practice few painters completely disregarded the associations of a particular site. This was especially true in the Old World, where even the pioneering celebrator of untrammeled wilderness, Thomas Cole, had fallen prey to the evocative historical richness of the Italian *campagna*. Gifford, though, even when painting European ruins, was usually able to keep history at arm's length, and the ramifications of maintaining this distance only grew with time. Essentially, he was calling into question the very idea of a meaningful "subject," the programmatic notion of content that had formerly given moral weight to the American landscape painter's uplifting and perfectible enterprise.

The attitude of Sanford Gifford isolated his art from that of his peers and certainly diminished the fruits of his stay in the Holy Land, where an almost oppressive sense of history seemed to overwhelm all else. It allowed him, however, to move toward an abstractive celebration of design and a reduced emphasis on subject well in advance of most of his colleagues. In this, Gifford looked forward to a new generation of Holy Land travelers. The young painter Lockwood de Forest, for example, made an extensive tour of the Middle East in 1876, but though he had been inspired and even briefly taught by Frederic Church, his trip affected him in ways quite different from what the older, more pious artist had experienced.[7] De Forest dutifully sought out the scenes memorialized by Church's great canvases of Damascus and Jerusalem, comparing his own experiences to his memories of those important paintings. Yet although he went so far as consciously to stand where Church had previously stood, de Forest refrained from following the lead of the older painter's grandiose, rhetorical canvases.

Even so, de Forest was able to accomplish more than Gifford, for he did actually execute a few finished Palestinian views. His aesthetic, however, moved well beyond a stone-by-stone rehearsal of the region, placing his sketchy, intimate landscape summaries firmly within the formal concerns of the late nineteenth century. His paintings tend to neglect the typical pilgrimage shrines and turn, like Gifford's Egyptian works, toward the desert and other vast, open spaces. In addition, de Forest was in no hurry to work up specific paintings from his Middle Eastern sketchbooks, and when he did, the identification of the actual site was of little importance. A drawing of Jaffa (1876, Archives of American Art), for instance, was the source for a striking painting, *Coast Scene* (fig. 97), executed sixteen years later. The historically important city, however, is barely visible on the horizon, unlike its prominent placement in

97. Lockwood de Forest, *Coast Scene*, 1892, National Academy of Design

the several views of the same Palestinian gateway by James Fairman. Instead, de Forest's picture emphasizes the simple, expansive sweep of the coastline as it poignantly leads to the lone Arab figure, turned squarely away from the viewer. The stage here has moved from the distant towers of Jaffa to the abstract junction of land and sea. This empty foreground becomes a charged field of loose, slick strokes that depends on the same evocative qualities of paint as Tanner's *Good Shepherd*, but appears to lack the latter's transformative infusion of deeply held belief.

Perhaps the most complete nullification of content in the Palestinian landscape, however, occurred in the early years of the twentieth century, when John Singer Sargent produced a series of vacant glimpses of blanched Eastern terrain that rejected all that his predecessors had deemed most notable in the region. His trip to the Holy Land took place during the winter months of 1905–6. Sargent's ostensible purpose was to conduct research; he claimed to be investigating material for the last installment of his huge mural cycle, *The Triumph of Religion*, in the Boston Public Library. This project—symbolically abstruse, awkwardly stylized, and highly intellectualized—occupied the painter for decades and was the antithesis of nearly all the portrait and genre work he produced throughout the rest of his career.[8]

Almost desperately, Sargent had thrown himself into a programmatic endeavor wholly premised on niceties of theological argument to which he was all but indifferent. The artist, according to his recent biographer, grew up in a peripatetic ex-

98. John Sargent, *The Plains of Esdraelon*, 1905–6, Tate Gallery

patriate American family "with no religious feelings whatsoever," and as an adult he was described as "quite emancipated from all religious ideas."[9] Not surprisingly, the sacred associations of the land of the Bible failed to make an impression on Sargent. His trip yielded little or no material for his figural allegory in Boston, and it is difficult even to imagine what he might have been looking for. Several years earlier, in fact, another late-century American muralist had similarly despaired of finding the local Palestinian landscape useful in his decorative productions. In his painting for the Church of the Ascension in New York (1888), John La Farge actually substituted Mount Fuji for the Judean hills because the latter "implied a given place."[10]

The cosmopolitan outlook of these muralists meant that they had little use for any specifics of geography, yet this did not mean that Sargent was idle in the Holy Land or unresponsive to its singular appearance. During his months of travel through Palestine he produced dozens of spare watercolor views and a startling group of full-scale oil landscapes. Perhaps in keeping with his lifelong expatriate rootlessness, these works differ from previous nineteenth-century images in their apparent lack of a partisan point of view. It seems that for the agnostic, wandering Sargent, there was little of unusual concern in the Holy Land; he abandoned the assertive, defensive landscapes of the earlier artists and instead filled his canvases with long, lingering stares of remarkable dispassion and ambivalence (figs. 98–100).

In her consideration of Sargent's views of Venice—a similarly localized group of interconnected works—Margaretta Lovell has written perceptively of the artist's penchant for treating "historically associated subjects . . . in a subtly or dramatically

99. John Sargent, *Near the Mount of Olives*, 1905–6, Fitzwilliam Museum

ahistorical manner." As a rule, his images "deliberately avoid overt meaning and purposefulness"; they are "fragmentized and completely decontextualized."[11] His works, that is, purport to tell no stories, illustrate no point, and require no local knowledge for their elucidation. They are neutral, fractional, vague, and resigned—and as such, somewhat troubling in their deceptively bland reportage. That Sargent could achieve this emotional leveling in his highly architectural, cramped images of Venice as well as in the structurally dissimilar, empty vistas of the Holy Land underscores both his independence of vision and the ideological disengagement of the era he epitomized.

On occasion in Palestine, Sargent appropriated the panoramic format of previous painters, climbing the same hills and reproducing the familiar prospects. Thus in *The Plains of Esdraelon* (see fig. 98) the artist did more or less what might be expected of him, ascending the rocky ridge at the valley's perimeter, turning, and offering a wide view of this celebrated historic and scriptural sight. Yet the picture finishes by slightly mocking its compositional prototype, demonstrating by example how barren of meaning a panorama can be. One of the few earlier American paintings to bear comparison to *The Plains of Esdraelon* is Edward Troye's *Dead Sea* (see pl. 2), but although that uneasy canvas is similarly blank and devoid of incident, Troye's picture still manages to convey belief and conviction through its monumental means and singular urgency of style. Sargent, on the other hand, gives little indication that his subject (aside from the pleasure of its loose, interlocking forms) is at all worthy of extended attention.

100. John Sargent, *Palestine*, 1905–6, private collection

In fact, the fertile Plains of Esdraelon were revered as the Bible's battlefield, the site of a continuing history of righteous slaughter from Josiah and Gideon to Napoleon, leading one midcentury American traveler to observe that "the place has no equal on the earth's broad surface."[12] None of this, however, is conveyed by Sargent's insouciant exploration of the formal patterns of cultivated strips of crops. His perspective has become far too distant for any communion with the land and the events it has witnessed. The expansive spread of rectangular plots visually approximates a vast bar graph, but in this case the axes of the graph are unlabeled, and it is unclear what, if anything, is being measured.

Sargent's Middle Eastern landscapes move toward extremes. While *The Plains of Esdraelon* stretches the panorama to an almost meaningless, telescoped image where distance and lack of detail militate against recognition and personal identification, a work like *Near the Mount of Olives* (see fig. 99) forces the nose of the viewer so close to the physical terrain that its overpowering materiality similarly precludes any intellectual or affective involvement. Here the horizon is pushed toward the upper edge of the picture, obliging a confrontation with an unrelieved surface of hot, quivering orange and green strokes, aptly described by one observer as "glutinous."[13] There is

no sense of visual command in the painting. Its perspective is demoralizingly close to the ground, much like that of the reclining Bedouin goatherd in Sargent's loosely brushed *Palestine* (see fig. 100)—a figure seemingly crushed by gravity and barely distinguishable from the broken rocks on which he is splayed.

If Sargent has somewhat fulfilled compositional expectations in the panoramic *Plains of Esdraelon,* he nevertheless renounces completely his pictorial "duty" before the sacred sites with his *Near the Mount of Olives.* Nothing in the painting serves to identify the vantage point or indicate the significance of the mount. Its very title, through its willful imprecision, appears to participate in this slight of a scriptural landmark. Yet as surprising as such an image may appear when compared to earlier nineteenth-century works, particularly Fairman's series devoted to the same place, *Near the Mount of Olives* does not seem to reveal any overt hostility toward the landscape on the part of the artist.

Instead, Sargent's pictures become a visual shrug before the topography of the Holy Land. There is a degree of profundity in them, but it is a kind of profound detachment characteristic of his modern era. In this they are neither empty nor meaningless. Rather, they announce a new set of concerns to guide the modern pilgrim, if that term still aptly describes a traveler of Sargent's equivocal demeanor. For all but a handful of faithful hangers-on, the imperatives that had structured the works of earlier generations of artists were no longer at issue when he arrived in Palestine. Born at a time when they were still operative yet also a witness to their general demise, Sargent came to the Holy Land with vague expectations that could not be fulfilled. His baffled sense of loss, though, did not arise simply because the landscape refused to yield the message that thousands of Westerners had previously been ready to receive. His self-aware ambivalence signaled a larger realization: not only was this message not likely to be found, but perhaps, from his secular point of view, it had never been there in the first place.

This stark epiphany, read large, constituted the fundamental cultural crisis of the late nineteenth century in the United States. It was not enough that the industrial world had changed outwardly beyond recognition. In the process the inner sustaining fabric had also been all but obliterated. The bedrock assumptions of preceding generations, the guiding metaphors that imposed a comfortable illusion of homogeneity and continuity, were now shown to be shockingly irrelevant. Darwin and Marx, the Civil War and Reconstruction, immigration and trade unions, suburbs and suffrage: All had a part in robbing the great American foundation myth—the Puritan invention of a divinely sanctioned, New England Protestant Zion—of its authority. In this light, desperate attempts like those of the late-century vacationers at Chautauqua to reclaim even a small part of that exclusive Old Testament polity within their treasured Palestine Park seem quite understandable.

Certainly, attitudes toward the Holy Land were only one small component of the radical global transformations negating the fundamental beliefs that had formerly ordered the early-nineteenth-century worldview. Within this limited realm, however, it should not be surprising that the impressions of a Paris-trained portraitist of the waning Gilded Age such as Sargent would have differed so extremely from those

of the American artists whose voyages took place in a less contested era. Yet to deny that Sargent had gained anything from his sojourn in the eastern Mediterranean would leave his substantial series of oils and watercolors largely unaccounted for. He had, in fact, evinced a highly personal reaction to the arresting visual character of the Holy Land, even if his motivation to paint it was less clear. The haunting, oddly belated recollections that strain to make themselves heard in his deserted landscapes are plain enough evidence of this. The responses of his predecessors who devoted their energies to celebrating the biblical terrain, whether for religious, scientific, commercial, or political reasons, were in their way no less personal.

In the end, then, there is a degree of commonality between Sargent and the other artists. Though their motivations varied widely, they usually arrived in Palestine to find something in its landscape that could meet their needs. Perhaps because it was reinvented each time a new visitor disembarked, the Holy Land could guarantee this constant supply of ideological and aesthetic sustenance. Americans departed from the biblical terrain again and again, confident that they had secured its secrets and truths. The mutability of those meanings, more than anything else, assured that no matter what had been taken away, there would always be others ready to start the process anew.

Notes

(*Works cited in the Select Bibliography appear here in shortened form.*)

INTRODUCTION

1. Willis, *Pencillings by the Way*, 2:58.

2. "The Platform," *Congressional Quarterly Almanac* 48 (1992): 78a. See Matt. 5:14.

3. King, *Looking Forward*, 7–8.

4. Miller, *Empire of the Eye*, offers a thoughtful and provocative treatment of these issues.

5. Writing to his wife in 1843, Thomas Cole declared, "I have found . . . that a Subject from Scripture particularly if a figure of Christ is introduced or even supposed is disgustful to the popular taste." Quoted in Wallach, "Ideal American Artist," 158. A later generation of American painters—Frederick Bridgman, Charles S. Pearce, Edwin Lord Weeks—would enthusiastically take up Orientalist genre painting in the European mode, but their interest in the Holy Land was minimal. For an attempt to distinguish between the stereotypical Orientalism of baths, harems, and carpet merchants and the Christian associations of the Holy Land, see "Orientalism," 479–96.

6. Appleton, *Syrian Sunshine*, 165–66.

7. Deborah Dash Moore, "Studying America and the Holy Land: Prospects, Pitfalls, and Perspectives," in Davis and Ben-Arieh, *With Eyes toward Zion—III*, 43. Moore rightly observes that heretofore, scholars, when they have considered visual images of the Holy Land at all, have seen them simply as unproblematic illustrations of verbal texts, rather than active producers of meaning—with their own "cognitive dissonances" demanding a more particularized analysis and interpretation (44).

8. "Dead Sea, Sodom, and Gomorrah," 187.

9. Urry, *Tourist Gaze*. See especially chap. 1.

10. Ibid., 8.

11. For good historical and political surveys, see Yapp, *Making of the Modern Near East*, and Divine, *Politics and Society*. A number of illuminating essays can also be found in Ma'oz, *Studies on Palestine*.

12. See Robert T. Handy, "Sources for Understanding American Christian Attitudes toward the Holy Land, 1800–1950," in Davis, *With Eyes toward Zion*, 37.

CHAPTER ONE

1. Cherry, *God's New Israel*, vii. The Massachusetts Assembly sermon was published as Danforth, *Vile Prophanations of Prosperity*, 12.

2. Bercovitch, *Puritan Origins*, 117. Bercovitch's important work provides a fundamental discussion of the prevalence and potency of the biblical myth that guided nearly every aspect of colonial culture during the seventeenth century. See also Bercovitch, "The Biblical Basis of the American Myth," in Gunn, *Bible and American Arts and Letters*, and Mason I. Lowance, Jr., *The Language of Canaan: Metaphor and Symbol in New England from the Puritans to the Transcendentalists* (Cambridge, Mass.: Harvard University Press, 1980).

3. Wakeman, *Sound Repentance*, 18.

4. Quoted in Bercovitch, *Puritan Origins*, 27. Few cultural phenomena are monolithic, however, and it should not be assumed that all New World settlers celebrated the ties to Israel. A notable exception is Roger Williams, who was banished from

Massachusetts for, among other heresies, questioning the communal identification with the biblical chosen people.

5. Steendam is quoted and discussed in Wayne Craven, *Colonial American Portraiture: The Economic, Religious, Social, Cultural, Philosophic, Scientific, and Aesthetic Foundations* (New York: Cambridge University Press, 1986), 89–90. Beverley is cited in Bercovitch, *Puritan Origins*, 138. Nineteenth-century equivalents of Beverley's associational geography are legion.

6. See Nelson, "Puritans of Massachusetts," 193, and Allen, "Founding of the City of Ararat," 321. Once Americans began traveling to the Middle East, it became standard to remark on the perceived physiognomic resemblance between Arabs and Native Americans.

7. On this general subject, see Walsh, "Holy Time and Sacred Space," and Daniel Scott Smith, "Continuity and Discontinuity in Puritan Naming: Massachusetts, 1771," *William and Mary Quarterly* 51 (January 1994): 67–91. The description of Hopkins's epiphany comes from his eulogy by the philanthropist Amos Lawrence. See *Extracts from the Diary and Correspondence of the Late Amos Lawrence* (Boston, 1856), 350.

8. John Winthrop, "A Modell of Christian Charity," in *Winthrop Papers*, 5 vols. (Boston: Massachusetts Historical Society, 1929–47), 2:295.

9. Samuel Langdon, "The Republic of the Israelites an Example to the American States," quoted in Cherry, *God's New Israel*, 98. See also Nelson, "Puritans of Massachusetts," 206.

10. A composite seal incorporating both ideas was offered to the committee in charge during the summer of 1776 but was eventually rejected. See John D. Champlin, Jr., "The Great Seal of the United States: Concerning Some Irregularities in it," *Galaxy* 23 (May 1877): 691–94.

11. Robinson, *Biblical Researches*, 1:46.

12. Warren, *Sights and Insights*, 246. Of note in the context of this study is the credit that Warren gives to "pictures" of the Holy Land in shaping his imagination. Warren and some of his contemporaries are discussed by Moshe Davis in "The Holy Land Idea in American Spiritual History," in Davis, *With Eyes toward Zion*, 3–33.

13. David C. Huntington has examined this connection in some detail in two publications: "Frederic Church's *Niagara*," 122–25, and "Olana: The Center of the Center of the World," in *World Art: Themes of Unity in Diversity*, ed. Irving Lavin, 3 vols. (University Park, Pa.: Pennsylvania State University Press, 1989), 3:767–68. The nineteenth-century source is William Gilpin, *The Central Gold Region* (Philadelphia: Sower, Barnes, 1860), 73.

14. R., "A Visit to Jerusalem. By an Officer of the United States' Navy," *Knickerbocker* 8 (December 1836): 698; "Illustrated Books: Pictures from Bible Lands," *Art Journal* 6 (February 1880): 55.

15. Wilbur Zelinsky, "Unearthly Delights: Cemetery Names and the Map of the Changing American Afterworld," in Lowenthal and Bowden, *Geographies of the Mind*, 181.

16. Gunn, introduction to *Bible and American Arts and Letters*, 1.

17. See Vincent's explanation of the system in his introduction to Hurlbut, *Manual of Biblical Geography*. For more on Vincent, see below, chap. 4.

18. Miller, "Garden of Eden," 102.

19. The most probing study of the painting in its religious climate is Bjelajac, *Millennial Desire*. Allston offers the unusual American example of qualified success in figural religious painting. In this he differs from the majority of the painters of landscape discussed in this study. Yet the constellation of ideals reflected by much of his figural oeuvre applies equally to religiously inspired landscape painting.

20. Ibid., 57. Bjelajac continued his exploration of the widespread importance

of Old Testament mythology for early-nineteenth-century Americans in "Washington Allston's Prophetic Voice."

21. Newhall, *Religious Patriotism*, 7. Newhall was a member of the conservative wing of the Congregationalist Church, intolerant of Unitarian reform.

22. Bercovitch, *American Jeremiad*, 166. It is illuminating that the key figure cited by Bercovitch in this enterprise was Philip Schaff, later a celebrated Holy Land scholar and the author of *Through Bible Lands*. See also Tuveson, *Redeemer Nation*, 120.

23. Quoted in Janet E. Buerger, "Ultima Thule: American Myth, Frontier, and the Artist-Priest in Early American Photography," *American Art* 6 (Winter 1992): 88. Patricia Hills has discussed the Jewett painting, its biblical associations, and the general notion of the West as promised land, in "Picturing Progress in the Era of Westward Expansion," in Truettner, *West as America*, 97–147.

24. For information on the Mormon identification with the Holy Land, see Tuveson, *Redeemer Nation*, 175–86; Davies, "Israel, the Mormons, and the Land"; Truman G. Madsen, "The Holy Land and the Mormon Restoration," in Davis, *With Eyes Toward Zion—II*, 342–45; and Klatzker, "American Christian Travelers," 170–82.

25. The term is Robert Handy's. See his "Interrelationships between America and the Holy Land," 289.

26. Albert J. Raboteau, "Black Americans," in *With Eyes toward Zion—II*, 313, 315. See also Raboteau, *Slave Religion*, 243–51, and more generally, Aamodt, "Righteous Armies." Significant exceptions to the dearth of American black travelers to the Holy Land are found in David F. Dorr, *A Colored Man Round the World* (which is possibly spurious), and Walker, *A Colored Man Abroad*.

27. See James M. McPherson, *Abraham Lincoln and the Second American Revolution* (New York: Oxford University Press, 1990),

36–37, and chap. 5, and Garry Wills, *Lincoln at Gettysburg: The Words that Remade America* (New York: Simon and Schuster, 1992), 98, 169, 185–86.

28. Quoted in Tuveson, *Redeemer Nation*, 195. Tuveson provides a useful examination of the diversity of contemporary religious attitudes toward the Civil War.

29. See James M. McPherson, *Battle Cry of Freedom: The Civil War Era* (New York: Oxford University Press, 1988), 281, and Aamodt, "Righteous Armies," 2. The important ways in which American millenarianism focused attention on the Holy Land will be considered below, in chap. 2.

30. Quoted in Hughes and Allen, *Illusions of Innocence*, 195.

31. B., "Jerusalem," *American Monthly Magazine* 6 (November 1835): 190, 193, 189.

32. See Miller, "Imperial Republic," 71; and Parry, *Art of Thomas Cole*, 131, 143–44.

CHAPTER TWO

1. If one can judge from the references to anonymous painters in the American travel and exploration literature concerning the Holy Land, though, this ballpark figure is conservative. Perhaps because of the greater availability of works, research has progressed much more rapidly on photography in the Holy Land. Although neither list is exhaustive, visiting American photographers are catalogued in Onne, *Photographic Heritage*, and Perez, *Focus East*.

2. Robert T. Handy calls missionary attitudes "the essence of American opinion." See his "Sources for Understanding American Christian Attitudes," 47. Lester I. Vogel also demonstrates the surprising magnitude of the missionary influence on what he calls "America's Holy Land consciousness." Vogel's comprehensive dissertation ("Zion as Place and Past") is the most complete attempt to bring together nearly all aspects of the American experience in the Holy Land: what Americans did, thought, and felt

there—and why. I am indebted to his dis-
cussion of many of the figures considered in
this chapter. Vogel's dissertation has now
been published in amended form as *To See a
Promised Land*. For another discussion of
the activities of missionaries, see Field,
America and the Mediterranean World,
chaps. 3 and 6.

3. Allan Cunningham, *The Life of Sir
David Wilkie*, 3 vols. (London: John Mur-
ray, 1843), 3:389, 404–9.

4. Rapelje, *Narrative of Excursions*, 5, 6.
Rapelje is considered briefly in Finnie, *Pi-
oneers East*, 182–83, and Klatzker, "Ameri-
can Christian Travelers" (1987), 13–14.

5. Robinson, *Biblical Researches*, 1:338.
For examples of Bradford's letters, see "Early
American Travellers."

6. Robinson, "John Landis, Painter,"
183–84. Landis includes a confused auto-
biography in the preface to his *Discourses on
the Depravity of the Human Family*. There
remains a possibility that the trip to the
Holy Land actually took place several years
after his return from Europe.

7. *Germantown Telegraph*, 1840, quoted
in Lichten, "John Landis," 51.

8. In another context, this notion has
been insightfully discussed by Brigitte Buett-
ner in her "Profane Illuminations, Secular
Illusions: Manuscripts in Late Medieval
Courtly Society," *Art Bulletin* 74 (March
1992): 82.

9. Klatzker, "American Christian Trav-
elers," speculates that the wife and daugh-
ters of Commodore Daniel T. Patterson of
the *Delaware* were the first American
women in the Holy Land (82). Consular re-
cords in the National Archives attest to the
frequent presence of United States ships at
Jaffa and the continued practice of allowing
sailors to tour the Holy Land in large
groups. See, for example, the "Travelers
Register" kept at the Jerusalem Consulate
from 1870 to 1877 (Record Group 84, Jeru-
salem Consulate Post Records, vol. C.39),
which notes the arrival of the crews of sev-
eral naval vessels.

10. R., "Visit to Jerusalem," 697, 699.
The other two contributions were Jones,
Excursions to Cairo, and Israel and Lundt,
Journal of a Cruize.

11. Stephens, *Incidents of Travel*. Cass and
his interest in Stephens are discussed in
Klatzker, "American Christian Travelers,"
12.

12. Stephens is a well-known figure. For
discussions of his life that pay particular at-
tention to his Middle Eastern journey, see
von Hagen, *Maya Explorer*, 30–70; Finnie,
Pioneers East, 4–6, 152–60, 168–70; and
Metwalli, "Lure of the Levant," 100–54.

13. See Brey, "Rau's Photographic Experi-
ence," 7. The identification of the flag-
wearing figure as the pioneering photogra-
pher Edward Wilson is somewhat uncertain;
another possibility is the missionary George
E. Post.

14. Lynch, *Narrative*, 377; Taylor, *Gyre
Thro' the Orient*, 164–65.

15. Middle East diary of Isabel M. C.
Church, 28 March 1868, typescript, Olana
State Historic Site, Hudson, New York. How-
ever, her husband, it should be noted, did
not fail to raise the obligatory flag above his
tent when traveling in the Holy Land. In-
deed, during the Civil War, Frederic Church
was known for his celebrations of the Stars
and Stripes, as evidenced by his paintings
Our Banner in the Sky (1861, Olana State His-
toric Site) and *Our Flag* (1864, Indianapolis
Museum of Art).

16. The American Colony in Jerusalem
was founded in 1881 by Chicagoans Anna
and Horatio Spafford. Their religious and
social commune had a long and fascinating
history in the holy city. An important "de-
partment" of the colony's activities was a
photographic enterprise that provided
thousands of Americans with hand-colored
prints and lantern slides. A large collection
of these works and their negatives is in the
Library of Congress. For a partisan history
of the sometimes controversial colony, see
Vester, *Our Jerusalem*.

17. "Stephens' Incidents of Travel,"

American Quarterly Review 21 (June 1837), quoted in Metwalli, "Lure of the Levant," 102.

18. See the numerous undated clippings in the John Banvard and Family Papers (hereafter, "Banvard Papers"), Minnesota Historical Society, microfilm roll 1, and Troye's advertisement in the *Boston Transcript*, 5 April 1859. Banvard and Troye are discussed below in chaps. 3 and 6, respectively.

19. Details of Robinson's life and intellectual formation can be found in, among other sources, Silberman, *Digging for God and Country*, 37–47, and Hovenkamp, *Science and Religion in America*, 152–58. For a modern appraisal of Robinson's methods and contributions to archaeology and geography, see Ben-Arieh, *Rediscovery of the Holy Land*, 84–91. The primary nineteenth-century source is Smith and Hitchcock, *Edward Robinson*.

20. Thompson, "American Explorers in Palestine," 7. For more on the American Palestine Exploration Society, see below, chap. 8.

21. Nathan M. Kaganoff, "Observations on America–Holy Land Relations in the Period before World War I," in Davis, *With Eyes toward Zion*, 81, and Broshi, "Religion, Ideology, and Politics."

22. After this difficulty, a full consular office was not established at Jerusalem until 1856. On the Cresson story, see Vogel, "Zion as Place and Past," 311–14.

23. Bercovitch, "Biblical Basis," 223.

24. Klatzker, "American Christian Travelers to the Holy Land, 1821–1939," in Davis and Ben-Arieh, *With Eyes toward Zion—III*, 67.

25. See Tuveson, *Redeemer Nation*.

26. Millerism has recently received considerable attention from historians of American religion. Particularly helpful in relation to the issues of this chapter are Doan, *Miller Heresy*, and Balmer, "Apocalypticism in America." Evidence of the continuing currency of millenarian thought in the nineteenth-century art world is found in Jasper Cropsey's canvas *The Millennial Age* (1854, Newington-Cropsey Foundation), which depicts an Arcadian flourishing of art and nature and makes explicit reference to prophetic passages from the Book of Isaiah.

27. Information on the Minor colony and later settlement schemes can be found in Alexander Bein, "American Settlement in Israel," in Davis, *Israel*, 298–309; Kark, "Millenarism"; and Vogel, "Zion as Place and Past," chap. 7. Some of Minor's views are set out in her *Meshullam!*

28. Field, *America and the Mediterranean World*, 81; Tuveson, *Redeemer Nation*, 43, 193.

29. Extensive documentation on the problems that beset United States consular officials is found in the National Archives, Record Groups 59 and 84. In reports from Jaffa, Jerusalem, Beirut, and Constantinople, consuls and their agents related their inability to negotiate between feuding factions of the colony and to ascertain a true picture of the state of its members. At one point, Adams was even imprisoned by the Jerusalem consul. For a popular account of the Adams colony, see Reed M. Holmes, *The Forerunners* (Independence, Mo., 1981).

30. The poignant correspondence relating to their plea is housed in the Jewish National and University Library, Hebrew University, Jerusalem (MS v.849).

31. Dodge, "Visit to Petra." For more on Church and Dodge, see below, chap. 8.

32. *New York Tribune*, 2 November 1867, quoted in Vogel, "Zion as Place and Past," 270.

33. *Boston Transcript*, 18 May 1858.

34. There is a large body of scholarly work on American travel writing. Two discussions that offer particular insight in the context of this discussion are Metwalli, "Lure of the Levant," and Terry Caesar, "'Counting the Cats in Zanzibar.'"

35. For a long, largely unfavorable review of the painting, see "Exhibition of the National Academy: Second Article," *Crayon* 3

(May 1856): 149. It is also discussed in Boime, *Magisterial Gaze*, 101–3. The costumed portrait of Taylor was not unique in Hick's oeuvre; his painting of the Egyptologist Henry Abbott (1863, New-York Historical Society) trades in nearly identical Middle Eastern stereotypes and includes a specific geographical reference in the background.

36. Bayard Taylor to Franklin Taylor, 26 October 1845, in Hansen-Taylor and Scudder, *Life and Letters of Bayard Taylor*, 1:57. See also Bayard Taylor, *Views A-foot; or, Europe Seen with Knapsack and Staff* (New York: George P. Putnam, 1854), 293–94.

37. Taylor, *Lands of the Saracen*. William Cullen Bryant made a similar trip to the Islamic world a year after Taylor's visit. Bryant's letters, first published in the *New York Evening Post*, later appeared as *Letters from the East*.

38. *The English Notebooks by Nathaniel Hawthorne*, ed. Randall Stewart (New York: Modern Language Association of America, 1941), 437. See also Thompson, *Melville's Quarrel with God*, and Edwin Cady, "'As Through a Glass Eye, Darkly': The Bible in the Nineteenth-Century American Novel," in Gunn, *Bible and American Arts and Letters*, 38.

39. Herman Melville, *Redburn: His First Voyage* (Chicago: Northwestern University Press, 1969), 5, and *White-Jacket; or, The World in a Man-of-War* (Chicago: Northwestern University Press, 1970), 151.

40. Melville, *Journal*, 144, 148, 150, 142–43, 140.

41. Ibid., 137.

42. Melville, *Clarel*. In his historical note to this edition, Hershel Parker discusses the pulping (639).

43. Rogin, *Subversive Genealogy*, xi. Rogin's book assumes a permeable membrane between biography, culture, history, and literature. It seeks to demonstrate the extent to which Melville's novels inscribe national as well as personal dilemmas—a useful way of approaching his Holy Land journal as well.

44. Baym, "Erotic Motif in Melville's *Clarel*."

45. Melville, *Journal*, 166, 263–64.

46. For an examination of this idea, see Goldman, "Melville's *Clarel*."

47. Clemens (Mark Twain) refers to Prime as "Grimes" throughout his *Innocents Abroad*; see 423. For a discussion of the reception of this highly popular book, see Louis J. Budd, *Our Mark Twain: The Making of His Public Personality* (Philadelphia: University of Pennsylvania Press, 1983), chap. 3. Prime, a somewhat influential figure within the New York art world, also played a significant role in supplying "authentications" for the promotion of various landscape views of the Holy Land.

48. Thomson, *Land and the Book*, 1:507. On the Protestant/Catholic issue and its relationship to the landscape, see Bendiner, "David Roberts in the Near East," 76–77.

49. Thomson, *Land and the Book*, 1:xv, vi, v.

50. The modern critique of Orientalism has demonstrated the problematic and manipulative nature of the assumption, underlying Thomson's method, that the Middle East (including its people and their culture) had not changed at all since the biblical era. See especially Said, *Orientalism*, and Nochlin, "Imaginary Orient." For a study of the sustained American hostility to Turks, Arabs, and Armenians, see Kearney, "American Images of the Middle East."

51. Rhodes, *Jerusalem As It Is*, 297–98, 332; Warren, *Underground Jerusalem*, 93; and Champney, *Three Vassar Girls*, 20.

52. Thomson, *Land and the Book*, 1:17, 2:468.

53. Edward Lear to Lady Waldegrave, 9 March 1867, *Edward Lear: Selected Letters*, ed. Vivien Noakes (Oxford: Clarendon Press, 1988), 209.

54. See *Mary Todd Lincoln: Her Life and Letters*, ed. Justin G. Turner and Linda Levitt Turner (New York: Knopf, 1972), 218,

400; and Vogel, "Zion as Place and Past," 88.

55. This was one reason cited by the Jerusalem consul, Victor Beauboucher, for a "rather unusual influx of visitors" in his State Department report of 24 July 1867. He estimated that about five hundred Americans had passed through the holy city during the previous eighteen months. See Ruth Kark, "Annual Reports of United States Consuls in the Holy Land as a Source for the Study of Nineteenth-Century Eretz Israel," in Davis, *With Eyes toward Zion—II*, 159. A perusal of the Jerusalem Consular Post Records (Record Groups 59 and 84) of the National Archives yields further information on this sustained surge in travel. Reports by Consul Richard Beardsley, for example, note several hundred American visitors during the winter season of 1871: "Compared numerically with travelers of other nationalities they have this year been at least three to one" (report of 20 April 1871, microfilm M453, roll 2). By 30 September, he had increased his estimate to five hundred Americans.

56. Warren, *Underground Jerusalem*, 23.

57. Taylor, *Gyre Thro' the Orient*, 275.

58. Morris et al., *Bible Witnesses from Bible Lands*, unpaged fasciculus.

59. Klatzker, "American Christian Travelers" (1987), 177.

60. Morris, *Catalogue*, 4; and *Freemasonry*, 596.

61. Clemens, *Innocents Abroad*, 390, 373.

62. Morris, *Catalogue*, 5.

63. In Morris et al., *Bible Witnesses from Bible Lands*.

64. Clemens, *Traveling*, 302, quoted in Vogel, "Zion as Place and Past," 145.

CHAPTER THREE

1. Quoted in Odell, *Annals of the New York Stage*, 1:18. A pair of camels was similarly exhibited in New York at "Mr. Parisee's Garden" in October 1818 (ibid., 2:539).

Odell's anthology is a valuable and comprehensive survey of (mainly) New York newspapers that lists "entertainments" year by year.

2. Ibid., 1:101–2.

3. Indeed, one of the most extensive nineteenth-century American endeavors in the Holy Land, the American Palestine Exploration Society, was formed for the sole purpose of gathering data for a map of the area east of the Jordan. See below, chap. 8.

4. The entire phenomenon of the panorama painting cannot be considered here. The literature on panoramas is growing, and scholars are now tracing the history of the medium as well as examining its theoretical and ideological ramifications. Of particular interest among recent contributions are Oettermann, *Das Panorama*; McGinnis, "Moving Right Along"; Angela Miller, "Imperial Republic"; and Hyde, *Panoramania!*

5. Odell, *Annals of the New York Stage*, 1:286, 2:143. The issue of whether this "view" of Jerusalem was a true panorama painting or a three-dimensional model has ramifications for the determination of the date when panoramas were initially introduced to the United States. Lee Parry, in an important article, claimed that the first American panorama was a view of London exhibited in New York in 1795, and others have followed him in this assumption (Parry, "Landscape Theatre in America," 54). Earlier, however, John Francis McDermott had noted the precedence of this Jerusalem "panorama" (*Lost Panoramas of the Mississippi*, 8). One of the great problems confronting students of the medium is the protean ambiguity of terms with which contemporaries described panoramas.

6. McDermott concentrates on five Mississippi panoramas; Miller mentions seven. On the other hand, in Oettermann's index of panorama subjects (from Europe and the United States), Jerusalem is the largest cate-

gory. My research, by no means exhaustive, has located references to some forty panoramas and related spectacles (cosmoramas, dioramas, etc.) of the Holy Land exhibited in the United States before 1900.

7. Quoted in Avery and Fodera, *John Vanderlyn's Panoramic View*, 30–31. Avery's helpful comments on the present chapter have greatly clarified much of the following discussion.

8. "The new Panorama," *New York Mirror*, 18 August 1838, quoted in McGinnis, "Moving Right Along," 97.

9. See Parry, "Thomas Cole," 79–86, and Parry, *Art of Thomas Cole*, 149–54.

10. "The Fine Arts," *Knickerbocker* 4 (October 1834): 325. The same painting was exhibited two years later in Boston. See *Boston Evening Transcript*, 12 May 1836. During this period, the terms "diorama" or "dioramic painting" were used to describe flat, unusually large pictures, often exhibited with elaborate scenery and effects of illumination. See, for example, the use of both expressions in "The Diorama," *New York Mirror*, 3 January 1835.

11. Both were exhibited in New York in 1835. See "Miscellaneous Notices of The Fine Arts, Literature, Science, the Drama, Etc.," *American Monthly Magazine* 4 (January 1835): 285–86; "The Fine Arts," *Knickerbocker* 5 (February 1835): 171; "The Fine Arts," *Knickerbocker* 6 (April 1835): 359; and Hyde, *Panoramania!*, 122–23.

12. David Bjelajac, "The Boston Elite's Resistance to Washington Allston's *Elijah in the Desert*," in Miller, *American Iconology*, 54, and Miller, *Empire of the Eye*, 36, 111.

13. See McDermott, *Lost Panoramas of the Mississippi*, 8; *Boston Evening Transcript*, 13 July 1840; and *New York Spirit of the Times*, 5 August 1848.

14. The canvas is now rolled up at the Wadsworth Atheneum and is not in a condition to be viewed. See Richard Saunders with Helen Raye, *Daniel Wadsworth: Patron*

of the Arts (Hartford, Conn.: Wadsworth Atheneum, 1981), 35–36.

15. Catherwood's biographer is Victor Wolfgang von Hagen. Material relevant to this discussion can be found in his "Mr. Catherwood's Panorama" and *F. Catherwood, Architect-Explorer*. See also Ben-Arieh, *Rediscovery of the Holy Land*, 79–82. Two rare Catherwood watercolors of sites in Palestine and Lebanon are preserved in the Avery Architectural and Fine Arts Library, Columbia University.

16. *Description of a View of the City of Jerusalem*.

17. Von Hagen, "Mr. Catherwood's Panorama," 146. The Jerusalem panorama was of the larger size, exhibited in the lower chamber. It was not a permanent feature in New York but traveled periodically to other northeastern cities.

18. Most accounts of the Jerusalem panorama conclude that it was destroyed when Catherwood's rotunda burned in New York in 1842. Yet an edition of the descriptive pamphlet (with the same accompanying engraving as earlier editions) was later printed in New York in 1845. (A copy is housed in the library of the National Gallery of Art, Washington.) One can surmise either that the panorama was on tour in another city at the time of the fire or that Catherwood secured a replacement copy—either from his own brush or from Burford in London.

19. Kevin J. Avery has noted this connection between pamphlets of moving panoramas and the guides produced for Church's *Heart of the Andes*. See Avery, "*The Heart of the Andes* Exhibited," 62–63.

20. See, generally, Michel Foucault, *Discipline and Punish: The Birth of the Prison*, trans. Alan Sheridan (New York: Vintage, 1979), 195–228; and more specifically, Wallach, "Making a Picture," 37–38.

21. In 1843, Catherwood further displayed his knowledge of the building by exhibiting a painting entitled *A View in the*

Interior of the Mosque of Omar (the misleading nineteenth-century Orientalist term for the Dome of the Rock) at the annual exhibition of the National Academy of Design (cat. 285).

22. B. Powell to Vanderlyn, quoted in Avery and Fodera, *John Vanderlyn's Panoramic View*, 25. McGinnis, "Moving Right Along," contrasts Catherwood's success to Vanderlyn's failed enterprise, commenting significantly that "the metaphor of the Holy Land was a part of American culture, Vanderlyn's Versailles was not" (96). She is the only author to have made this important connection between panoramic imagery of the Holy Land and the American self-definition as a new Israel.

23. *Description of a View*, 3.

24. Reprinted on a publicity broadside in the collection of the New-York Historical Society.

25. For a discussion of this debate, see O'Doherty, "Some American Words."

26. *New York Mirror*, 18 August 1838, quoted in McGinnis, "Moving Right Along," 97; and the *Providence Journal*, the *New-York Evening Star*, and the *New-York Christian Advocate and Journal*, all quoted on the broadside discussed in the previous note. Additional notices include "Catherwood's Panoramas"; "Mr. Catherwood's Panoramas," *Knickerbocker* 12 (September 1838): 283; and "Panoramas of Jerusalem and Thebes," *New York Evening Post*, 29 August 1839.

27. A list of both types, with approximate dates and representative venues, would include Joshua Shaw's panorama of the Holy Land, Philadelphia, 1847; Brunetti's panorama of Jerusalem, New York and Brooklyn, 1848–52 (probably a model); Henry C. Pratt's panorama of the Garden of Eden, Boston, 1849; John I. Williams's panorama of the Bible, Boston, 1849; King's panorama of the Holy Land, Brooklyn, 1850; Hathaway's panorama of the life of Christ, New Bedford and Boston, 1851–52; Professor Hart's "panoramic mirror" of the New Testament and scenes in the Holy Land, New York, 1852–53; Cannon's panorama of the Bible, New York, 1854; Perrine's panorama of the Holy Land, Chicago, 1861; and DuBoce's panorama of Palestine, Chicago, 1861.

28. The facts of Banvard's life are difficult to ascertain because of the highly elastic treatment of his biography in the large body of promotional literature he generated. However, much can be culled from the Banvard Papers. For a full consideration of his career, see also Hanners, "Adventures of an Artist."

29. McDermott, *Lost Panoramas of the Mississippi*, 12, 22, 23, and George C. Groce and David H. Wallace, *The New-York Historical Society's Dictionary of Artists in America, 1564–1860* (New Haven, Conn.: Yale University Press, 1957), 303. Groce and Wallace assume incorrectly that Hayden was the painter of the panoramas she owned.

30. There is conflicting evidence about the dates of Banvard's Middle Eastern sojourn. Given that his early panorama of Jerusalem was executed without benefit of a visit to the site, and given his propensity to stretch the facts of his biography, it would not be unreasonable to doubt that he ever actually made the trip to the Holy Land. Research in the consular records of the National Archives, however, confirms that Banvard and his companion, Frederick R. Fowler, were issued certificates of residence and nationality by the American representative in Alexandria, Egypt, on or before 4 January 1851. See the letter from D. S. McCauley to Daniel Webster, Record Group 59, microfilm T45.

31. Banvard gives the date of the sermon as 24 June 1849. See "Notes" in Banvard Papers, roll 2.

32. Scrapbook, Banvard Papers, roll 1, frs. 481, 478, 488, 464; Hanners, "Adventures of

an Artist," 110. Because the Holy Land panorama has not survived, its size cannot be confirmed. Most writers on Banvard assume that it was taken by the artist to South Dakota when he retired. It is possible that it was then cut up for stage scenery.

33. Communipaw [pseud.], "Foreign Correspondence of the Boston Post," in Scrapbook, Banvard Papers, roll 1, frs. 455, 488.

34. Unidentified clipping by "S.C., Jr.," Scrapbook, Banvard Papers, roll 1, fr. 491.

35. A ground plan of the church, along with crude engravings from the panorama, was reproduced in an article on Banvard and his painting. See "The Holy Land," 388.

36. Approximate touring dates have been ascertained from newspaper reviews. See "Banvard's Georama," 2. The Brooklyn Sunday-school showing is mentioned in Odell, *Annals of the New York Stage*, 7:541.

37. "Banvard's New Panorama," *Boston Transcript*, 4 December 1854, and Scrapbook, Banvard Papers, roll 1, fr. 491.

38. Scrapbook, Banvard Papers, roll 1, frs. 464, 466.

39. Copies of poems are found in the Banvard Papers, roll 1, beginning with fr. 106.

40. Commenting on a Banvard Egyptian painting at the National Academy, a critic wrote sarcastically, "Egypt, we believe, is not addicted to volcanic excesses. This it to be regretted, for if Koom-Ombos had met with a fate similar to that which befell Herculaneum and Pompeii, probably this picture would not have been painted." ("National Academy of Design, Thirty-Fourth Exhibition," *New York Evening Post*, 14 May 1859.)

41. An article entitled "The Sea of Galilee," which describes the evening, can be found in the Scrapbook, Banvard Papers, roll 1, fr. 341.

42. *Banvard's Historical Landscape.*

43. This is not to say that the public lacked Holy Land panoramas in the later decades of the nineteenth century. The decline of the moving panorama soon gave way to a renaissance of its circular, stationary form. "Cycloramas," as they were usually called in the 1880s and 1890s, became newly popular, and thanks to an enterprising team of Germans—Karl Frosch, Wilhelm Heine, and August Lohr—several versions of a 360-degree painting of Jerusalem and the Crucifixion, based on a European prototype (1886) by Bruno Piglheim, were seen in Buffalo, New York City, Chicago, Philadelphia, and Milwaukee. The story of this painting is traced by Oettermann in *Das Panorama*, 216–21.

CHAPTER FOUR

1. *Boston Evening Transcript*, 31 March 1870. See also "Domestic Art Gossip," *Crayon* 1 (March 1856): 91.

2. The state of research on photographers in the Holy Land is considerably more advanced than that on painters. My discussion only glances at some aspects of this episode that added to the popular notion of the biblical landscape. Other surveys of Western photographic activity in the region that include discussions of Americans are Onne, *Photographic Heritage*; Louis Vaczek and Gail Buckland, *Travelers in Ancient Lands: A Portrait of the Middle East, 1839–1919* (Boston: New York Graphic Society, 1981); Nir, *Bible and the Image*; and Perez, *Focus East*.

3. On stereographs in general, see the publications of William C. Darrah, such as *World of Stereographs*, where the figure of five million discrete views (let alone multiples of those views) is given on p. 6. Lester Irwin Vogel introduces his dissertation with a discussion of stereo photography that hints at its importance for depictions of the Holy Land ("Zion as Place and Past," 1–6).

4. Bierstadt, an older brother of the more famous painter, is one of the few Holy Land

stereographers to have been accorded an extended study. See Goldman, "Charles Bierstadt." On James, see Hirst and Rowles, "William E. James's Stereoscopic Views."

5. Holmes, "Stereoscope and the Stereograph," 746. Jonathan Crary's discussion of the stereoscope sheds light on these and other issues. See his *Techniques of the Observer*, 116–36.

6. Macmillan, *Bible Teachings in Nature*, quoted in Moore, "Storm and the Harvest," 32.

7. *The Historical Library of the Land and the Book. . . .* (St. Louis, Mo.: Bible Education Society, 1908). An example of a "personal" pilgrimage is Elmendorf, *Camera Crusade*, based on his trip of 1901. Elmendorf, a popular lecturer based in Brooklyn, New York, frankly stated that he took his camera to Palestine and Syria because "my faith was wavering, I was in doubt." Yet after returning with the evidence of his pictures, he was able to write confidently, "I doubt no longer, now I know" (p. vii).

8. See Sontag, *On Photography*, 155.

9. Vincent and Lee, *Earthly Footsteps*. Because of the problem of this volume's erratic pagination, quotations from *Earthly Footsteps* will not be given citations in the notes, but will be identified in the text by reference to the specific introductory essay or caption. A rare collection of some, but unfortunately not all, of the original photographs used in the volume is in the Library of Congress, Prints and Photographs Division. Many of these still retain typewritten paper labels, presumably pasted on the images by Bain for copyright purposes.

10. This concept of a "conquête pacifique" was standard in nineteenth-century photographic literature. Abigail Solomon-Godeau has noted that "in no part of the world were these peaceful conquests made so frequently as in the Middle East." See her thoughtful essay, "A Photographer in Jerusalem, 1855: Auguste Salzmann and His Times," in her *Photography at the Dock*, 159.

11. Ibid., 161.

12. This problem in Holy Land photography has been considered by Marjorie Munsterberg in "Louis de Clercq's *Stations of the Cross*."

13. The useful term "geopiety" was coined by Wright and is discussed in his *Human Nature in Geography*, 250–85. For further consideration of the implications of the term, see Yi-Fu Tuan, "Geopiety: A Theme in Man's Attachment to Nature and to Place," in Lowenthal and Bowden, *Geographies of the Mind*, 11–39.

14. I have paraphrased from Branham, "Sacred Space under Erasure," 375.

15. The feminizing of the Middle Eastern landscape by Western viewers is a topic that merits further exploration. See the suggestive, preliminary remarks in Hastings, "Said's *Orientalism*." For a discussion of the turn-of-the-century issue of photographing an unsuspecting or unwilling subject, see Mensel, "'Kodakers Lying in Wait.'" Mensel notes, in particular, the heightened stakes when the photographic subject was female.

16. Wilson, *In Scripture Lands*, 265 (emphasis added).

17. Caption for Bain's *Moslem Ovens, Nazareth*. For sentiments echoing Lee's, see "The Future of Islam," *New York Times*, 9 November 1879. In a more contemporary context, Edward W. Said has subjected a similar series of twentieth-century photographs of Palestinians to a thoughtful and personal exegesis. See his *After the Last Sky*.

18. Roosevelt is quoted in Hurlbut, *Story of Chautauqua*, x. For nineteenth-century sources, see "Chautauqua," *Harper's New Monthly Magazine* 59 (August 1879): 350–60; and Vincent, *Chautauqua Movement*.

19. Wythe was also responsible for a detailed model of the city of Jerusalem (destroyed by a storm in 1893) that was housed in a small, roofed amphitheater at Chautauqua. Soon a Jerusalem model became a requisite component of almost every Christian

resort, even those, such as Ocean Grove, New Jersey, that were not formally affiliated with Chautauqua. Ruth Kark has published one of these "relief maps" dating from the 1870s, now preserved at the American Jewish Historical Society. See her "Jerusalem in New England."

20. Alden, *Four Girls at Chautauqua*, 233, 399, 454. Ida M. Tarbell, writing of her childhood summers at Chautauqua in the 1880s, confirms that a good deal of play did take place in Palestine Park, such as a game of tag in which "you could not be tagged if you straddled Jerusalem." See her *All in the Day's Work* (New York: Macmillan, 1939), 67.

21. "The Children's Pilgrimage," *Chautauqua Assembly Herald*, 19 August 1878.

22. Bachelard, *Poetics of Space*, 161.

23. Hurlbut, *Story of Chautauqua*, 47; Vincent, *Chautauqua Movement*, 235.

24. See Hurlbut, *Story of Chautauqua*, 66–67, and "Palestine," *Chautauqua Assembly Daily Herald*, 12 August 1876. Hurlbut, however, notes of Van Lennep's call to prayer, "I failed to observe . . . the people at Chautauqua prostrating themselves at the summons. Indeed, some of them actually mocked the make-believe muezzin before his face"—remarks that indicate a higher threshold of acceptance for Ostrander's pretend Judaism than for Van Lennep's ersatz Islam.

25. "Oriental Life," *Chautauqua Assembly Daily Herald*, 15 June 1876. Alan Trachtenberg considers the ritual aspects of Chautauqua life in his "'We Study the Word and Works of God.'"

26. Representative books include Poole, *Anglo-Israel*; Spencer, *Missing Links*; and Streator, *Anglo-American Alliance*.

27. See the far-reaching discussion throughout Lears, *No Place of Grace*. Thorstein Veblen was undoubtedly the earliest scholar to recognize this trend. See his discussion of fin de siècle ceremonial atavism and archaic ritual in *Theory of the Leisure*

Class, 372–74. For a more contemporary analysis of this performative aspect of the American search for cultural identity, see Green, "Tribe Called Wannabee."

28. See discussions in Baltz, "Pageantry and Mural Painting," and Banta, *Imaging American Women*, chaps. 5 and 15.

29. J. A. Hill, *Hill's Book of Tableaux. . . .* (Indianapolis, Ind.: Fraternity, 1884), n.p. Perhaps the most notorious American assumption of a biblical role took place in 1898 when, on a hill outside Norwood, Massachusetts, the photographer F. Holland Day took off his clothes and climbed up onto a cross made of wood imported from Syria. The outcry that greeted the photographs of Day's emaciated, diapered body indicates that there were indeed limits to the late nineteenth century's tolerance of Middle Eastern role-playing. See Day, "Sacred Art and the Camera," and Estelle Jussim's unfortunately homophobic *Slave to Beauty: The Eccentric Life and Controversial Career of F. Holland Day, Photographer, Publisher, Aesthete* (Boston: David R. Godine, 1981), chap. 9.

30. See MacMechen, *True and Complete Story*, 31–32.

31. See Benedict, *Anthropology of World's Fairs*, 34, 43–44, 58, and especially Rydell, *All the World's a Fair*, chap. 6. On the general Western interaction with Islam at expositions, see Çelik, *Displaying the Orient*.

CHAPTER FIVE

1. Although he was elected an honorary member of the National Academy of Design in 1851, he never considered himself a part of that circle of artists. Like James Fairman (see chap. 7), he often criticized the academy in his newspaper articles. A profile of Kellogg in the New York *Sunday Times and Messenger* (14 March 1880) reported, "The management of the Academy have exhibited to him, as to many others, characteristics of narrowness that have separated

him wholly from them." See the artist's scrapbook, Kellogg Papers, Archives of American Art (hereafter, AAA), microfilm roll 986, fr. 1167.

2. Richardson, "Records of Art Collectors and Dealers," 271. The most comprehensive account of Kellogg's life is found in his own journals and correspondence. His papers are divided among several institutions, the most significant of which are the Archives of American Art, the Indiana Historical Society, the Cincinnati Historical Society, and the Barker Texas History Center, University of Texas.

3. Miner Kellogg, "Brief Notes for an autobiography of Miner K. Kellogg," Kellogg Papers, Indiana Historical Society.

4. On the sexual stigma, see Schrock, "Joseph Andrews, Engraver," 177. References bearing on the discussion of American Swedenborgianism in Cincinnati include A. G. W. Carter, *Address on The Life, Services, and Character of the Rev. Adam Hurdus* (New York, 1865); Smith, "Adam Hurdus and the Swedenborgians in Early Cincinnati"; and Smith, "Beginnings of the New Jerusalem Church."

5. Margaret Beck Block gives the surprisingly low figure of only five hundred American members of the New Jerusalem Church in 1830 and maintains that the church was still significantly short of ten thousand official adherents by the end of the century (*New Church in the New World*, 173). A partial list of other nineteenth-century American artists influenced by Swedenborg includes Joseph Andrews, Thomas Anshutz, Ralph Blakelock, Samuel Colman, John Cranch, John Durand, George Inness, George Inness, Jr., William Keith, William Page, Howard Pyle, Joseph Ropes, William Stillman, Cephas G. Thompson, and Eunice M. Towle. Attempts to understand individual American artists through their Swedenborgian beliefs include Taylor, *William Page*, Reynolds, "The 'Unveiled Soul,'" and Martha Gyllenhaal et al,

Ten Artists Inspired by Emanuel Swedenborg (Bryn Athyn, Pa.: Glencairn Museum, 1988).

6. Kellogg, "Brief Notes." For a comprehensive account of New Harmony, see Wilson, *Angel and the Serpent*.

7. See his entry of 23 June 1833 in "M. K. Kellogg's Journal, Cincinnati May 18th 1833, vol. 1st," Cincinnati Historical Society.

8. Kellogg to Powers, 24 December 1843, Hiram Powers Papers (hereafter, "Powers Papers"), Cincinnati Historical Society, microfilm, AAA roll 816.

9. Kellogg to Powers, 4 February 1844, Powers Papers, AAA roll 816. Egyptian ruins had earlier caused a crisis in earthly chronology when Napoleonic scientists discovered a zodiac figure on the ceiling of the Temple of Dendera that seemed to refute the Mosaic account. In his autobiography, the early American artist William Dunlap describes what is likely this same zodiac as a current topic of conversation among his friends during the mid-1820s. See Dunlap, *History*, 1:298.

10. Kellogg to Powers, n.d. and 4 February 1844, Powers Papers, roll AAA 816. Barrett explained, "*Waters*, in the language of correspondence, signify either truths or falses, according to the subject treated of. Hence, by a *flood of waters* destroying every living substance from off the face of the earth, is denoted such an accumulation of falses in the church, as to overwhelm and destroy all genuine good and truth" (Barrett, *Course of Lectures*, 57).

11. A particularly liberal treatment of the subject is found in "Geology and Revealed Religion." The cultural and artistic repercussions of this debate are considered in Novak, *Nature and Culture*, chap. 4.

12. Thomson, *Land and the Book*, 1:69, and DeHass, *Buried Cities Recovered*, 136. Stephen Jay Gould argues that the Mosaic chronology of five thousand years had been essentially abandoned by scientists by about 1800. See his *Time's Arrow, Time's Cycle: Myth and Metaphor in the Discovery of Geo-*

logical Time (Cambridge, Mass.: Harvard University Press, 1987), 112.

13. Kellogg to Powers, 23 January 1844, Powers Papers, AAA roll 816. With the exception of twenty-one studies of camels at the Toledo Art Museum and several scattered portrait drawings and Ohio landscape sketches, the vast majority of works on paper by the artist (some four hundred items) is preserved at the National Museum of American Art.

14. The series of *Western General Advertiser* letters was published over the course of two months beginning on 17 July 1844. Most are found in the scrapbook, Kellogg Papers, AAA roll 986.

15. The painting was donated to the Cincinnati Museum of Art by descendants of the artist's brother Sheldon, who is documented as owning a view "from nature" of Jerusalem that was exhibited shortly after the artist's final return to the United States. See the scrapbook, Kellogg Papers, AAA roll 986, fr. 1153, for a long review of a Kellogg painting of Jerusalem, almost certainly this same work.

16. Miner Kellogg, "Constantinople. Asia Minor. Phrygia," Kellogg Papers, Indiana Historical Society. Many of the sketches made on the trip are now at the National Museum of American Art. There were also at least two "Turkish" portraits of Layard executed by Kellogg, one of which was recently published in Fales and Hickey, *Austen Henry Layard*, pl. 7.

17. Kellogg to Layard, 24 May 1846, Layard Papers, Add. Mss. 38,976, f. 373, British Library.

18. Kellogg to Layard, 15 November 1847, Layard Papers, Add. Mss. 38,977, f. 355, British Library.

19. "Literary Notices," *New York Home Journal*, 7 April 1849.

20. "Original Letter from Dr. Layard upon Ancient Art, Etc.," *International Weekly Miscellany*, 1 July 1850, 5. Other letters published and introduced by Kellogg include "Extraordinary Antiquarian Researches and Discoveries in the East," *Knickerbocker* 29 (March 1847): 267–71, and "The Discoveries at Ninevah [*sic*]," *Washington National Intelligencer*, 22 March 1848. See also "Art Among the Hebrews," 259.

21. "Ancient Nineveh." The sermon is discussed at greater length in Husch, "'Something Coming,'" 141–42.

22. Layard to Kellogg, 16 January 1848, Layard Papers, Add. Mss. 42,711, British Library. The unnamed friend of Layard is quoted in Bendiner, "David Roberts in the Near East," 72.

23. See Hyman, "*The Greek Slave* by Hiram Powers," and Kasson, *Marble Queens and Captives*, chap. 3. Although Kellogg's efforts created unprecedented fame and revenue for Powers, the two (both known for their sometimes difficult personalities) ultimately had a falling-out over the financial accounts of the tour. For Kellogg's side of the controversy (which, to a degree, is supported by primary evidence in the Powers and Kellogg papers), see his pamphlet, *Mr. Miner K. Kellogg to His Friends* (Paris, 1858).

24. Kellogg, "Position of Mount Sinai Examined," 44.

25. Kitto, *Scripture Lands*, 66–73.

26. See Miner K. Kellogg, *Researches into the History of a Painting by Raphael of Urbino entitled "La Belle Jardinière"* (London, 1860), and *Documents relating to a Picture by Leonardo da Vinci, entitled "Herodias"* (London: W. Allen, 1864).

27. The former, apparently painted in 1859, entered the collection of a Russian nobleman in St. Petersburg, according to an inscription on a period photograph of it, now in the Kellogg collection of the National Museum of American Art. The latter probably depicted its owner, Judge Edward King of Philadelphia. It was exhibited at the Royal Academy (cat. 232) in 1857 and the Pennsylvania Academy of Fine Arts (cat. 60) in 1858, receiving a positive review in "The Exhibition of the Royal Academy," *Art Journal* (London) 19 (June 1857): 169.

28. Kellogg's scrapbook, AAA roll 986, is

concrete evidence of his astonishing adeptness at self-promotion and his versatility as a writer. In these efforts, he might have been working against public resentment of his long years abroad. Thus, at least one press notice made a point of describing him as "thoroughly American in every respect, and in love [with] everything American, notwithstanding his long residence abroad in Europe and the Levant" ("The Fine Arts—'Mount Sinai,'" *Washington National Republican*, 2 December 1868).

29. The present whereabouts of *Mount Sinai and the Valley of Es-Sebaʾîyeh* are unknown. Kellogg sold the work to a Washington dental surgeon and inventor named Edward Maynard. It was apparently last exhibited by that owner at the Loan Exhibition of the Metropolitan Museum of Art in 1874 (cat. 178). The painting is known, however, from a period photograph (National Museum of American Art) that Kellogg retained until his death. Records in the Library of Congress indicate that the artist filed for the copyright of this image in 1870.

30. "Art," *Baltimore Southern Society*, 26 October 1867.

31. Robinson, *Biblical Researches*, 1:134.

32. For the Pratt painting, see Parry, "When a Cole Is Not a Cole." Artists T. G. Gates and A. W. Twitchell also showed paintings entitled *Moses on the Mount* at the National Academy of Design Annuals of 1848 and 1850, respectively.

33. Kellogg Papers, AAA roll D30, frs. 76–77.

34. "Peabody Institute Lectures," *Baltimore American*, 31 January 1867; "Fine Works of Art," *Baltimore Sun*, 4 April 1868; and "Portrait of the Chief Justice," *Washington Evening Express*, 21 October 1868.

35. "The Fine Arts—'Mount Sinai'"; "A Visit to Kellog's [*sic*] Studio," *Washington Daily Chronicle*, 22 September 1869; and "Peabody Institute Lectures," *Baltimore American*, 14 February 1867. These and other reviews are collected in the scrapbook, Kellogg Papers, AAA roll 986.

36. Kellogg, "Geography of Mount Sinai," 398–99.

37. Ibid., 399. Joshua Taylor has attributed the popularity of Swedenborgianism among American artists (one thinks of landscape painters in particular here) to its ability to resolve this dichotomy: "Swedenborg provided the unusual attraction of expressing a clinical concern for nature and yet, through the simple device of a spiritual metaphor, could remain in touch with the spiritual world" (Taylor, "Religious Impulse," 99–100).

38. Bryant, *Philosophy of Landscape Painting*, 182. On mountain typology, see Moore, "Storm and the Harvest," 137, and Miller, *Empire of the Eye*, 265–70.

39. Eliade, *Patterns in Comparative Religion*, 216. See also pp. 100–101.

40. Kellogg to Powers, 31 March 1844, Powers Papers, AAA roll 816.

41. *Summary Exposition*, 32.

42. It is possible that Kellogg's St. John drawing was executed as a study for a painting the artist is known to have been working on in Florence during the year before his Middle Eastern trip. It was described in a newspaper account as "a somewhat extensive group, illustrative . . . of New Church 'Theology'" ("Kellogg, the Artist," *Cincinnati Gazette*, 24 January 1843).

43. Barrett, *Course of Lectures*, 194; and Kellogg to Powers, 31 March 1844, Powers Papers, AAA roll 816.

44. See, for example, "Peabody Institute Lectures," *Baltimore American*, 14 February 1867.

45. See the entries for "tree" and "trees" in *Dictionary of Correspondences*, 370, 371.

46. Taylor, "Religious Impulse," 101.

47. Barrett, *Course of Lectures*, 191. For these particular correspondences, I have paraphrased from pp. 100, 222, and 321. Since Kellogg is known to have read it while in the Holy Land, Barrett's *Course of Lectures* provides a logical contemporary reference, but the text does not differ greatly from other Swedenborgian guides.

48. Kellogg, "Emanuel Swedenborg." A tiny booklet dedicated to his daughter in the Kellogg Collection, National Museum of American Art, indicates that she was baptized in the New Jerusalem Church, Argyle Square, London, on 11 March 1861.

49. Macmillan, *Bible Teachings in Nature*, vi, x.

50. Ropes, "Lecture on Painting," 91–92, quoted in Schrock, "Joseph Andrews, Engraver," 179.

51. Miner Kellogg, "Personal to Myself," Kellogg Papers, Indiana Historical Society. Shortly before his death, Kellogg traded his Old Master collection as well as most of his own unsold paintings to a Cleveland financier, L. E. Holden, in exchange for a monthly pension. After the artist's death, Holden's family, interested only in the Old Masters, destroyed or gave away the works by Kellogg, which, for the most part, have not resurfaced.

Chapter Six

1. The facts of Troye's biography can be found in Mackay-Smith, *Race Horses of America*.

2. Ibid., 171; see chap. 19 of this source for basic information on Richards, his finances, and his interests.

3. Richards, "Arab Horses and Dromedaries."

4. Troye's itinerary and activities in the Middle East have been reconstructed by Mackay-Smith. An important primary source that also yields pertinent data is Troye's travel journal, a typescript of which is housed in the National Sporting Library, Middleburg, Virginia.

5. Troye journal (typescript), 13.

6. Ibid., 18–19, 20.

7. See Mackay-Smith, *Race Horses of America*, 175, 191; Richards, "Arab Horses and Dromedaries"; and Campbell, "Paintings from the Holy Land," 456.

8. There are many reviews and notices of

these three exhibition venues in the contemporary press. The paintings also seem to have been shown in Washington, D.C., and Montreal, Canada, although there is less documentation for these stops on the tour.

9. "The Holy Land," *Boston Transcript*, 27 April 1859.

10. The letters were printed on a broadside and also included at the end of the pamphlet *Troye's Oriental Paintings*.

11. New Orleans *Daily Crescent*, 15 and 20 April 1857.

12. On Palmer, see Hughes and Allen, *Illusions of Innocence*, chap. 9.

13. Mackay-Smith, *Race Horses of America*, 4, 354.

14. On this latter issue, see Miller, *Empire of the Eye*, 182–87. For the Civil War and Holy Land imagery, see above, chap. 1.

15. *Boston Transcript*, 25 March 1859 and 18 May 1858.

16. *Troye's Oriental Paintings*, 1.

17. Ibid., 4.

18. "Paintings from the Holy Land," 456.

19. The link between Richards's memory of Alexander Campbell's lectures on the river Jordan and the "water" element of Troye's paintings was first pointed out by Nancy Davenport in her manuscript, "Five Luminist Paintings of the Orient by Edward Troye," copy at Bethany College.

20. Thomson, *Land and the Book*, 2:71–72.

21. Troye's reviews also remarked on this superabundance. See *Boston Transcript*, 18 May 1858, for an example.

22. *Troye's Oriental Paintings*, 3.

23. Ibid., 2.

24. Troye journal (typescript), 15. A few relevant biblical verses are "You shall not plow with an ox and an ass together" (Deut. 22:10); "The sluggard does not plow in the autumn; he will seek at harvest and have nothing" (Prov. 20:4); and "No one who puts his hand to the plow and looks back is fit for the kingdom of God." (Luke 9:62).

25. Thomson, *Land and the Book*, 1:207–

9; Morris, *Bible Witnesses from Bible Lands*, 64.

26. *Troye's Oriental Paintings*, 2, 3. Troye executed a "portrait" of four of these bulls in a painting entitled *Bashan Cattle* (private collection).

27. *Troye's Oriental Paintings*, 2; *Dead Sea*; and William C. Prime to Edward Troye, 14 April 1858, reprinted in *Troye's Oriental Paintings*, n.p.

28. Ibid., 6; *Dead Sea*, 8. For a discussion of volcanic activity and the traditional nineteenth-century American view of godly creation and destruction, see Manthorne, *Tropical Renaissance*, chap. 3.

29. Lynch, *Narrative*. The publishing figures are given by James A. Field, Jr., who also mentions the gift of the Catlin reproductions (*America and the Mediterranean World*, 278–79).

30. Lynch, *Narrative*, 18, 318, 380.

31. "Dead Sea, Sodom, and Gomorrah," 187; Lynch, *Commerce and the Holy Land*, 31, 33, 37. Lynch's pamphlet ends, even more curiously, with an examination of biblical texts in their ancient language in order to prove that scripture prophesied the introduction of the telegraph to Palestine. Ernest Lee Tuveson mentions the telegraph as figuring importantly within the general millennial scheme (*Redeemer Nation*, 161–62).

32. Wilson, *In Scripture Lands*, 130; Melville, *Journal*, 136.

33. Eliade, *Sacred and the Profane*, 21, 26, 45, 63.

34. Despite the similarities in their work, no documentation exists to link Troye and Hunt. Although there was a slight overlap in their Holy Land sojourns, they were apparently in separate cities and did not meet. Hunt had sent his *Scapegoat* canvas to England several months before Troye arrived in Beirut, and the latter's journal makes no mention of the English painter.

35. On the general British artistic interest in Palestine, see Staley, *Pre-Raphaelite Landscape*, and Bendiner, "Portrayal of the Middle East." On *The Scapegoat* itself, see Hunt, "Painting 'The Scapegoat,'" and Bronkhurst, "An interesting series of adventures."

36. Quoted in Staley, *Pre-Raphaelite Landscape*, 69.

37. Ibid., 70. In considering the differing critical reactions to these two works, it should be noted that the Royal Academy, where *The Scapegoat* was exhibited, was not the same type of venue as the rented halls used by the American artist. Troye's reception would have been more problematic, one can assume, had he attempted to have his oversized work hung on the more discriminating walls of the National Academy of Design's annual exhibition.

38. "Paintings from the Holy Land," 462.

39. Lester G. McAllister and William E. Tucker, *Journey in Faith: A History of the Christian Church (Disciples of Christ)* (Saint Louis, Mo., 1975), 29.

40. Campbell's unifying vision, however, would also be shattered by the Civil War. His views on primitive Christianity are discussed in ibid., chaps. 7 and 8. See also Gifford, "Space and Time," 117.

41. For more on Barclay, see above, chap. 4. His Jerusalem mission is described in Burnet, *Jerusalem Mission*, and Barclay, *City of the Great King*.

42. Eames, *Philosophy of Alexander Campbell*, 77, 80.

43. Ibid., 33, 42.

44. Campbell, *Christian System*, 15.

45. The nineteenth-century view that the moral benefits of landscape study would be appropriate for a collegiate institution was not limited to Bethany College. Views of the Holy Land by James Fairman were placed in religious and educational contexts similar to that of the Troye series (see below, chap. 7). Moreover, the landscapes did not necessarily have to be "holy" in subject matter to have the desired effect. See the example of Vassar College in Ella M. Foshay and Sally Mills, *All Seasons and Every Light:*

Nineteenth-Century American Landscapes from the Collection of Elias Lyman Magoon (Poughkeepsie, N.Y.: Vassar College Art Gallery, 1983).

46. Quoted in Hughes and Allen, *Illusions of Innocence*, 176. The authors point out (188–90) that during the decades leading up to the Civil War, the South as a whole began to reject the universalist notion of "nature's God" as the legacy of such "heathen" northerners as Benjamin Franklin and Ralph Waldo Emerson.

47. Campbell himself provides an example of an extreme case of this blurring of boundaries. Late in life he became convinced that he had earlier made a pilgrimage to the Holy Land. In fact, he had never set foot in the Middle East, but his experience of it, through letters and images, was evidently enough to convince him otherwise. See Richardson, *Memoirs*, 647–48.

Chapter Seven

1. There is virtually no modern literature on Fairman. The broad outlines of his life are given in an eight-page celebratory pamphlet, signed by his friend the clergyman John Henry Barrows (though almost certainly ghostwritten by the artist): *James Fairman, the American Artist and Art Lecturer*. With minor additions, this was reprinted as *Biographical Sketch of Col. James Fairman, A.M., the American Artist and Art Lecturer*.

2. Barrows, *James Fairman*, 3. Edward Delafield Smith was the Republican U.S. district attorney in Manhattan in the early 1860s and was also active in the antislavery movement.

3. "The Charter Election," *New York Times*, 8 December 1858. Two days earlier, the *Times* had described Fairman as "a young mechanic of ability [who] has already made himself known as a public speaker" ("City Politics," *New York Times*, 6 December 1858). By the following June, the new

members were able to submit bylaws guaranteeing the reading of the Protestant Bible in the public schools. The bylaws were adopted in July.

4. Francis E. Fairman provided information on his great-grandfather's ties to the powerful Evarts (who later served as a United States secretary of state and a New York senator) in a letter to the author, 17 October 1989. In the New York Public Library's collection of Civil War songs is a broadside lyric, "The 2^d N.Y. Fire-Zouaves," dedicated to Fairman and filled with enthusiastic praise for "our gallant Colonel" (Broadside SY 1865, no. 149). For more on Fairman's military career, see *The War of the Rebellion: A Compilation of the Official Records of the Union and Confederate Armies*, ser. 1, vol. 2 (Washington, D.C.: Government Printing Office, 1884), pt. 1, 926; pt. 2, 216, 219.

5. Barrows, *James Fairman*, 4.

6. See ibid.; the papers of the Water Color Society, AAA roll N68–8; and James L. Yarnall and William H. Gerdts, compilers, *The National Museum of American Art's Index to American Art Exhibition Catalogues* (Boston: G. K. Hall, 1986), nos. 29703–7.

7. These quotations come from a letter to a business associate, S. A. Coale, Jr., 25 July 1876 (Duveen Collection, AAA roll DDU 1); two letters to the editor of the *New York Times*: "Fine Art and Its Parasites," 11 February 1882, and "Obstructionists in Art," 18 March 1882; and Fairman, *Essays on Art*, 18. The artist's attacks were not reserved for New York organizations. In 1891, he launched a campaign against the San Francisco Art Association, where a "covert mafia" had rejected his works ("Art Notes," *New York Times*, 24 May 1891).

8. *Biographical Sketch*, 3.

9. See "Brooklyn News," *New York Times*, 14 April 1867. One of Fairman's "art circles," in Lawrence, Massachusetts, is described by the daughter of the artist's biog-

rapher, John Henry Barrows. See Mary Eleanor Barrows, *John Henry Barrows: A Memoir* (Chicago, 1904), 135.

10. "Travelers Register," Record Group 84, Jerusalem Consular Post Records, vol. C.39, National Archives. See chap. 2 for statistics on the increased number of American visitors in 1871.

11. Barrows, *James Fairman*, 5.

12. Henry James, *Parisian Sketches* (New York: New York University Press, 1957), 166.

13. "Art Notes," *New York Evening Post*, 8 July 1872.

14. Few of the current titles of Fairman's Holy Land paintings date to the nineteenth century. Although provenance and pictorial details occasionally suggest identification with specific works mentioned in reviews or in the valuable pamphlet *Pictures Painted by James Fairman*, I have generally used the titles given the paintings by their present owners.

15. "Col. James Fairman's Pictures," *American Art Journal* 36 (19 November 1881): 69.

16. Letters to the *Boston Journal* and the *Cleveland Daily Sunday Voice*, reprinted in *Notices of James Fairman, as Artist and Art Lecturer* (n.p., n.d.), 1, 3–4; Barrows, *James Fairman*, 6, 8.

17. Barrows, *James Fairman*, 8; "A Master of Art," *Newburyport Herald*, in *Notices of James Fairman*, 2.

18. "Obstructionists in Art." The *Cleveland Daily Sunday Voice* is quoted in *Notices of James Fairman*, 3.

19. "Some New Pictures by Col. James Fairman," *Chicago Tribune*, 15 February 1880.

20. On the history and ramifications of this assertive frame, see Avery, "*The Heart of the Andes* Exhibited."

21. "Art and Artists," *Boston Daily Evening Transcript*, 24 February 1880. Jarves (*The Art-Idea*, 1864) is quoted in Novak, *Nature and Culture*, 24.

22. "A Crichton of the Brush." The let-

ter from the artist's son George Fairman was discussed in "Art Notes," *New York Times*, 31 May 1891.

23. Letter in the *Boston Journal*, in *Notices of James Fairman*, 1; Barrows, *James Fairman*, 7.

24. See Sheila ffoliott, "James J. Hill as Art Collector: A Documentary View," in *Homecoming: The Art Collection of James J. Hill* (St. Paul: Minnesota Historical Society Press, 1991), 22.

25. Several letters from Fairman to Coale, one of which mentions additional St. Louis patrons, are found in the Albert Duveen Collection, AAA roll DDU 1, frs. 169–76. For evidence of his contact with other American artists, see Coale's correspondence with Asher B. Durand, Durand Papers, AAA roll N20, and "Jervis McEntee's Diary, 1874–1876," *Archives of American Art Journal* 31, no. 1 (1991): 13.

26. "Colonel James Fairman's Exhibition," *Art Journal* (London) 18 (June 1879): 118–19. Hall's authorship of another laudatory biographical sketch of Fairman was asserted by the artist's son in the aforementioned letter in "Art Notes," *New York Times*, 31 May 1891.

27. Barrows, *James Fairman*, 8. Elizabeth Broun has noted the existence of a significant Anglo-Scottish community of picture buyers and dealers in the United States and Canada during the late nineteenth century in her *Albert Pinkham Ryder* (Washington, D.C.: Smithsonian Institution Press, 1989), 150.

28. Although there is no evidence to indicate that Fairman ran for any political office after the Civil War, indirect connections to the party are notable as late as the 1890s, when his second wife and one of his daughters, Sarah and Evelina Fairman, were reported to be active in the Women's Republican Association. See "All About Citizenship" and "Our Government and Cuba," *New York Times*, 31 October 1896 and 6 May 1898.

29. Information on Fairman's connection to Olivet College is found in Wolcott B. Williams, *A History of Olivet College* (Olivet, Mich.: Olivet College, 1901) and the Olivet College Archives. As a result of his position at Olivet, Fairman lived for a time in Chicago during the early 1880s.

30. A nearly identical painting by Fairman was sold by Christie's, London, on 22 October 1991 (under the incorrect title *Jerusalem from the Mount of Olives*).

31. "Jerusalem from the Mount of Olives, by James Fairman, M.A.," broadside, Carnegie Museum of Art, Pittsburgh. On American-Turkish relations during the period, see Field, *America and the Mediterranean World*, 307–9.

32. Fairman to Macbeth (penciled date, 1899), Macbeth Gallery Papers, AAA Nmc6, frs. 1122–23.

33. See Gwendolyn Owens, "Art and Commerce: William Macbeth, The Eight, and the Popularization of American Art," in Elizabeth Milroy, *Painters of a New Century: The Eight and American Art* (Milwaukee, Wis.: Milwaukee Art Museum, 1991), 61–84.

34. "Three Fairman Wills and a Widow Appear," *New York Times*, 27 March 1904. Following Fairman's death, several newspaper articles demonstrated a surprisingly sensitive understanding of both the uniqueness and the cultural importance of the artist's lifelong quest for patronage and recognition. See "Art Treasures of Colonel Fairman," *New York Herald*, 24 November 1904, and "News of Art and Artists," *New York Globe and Commercial Advertiser*, 25 November 1904.

Chapter Eight

1. McEntee to Bayard Taylor, 1 March 1868, quoted in Weiss, *Poetic Landscape*, 25. The following year, McEntee made it as far as Italy, but was forced to give up his plans to travel in Palestine because of a lack of funds. His ambitious but ultimately thwarted exploration of the Holy Land was announced in S. S. C[onant], "Art and Artists," *Galaxy* 6 (July 1868): 141–42.

2. Church's ties to Cole, along with the degree to which his early works are indebted to his teacher, have been explored in Kelly and Carr, *Early Landscapes*, and Kelly, *National Landscape*, chap. 1, to which my discussion of Church's early paintings owes a great deal.

3. See Huntington, *Landscapes*, 28; Huntington, "Church and Luminism: Light for America's Elect," in Wilmerding, *American Light*, 156; and Baigell, "Frederic Church's 'Hooker and Company.'"

4. Thomas Hooker, *The Application of Redemption* (1656), quoted in Bercovitch, *Puritan Origins*, 31; I. W. Stuart, *Hartford in the Olden Times* (1853), quoted in Huntington, *Landscapes*, 28.

5. Cotton Mather, *Wonders of the Invisible World* (1693), quoted in Bercovitch, *Puritan Origins*, 108; Huntington, "Church and Luminism," 186.

6. Christopher Kent Wilson relates this story in "Landscape of Democracy." Kelly (*National Landscape*, 22–24) also discusses the painting's "deeper associations" and provides the interpretation of it, which I have outlined, of a "fusion" of the real and the ideal inherited from Cole.

7. See Katherine Manthorne, Richard S. Fiske, and Elizabeth Nielsen, *Creation and Renewal: Views of Cotopaxi by Frederic Edwin Church* (Washington, D.C.: Smithsonian Institution Press, 1985), and Jeremy Elwell Adamson, "Frederic Church's 'Niagara': The Sublime as Transcendence" (Ph.D. diss., University of Michigan, 1981), epilogue. On the inward shift in postbellum landscape imagery, see Miller, "Everywhere and Nowhere," 220.

8. Church to Heade, 22 January 1868, AAA roll D5, fr. 633. Church's itinerary is easily reconstructed from his correspondence and the diaries that he and his wife

kept while in the Middle East. Typescripts of most of this material are available at Olana State Historic Site, Hudson, New York.

9. Church to Osborn, 18 April 1868, typescript, Olana.

10. Morris (see above, chap. 2) related his meeting with the artist in *Freemasonry*, 370.

11. Church to Heade, 22 January 1868, AAA roll D5, fr. 632. A "Church" was listed by Dodge in his account books as having donated to the college in 1868. See Penrose, *That They May Have Life*, 23. One of Church's patrons, Morris K. Jesup, was also an early contributor.

12. Middle East diary of Isabel M. C. Church, typescript, Olana. Frederic Church was well known in American art circles for his piety. He and his wife were mocked on one occasion in 1873 by Jervis McEntee, who, after being asked to the theater by them, wrote in his diary, "I thought they only went to prayer meetings." ("Jervis McEntee's Diary," *Archives of American Art Journal* 8 [July–October 1968]: 18.)

13. Church to Osborn, 6 January 1868, typescript, Olana.

14. Church to Osborn, 29 September and 29 July 1868, typescript, Olana.

15. Convulsions were "needed" to break up the otherwise "uninterrupted span of epochs" of Darwin's astonishingly long account of evolutionary change. See Manthorne, *Tropical Renaissance*, 79, 117. The standard and pioneering treatments of the subject of Church and science are found throughout Huntington, *Landscapes*, and Novak, *Nature and Culture*. Novak writes of Church's generation of landscape painters, "If science could help them, they eagerly accepted its aid. To assume a scientific attitude towards nature, to read its 'manner and method' through the lens of science, was, in this sense, a religious act" (54).

16. Macmillan, *Bible Teachings in Nature*, vi–vii.

17. Eugene Benson, "Pictures in the Pri-

vate Galleries of New York," *Putnam's Magazine* 6 (July 1870): 84.

18. Stephen Jay Gould, "Church, Humboldt, and Darwin: The Tension and Harmony of Art and Science," in Kelly et al., *Frederic Edwin Church*, 106.

19. Huntington ("Church and Luminism") has considered the import of both Bushnell and McCosh on Church. James Collins Moore noted the marginalia in the artist's copy of Geikie in "Storm and the Harvest," 31–32.

20. See Kelly, *National Landscape*, 75, and Gerald L. Carr, *Frederic Edwin Church: The Icebergs* (Dallas, Tex.: Dallas Museum of Fine Arts, 1980), 59.

21. Church described the completed work as a "3 footer" in a letter to Osborn from Rome, 4 November 1868 (typescript, Olana).

22. De Lancey to Church, 27 April 1868, Olana.

23. When at the Vose Galleries, Boston, in the late 1960s, *Ruins at Baalbek* was known by the more plausible title *Mountains of Lebanon*. The ancient city of Baalbek is situated near the present border of Lebanon and Syria and is not close to any large body of water. The water in fig. 75 is undoubtedly the "stretch of the Mediterranean" that de Lancey considered such a happy addition to the work (de Lancey to Church, 27 December 1868, Olana).

24. Church to Osborn, 29 September 1868, typescript, Olana; de Lancey to Church, 27 December 1868, Olana. In a subsequent letter to Osborn, Church offered to paint his friend a "Syrian" picture, "ruins, Arabs, goats and all," thus enumerating the elements he thought most necessary for a successful treatment (Church to Osborn, 9 November 1868, typescript, Olana).

25. The exhibitions took place at the Century Club, Goupil's Gallery, the Brooklyn Art Association, and the Chicago Academy of Fine Arts. *Anti-Lebanon* has

been known by at least six different titles (including *Valley of Lebanon, Syrian Landscape,* and *Temple of Bacchus, Baalbek*). I have chosen to use "Anti-Lebanon" because this was the title employed by Church in his correspondence, and by its first owner when it was periodically sent to exhibition. Gerald Carr has devoted the most attention to the specifics of Church's public exhibitions and the success of his considerable promotional apparatus. See his *Icebergs,* chap. 1, and his "Frederic Edwin Church as a Public Figure," in Kelly and Carr, *Early Landscapes,* 1–30.

26. Records in the Kennedy Galleries, New York, identify the "Mr. Borthwick" of Church's letters as Cunningham Borthwick, an English railroad entrepreneur who probably had business dealings with Osborn.

27. Church to Osborn, 29 September 1868 and 1 January 1869, typescript, Olana.

28. On Frère, see Stevens, *Orientalists,* 133.

29. "Church's Pictures of the Orient," *Chicago Tribune,* 12 December 1869.

30. See Kelly, *National Landscape,* 115, and Sweeney, "'Endued with Rare Genius,'" 56. Cole's long poem "The Lament of the Forest" is published in *Thomas Cole's Poetry,* ed. Marshall B. Tymn (York, Penn.: Liberty Cap Books, 1972), 107–12.

31. See Miller, "Imperial Republic," 85–101, and Parry, *Art of Thomas Cole,* 144.

32. The sketch for this section of entablature is at the Cooper-Hewitt Museum (acc. no. 1917-4-581). A photograph of the same oversized block is also preserved at Olana.

33. *Damascus* was owned by the wealthy politician William Walter Phelps; it was the most notable picture in the collection at his New Jersey estate, Teaneck Grange. The painting was destroyed in 1888 when a gas explosion burned the house to the ground. See Hugh M. Herrick, *William Walter Phelps: His Life and Public Services* (New York: Knickerbocker, 1904), 175, 194–95. The destruction of *Damascus* was mentioned in the *Critic* (19 May 1888): 248.

34. Church to Osborn, 13 January 1868, typescript, Olana.

35. Clemens, *Innocents Abroad,* 361, 369.

36. "Letter from Church, the Artist," *New York Evening Post,* 15 February 1869.

37. Manthorne cites Melrose's *Morning in the Andes* (1870) as evidence of the influence of Church's *Heart of the Andes* (*Tropical Renaissance,* 56), and another work by the artist, entitled *The Oxbow* (Christie's, New York, 4 December 1987), mimics Cole's famous canvas. Born in Scotland, Melrose (1836–1901) was based in New York and New Jersey in the decades after the Civil War. Manthorne found no evidence that Melrose ever traveled to South America, and I have located no trace of his presence in the Holy Land. His *Sea of Galilee* (1880, Sotheby's, New York, 16 October 1974) and *Jerusalem and Mount of Olives from the Road to Bethany* (Christie's, New York, 21 May 1991) nevertheless argue for more than a passing familiarity with Palestine.

38. "Mr. Church's Damascus," *London Morning Post,* 24 June 1869. Longfellow's comment is related in Church to Osborn, 1 January 1869, typescript, Olana.

39. "Church's View of Damascus," *Art Journal* (London) 21 (June 1869): 194.

40. Herrick, *William Walter Phelps,* 70.

41. "The Academy of Design," *New York Tribune,* 15 April 1870, and "Church's Pictures of the Orient." The mention of a work by George Inness likely refers to his *New Jerusalem,* a lost painting that is known to have been exhibited in Boston in 1867 at De Vrie's Gallery (see "Inness," *Art Journal* [Chicago] 1 [15 November 1867]: 16).

42. De Lancey to Church, 27 December 1868, Olana. In a letter to the artist J. F. Weir (8 June 1871, typescript, Olana), Church expressed his hope that the owner of *Jerusalem* would allow it to be shown in New Haven, where his *Damascus* was also to be exhibited.

43. Petra Diary, 8 February 1868, typescript, Olana.

44. Warren, *Underground Jerusalem,* 355.

45. Other than its own "Statements" and "Bulletins" published in the 1870s, the best sources on the American organization are Moulton, "American Palestine Exploration Society," and MacAdam, *Studies*, 234–38, 257–76.

46. Church is also listed in the society's statements as a contributor, along with such members of his patron group as William E. Dodge, Jr., Cyrus W. Field, and Morris K. Jesup. Further evidence of his involvement is found at Olana, where his collection of Holy Land photographs includes rare examples of prints from one of the society's expeditions, a series issued in 1876.

47. Appleton, *Syrian Sunshine*, 228; Thompson, "Concluding Appeal," 34, 35.

48. Stanley, *Sinai and Palestine*, 186. A marginal comment penciled in the painter's hand, on page 98 of Church's copy of *Sinai and Palestine* (at Olana), indicates that he read the book carefully.

49. Middle East diary of Isabel Church, 28 March 1868, typescript, Olana.

50. Church to Osborn, 18 April 1868, typescript, Olana.

51. M. Knoedler to Church, 22 May 1868, typescript, Olana. While *Jerusalem* is dated 1870, correspondence at Olana indicates that Church was still putting on finishing touches up until its opening in March 1871. Helpful bibliographic data is found in Gerald L. Carr's catalogue entry on the painting, in Stevens, *Orientalists*, 122.

52. Diary entry of 18 April 1875, published in "Jervis McEntee's Diary, 1874–1876," 6.

53. "'Jerusalem.' The Latest Important Work of Frederick [sic] E. Church," *New York Evening Mail*, 31 March 1871.

54. "Art Notes," *Appleton's Journal* 5 (10 June 1871): 688, and "The Exhibition of the Hartford Art Association," *Hartford Evening Post*, 6 June 1872. According to an obituary, Church shared the opinion of the *Evening Mail* critic, considering *Jerusalem* "his finest work." See "Frederic Edwin Church," *Hart-*

ford Daily Courant, 9 April 1900. *Jerusalem* was exhibited in Church's native city, Hartford, because it had been purchased by one of its wealthiest residents, Timothy Mather Allyn, a dry goods merchant of Unitarian/Congregationalist background.

55. "Church's Jerusalem," *New York Tribune*, 31 March 1871; "Church's Jerusalem," *New York World*, 2 April 1871; and "Mr. Church's Jerusalem," *New York Times*, 2 April 1871.

56. "'Jerusalem,'" *New York Evening Mail*.

57. Tuckerman, referring to *The Andes of Ecuador* (1855, Reynolda House, Winston-Salem, North Carolina), is quoted in Novak, *Nature and Culture*, 38. For Eliade on these aspects of sacred space, see his *Sacred and the Profane*, 35, 63, and "Sacred Architecture and Symbolism," in Apostolos-Cappadona, *Symbolism*, 109–10. One of the few scholars to look thoughtfully at the transcendent structure of Church's *Jerusalem* is John R. Peters-Campbell, in his "Big Picture," 138–39.

58. Bermingham, *Landscape and Ideology*, 123.

59. Church to Palmer, 10 March 1868, Albany Institute of History and Art, typescript, Olana; Petra diary, 20 February 1868, typescript, Olana; and "Letter from Church, the Artist."

60. Petra diary, 22 and 23 February 1868, typescript, Olana; and Church to Osborn, 21 January, 8 August, and 21 November 1870, typescript, Olana.

61. Church to Osborn, 1 April 1868, typescript, Olana.

62. That Church chose 1874 as the year for his last major exhibition at the academy was fortuitous. The Hanging Committee was unusually conservative and tended to favor the older generation of artists. Consequently, *El Khasné, Petra* was hung in a place of honor on the line. See Lois Marie Fink and Joshua C. Taylor, *Academy: The Academic Tradition in American Art* (Washington, D.C.: Smithsonian Institution

Press, 1975), 73–75, and the Jervis McEntee diary, 7 April 1874, AAA roll D180.

63. "The Academy of Design," *New York Times*, 13 April 1874; "National Academy of Design," *New York World*, 27 April 1874; "The Exhibition of the Academy of Design," *New York Sun*, 15 April 1874. For a bibliography of reviews of the painting, see Gerald L. Carr's catalogue entry in Stevens, *Orientalists*, 122.

64. "Church's Picture of the City of Petra," *Chicago Tribune*, 6 March 1875; DeHass, *Buried Cities Recovered*, 106; "The Academy of Design, Some of the Gems of the Present Exhibition, The Hanging Committee's Work," *New York Herald*, 20 April 1874. An earlier instance of the use of Petra as a warning against societal evil is found in the poem "The Desolation of Edom," *Knickerbocker* 41 (June 1853): 496.

65. "Church's Brilliant View of the Rock-Hewn Treasure-House of Pharaoh at Petra," *Chicago Evening Journal*, 6 March 1875; "Church's Picture of the City of Petra." I illustrate Church's oil sketch for these figures, as they are difficult to see in photographic details of the painting itself.

66. De Forest, *Oriental Acquaintance*, 267.

67. The incident took place in 1882 and is recounted in Edward L. Wilson, *In Scripture Lands*, 115–16.

68. See the analyses of similar verbal and visual structures in Miller, *Dark Eden*, 35, 172–73.

69. There were likely no friends of Church, particularly late in life, who were closer to the artist—intellectually, religiously, emotionally—than Osborn and his family. The ever acerbic Jervis McEntee recorded their similarity of outlook in his diary, noting, "I think one trouble with Church and the Osborns, too, perhaps, is that they are too heavily weighted with their Presbyterian strictures to have a very good time" (quoted in Huntington, "Church and Luminism," 160).

70. Gerald L. Carr has discussed the re-

curring column in *Sunrise in Syria* and several other Middle Eastern works by the artist, relating them to landscapes by Claude Lorraine and Church's experience of Roman ruins ("Frederic Edwin Church and Italy," in *The Italian Presence in American Art, 1860–1920*, ed. Irma B. Jaffe [New York: Fordham University Press, 1992], 23–42).

71. "Art Notes," *Appleton's Journal* 10 (27 December 1873): 827, and "Fine Arts. Pictures at the Century," *New York Daily Tribune*, 9 December 1873.

72. The problem of the spectator's point of view in Church's South American landscapes, and the resulting "physical and psychological detachment," is discussed in Manthorne, *Tropical Renaissance*, 6.

73. See Kelly, *National Landscape*, 140 n. 36.

74. Church to John D. Champlin, 11 September 1885, AAA roll DDU 1, fr. 116. Franklin Kelly made the comparison with *A Composition* in Kelly et al., *Frederic Edwin Church*, 67.

75. Martin Christadler, "Romantic Landscape Painting in America: History as Nature, Nature as History," in Gaehtgens and Ickstadt, *American Icons*, 110.

76. Thomson, *Land and the Book*, 1:vii; and DeHass, *Buried Cities Recovered*, 24.

77. Clearly derived from the same Syrian oil sketch as *Anti-Lebanon* (see fig. 78), this later version is nevertheless known today by the title *Moonrise in Greece*.

78. Husch, "'Something Coming,'" 338–39.

79. See Moore, "Storm and the Harvest," 99.

80. Church's comment on science is found in a letter to Thomas G. Appleton, 1 May 1883, typescript, Olana. The visitor to Olana was Kate Bradbury, writing to an unidentified correspondent (typescript, Olana).

81. "The Goupil Gallery," *New York World*, 25 April 1878; and Benjamin, *Art in America*, 83.

82. Benjamin, *Art in America*, 81.

83. Roger B. Stein's probing consideration of Olana sheds light on this subject in "Artifact as Ideology," 24–25.

EPILOGUE

1. MacChesney, "Poet-Painter of Palestine."

2. Tanner, "Story of an Artist's Life," 11774. See also Mosby, Sewell, and Alexander-Minter, *Henry Ossawa Tanner*.

3. Letter-Journal of Sanford R. Gifford, 25 April 1869, AAA roll D21.

4. Gifford's remarkable social and intellectual milieu is discussed at some length in Weiss, *Poetic Landscape*, chap. 2; see also p. 139.

5. Letter-Journal of Sanford R. Gifford, 22 January 1869, AAA roll D21.

6. Gifford, paraphrased by Worthington Whittredge, is quoted in Weiss, *Poetic Landscape*, 164–65.

7. See Lewis, *Lockwood de Forest*, for information on de Forest's career, religious views, relationship to Church, and interest in Eastern cultures.

8. The murals are considered in detail in Kingsbury, "John Singer Sargent" and "Sargent's Murals."

9. Olson, *John Singer Sargent*, 9, 84 (quoting Violet Paget).

10. La Farge, quoted in James L. Yarnall, "John La Farge and Henry Adams in Japan," *American Art Journal* 21, no. 1 (1989): 67.

11. Lovell, *Venice*, 14, 95, 96. See also Lovell's sensitive analysis of the structural dynamics of the Venice works in her *A Visitable Past: Views of Venice by American Artists, 1860–1915* (Chicago: University of Chicago Press, 1989), chaps. 4 and 5.

12. Taylor, *Gyre Thro' the Orient*, 266.

13. Ormond, *John Singer Sargent*, 70. Patricia Hills also discusses the Palestinian paintings in "'Painted Diaries': Sargent's Late Subject Pictures," in Hills et al., *John Singer Sargent*, 182–83.

Select Bibliography

Primary Sources

Alden, Isabella M. [Pansy, pseud.]. *Four Girls at Chautauqua.* Boston: D. Lothrop, 1876.

Allen, Lewis F. "Founding of the City of Ararat on Grand Island—by Mordecai M. Noah." *Buffalo Historical Society Publications* 1 (1879): 305–28.

"Ancient Nineveh. A Lecture suggested by the recent discovery of the ruins of that city." *New-York Daily Tribune*, 25 May 1849.

Andrews, Joseph. "Representative Art." *New Jerusalem Magazine* 16 (August 1843): 485–91; 17 (October 1843): 8–12, 88–94.

Appleton, Thomas G. *Syrian Sunshine.* Boston: Roberts Bros., 1877.

"Art Among the Hebrews." *Crayon* 3 (September 1856): 258–63.

Banvard, John. *The Origin of the Building of Solomon's Temple: An Oriental Tradition.* Boston: Howard Gannett, 1880.

"Banvard's Georama." *Home Journal*, 22 January 1853, 2.

Banvard's Historical Landscape of the Sea of Galilee. New York: T. R. Dawley, 1863.

Barclay, James T. *The City of the Great King; or, Jerusalem as it was, as it is, and as it is to be.* Philadelphia: Charles Desilver, 1859.

Barrett, Benjamin F. *A Course of Lectures on the Doctrines of the New Jerusalem Church, As Revealed in the Theological Writings of Emanuel Swedenborg.* New York: privately printed, 1842.

Barrows, John Henry. *James Fairman, The American Artist and Art Lecturer.* Lawrence, Mass., 1878.

Bartlett, William H. *Jerusalem Revisited.* London: A. Hall, Virtue, 1855.

Benjamin, S. G. W. *Art in America: A Critical and Historical Sketch.* New York: Harper and Bros., 1880.

――――. "Fifty Years of American Art, 1828–1878: II." *Harper's New Monthly Magazine* 59 (September 1879): 487–92.

Biographical Sketch of Col. James Fairman, A.M. . . . London: E. W. Allen, 1880.

Bliss, Frederick Jones. *The Development of Palestine Exploration.* London: Hodder and Stoughton, 1906.

Bryant, William Cullen. *Letters from the East.* New York: G. P. Putnam and Son, 1869.

Bryant, William M. *Philosophy of Landscape Painting.* St. Louis, Mo.: St. Louis News Company, 1882.

Burnet, D. S., comp. *The Jerusalem Mission under the Direction of the American Christian Missionary Society.* 1853. Reprint, New York: Arno, 1977.

Campbell, Alexander. *The Christian System.* Cincinnati, Ohio: H. S. Bosworth, 1866.

C[ampbell], A[lexander]. "Paintings from the Holy Land." *Millennial Harbinger* 3 (August 1860): 455–62.

"Catherwood's Panoramas." *Knickerbocker* 12 (July 1838): 84–85.

Champney, Elizabeth W. *Three Vassar Girls in the Holy Land.* Boston: Estes and Lauriat, 1892.

Clemens, Samuel. *The Innocents Abroad; or, The New Pilgrims' Progress.* New York: Library of America, 1984.

――――. *Traveling with the Innocents Abroad: Mark Twain's Original Reports from Europe and the Holy Land.* Edited by Daniel M. McKeithan. Norman: University of Oklahoma Press, 1958.

"A Crichton of the Brush." *Art Amateur* 6 (January 1882): 24.

Danforth, John. *The Vile Prophanations of Prosperity by the Degenerate Among the People of God. . . .* Boston: Samuel Phillips, 1704.

Day, F. Holland. "Sacred Art and the Camera." *Photogram* 6 (February 1899): 37–38.

The Dead Sea and the Ruins of Sodom and Gomorrah; including also a Description of Troye's Painting of the Dead Sea. New York: W. A. Townsend, 1858.

"The Dead Sea, Sodom, and Gomorrah." *Harper's New Monthly Magazine* 10 (January 1855): 187–93.

de Forest, John William. *Oriental Acquaintance; or, Letters from Syria.* New York: Dix, Edwards, 1865.

DeHass, Frank S. *Buried Cities Recovered; or, Explorations in Bible Lands.* Philadelphia: Bradley, 1887.

Description of a View of the City of Jerusalem and the Surrounding Country. Boston: Perkins and Marvin, 1837.

Dictionary of Correspondences, Representatives, and Significations, Derived from the Word of the Lord. Extracted from the Writings of Emanuel Swedenborg. Boston: Otis Clapp, 1841.

Dodge, D. Stuart. "Visit to Petra." *New York Evangelist,* 23 April 1868.

Dorr, David F. *A Colored Man Round the World.* Cleveland, Ohio: privately printed, 1858.

Dunlap, William. *History of the Rise and Progress of the Arts of Design in the United States.* 2 vols. New York: George P. Scott, 1834.

"Early American Travellers in the Holy Land." *Knickerbocker* 25 (April 1845): 358–59.

Elmendorf, Dwight L. *A Camera Crusade through the Holy Land.* New York: Charles Scribner's Sons, 1912.

Fairman, James. *Essays on Art.* Pittsburgh, Pa.: H. Kleber, 1898.

Geikie, Cunningham. *Hours with the Bible; or, The Scriptures in the Light of Modern Discovery and Knowledge.* 6 vols. New York: James Pott, 1882–84.

"Geology and Revealed Religion." *Knickerbocker* 7 (May 1836): 441–52.

Grand Exhibition of Paintings at the Academy of Fine Arts, in Barclay Street. New York: Vinton, n.d.

Hansen-Taylor, Marie, and Horace E. Scudder, eds. *Life and Letters of Bayard Taylor.* 2 vols. Boston: Houghton, Mifflin, 1885.

Headley, J. T. *Sacred Mountains, Characters, and Scenes in the Holy Land.* New York: E. B. Treat, 1867.

Holmes, Oliver Wendell. "The Stereoscope and the Stereograph." *Atlantic Monthly* 3 (June 1859): 738–48.

"The Holy Land." *Gleason's Pictorial Drawing Room Companion* 7 (December 1854): 388–89.

Hunt, William Holman. "Painting 'The Scapegoat.'" *Contemporary Review* 52 (July 1887): 21–38; (August 1887): 206–20.

Hurlbut, Jesse Lyman. *Manual of Biblical Geography, A Text-Book on the Bible History especially prepared for the use of Students and Teachers of the Bible, and for Sunday School Instruction.* Chicago: Rand, McNally, 1884.

———. *The Story of Chautauqua.* New York: G. P. Putnam's Sons, 1921.

———. *Traveling in the Holy Land through the Stereoscope.* New York: Underwood and Underwood, 1900.

Israel, J., and H. Lundt. *Journal of a Cruize in the U.S. Ship Delaware 74, in the Mediterranean, in the years 1833 & 34, Together with a Sketch of a Journey to Jerusalem.* Mahon, Minorca: Widow Serra and Son, 1835.

Jones, George. *Excursions to Cairo, Jerusalem, Damascus and Balbec from the United States Ship Delaware, During Her Recent Cruise, with an Attempt to Discriminate Between Truth and Error in Regard to the Sacred Places of the Holy City.* New York: Van Nostrand and Dwight, 1839.

Kellogg, Miner K. "Emanuel Swedenborg." *Baltimore Southern Society,* 21 December 1867.

———. "The Geography of Mount Sinai." *Journal of the American Geographical Society of New York* 3 (1873): 379–400.

———. "Miner K. Kellogg: Recollections of New Harmony." Edited by Lorna Lutes Sylvester. Contributed by C. W. Hackensmith. *Indiana Magazine of History* 64 (March 1968): 39–64.

———. *M. K. Kellogg's Texas Journal.* Edited

by Llerena Friend. Austin: University of Texas Press, 1967.

———. "The Position of Mount Sinai Examined." *Literary World* 3 (February 1848): 44–46.

Kent, Charles Foster. *Descriptions of One Hundred and Forty Places in Bible Lands*. New York: Underwood and Underwood, 1900.

King, Arthur. *Looking Forward: A Dream of the United States of the Americas in 1999*. Utica, N.Y.: L. C. Childs and Son, 1899.

Kitto, John. *Scripture Lands; Described in a Series of Historical, Geographical, and Topographical Sketches*. London: Henry G. Bohn, 1850.

Laborde, Léon de. *Journey Through Arabia Petraea*. 2d ed. London: John Murray, 1838.

Landis, John. *Discourses on the Depravity of the Human Family; Particularly applied to this Nation and these Times*. Harrisburg, Pa.: R. S. Elliot, 1839.

Lyell, Charles. *Principles of Geology*. London: J. Murray, 1830.

Lynch, William F. *Commerce and the Holy Land*. Philadelphia: King and Baird, 1860.

———. *Narrative of the United States' Expedition to the River Jordan and the Dead Sea*. Philadelphia: Lea and Blanchard, 1849.

MacChesney, Clara T. "A Poet-Painter of Palestine." *International Studio* 50 (July 1913): xi–xiv.

MacMechen, Thomas R. "Down 'The Pike': The 'Boulevard of Gaiety' at the St. Louis Exposition." *Pacific Monthly* 12 (July 1904): 30–35.

———. *The True and Complete Story of the Pike and Its Attractions*. St. Louis, Mo.: Division of Concessions and Amusements, Louisiana Purchase Exposition, 1904.

Macmillan, Hugh. *Bible Teachings in Nature*. New York: D. Appleton, 1867.

McCosh, James, and George Dickie. *Typical Forms and Special Ends in Creation*. New York: Robert Carter and Bros., 1872.

Melville, Herman. *Clarel: A Poem and Pilgrimage in the Holy Land*. Chicago: Northwestern University Press, 1991.

———. *Journal of a Visit to Europe and the Levant, October 11, 1856–May 6, 1857*. Edited by Howard C. Horsford. Princeton, N.J.: Princeton University Press, 1955.

[Minor, Clorinda]. *Meshullam! or, Tidings from Jerusalem*. Philadelphia: privately printed, 1850.

Morris, Robert, et al. *Bible Witnesses from Bible Lands*. New York: American–Holy Land Exploration, 1874.

———. *Catalogue of Holy Land Cabinets*. Chicago: Hazlitt and Reed, 1868.

———. *Freemasonry in the Holy Land; or, Handmarks of Hiram's Builders*. 1872. Reprint, New York: Arno, 1977.

Newhall, Ebenezer. *Religious Patriotism; or, Attachment to Jerusalem*. Boston: T. R. Marvin, 1830.

"Orientalism." *Knickerbocker* 41 (June 1853): 479–96.

Pictures Painted by James Fairman, A.M., with the Names of Possessors. London and New York, [1879?].

Poole, W. H. *Anglo-Israel; or, The Saxon Race Proved to be the Lost Tribes of Israel*. New York: J. Higgins, 1880.

Prime, William C. *Tent Life in the Holy Land*. New York: Harper and Bros., 1857.

Rapelje, George. *A Narrative of Excursions, Voyages, and Travels, Performed at Different Periods in America, Europe, Asia, and Africa*. New York: West and Trow, 1834.

Rawson, Albert. *The Bible Hand-book*. New York: R. B. Thompson, 1870.

———. "Palestine." *Journal of the American Geographical Society* 7 (1878): 101–13.

"The Recovery of Jerusalem." *Appleton's Journal* 5 (February 1871): 181–85.

Rhodes, Albert. *Jerusalem As It Is*. London: John Maxwell, 1865.

Richards, Alexander Keene [Hadjee, pseud.]. "Arab Horses and Dromedaries for the United States." *New York Spirit of the Times*, 23 August 1856.

Richardson, Robert. *Memoirs of Alexander Campbell*. Philadelphia: J. B. Lippincott, 1871.

Robinson, Edward. *Biblical Researches in Pal-*

estine, Mount Sinai and Arabia Petraea. 3 vols. Boston: Crocker and Brewster, 1841.

Ropes, Joseph. "Lecture on Painting." *New Jerusalem Magazine* 15 (November 1841): 81–93.

Schaff, Philip. *Through Bible Lands: Notes of Travel in Egypt, the Desert, and Palestine.* New York: American Tract Society, 1878.

Smith, Henry B., and Roswell D. Hitchcock. *The Life, Writings and Character of Edward Robinson, D.D., L.L.D.* New York: Anson D. F. Randolph, 1863.

Spencer, Morton W. *The Missing Links; or, The Anglo-Saxons, the Ten Tribes of Israel. . . .* [St. Augustine, Fla. ?]: M. W. Spencer, 1895.

Stanley, Arthur Penrhyn. *Sinai and Palestine in Connection with Their History.* New York: W. J. Widdleton, 1865.

Stephens, John Lloyd. *Incidents of Travel in Egypt, Arabia Petraea, and the Holy Land.* 2 vols. New York: Harper and Bros., 1837.

Streator, Martin Lyman. *The Anglo-American Alliance in Prophecy; or, The Promises to the Fathers.* New Haven, Conn.: Our Race, 1900.

A Summary Exposition of the Creed of the New Jerusalem Church. Manchester, England: Bottomley and Son and Jolley, 1836.

Tanner, Henry O. "The Story of an Artist's Life, Part II." *World's Work* 18 (July 1909): 11769–75.

Taylor, Bayard. *The Lands of the Saracen; or, Pictures of Palestine, Asia Minor, Sicily and Spain.* New York: G. P. Putnam, 1855.

Taylor, Joseph I. *A Gyre Thro' the Orient.* Princeton, N.J.: Republican Book and Job Printing Office, 1869.

Thompson, Joseph P. "American Explorers in Palestine." *Palestine Exploration Society,* no. 1 (July 1871): 5–7.

———. "Concluding Appeal." *Palestine Exploration Society,* no. 1 (July 1871): 34–36.

Thomson, William M. *The Land and the Book; or, Biblical Illustrations drawn from The Manners and Customs, The Scenes and Scenery of the Holy Land.* 2 vols. New York: Harper and Bros., 1859.

Troye's Oriental Paintings. New York. 1858.

Veblen, Thorstein. *The Theory of the Leisure Class: An Economic Study in the Evolution of Institutions.* 1899. Reprint, New York: Modern Library, 1934.

Vincent, John Heyl. *The Chautauqua Movement.* 1885. Reprint, Freeport, N.Y.: Books for Libraries, 1971.

Vincent, John Heyl, and James W. Lee. *Earthly Footsteps of the Man of Galilee, Being Four Hundred Original Photographic Views and Descriptions of the Places Connected with the Earthly Life of Our Lord and his Apostles, Traced with Note Book and Camera, Showing where Christ was born, brought up, baptized, tempted, transfigured and crucified, Together with the scenes of his prayers, tears, miracles and sermons, and also places made sacred by the labors of his Apostles, from Jerusalem to Rome.* St. Louis, Mo.: N.D. Thompson, 1895.

Wakeman, Samuel. *Sound Repentance the Right way to escape deserved Ruine.* Boston: Samuel Green, 1685.

Walker, Charles T. *A Colored Man Abroad: What He Saw and Heard in the Holy Land and Europe.* Augusta, Ga.: J. M. Weigle, 1892.

Warner, Charles Dudley. *In the Levant.* Boston: Jas. R. Osgood, 1877.

Warren, Charles. *Underground Jerusalem.* London: Richard Bentley and Son, 1876.

Warren, Charles, and Charles W. Wilson. *The Recovery of Jerusalem: A Narrative of Exploration and Discovery in the City and the Holy Land.* New York: Appleton, 1871.

Warren, Henry White. *Sights and Insights; or, Knowledge by Travel.* New York: Nelson and Phillips, 1874.

Willis, N. P. *Pencillings by the Way.* 2 vols. Philadelphia: Carey, Lea, and Blanchard, 1836.

Wilson, Edward L. *In Scripture Lands: New Views of Sacred Places.* New York: Charles Scribner's Sons, 1890.

SECONDARY SOURCES

Aamodt, Terrie Dopp, "Righteous Armies, Holy Cause Apocalyptic Imagery, and the Civil War." Ph.D. diss., Boston University, 1986.

Ahlstrom, Sydney E. *A Religious History of the American People*. 2 vols. Garden City, N.Y.: Doubleday, 1975.

Apostolos-Cappadona, Diane, ed. *Symbolism, the Sacred, and the Arts*. New York: Crossroad, 1986.

Avery, Kevin J. "*The Heart of the Andes* Exhibited: Frederic E. Church's Window on the Equatorial World." *American Art Journal* 18, no. 1 (1986): 52–72.

Avery, Kevin J., and Peter L. Fodera. *John Vanderlyn's Panoramic View of the Palace and Gardens of Versailles*. New York: Metropolitan Museum of Art, 1988.

Bachelard, Gaston. *The Poetics of Space*. Boston: Beacon Press, 1969.

Baigell, Matthew. "Frederic Church's 'Hooker and Company': Some Historic Considerations." *Arts Magazine* 56 (January 1982): 124–25.

Balmer, Randall. "Apocalypticism in America: The Argot of Premillennialism in Popular Culture." *Prospects* 13 (1988): 417–33.

Baltz, Trudy. "Pageantry and Mural Painting: Community Rituals in Allegorical Form." *Winterthur Portfolio* 15 (Autumn 1980): 211–28.

Banta, Martha. *Imaging American Women: Ideas and Ideals in Cultural History*. New York: Columbia University Press, 1987.

Baym, Nina. "The Erotic Motif in Melville's *Clarel*." *Texas Studies in Literature and Language* 16 (Summer 1974): 315–28.

Ben-Arieh, Yehoshua. "The Geographical Exploration of the Holy Land." *Palestine Exploration Quarterly* 104 (July–December 1972): 81–92.

———. *The Rediscovery of the Holy Land in the Nineteenth Century*. Detroit, Mich.: Wayne State University Press, 1979.

Bendiner, Kenneth Paul. "David Roberts in the Near East: Social and Religious Themes." *Art History* 6 (March 1983): 67–81.

———. "The Portrayal of the Middle East in British Painting, 1835–1860." Ph.D. diss., Columbia University, 1979.

Benedict, Burton, ed. *The Anthropology of World's Fairs: San Francisco's Panama Pacific International Exposition of 1915*. Berkeley, Calif.: Lowie Museum of Anthropology, 1983.

Bercovitch, Sacvan. *The American Jeremiad*. Madison: University of Wisconsin Press, 1978.

———. *The Puritan Origins of the American Self*. New Haven, Conn.: Yale University Press, 1975.

Bermingham, Ann. *Landscape and Ideology: The English Rustic Tradition, 1740–1860*. Berkeley and Los Angeles: University of California Press, 1986.

Bjelajac, David. *Millennial Desire and the Apocalyptic Vision of Washington Allston*. Washington, D.C.: Smithsonian Institution, 1988.

———. "Washington Allston's Prophetic Voice in Worshipful Song with Antebellum America." *American Art* 5 (Summer 1991): 69–87.

Block, Margaret Beck. *The New Church in the New World*. New York: Holt, 1932.

Boime, Albert. *The Magisterial Gaze: Manifest Destiny and American Landscape Painting c. 1830–1865*. Washington, D.C.: Smithsonian Institution Press, 1991.

Boyle, Richard J. "Miner Kilbourne Kellogg." *Cincinnati Art Museum Bulletin* 8 (February 1966): 17–23.

Branham, Joan R. "Sacred Space under Erasure in Ancient Synagogues and Early Churches." *Art Bulletin* 74 (September 1992): 375–94.

Brey, William. "William H. Rau's Photographic Experience in the East." *Stereo World* 11 (May–June 1984): 4–11.

Bronkhurst, Judith. "'An Interesting Series of Adventures to Look Back Upon': William

Holman Hunt's Visit to the Dead Sea in November 1854." In *Pre-Raphaelite Papers*, edited by Leslie Parris, 111–25. London: Tate Gallery, 1984.

Broshi, Magen. "Religion, Ideology, and Politics and Their Impact on Palestinian Archaeology." *Israel Museum Journal* 6 (Spring 1987): 17–32.

Caesar, Terry. "'Counting the Cats in Zanzibar': American Travel Abroad in American Travel Writing to 1914." *Prospects* 13 (1988): 95–134.

Çelik, Zeynep. *Displaying the Orient: Architecture of Islam at Nineteenth-Century World's Fairs.* Berkeley: University of California Press, 1992.

Chamberlain, George Walter. "A New England Crusade." *New England Magazine* 36 (April 1907): 195–98.

Cherry, Conrad, ed. *God's New Israel: Religious Interpretations of American Destiny.* Englewood Cliffs, N.J.: Prentice-Hall, 1971.

Coleman, J. Winston. *Edward Troye, Animal and Portrait Painter.* Lexington, Ky.: Winburn, 1958.

Crary, Jonathan. *Techniques of the Observer: On Vision and Modernity in the Nineteenth Century.* Cambridge, Mass.: MIT Press, 1990.

Darrah, William C. *The World of Stereographs.* Gettysburg, Pa.: Darrah, 1977.

Davies, W. D. "Israel, the Mormons, and the Land." In *Reflections on Mormonism: Judaeo-Christian Parallels*, edited by Truman G. Madsen, 79–98. Provo, Utah: Religious Studies Center, Brigham Young University, 1978.

Davis, John. "Frederic Church's 'Sacred Geography.'" *Smithsonian Studies in American Art* 1 (Spring 1987): 78–96.

———. "Holy Land, Holy People? Photography, Semitic Wannabes, and Chautauqua's Palestine Park." *Prospects* 17 (1992): 241–71.

Davis, Moshe, ed. *Israel: Its Role in Civilization.* New York: Harper and Bros., 1956.

———. *With Eyes toward Zion.* New York: Arno, 1977.

———. *With Eyes toward Zion—II: Themes and Sources in the Archives of the United States, Great Britain, Turkey, and Israel.* New York: Praeger, 1986.

Davis, Moshe, and Yehoshua Ben-Arieh, eds. *With Eyes toward Zion—III: Western Societies and the Holy Land.* New York: Praeger, 1991.

Divine, Donna Robinson. *Politics and Society in Ottoman Palestine: The Arab Struggle for Survival and Power.* Boulder, Colo.: Lynne Rienner, 1994.

Doan, Ruth Alden. *The Miller Heresy, Millennialism, and American Culture.* Philadelphia: Temple University Press, 1987.

Eames, S. Morris. *The Philosophy of Alexander Campbell.* Bethany, W. Va.: Bethany College, 1966.

Eliade, Mircea. *Patterns in Comparative Religion.* New York: Meridian, 1958.

———. *The Sacred and the Profane: The Nature of Religion.* San Diego, Calif.: Harcourt Brace Jovanovich, 1959.

Fales, F. M., and B. J. Hickey, eds. *Austen Henry Layard: Tra L'Oriente e Venezia.* Rome: "L'Erma" di Bretschneider, 1987.

Field, James A., Jr. *America and the Mediterranean World, 1776–1882.* Princeton, N.J.: Princeton University Press, 1969.

Finnie, David H. *Pioneers East: The Early American Experience in the Middle East.* Cambridge, Mass.: Harvard University Press, 1967.

Flint, Janet A. *The Way of Good and Evil: Popular Religious Lithographs of Nineteenth-Century America.* Washington, D.C.: National Collection of Fine Arts, 1972.

Gaehtgens, Thomas W., and Heinz Ickstadt, eds. *American Icons: Transatlantic Perspectives on Eighteenth- and Nineteenth-Century American Art.* Santa Monica, Calif.: Getty Center for the History of Art and the Humanities, 1992.

Gifford, Carey. "Space and Time as Themes in Alexander Campbell." In *The Coming Kingdom: Essays in American Millennialism and Eschatology*, edited by M. Darrol

Bryant and Donald W. Dayton, 111–30. Barrytown, N.Y.: New Era Books, 1983.

Gillispie, Charles Coulston. *Genesis and Geology*. Cambridge, Mass.: Harvard University Press, 1951.

Goldman, Richard H. "Charles Bierstadt, 1819–1903: American Stereograph Photographer." Master's thesis, Kent State University, 1974.

Goldman, Stanley A. "Melville's *Clarel*: The Hiddenness and Silence of God." Ph.D. diss., Emory University, 1987.

Gould, Stephen Jay. *Ever Since Darwin: Reflections in Natural History*. New York: W. W. Norton, 1977.

Green, Rayna. "The Tribe Called Wannabee: Playing Indian in America and Europe." *Folklore* 99 (1988): 30–55.

Greene, Mott. *Geology in the Nineteenth Century*. Ithaca, N.Y.: Cornell University Press, 1982.

Grose, Peter. *Israel in the Mind of America*. New York: Knopf, 1984.

Gunn, Giles, ed. *The Bible and American Arts and Letters*. Philadelphia: Fortress, 1983.

Handy, Robert T. "Studies in the Interrelationships between America and the Holy Land: A Fruitful Field for Interdisciplinary and Interfaith Cooperation." *Journal of Church and State* 13 (Spring 1971): 283–301.

———, ed. *The Holy Land in American Protestant Life, 1800–1948: A Documentary Reader*. New York: Arno, 1981.

Hanners, John. "The Adventures of an Artist: John Banvard (1815–1891) and His Mississippi Panorama." Ph.D. diss., Michigan State University, 1979.

———. "'Vicissitude and Woe': The Theatrical Misadventures of John Banvard." *Theatre Survey* 23 (November 1982): 177–88.

Hastings, Tom. "Said's *Orientalism* and the Discourse of (Hetero)sexuality." *Canadian Review of American Studies* 23 (Fall 1992): 127–47.

Higham, John. *Strangers in the Land: Patterns of American Nativism, 1860–1925*. 2d ed.

New Brunswick, N.J.: Rutgers University Press, 1988.

Hills, Patricia, et al. *John Singer Sargent*. New York: Whitney Museum of American Art, 1986.

Hirst, Robert H., and Brandt Rowles. "William E. James's Stereoscopic Views of the *Quaker City* Excursion." *Mark Twain Journal* 22 (Spring 1984): 15–33.

Hovenkamp, Herbert. *Science and Religion in America, 1800–1860*. Philadelphia: University of Pennsylvania Press, 1978.

Hughes, Richard T., and C. Leonard Allen. *Illusions of Innocence: Protestant Primitivism in America, 1630–1875*. Chicago: University of Chicago Press, 1988.

Huntington, David C. "Frederic Church's *Niagara*: Nature and the Nation's Type." *Texas Studies in Literature and Language* 25 (Spring 1983): 100–138.

———. *The Landscapes of Frederic Edwin Church: Vision of an American Era*. New York: George Braziller, 1966.

Husch, Gail E. "'Something Coming': Prophecy and American Painting, 1848–1854." Ph.D. diss., University of Delaware, 1992.

Hyde, Ralph. *Panoramania! The Art and Entertainment of the "All-Embracing" View*. London: Barbican Art Gallery, 1988.

Hyman, Linda. "*The Greek Slave* by Hiram Powers: High Art as Popular Culture." *Art Journal* 35 (Spring 1976): 216–23.

Kark, Ruth. "Jerusalem in New England." *Ariel* 69 (1987): 52–61.

———. "Millenarism and Agricultural Settlement in the Holy Land in the Nineteenth Century." *Journal of Historical Geography* 9 (1983): 47–62.

Kasson, Joy S. *Marble Queens and Captives: Women in Nineteenth-Century American Sculpture*. New Haven, Conn.: Yale University Press, 1990.

Kearney, Helen McCready. "American Images of the Middle East, 1824–1924: A Century of Antipathy." Ph.D. diss., University of Rochester, 1976.

Kelly, Franklin. *Frederic Edwin Church and the*

National Landscape. Washington, D.C.: Smithsonian Institution Press, 1988.

Kelly, Franklin, and Gerald L. Carr. *The Early Landscapes of Frederic Edwin Church, 1845–1854.* Fort Worth, Tex.: Amon Carter Museum, 1987.

Kelly, Franklin, et al. *Frederic Edwin Church.* Washington, D.C.: National Gallery of Art, 1989.

Kingsbury, Martha. "John Singer Sargent: Aspects of His Work." Ph.D. diss., Harvard University, 1969.

———. "Sargent's Murals in the Boston Public Library." *Winterthur Portfolio* 11 (1976): 153–72.

Klatzker, David E. "American Christian Travelers to the Holy Land, 1821–1939." Ph.D. diss., Temple University, 1987.

Lears, T. J. Jackson. *No Place of Grace: Antimodernism and the Transformation of American Culture, 1880–1920.* New York: Pantheon, 1981.

Lewis, Anne Suydam. *Lockwood de Forest: Painter, Importer, Decorator.* Huntington, N.Y.: Heckscher Museum, 1976.

Lichten, Frances. "John Landis, 'Author and Artist and Oriental Tourist.'" *Philadelphia Museum of Art Bulletin* 53 (Spring 1958): 51–53.

Lipman, V. D. *Americans and the Holy Land through British Eyes: 1820–1917.* London: privately printed, 1989.

Lovell, Margaretta M. *Venice: The American View, 1860–1920.* San Francisco: Fine Arts Museums of San Francisco, 1984.

Lowenthal, David, and Martyn J. Bowden, eds. *Geographies of the Mind: Essays in Historical Geosophy in Honor of John Kirtland Wright.* New York: Oxford University Press, 1976.

MacAdam, Henry Innes. *Studies in the History of the Roman Province of Arabia: The Northern Sector.* Oxford: BAR International Series, 1986.

Mackay-Smith, Alexander. *The Race Horses of America, 1832–1872: Portraits and Other Paintings by Edward Trove.* Saratoga Springs, N.Y.: National Museum of Racing, 1981.

Manthorne, Katherine Emma. *Tropical Renaissance: North American Artists Exploring Latin America, 1839–1879.* Washington, D.C.: Smithsonian Institution Press, 1989.

Ma'oz, Moshe, ed. *Studies on Palestine during the Ottoman Period.* Jerusalem: Magnes, 1975.

McAllister, Lester G., and William E. Tucker. *Journey in Faith: A History of the Christian Church (Disciples of Christ).* St. Louis, Mo.: Bethany, 1975.

McDermott, John Francis. *The Lost Panoramas of the Mississippi.* Chicago: University of Chicago Press, 1958.

McGinnis, Karin Hertel. "Moving Right Along: Nineteenth-Century Panorama Painting in the United States." Ph.D. diss., University of Minnesota, 1983.

Mensel, Robert E. "'Kodakers Lying in Wait': Amateur Photography and the Right of Privacy in New York, 1885–1915." *American Quarterly* 43 (March 1991): 24–45.

Metwalli, Ahmed Mohamed. "The Lure of the Levant: The American Literary Experience in Egypt and the Holy Land, a Study in the Literature of Travel, 1800–1865." Ph.D. diss., State University of New York at Albany, 1971.

Meyers, Mary Ann. *A New World Jerusalem: The Swedenborgian Experience in Community Construction.* Westport, Conn.: Greenwood, 1983.

Miles, Margaret R. *Image as Insight: Visual Understanding in Western Christianity and Secular Culture.* Boston: Beacon, 1985.

Miller, Angela. *The Empire of the Eye: Landscape Representation and American Cultural Politics, 1825–1875.* Ithaca, N.Y.: Cornell University Press, 1993.

———. "Everywhere and Nowhere: The Making of the National Landscape." *American Literary History* 4 (Summer 1992): 207–29.

———. "'The Imperial Republic': Narratives of National Expansion in American Art,

1820–1860." Ph.D. diss., Yale University, 1985.

Miller, David C. *Dark Eden: The Swamp in Nineteenth-Century American Culture.* Cambridge: Cambridge University Press, 1989.

————., ed. *American Iconology: New Approaches to Nineteenth-Century Art and Literature.* New Haven, Conn.: Yale University Press, 1993.

Miller, Perry. "The Garden of Eden and the Deacon's Meadow." *American Heritage* 7 (December 1955): 54–61, 102.

Moore, James Collins. "The Storm and the Harvest: The Image of Nature in Mid-Nineteenth-Century American Landscape Painting." Ph.D. diss., Indiana University, 1974.

Morrison, Theodore. *Chautauqua: A Center for Education, Religion, and the Arts in America.* Chicago: University of Chicago Press, 1974.

Mosby, Dewey F., Darrell Sewell, and Rae Alexander-Minter. *Henry Ossawa Tanner.* Philadelphia: Philadelphia Museum of Art, 1991.

Moulton, Warren J. "The American Palestine Exploration Society." *Annual of the American Schools of Oriental Research* 8 (1928): 55–78.

Munsterberg, Marjorie. "Louis de Clercq's *Stations of the Cross.*" *Arts Magazine* 61 (May 1987): 48–53.

Nelson, Truman. "The Puritans of Massachusetts: From Egypt to the Promised land." *Judaism* 16 (1967): 193–206.

Nir, Yeshayahu. *The Bible and the Image: The History of Photography in the Holy Land, 1839–1899.* Philadelphia: University of Pennsylvania Press, 1985.

Nochlin, Linda. "The Imaginary Orient." *Art in America* 71 (May 1983): 118–31, 187–91.

Novak, Barbara. *Nature and Culture: American Landscape and Painting, 1825–1875.* New York: Oxford University Press, 1980.

Odell, George C. D. *Annals of the New York Stage.* 15 vols. New York: Columbia University Press, 1927–49.

O'Doherty, Barbara Novak. "Some American Words: Basic Aesthetic Guidelines, 1825–1870." *American Art Journal* 1 (Spring 1969): 78–91.

Oettermann, Stephan. *Das Panorama: Die Geschichte eines Massenmediums.* Frankfurt am Main: Syndikat, 1980.

Olsen, Stanley. *John Singer Sargent: His Portrait.* London: Macmillan, 1986.

Onne, Eyal. *Photographic Heritage of the Holy Land, 1839–1914.* Manchester, England: Manchester Polytechnic, 1980.

Ormond, Richard. *John Singer Sargent: Paintings, Drawings, Watercolors.* New York: Harper and Row, 1970.

Parry, Ellwood C., III. *The Art of Thomas Cole: Ambition and Imagination.* Newark: University of Delaware Press, 1988.

————. "Thomas Cole and the Problem of Figure Painting." *American Art Journal* 4 (Spring 1972): 66–86.

————. "When a Cole Is Not a Cole: Henry Cheever Pratt's *Moses on the Mount.*" *American Art Journal* 16 (Winter 1984): 34–45.

Parry, Lee. "Landscape Theatre in America." *Art in America* 59 (November–December 1971): 52–61.

Penrose, Stephen B. L., Jr. *That They May Have Life: The Story of the American University of Beirut, 1866–1941.* Princeton, N.J.: Princeton University Press, 1941.

Perez, Nissan N. *Focus East: Early Photography in the Near East (1839–1885).* New York: Abrams, 1988.

Peters-Campbell, John R. "The Big Picture and the Epic American Landscape." Ph.D. diss., Cornell University, 1989.

Raboteau, Albert J. *Slave Religion: The "Invisible Institution" in the Antebellum South.* New York: Oxford University Press, 1978.

Reynolds, Donald M. "The 'Unveiled Soul': Hiram Powers's Embodiment of the Ideal." *Art Bulletin* 59 (September 1977): 394–414.

Richardson, Edgar P. "Records of Art Collectors and Dealers: I. Miner K. Kellogg." *Art Quarterly* 23 (Autumn 1960): 271–78.

Robinson, Mary N. "John Landis, Painter."

Historical Papers and Addresses of the Lancaster County Historical Society 16 (1912): 179–85.

Rogin, Michael Paul. *Subversive Genealogy: The Politics and Art of Herman Melville.* New York: Knopf, 1983.

Rydell, Robert W. *All The World's a Fair: Visions of Empire at American International Expositions, 1876–1916.* Chicago: University of Chicago Press, 1984.

Said, Edward W. *After the Last Sky: Palestinian Lives.* New York: Pantheon, 1986.

———. *Orientalism.* New York: Pantheon, 1978.

———. "Orientalism Reconsidered." *Cultural Critique* 1 (Fall 1985): 89–107.

Schrock, Nancy Carlson. "Joseph Andrews, Engraver: A Swedenborgian Justification." *Winterthur Portfolio* 12 (1977): 165–82.

Silberman, Neil Asher. *Digging for God and Country: Exploration, Archaeology and the Secret Struggle for the Holy Land, 1799–1917.* New York: Knopf, 1982.

Smith, Ophia D. "Adam Hurdus and the Swedenborgians in Early Cincinnati." *Ohio State Archaeological and Historical Quarterly* 53 (1944): 106–34.

———. "The Beginnings of the New Jerusalem Church in Ohio." *Ohio State Archaeological and Historical Quarterly* 61 (1952): 235–61.

Solomon-Godeau, Abigail. *Photography at the Dock: Essays on Photographic History, Institutions, and Practices.* Minneapolis: University of Minnesota Press, 1991.

Sontag, Susan. *On Photography.* New York: Dell, 1977.

Staley, Allen. *The Pre-Raphaelite Landscape.* London: Oxford University Press, 1973.

Stein, Roger B. "Artifact as Ideology: The Aesthetic Movement in Its American Cultural Context." In *In Pursuit of Beauty: Americans and the Aesthetic Movement*, 23–51. New York: Metropolitan Museum of Art, 1986.

Stevens, MaryAnne, ed. *The Orientalists: Delacroix to Matisse. The Allure of North Africa and the Near East.* Washington, D.C.: National Gallery of Art, 1984.

Sweeney, J. Gray. "'Endued with Rare Genius': Frederic Edwin Church's *To the Memory of Cole.*" *Smithsonian Studies in American Art* 2 (Winter 1988): 44–71.

Taylor, Joshua. "The Religious Impulse in American Art." In *Art, Creativity, and the Sacred*, edited by Diane Apostolos-Cappadona, 95–104. New York: Crossroad, 1984.

———. *William Page: The American Titian.* Chicago: University of Chicago Press, 1957.

Thompson, D. Dodge. "American Artists in North Africa and the Middle East, 1797–1914." *Antiques* 126 (August 1984): 303–12.

Thompson, Lawrance. *Melville's Quarrel with God.* Princeton, N.J.: Princeton University Press, 1952.

Trachtenberg, Alan. "'We Study the Word and Works of God': Chautauqua and the Sacralization of Culture in America." *Henry Ford Museum and Greenfield Village Herald* 13 (1984): 3–11.

Truettner, William H., ed. *The West as America: Reinterpreting Images of the Frontier, 1820–1920.* Washington, D.C.: Smithsonian Institution Press, 1991.

Tuan, Yi-Fu. *Topophilia.* Englewood Cliffs, N.J.: Prentice-Hall, 1974.

Tuveson, Ernest Lee. *Redeemer Nation: The Idea of America's Millennial Role.* Chicago: University of Chicago Press, 1968.

Urry, John. *The Tourist Gaze: Leisure and Travel in Contemporary Societies.* London: Sage, 1990.

Vester, Bertha Spafford. *Our Jerusalem: An American Family in the Holy City, 1881–1949.* Beirut: Middle East Export Press, 1950.

Vogel, Lester I. *To See a Promised Land: Americans and the Holy Land in the Nineteenth Century.* University Park: Pennsylvania State University Press, 1993.

———. "Zion as Place and Past: An American Myth, Ottoman Palestine in the American Mind Perceived through Protestant Con-

sciousness and Experience." Ph.D. diss., George Washington University, 1984.

von Hagen, Victor Wolfgang. *F. Catherwood, Architect-Explorer of Two Worlds.* Barre, Mass.: Barre, 1968.

———. "'F. CATHERWOOD Archᵗ' (1799–1854)." *New-York Historical Society Quarterly* 30 (January 1946): 17–29.

———. *Maya Explorer: John Lloyd Stephens and the Lost Cities of Central America and Yucatán.* Norman: University of Oklahoma Press, 1947.

———. "Mr. Catherwood's Panorama." *Magazine of Art* 40 (April 1947): 143–46.

Walker, Franklin. *Irreverent Pilgrims: Melville, Browne, and Mark Twain in the Holy Land.* Seattle: University of Washington Press, 1974.

Wallach, Alan Peter. "The Ideal American Artist and the Dissenting Tradition: A Study of Thomas Cole's Popular Reputation." Ph.D. diss., Columbia University, 1973.

———. "Making a Picture of the View from Mount Holyoke." *Bulletin of the Detroit Institute of Arts* 66 (1990): 35–45.

Walsh, James P. "Holy Time and Sacred Space in Puritan New England." *American Quarterly* 32 (Spring 1980): 79–95.

Waterfield, Gordon. *Layard of Nineveh.* London: John Murray, 1963.

Weiss, Ila. *Poetic Landscape: The Art and Experience of Sanford R. Gifford.* Newark: University of Delaware Press, 1987.

West, Robert Frederick. *Alexander Campbell and Natural Religion.* New Haven, Conn.: Yale University Press, 1948.

Wilmerding, John, et al. *American Light: The Luminist Movement, 1850–1875.* Washington, D.C.: National Gallery of Art, 1980.

Wilson, Christopher Kent. "The Landscape of Democracy: Frederic Church's *West Rock, New Haven.*" *American Art Journal* 18, no. 3 (1986): 20–39.

Wilson, William E. *The Angel and the Serpent: The Story of New Harmony.* Bloomington: Indiana University Press, 1964.

Wright, John Kirtland. *Human Nature in Geography.* Cambridge, Mass.: Harvard University Press, 1966.

Wunder, Richard P. *Hiram Powers: Vermont Sculptor, 1805–1873.* Vol. 1, *Life.* Newark: University of Delaware Press, 1991.

Yapp, M. E. *The Making of the Modern Near East, 1792–1923.* London: Longman, 1987.

Index

Abbott, Henry, 224n35
Abd ul-Mejid, 8
Adams, George Jones, 39–41, *39*, 49, 223n29
African-Americans, 22–23
African Methodist Episcopal Church, 209
Albany, N.Y., 56
Albion College, 89
Albright, William F., 36
Alden, Isabella, 90, 92
Alexandria, 28, 30, 105, 172, 227n30
Allston, Washington, 19–20, 104, 220n19
 WORKS: *Belshazzar's Feast*, 19–20, *19*
Allyn, Timothy Mather, 241n54
American Academy of the Fine Arts, 56–57
American Board of Commissioners for Foreign
 Missions, 28, 47, 64
American Christian Missionary Society, 146
American Colony in Jerusalem, 33, *35*, 222n16
American Ethnological Society, 112–13, 115
American flag, 33
American Geographic and Statistical Society, 71, 116,
 119
American Palestine Exploration Society, 36, 186–87,
 195, 225n3, 241n46
American School of Oriental Research, 36
American Society of Painters in Water Colors, 152
American University of Beirut, 173, 185, 239n11
Andover Theological Seminary, 28, 35–36
Andrews, Joseph, 231n5
Anshutz, Thomas, 231n5
Antwerp, 133
Appleton, Thomas G., 4, 187
Athens, 204, 211
Avery, Kevin J., 226n19

Baalbek, 33, 109, 173, 182, 204, 239n23
Babylon, 20
Bachelard, Gaston, 92
Bain, Robert E. M., 77–88, 96, 200, 208, 229n9
 WORKS: *The Arch of the Ecce Homo, Jerusalem*, 80, *80*;
 Ancient Bronze Doors, Tiberias, 84–86, *85*; *Dervish
 Beggars*, 87–88, *88*; *Flocks Near the Pit into Which
 Joseph Was Thrown by His Brethren*, 83–84, *84*; *Inn
 of the Good Samaritan*, 78, *79*; *The Lower Pool of
 Solomon*, 80–81, *81*; *Military Mosque, Damascus*, 87;
 Mount Tabor, 78, *79*; *Rock upon Which Jesus Leaned*,

 82; *Ruins of the Synagogue at Capernaum*, 200, *201*;
 The Spot where Christ Prayed—Garden of Gethsemane,
 82–83, *82*, 96; *The Tower of Jezreel*, 84, *85*; *Wall of
 Tiberias*, 87; *A Woman of Samaria*, 86–87, *86*
Baltimore, Md., 70, 115–16, 125
Banvard, John, 34, 63, 65–72, 133, 159, 167, 208,
 227n28, n30, 228n32, n35, n40
 WORKS: panorama of Jerusalem, 66, 227n30;
 panorama of the Holy Land, 34, 65–70, 228n32,
 n35; panorama of the Mississippi River, 66–68;
 panorama of Venice, 66; *Sea of Galilee*, 71–72, *71*
Baptist Church, 128
Baptist Theological Seminary, Chicago, 163
Barclay, James T., 73–75, 146–47, 176, 186
 WORKS: *The City of the Great King*, 73, 176;
 panorama of Jerusalem and the Holy Land, 73
Bartlett, W. H., 176
Barrett, Benjamin Fiske, 105–6, 119–20, 124, 233n47
Barrows, John Henry, 153, 157, 161–62, 236n1, 237n9
Baym, Nina, 45
Beardsley, Richard, 225n55
Beauboucher, Victor, 225n55
Beecher, Henry Ward, 153
Beirut, 28–29, 109, 129, 133, 168, 173, 176, 178, 182,
 223n29, 235n34
Benjamin, S. G. W., 204–5
Bercovitch, Sacvan, 20, 219n2
Bermingham, Ann, 192
Bethany, 191
Bethany College, 127–28, 137, 145–48, 235n45
Bethlehem, 16, 37, 68, 77, 109, 209
Beverley, Robert, 14, 220n5
Bierstadt, Albert, 159, 228n4
 WORKS: *The Rocky Mountains*, 159
Bierstadt, Charles, 74, 228–29n4
Bird, Arthur, 3–4
Bird, Isaac, 64
Bjelajac, David, 19–20
Blakelock, Ralph, 231n5
Bonaparte, Napoleon, *see* Napoleon Bonaparte
Borthwick, Cunningham, 178, 240n26
Bosnia, 9
Boston, 19, 54, 56, 59, 67–68, 70, 73, 133, 226n10,
 227n27, 240n41
Boston Athenaeum, 71
Boston Public Library, 213

Bradbury, Kate, 242n80
Bradford, Cornelius, 29
Branham, Joan R., 83
Bridgman, Frederick, 219n5
Brooklyn, N.Y., 70, 94, 167, 227n27, 228n36, 229n7
Brooklyn Academy of Design, 153
Brooklyn Art Association, 239n25
Broun, Elizabeth, 237n27
Brown, Henry Kirke, 104
Bryant, William Cullen, 224n37
Buffalo, N.Y., 152, 228n43
Bulgaria, 9
Buncher, Charles, 161
Bunsen, Robert Wilhelm, 158
Burford, Robert, 59, 226n18
Bursa, 111
Burt, Nathaniel Clark, 185
Bushnell, Horace, 175, 204, 239n19

Cairo, 8–9, 59, 107, 173
Calhoun, John C., 37
Campbell, Alexander, 127–28, 137, 145–48, 234n19,
 235n40, 236n47
Canning, Stratford, 111
Capernaum, 129
Carr, Dabney, 111
Carr, Gerald, 240n25
Cass, Lewis, 32
Catherwood, Frederick, 14, 56, 59, 62–65, 68–71,
 226n15, n18, 226–27n21, 227n22
 WORKS: panorama of Jerusalem, 34, 56, 59, 62–65,
 62, 69, 226n17–18; A View in the Interior of the
 Mosque of Omar, 226–27n21
Catlin, George, 142, 235n29
Catskill, N.Y., 169
Century Club, New York City, 193, 239n25
Champney, Elizabeth, 48
Champney, James Wells, 48
Chandler, Zachariah, 162
Charles I, 14
Chautauqua, N.Y., 78, 89–97, 123, 167, 217, 229–
 30n19–20, 230n24–25
Cheever, George B., 150
Cherry, Conrad, 13
Chicago, 50, 152, 161, 186, 227n27, 228n43, 238n29
Chicago Academy of Fine Arts, 239n25
Christadler, Martin, 201
Church of the Ascension, New York City, 214
Church of the Holy Sepulchre, Jerusalem, 44, 50, 62–
 63, 68, 69, 186, 190, 212, 228n35
Church of Jesus Christ of Latter-day Saints, see
 Mormons

Church, Frederic Edwin, 7, 28, 33, 40, 43, 45, 61, 149,
 159, 168–208, 210, 212, 222n15, 238n2, 238–39n8,
 239n11–12, n15, 239–40n24–25, 241n46, n54, n62,
 242n69, 243n7
 WORKS: The Aegean Sea, 204–5, 205; The Andes of
 Ecuador, 199, 241n57; Anti-Lebanon, 178, 178,
 180, 182, 184, 197, 202, 239–40n25, 242n77;
 Aurora Borealis, 184; Chimborazo, 184; Classical
 Ruins, Syria, 180–81, 180; A Composition, 201,
 202; Cotopaxi, 174, 175, 184, 199–200; Damascus
 from the Heights of Salchiyeh, 182–90, 197, 200,
 212, 240n33, n42; El Khasné, Petra, 193–97,
 241n62, 242n65, pl. 7; Heart of the Andes, 159,
 160, 174, 181, 184, 189, 204, 226n19, 237n20,
 240n37; Hooker and Company Journeying through the
 Wilderness from Plymouth to Hartford, in 1636, 169–
 71, 170; Icebergs, 184; Jerusalem from the Mount of
 Olives, 61, 179, 185–93, 187, 196–97, 200, 212,
 240n42, 241n51, n54, n57, pl. 5; key to, 190–91,
 190; Moonrise in Greece, 202, 203, 242n77; Mor-
 ning in the Tropics, 197; Moses Viewing the Promised
 Land, 169–71, 170; Mountains of Edom, 193–94,
 193, 197; Mountains of Lebanon, see Ruins at
 Baalbek; Niagara, 184, 189; Niagara Falls, from the
 American Side, 172, 189; Our Banner in the Sky,
 222n15; Our Flag, 222n15; The Parthenon, 188;
 Ruins at Baalbek, 177–78, 177, 180, 182, 239n23;
 Sunrise in Syria, 197, 199, 242n70; Syria by the
 Sea, 197–202, pl. 6; Syria—Ruins by the Sea, 205,
 206; Syrian Landscape, see Anti-Lebanon; Temple of
 Bacchus, Baalbek, see Anti-Lebanon; To the Memory of
 Cole, 181; Two Bedouin, 195, 242n65; Tropical
 Moonlight, 197, 198; Twilight in the Wilderness,
 181; Valley of Lebanon, see Anti-Lebanon; View from
 the Mountains toward Damascus, Syria, 183, 183;
 View of Cotopaxi, 172; West Rock, New Haven, 171–
 72, 171
Church, Isabel, 33, 172–73, 188, 190–91, 194, 238n8,
 239n12
Church, Richard, 169
Cincinnati, Ohio, 103–5, 107, 152, 231n4
Civil War, 7, 23–24, 39, 41, 44–45, 48–49, 72, 74, 101,
 134, 151, 172, 192, 207, 217, 222n15, 234n14, 235n40,
 236n46, n4, 237n28, 240n37
Claude Lorrain, 72, 242n70
Clemens, Samuel, 40–41, 46, 50–51, 182–83
Cleveland, Ohio, 73, 115, 125, 158, 234n51
Clevinger, Shobal Vail, 105
Coale, Jr., S. A., 161, 237n25
Cole, Thomas, 3–4, 24, 56–57, 72, 113, 169, 181, 185,
 201–2, 204, 212, 219n5, 238n2, n6, 240n30, n37
 WORKS: The Angel Appearing to the Shepherds, 56–57,

56; *Course of Empire*, 24, 25, 57, 72, 113, 201–2, 204; *The Cross and the World*, 169, 185; "The Lament of the Forest," 181, 240n30; *The Oxbow*, 240n37

Colman, Samuel, 231n5

Columbia College, 29, 32

Congregationalism, 20, 35, 162, 221n21, 241n54

Constantinople, 7, 9, 43, 111, 129, 142, 173, 204, 210, 223n29

Constitution, U.S.S., 32

consuls, 29, 37, 39, 48, 133, 153, 222n9, 223n22, n29, 225n55, 227n30

Cotton, John, 14

Cranch, John, 231n5

Cresson, Warder, 37

Cropsey, Jasper, 202–4, 223n26
Works: *The Millennial Age*, 223n26; *Spirit of Peace*, 202, 203

Currier and Ives, 68
Works: *Entrance to the Holy Sepulchre, Jerusalem*, 69

Damascus, 9, 42, 109, 129, 135, 139, 173, 176, 182–83, 204

Danforth, John, 13

Darwin, Charles, 89, 94, 174–75, 202, 217, 239n15

Davies, Arthur B., 167

Day, F. Holland, 230n29

De Forest, John William, 196

De Forest, Lockwood, 212–13, 243n7
Works: *Coast Scene*, 212–13, 213

De Lancey, Edward Floyd, 176–77, 186, 239n23

De Vrie's Gallery, Boston, 240n41

Dead Sea, 21, 33, 43, 50, 68, 109, 118, 129, 132–33, 137, 141–44

Delaware, U.S.S., 17, 32, 222n9

DeHass, Frank, 195, 202

Democratic Party, 20, 29, 32, 104

Detroit, Mich., 161

Dickie, George, 175

Disciples of Christ, 7, 73, 127–28, 146–47, 186

Diness, John Mendel, 74

Dodge, D. Stuart, 40, 173, 239n11

Dodge, Ellen Ada, 173, 185

Dodge, William E., 241n46

Dome of the Rock, Jerusalem, 59, 62, 154, 157, 163–64, 212, 227n21

Dotterer, A. F., 74

Dunlap, William, 231n9

Durand, Asher B., 104

Durand, John, 231n5

Düsseldorf, 153

Earthly Footsteps of the Man of Galilee, 77–89, 97, 208, 229n9

Eckstein, Frederick, 103

Edson, James L., 161

Eliade, Mircea, 119–20, 122, 143, 191

Elmendorf, Dwight, 229n7

Emerson, Ralph Waldo, 236n46

Episcopal Church, 103, 176

Evans, Thomas, 54

Evarts, William Maxwell, 151, 236n4

Fairman, Evelina, 237n28

Fairman, George, 237n22, n26

Fairman, James, 7, 149–68, 150, 191, 208, 210, 213, 217, 230n1, 235n45, 236n3–4, n7, n9, 237n14, n26, n28, 238n29, n34
Works: *Alpine Landscape with River*, 154, 154; *Cows in a Pasture*, 161; *The Damascus Gate, Jerusalem*, 154; *Figures in a Middle Eastern Landscape*, 157, 158, 165–66; *The Holy Land*, 157; *Jaffa*, 157, 157; *Jerusalem*, 154, 156, 165; *Jerusalem from Aceldama*, 163; *Jerusalem from the Mount of Olives*, 154, 155, 166; *Mount Moriah, Jerusalem*, 162; *Mount of Olives from Mount Zion*, 162–63; *The Mussulman's Call to Prayer*, 163–65, 164, pl. 2; *The Plains of Sharon*, 161; *Sunset*, 165–66, pl. 4; *Sunset over the City of Jerusalem*, 167; *The Valley of Jehoshaphat*, 154; *View of Aceldama*, 154; *View of Jerusalem*, 154, 155–56, 166; *Wetterhorn, Switzerland*, see *Alpine Landscape with River*

Fairman, Sarah, 237n28

Field, Cyrus W., 241n46

Fisk, Pliny, 28

Florence, 42, 105, 115, 233n42

Foucault, Michel, 61

Fowler, Alexander, 173

Fowler, Frederick R., 227n30

Franklin, Benjamin, 15, 236n46

Free Religious Association, New York City, 211

Frémont, John C., 21

Frère, Edouard, 178–79

Frère, Théodore, 178–79
Works: *Jerusalem, View from the Valley of Jehoshaphat*, 179, 179

Frosch, Karl, 228n43

Gates, T. G., 233n32

Geikie, Cunningham, 175–76, 239n19

George III, 14

Georgetown, Ky., 127

Gifford, Sanford, 28, 210–12
WORKS: *Jaffa Gate, David's Tower*, 211; *Ruins of the Parthenon*, 211
Gilpin, William, 17
Glasgow, 150
Glueck, Nelson, 37
Gould, Stephen Jay, 175, 231n12
Goupil's Gallery, New York City, 183, 188, 190, 193, 239n25
Granet, François Marius, 135
WORKS: *Choir of the Capuchin Church of Santa Maria della Concezione in Rome*, 135, 136
Grant, Allen, 175
Grayson, Andrew Jackson, 21–22
Gunn, Giles, 17

Hall, S. C., 162, 237n26
Hamilton College, 35
Haram al-Sharif, Jerusalem, 62–63, 69, 163
Harrisburg, Pa., 30
Hart, William, 152
Hartford, Conn., 200, 241n54
Harvard University, 15, 35
Hawthorne, Nathaniel, 43
Haydon, Benjamin Robert, 151–52
Heade, Martin Johnson, 172–73
Hebron, 109
Heine, Wilhelm, 228n43
Herzegovina, 9
Hicks, Thomas, 41–43, 224n35
WORKS: *Bayard Taylor*, 41, 42, 43, 224n35
Higginson, Francis, 14
Hill, James J., 161
Holden, L. E., 234n51
Holmes, Oliver Wendell, 74–75
Hooker, Thomas, 169
Hopkins, Edward, 14
Hopkins, Mark, 15
Hovenden, Thomas, 17
WORKS: *Jerusalem the Golden*, 17, 18
Howe, Julia Ward, 23
Humboldt, Alexander von, 175, 204
Hunt, William Holman, 144–45, 235n34
WORKS: *The Scapegoat*, 144–45, 145, 235n34, n37
Huntington, David, 171
Hurdus, Adam, 103
Husch, Gail, 204
Hyde, Orson, 22
Hyers, Laurence, 54

Inness, George, 185, 231n5, 240n41
WORKS: *New Jerusalem*, 240n41

Inness, George, Jr., 231n5
Israel, Michael Boaz, *see* Cresson, Warder
Istanbul, *see* Constantinople

Jackson, Andrew, 20, 104
Jaffa, 17, 32–33, 39–40, 49, 95, 153–54, 173, 212–13, 222n9, 223n29
James, Henry, 153
James, William, 74
WORKS: *Mount Olivet*, 75
Jarves, James Jackson, 159
Jefferson, Thomas, 15
Jeffersonville, Ind., 104
Jericho, 109, 137
"Jerusalem" (poem), 24
Jerusalem, 8–9, 15–16, 19–20, 22, 24, 28–30, 32–33, 37, 43–44, 48–50, 54–55, 59–69, 73, 75, 81, 95, 109–10, 120, 129, 133, 138–39, 146–47, 149, 153–57, 163–67, 173, 179, 186–92, 204, 208, 210, 212, 223n22, n29, 225n55, n5–6, 232n15, 235n41
Jesup, Morris K., 239n11, 241n46
Jewett, William, 21–22, 171
WORKS: *The Promised Land—The Grayson Family*, 21, 22, 171, 221n23
Jordan River, 43–44, 75, 109, 137–38, 142–43, 186, 225n3, 234n19

Kansas City, Mo., 162
Keith, Alexander, 76
Keith, William, 231n5
Kellogg, Charles, 103
Kellogg, Miner Kilbourne, 7, 28, 42–43, 101–26, 102, 149, 153, 168, 208, 230–31n1–2, 232n13, n16, n23, 232–33n28–29, 233n42, 233–34n47–48, 234n51
WORKS: *An American Gentleman, in the Costume of a Bedouin Sheikh—Mount Sinai in the Background*, 115, 232n27; *Beirout and Mt. Lebanon*, 115, 232n27; *Christ and the Woman of Samaria*, 125; *Hagar Expelled*, 125; *Jerusalem*, 109, 109; *Mount Sinai and the Valley of Es-Seba'iyeh*, 101–3, 115–20, 116, 124–25, 233n29; *Nile, 3rd and 4th Views*, 106, 107; *Self-Portrait*, 102; *Sketch of the Artist Camped Outside Jerusalem*, 110–11, 110, 232n15; *The Sphinx*, 123, 123; *Sphynx with Pyramids of Ghizeh*, 106, 108, 123; *St. John—Descent of the New Jerusalem*, 120, 121, 122–23, 233n42; *The Top of Mount Sinai with the Chapel of Elijah*, 121–24, *pl. 1*; *View of Theban Mountains*, 106, 108
Kellogg, Sheldon, 107, 232n15
Kellogg, Virginia, 124, 234n48

Kilburn, Benjamin West, 74
 WORKS: *Tilling the Soil in Palestine*, 140
King, Edward, 232n27
King, Jonas, 28
Kitto, John, 115

La Farge, John, 214
Lakeside, Ohio, 90
Landis, John, 29–30, 222n6
 WORKS: *Jesus in the Upper Room*, 30, 31; *Madonna and Child Visiting the Family of John the Baptist*, 30, 31; *A Treatise magnifying, lauding and applauding God! and extolling the Redemption, by the Sister Arts of Poetry and Painting, with Sacred Poetical Effusions*, 30
Langdon, Samuel, 15
Lawrence, Mass., 236n9
Layard, Austen Henry, 111–13, 232n16, n22
Lear, Edward, 48
Lears, T. J. Jackson, 94
Lee, James W., 77–78, 83, 86–88
Lee, Robert E., 23
Leutze, Emanuel, 185
Lincoln, Abraham, 14, 23–24, 49
Lohr, August, 228n43
London, 56, 59, 127, 150, 153, 159, 172, 184, 225n5, 226n18, 234n48
Longfellow, Henry Wadsworth, 184
Louisiana Purchase Exposition, St. Louis, 95–97
Lovell, Margaretta, 214–15
Lucas, George, 179
Lyell, Charles, 174, 181–82
Lynch, William F., 33, 72, 133, 141–43, 235n31
Lyons, 29

Macbeth, William, 167, 209
Macmillan, Hugh, 125
Mahmud II, 8
Manifest Destiny, 17
Manthorne, Katherine, 240n37
Marseilles, 172
Martin, Homer D., 167
Martin, John, 57, 185
 WORKS: *Belshazzar's Feast*, 57, 58
Marx, Karl, 217
Mather, Cotton, 14, 169
Maynard, Edward, 233n29
McCosh, James, 175, 239n19
McEntee, Jervis, 168, 188–89, 238n1, 239n12, 242n69
McLean, L. M., 184
McMillan, James, 162
Mecca, 70, 164

Melrose, Andrew, 183, 240n37
 WORKS: *Damascus*, 183, 184; *Jerusalem and Mount of Olives from the Road to Bethany*, 240n37; *Morning in the Andes*, 240n37; *The Oxbow*, 240n37; *Sea of Galilee*, 240n37
Melville, Herman, 43–45, 143
Meshullum, John, 38
Methodist Episcopal Church, 18, 77
Metropolitan Museum of Art, 115, 233n29
Millennialism, 20, 28, 37–39, 146, 204, 221n29, 223n26, 235n31
Miller, Angela, 181
Miller, Perry, 19
Miller, William, 38
Millman, Henry Hart, 66–67
Milwaukee, Wis., 228n43
Minneapolis, Minn., 161
Minor, Clorinda S., 38
missionaries, 6, 9, 28–29, 35, 47, 51, 109, 173, 222n13, 235n41
Mississippi River, 55, 66
Moab, Utah, 21
Mobile, Ala., 134
Monroe Doctrine, 4
Montreal, 152, 234n8
Moore, Deborah Dash, 5, 219n7
Moravians, 66
Mormons, 20–22, 39
Morris, Robert, 49–51, 64, 140, 173, 200
Mosque of al-Aqsa, Jerusalem, 163–64
Mount Hor, 200
Mount Horeb, 113, 118
Mount of Olives, 22, 48, 63, 68, 75, 109, 119, 154, 157, 163–64, 188, 190–91, 200, 217
Mount Sinai, 107, 113–19, 121–22
Mount Tabor, 78, 109, 119
Muhammad 'Ali, 8, 30
Murphy, J. Francis, 167

Nablus, 109
Naples, 104
Napoleon Bonaparte, 8, 20, 216
Nashville, Tenn., 66
National Academy of Design, 7, 41, 71, 150, 152, 188, 194, 205, 227n21, 228n40, 230n1, 233n32, 235n37, 241n62
Native Americans, 14, 20, 142, 220n6
Nazareth, 68, 109
New Bedford, Mass., 227n27
New Harmony, Ind., 104
New Haven, Conn., 240n42
New Jerusalem Church, *see* Swedenborgianism

New Orleans, 23, 133–34
New York City, 7, 14, 32, 34–35, 54–57, 59, 63, 66–67, 70–71, 113, 115–16, 133, 150–53, 161–62, 177–78, 180, 186–87, 204, 225n5, 226n11, n17–18, 227n27, 228n43, 236n2, n7
Newhall, Ebenezer, 20, 221n21
Nile River, 43, 105–6, 211
Noah, Mordecai M., 14
Noble, Louis, 174
Norwood, Mass., 230n29
Novak, Barbara, 239n15

Ocean Grove, N.J., 230n19
Olana, 175, 194, 200, 204–7, 242n80
Olivet, *see* Mount of Olives
Olivet College, 159, 162–63, 238n29
Osborn, William, 173–74, 177–78, 182, 194, 197, 204–5, 239n24, 240n26, 242n69
Ostrander, J. S., 92, 223n24
Ottoman Empire, 7–9, 28, 30, 40, 165, 187, 211
Owen, Robert, 104

Page, William, 122–23, 231n5
 WORKS: *Moses, Aaron, and Hur on Mount Horeb*, 122–23
Palestine Exploration Fund, 48, 186
Palmer, Benjamin M., 23, 134, 146
Palmer, Erastus Dow, 193–94
panoramas, 6, 15, 34, 53–56, 59–73, 110, 118, 133, 149, 159, 167, 189, 225n4–6, 227n27–30, 228n32, n35, n43
Paris, 56, 115, 129, 153, 162, 172, 217
Parry, Ellwood, 182, 225n5
Parsons, Levi, 28
Patterson, Daniel T., 222n9
Peabody Institute, Baltimore, 116
Pearce, Charles S., 219n5
Pennsylvania Academy of The Fine Arts, 30, 232n27
Perrine, William Henry, 89
Pestalozzi, Johann, 104
Petra, 32, 34, 128, 173, 176, 193–96, 204, 242n64
Phelps, William Walter, 185, 240n33
Philadelphia, 37, 70, 152, 183, 227n27, 228n43, 232n27
Pickett, Joseph Desha, 128
Piglheim, Bruno, 228n43
Pisa, 49
Pittsburgh, Pa., 152
Polk, James K., 104
Poole, William, 94
Post, George E., 222n13
Powers, Hiram, 42, 101, 103, 105–6, 111, 113, 115, 120–21, 232n23
 WORKS: *Greek Slave*, 101, 113

Pratt, Henry Cheever, 117–18, 227n27
 WORKS: *Moses on the Mount*, 117–18, *117*; panorama of the Garden of Eden, 227n27
Prendergast, Maurice B., 167
Presbyterians, 47, 103, 128–29, 162, 242n69
Prime, William Cowper, 45–46, *46*, 64, 71, 133, 141, 176, 224n47
Providence, R.I., 73
Puritans, 4, 13–14, 17, 20, 23–24, 37, 40, 169, 217
Pyle, Howard, 231n5

Quaker City, 41
Quakers, 37

Raboteau, Albert, 23
Rapelje, George B., 29
Rau, William H., 33
 WORKS: *E. Wilson Seated atop the Great Pyramid, with American Flag Jacket*, 33, *34*
Rawson, Albert, 28
Read, Hollis, 23
Red Sea, 13, 15, 23, 119, 169
Republican Party, 3, 151, 162, 236n2, 237n28
Rhodes, Albert, 48
Richards, Alexander Keene, 127–29, 132–35, 137, 145, 234n19
Roberts, David, 57
 WORKS: *Departure of the Israelites from Egypt*, 57, *58*
Robinson, Edward, 16, 18, 29, 32, 34–37, 47, 64, 113, 115–17, 141, 176
Rodolph of Fulda, 191
Rogin, Michael Paul, 44, 224n43
Roman Catholicism, 28–29, 46, 147, 151, 176, 186, 224n48
Rome, 173–74, 183–84
Roosevelt, Theodore, 89
Ropes, Joseph, 125, 231n5
Rossetti, William Michael, 144
Round Lake, N.Y., 90
Royal Academy, London, 232n27, 235n37
Ruskin, John, 125–26, 144

Said, Edward W., 229n17
San Francisco Art Association, 236n7
Sargent, John Singer, 213–18
 WORKS: *Near the Mount of Olives*, *215*, 216–17; *Palestine*, 216, *216*, 217; *The Plains of Esdraelon*, *214*, 215–17; *The Triumph of Religion*, 213–14
Schaff, Philip, 221n22
Schlegel, Fridolin, 45
 WORKS: *Braheem Effendi, Portrait of William C. Prime*, 45, *46*

Sea of Galilee, 71–72, 87, 109, 129, 137, 142, 153

Sea of Tiberias, *see* Sea of Galilee

Second Great Awakening, 19, 38

Selim III, 8

Shakers, 105

Shaw, Joshua, 227n27
 Works: panorama of the Holy Land, 227n27

Sidon, 24, 109

Sinai, 16, 21, 32, 43, 59, 102, 107, 109, 119, 173, *see also* Mount Sinai

Smith, E. Delafield, 150, 236n2

Smith, Eli, 36

Smith, Henry, 162

Smith, Joseph, 21

Social Darwinism, 95

Solomon-Godeau, Abigail, 229n10

Spafford, Anna, 222n16

Spafford, Horatio, 222n16

Spencer, Morton, 94

Spring Hill College, 134

Springfield, Ill., 153

Springfield, Mass., 39

St. Augustine, Fla., 94

St. Louis, Mo., 66–67, 77, 95–96, 152–53, 161

St. Paul, Minn., 161

Stanley, Arthur Penrhyn, 176, 188

Steendam, Jacob, 14

Stephens, John Lloyd, 32–34, 37, 43

Stereo photography, 74–76, 228n3

Stillman, William, 231n5

Strong, James, 74

Swedenborg, Emanuel, 103, 105–6, 112, 119–20, 124–25, 231n5, 233n37

Swedenborgianism, 7, 103–6, 112, 119–22, 124–25, 231n4–5, 233n37, 233–34n47–48

Syrian Protestant College, *see* American University of Beirut

tableaux vivants, 94–95

Tanner, Benjamin Tucker, 209

Tanner, Henry Ossawa, 208–10, 213
 Works: *The Good Shepherd*, 209, *210*, 213

Tarbell, Ida M., 230n20

Taylor, Bayard, 41–43, *42*, 45, 244n35

Taylor, Joseph Inskeep, 33, 49

Taylor, Joshua, 122–23, 233n37

Thompson, Cephas G., 231n5

Thompson, J. P., 113

Thomson, William McClure, 45–48, 77, 106, 138, 140, 173, 201, 224n50

Toledo, Ohio, 115

Towle, Eunice M., 231n5

Troy, Charles de, 133

Troye, Edward, 7, 34, 41, 127–49, 162, 168, 191, 215, 235n34, n37
 Works: *Bashan Cattle*, 235n26; *Bazaar in Damascus*, 129, *130*, 133, 135, 137; *The Dead Sea*, 129, *132*, 134–35, 137–39, 141–45, 191, 215, *pl. 2*; *John Bascombe*, *128*, 135; *River Jordan—Bethabara*, 129, *131*, 135, 137–38; *The Sea of Tiberius*, 129, *131*, 135, 137–38; *Self-Portrait in a Carriage*, 135–37, *136*; *Syrian Ploughman*, 129, *132*, 135, 137, 139–40

Tuckerman, Henry, 191–92

Turner, Joseph Mallord William, 158, 182, 184, 199, 204

Twitchell, A. W., 233n32
 Works: *Moses on the Mount*, 233n32

Tyre, 24

Underwood and Underwood, 75–76

Union Theological Seminary, 35

Unitarianism, 35, 103, 211, 221n21, 241n54

United States Navy, 30, 33, 118, 141, 222n9

Universalism, 103

Urry, John, 6

Utica, N.Y., 152

Vanderlyn, John, 55, 63, 104, 227n22
 Works: panorama of Versailles, 63, 227n22

Van Buren, Martin, 104

Van Lennep, A. O., 92, 223n24

Vassar College, 235n45

Veblen, Thorstein, 230n27

Venice, 66, 205, 210, 214

Victoria I, 66

Vienna, 36

Vincent, John Heyl, 18, 77–78, 89, 92

Vogel, Lester Irwin, 211–22n2, 228n3

Wakeman, Samuel, 14

Wales, Salem H., 162

Walker, J. M., 178

Wallach, Alan, 61

Warren, Charles, 48–49, 186, 189, 220n12

Warren, Henry White, 16–18

Washington, D.C., 115–16, 142, 233n29, 234n8

Washington, George, 14

Webster, Daniel, 20

Weeks, Edwin Lord, 219n5

Weir, Robert W., 104

West, Benjamin, 57
 Works: *Death on a Pale Horse*, 57

West Point, N.Y., 104

Whichelo, John, 57, 61
 WORKS: *Destruction of Jerusalem*, 57, 60, 61
Whig Party, 20
White, John, 14
Whiting, George B., 64
Whittredge, Worthington, 143
 WORKS: *Graves of Travellers, Fort Kearney, Nebraska*,
 143, *144*
Wilkie, David, 28
Williams College, 15
Williams, John I., 227n27
 WORKS: panorama of the Bible, 227n27
Williams, Milo, 103

Williams, Roger, 219–20n4
Willis, Nathaniel Parker, 3–4
Wilson, Edward L., 87, 143, 196, 222n13
Winthrop, John, 14–15
Winthrop, Theodore, 174
Wood, Henry, 133
Wright, John Kirkland, 83, 229n13
Wythe, W. W., 89, 229n19

Yale University, 185

Zelinsky, Wilbur, 17
Zionism, 23